Photographer's Guide to the Sony a7C

		,		
			•	
	9			

Photographer's Guide to the Sony a7C

Getting the Most from Sony's Compact Full-Frame Camera

Alexander S. White

WHITE KNIGHT PRESS HENRICO, VIRGINIA

Copyright © 2021 by Alexander S. White.

All rights reserved.

No part of this publication may be reproduced, stored in a retrieval system or transmitted in any form or by any means, electronic, mechanical, photocopying, recording or otherwise, without the prior written permission of the copyright holder, except for brief quotations used in a review.

The publisher does not assume responsibility for any damage or injury to property or person that results from the use of any of the advice, information, or suggestions contained in this book. Although the information in this book has been checked carefully for errors, the information is not guaranteed. Corrections and updates will be posted as needed at whiteknightpress.com.

Product names, brand names, and company names mentioned in this book are protected by trademarks, which are acknowledged.

Published by White Knight Press 9704 Old Club Trace Henrico, Virginia 23238 www.whiteknightpress.com contact@whiteknightpress.com

ISBN: 978-1-937986-88-9 (paperback) 978-1-937986-89-6 (ebook)

Contents

INTRODUCTION	
Chapter 1: Preliminary Setup	3
Charging and Inserting the Battery	4
Chapter 2: Basic Operations)
Introduction to Main Controls Top of Camera Back of Camera Front of Camera Left Side of Camera Right Side of Camera Bottom of Camera Taking Pictures in Intelligent Auto Mode Variations from Fully Automatic Focus Focus Modes Tracking Autofocus Other Settings	9 0 11 12 12 13 15 15
Flash	16 17 18 19
CHAPTER 3: SHOOTING MODES FOR STILL IMAGES Intelligent Auto Mode	21

Aperture Priority Mode					
Manual Exposure Mode					
Memory Recall Mode					
, , , , , , , , , , , , , , , , , , , ,					
Chapter 4: The Camera	SETTING	gs1 M	ENU		32
File Format (Still Images)					
Raw File Type					_
JPEG Quality					-
JPEG Image Size					
Aspect Ratio					-
APS-C/Super 35mm					
Long Exposure Noise Reduction					
High ISO Noise Reduction					
Color Space					
Lens Compensation					
Chromatic Aberration Compensation					
Distortion Compensation					
Drive Mode					
Single Shooting					
Continuous Shooting					
Self-Timer					
Self-Timer (Continuous)					
Continuous Exposure Bracketing					
Single Exposure Bracketing					
White Balance Bracketing					
DRO Bracketing					
Bracket Settings					
Interval Shooting Function					
Recall				 	 50
Memory					
Register Custom Shooting Settings				 	 51
Focus Mode					
Single-Shot AF					
Automatic AF				 	 54
Continuous AF				 	 54
DMF					
Manual Focus					
Priority Set in AF-S					
Priority Set in AF-C					
Focus Area					
Wide					
Zone					
Center					
Flexible Spot					
Expand Flexible Spot					
Tracking					
Focus Area Limit				 	 62
Switch Vertical/Horizontal AF Area AF Illuminator					
AF Illuminator					64
AF Tracking Sensitivity (Still Images)					64
Aperture Drive in AF (Still Images)				 	 65
AF w/Shutter (Still Images)					
Pre-AF (Still Images)					66

Eye-Start AF (Still Images)	6
AF Area Registration	6
Delete Registered AF Area	
Focus Frame Color	57
AF Area Auto Clear	57
Display Continuous AF Area	57
Circulation of Focus Point	8
AF Frame Move Amount	8
AF Micro Adjustment	8
Exposure Compensation	59
Reset EV Compensation	70
ISO Setting	71
ISO	
ISO Range Limit	72
ISO Auto Minimum Shutter Speed	
Metering Mode	
Face Priority in Multi Metering	
Spot Metering Point	
Exposure Step	
AEL with Shutter	
Exposure Standard Adjustment	
Flash Mode	
Flash Off	
Autoflash	
Fill-Flash	
Slow Sync	
Rear Sync	
Flash Compensation	
i .	80
	80
Using Sony's Light-Based Wireless Protocol	
Using Sony's Radio-Based Flash System	
Red Eye Reduction	
External Flash Setting	
White Balance	
Priority Set in Auto White Balance	
,	86
	89
	90
Standard	_
Vivid	
Neutral	
Clear.	
Deep	
Light	
Portrait	
Landscape	
Sunset	
Night Scene	
Autumn Leaves	
B/W	
Sepia	
Picture Effect	
Off	
Toy Camera	
Pop Color	
Posterization	94

Retro Photo	94
Soft High-Key	. 95
Partial Color	. 95
High Contrast Monochrome	. 95
Rich-Tone Monochrome	. 95
Picture Profile	96
Shutter Auto White Balance Lock	
Focus Magnifier	
Focus Magnification Time	
Initial Focus Magnification	
AF in Focus Magnifier	
MF Assist	
Peaking Setting	
Anti-Flicker Shooting	
Face Registration.	
Registered Faces Priority	
registered recording to the control of the control	104
	05
Exposure Mode (Movies)	
Exposure Mode (S & Q)	
File Format (Movies)	
Record Setting	
S & Q Settings	
Proxy Recording	
AF Transition Speed	
AF Subject Shift Sensitivity	
Auto Slow Shutter	
Initial Focus Magnification (Movies)	
Audio Recording	
Audio Recording Level	
Audio Level Display	
Audio Out Timing	
Wind Noise Reduction	
Marker Display	
Marker Settings	
Video Light Mode	
Movie w/Shutter	108
Silent Shooting (Still Images)	108
Release without Lens	108
Release without Card	108
	109
	109
Zoom	110
Zoom Setting	111
Zoom Ring Rotate	113
Display Button	114
	116
Finder Frame Rate	116
Zebra Setting	117
Grid Line	118
	119
Square Grid	119
Diagonal Plus Square Crid	119
Evangura Cattinga Cuida	119
Live View Display	120
Continuous Charting Laureth	121

Auto Review	
Custom Key (Still Images)	 121
AF-ON Button	 122
Recall Custom Hold 1, 2, and 3	 123
Recall Custom Hold 1, 2, and 3	 125
AF/MF Control Togglo	 125
AF/MF Control Toggle	 126
Focus Standard	 126
Registered AF Area Hold/Registered AF Area Toggle/Registered AF Area + AF On	
rideking Off	
Lye Ar	
Subject Detection	407
Switch right/Left Eye	
Switch AF Frame Move Hold	120
Ar On	0
rocus Hold	400
ALL Hold	400
AEL loggie	400
Spot AEL Toggle	 129
Spot AEL Toggle	 129
Wireless Test Flash	 129
FEL Lock Hold/FEL Lock Toggle/FEL Lock/AEL Hold/FEL Lock/AEL Toggle	 129
AWB Lock Hold/AWB Lock Toggle	 129
AWB Lock Hold/AWB Lock Toggle	 130
In-Camera Guide	 130
Movie (Shooting)	 131
Aperture Preview	 131
Shot result Preview	
bright worldong	404
My Diai 1/2/3 During Hold	121
My Dial 1—2—3	
loggie My Diai 1/2/3	420
Flayback	422
MENO	122
Display My Menu	
Not set	400
Custom (C) Button	
Center Button	 133
Left Button	 133
Right Button	 133
Down Button	 134
Down Button	 134
Focus Hold Button	 134
Custom Key (Movies)	 134
AF-ON, Custom (C), Movie, and Focus Hold Buttons:	 134
Center Button	 135
Left, Right, and Down Buttons	 135
Custom Key (Playback)	 135
Function Menu Settings	 136
My Dial Settings	138
Dial/wheel Setup	139
AV/ IV hotale	139
Dial/wheel Ev Compensation	140
runction king (Lens)	140
Function of Touch Operation	
rouch shutter	140
Touch Focus.	 140
Touch Tracking	141
Dial/Wheel Lock	 141
Audio Signals	 141
	 142

Chapter 6: Physical Controls	143
Shutter Button	143
On 10ff Switch	143
Made Diel	143
Movie Button	144
Multi Interface Shoe	144
Sensor Plane Indicator	144
Speaker	144
Viewfinder and Eye Sensor	144
Diopter Adjustment Wheel	145
Menu Button	145
Control Dial	146
AF-ON Button	146
Function Button	146
Menu System Navigation	146
Function Menu	147
Quick Navi System	148
Dial/Wheel Lock	
Send to Smartphone	149
Playback Button	149
Custom/Delete Button	149
Control Wheel and its Buttons	149
Control Wheel	150
Center Button	151
Up Button: Display	151
Up Button: Display	151
Right Button	151
Down Button	151
LCD Monitor	151
Tilting and Swiveling Features	151
Touch Cerean Features	152
Parts for Audio HDMI and Other Functions	154
NEC Active Area	154
Long Mount and Lens Release Button	155
AF Illuminator/Self-Timer Lamp	155
Microphone	155
Bottom of Camera	155
Chapter 7: Playback	156
Normal Playback	156
Normal Playback	156
Index View and Enlarging Images	158
Deleting Images with the Delete Button	159
Playback Menu	159
Protect	160
Rotate	16
Delete	16
Rating	16
Rating Set (Custom Key)	16
Specify Printing	10.
Photo Capture	104
Enlarge Image	102
Enlarge Initial Magnification	10
Enlarge Initial Position	16

Contents

Continuous Playback for Interval Shooting/Playback Speed for Interval Shooting	16
Continuous Playback for Interval Shooting/Playback Speed for Interval Shooting	
/iew Mode	
mage Index	
Display as Group	
Display Rotation	16
mage Jump Setting	16
pter 8: The Setup Menu and My Menu	17
up Menu	1
20 1	
Monitor Brightness	
Viewfinder Brightness	
Finder Color Temperature	
Gamma Display Assist	
Volume Settings	
Delete Confirmation	1
Display Quality	1
Power Save Start Time	1
Auto Power Off Temperature	1
NTSC/PAL Selector	1
Cleaning Mode	
Touch Operation	
Touch Panel/Pad	
Touch Pad Settings	
TC/UB (Time Code/User Bit) Settings	
TC/UB Display Setting	
TC Preset	
UB Preset	
TC Format	
TC Run	1
TC Make	1
UB Time Record	1
HDMI Settings	1
HDMI Resolution	1
24p/60p Output	1
HDMI Information Display	
TC Output	
Rec Control	
CTRL for HDMI	
4K Output Select	
Memory Card + HDMI	
HDMI Only (30p)	
HDMI Only (24p)	
HDMI Only (25p)	
USB Connection	
USB LUN Setting	′
USB Power Supply	
Language	
Date/Time Setup	
Area Setting	
IPTC Information	
Copyright Info	
Write Serial Number	
Format	
Select REC Folder	
New Folder	

File/Folder Settings (Still Images)	 	 	186
File Number	 	 	186
Set File Name	 	 	186
Folder Name	 	 	186
File Settings (Movies)	 	 	187
File Number	 	 	187
Series Counter Reset	 	 	187
File Name Format	 	 	187
Title Name Settings	 	 	187
Recover Image Database	 	 	188
Display Media Info	 	 	188
Version			
Setting Reset	 	 	189
My Menu	 	 	189
Chapter 9: Motion Pictures			191
Movie-Making Overview	 	 	191
Details of Settings for Shooting Movies			
Movie-Related Menu Options	 	 	192
Exposure Mode (Movies)	 	 	192
Program Auto	 	 	193
Aperture Priority	 	 	193
Shutter Priority	 	 	194
Manual Exposure	 	 	194
Exposure Mode (S & Q)	 	 	195
File Format (Movies)	 	 	195
XAVC S 4K	 	 	195
XAVC S HD	 	 	196
Record Setting	 	 	196
XAVC S 4K			
XAVC S HD			
S & Q Settings			
Proxy Recording			
AF Transition Speed			
AF Subject Shift Sensitivity			
Auto Slow Shutter			
Initial Focus Magnification (Movies)			
Audio Recording			
Audio Recording Level			
Audio Level Display			
Audio Out Timing			
Wind Noise Reduction			
Marker Display			
Marker Settings			
Video Light Mode			
Movie with Shutter			
Custom Key (Movies)			
Effects of Mode Dial Position on Recording Mo			
Effects of Camera Settings 1 Menu Settings on			
Effects of Physical Controls When Recording M			
Slow and Quick Motion Recording			
Recording to an External Video Recorder			
Capturing Still Images from Video Recording			
Summary of Options for Recording Movies			
Other Settings and Controls for Movies			
Movie Playback	 	 	213

Contents

Editing Movies 21 Stabilizing Movies Using Software 21 Catalyst Browse 22 Movie Edit Add-on for Imaging Edge Mobile App 22	15 15
Chapter 10: Wi-Fi, Bluetooth, and Other Topics 217	7
Wi-Fi and Bluetooth Features	17 18
Sending Images to a Computer Using the FTP Transfer Function	20
Remote Control of Camera from Computer (Tethered Shooting)	
Adding Location Information to Images Using Bluetooth Connection from Smart Device	
Using the a7C Camera as a Webcam	
The Network Menu	
Send to Smartphone Function	
FTP Transfer Function	
PC Remote Function	
PC Remote	
PC Remote Connect Method	
Pairing	29
Airplane Mode	
Wi-Fi Settings	
WPS Push	
Access Point Settings	
Frequency Band	
SSID/PW Reset	
Bluetooth Settings	
	231
	231
Edit Device Name	232
Import Root Certificate	
Security (IPSEC)	
Reset Network Settings	
Other Topics	
Street Photography	
Astrophotography and Digiscoping	-34
Appendix A: Lenses and Accessories 23	5
Lenses	235
E mount beinges for fair frame of the first state o	235
E modific Ecriscs for this election cannot be a series of the control of the cont	235
A modific Bellocol 1 1 1 1 1 1 1 1 1 1 1 1 1 1 1 1 1 1 1	237
Casesiiiiiiiiiiiiiiiiiiiiiiiiiiiiiiiiiii	238
butteries and energets 1.1.1.1.1.1.1.1.1.1.1.1.1.1.1.1.1.1.1.	238 239
	239 241
Remote Controls	
External LCD Monitor	
External Microphones	
External Video Recorder	

Appendix B: Quick Tips	2	24	18
Appendix C: Resources for Further Information		25	52
Websites and Videos. Digital Photography Review. Reviews and Demonstrations of the a7C White Knight Press. Official Sony Sites. Other Resources.			252 252 252 252 253
Index			254

Introduction

since I started writing and publishing camera guide books in 2009, almost all of the cameras I covered were compact models with fixed lenses and relatively small image sensors. I generally did not create guide books for cameras that take interchangeable lenses or that have "full-frame" sensors. The two exceptions were the books for the Sony DSC-RX1R II, which has a full-frame sensor but a fixed lens, and the Sony a6400, which takes interchangeable lenses but has an APS-C-sized sensor, smaller than full-frame. Both of those cameras were sufficiently compact to come within my area of interest.

With the Alpha 7C (called the a7C in this book and also known as the ILCE-7C), Sony has released a camera that is equipped with a large sensor, takes interchangeable lenses, and still manages to remain compact. The camera's body is roughly the size of the a6400, but it includes a full-frame sensor like those in the company's larger, professional-level models, such as the a7S series.

The full-frame image sensor allows the camera to achieve a blurred background quite easily, and to create images that can be enlarged to generous sizes without losing details. The camera also has advanced focusing capabilities, excellent continuous-shooting features, and the ability to shoot video without an arbitrary time limitation, often about 29 minutes for many compact cameras.

The camera also includes in-body optical image stabilization, allowing the capture of still photographs with a minimum of blur caused by camera shake. It has a fully articulated LCD display, providing flexibility for video capture and self-portraits. It uses the NP-FZ100 battery, a larger battery than that used in other small cameras, to provide a robust capacity for image and video capture without constantly recharging or changing batteries. It includes the ability to use Bluetooth and Wi-Fi options to enable wireless tethered shooting, the use of Bluetooth remote controls, among

other features. It can take full advantage of Sony's newly released ECM-B1M microphone, with digital audio processing.

There have been some criticisms of the a7C, as there are with any camera model, but they do not involve major problems. Probably the main complaint is that the viewfinder is small, which was a necessary tradeoff in order to include a full-frame sensor in a small camera body. In addition, the camera does not have dual memory card slots, and it does not include the newer menu system that is found in other recent Sony cameras, but once you get used to the existing menu system, which is carried over from earlier models, you should have no problems getting access to all of the camera's features quickly and efficiently.

My goal with this book is to provide a thorough guide to the camera's features, explaining how they work and when you might want to use them. The book is aimed largely at beginning and intermediate photographers who are not satisfied with the documentation that comes with the camera and who prefer a more complete explanation of the camera's controls and menus. For those seeking more advanced information, I discuss some topics that go beyond the basics, and I include in the appendices information about additional resources. I will provide updates at my website, whiteknightpress. com, as warranted.

One note on the scope of this guide: I live in the United States, and I bought my camera here. I am not very familiar with the variations for cameras sold in Europe or elsewhere, such as different chargers. The photographic functions are generally not different, so this guide should be useful to photographers in all locations. I should note that the standard frame rates for video recording are different in different areas. In North America, Japan, and some other areas, the NTSC video system is generally used, whereas in Europe and elsewhere, the PAL system is in use. In this book, I discuss video frame

rates in the context of the NTSC system. Also, I have stated measurements of distance and weight in both the Imperial and metric systems, for the benefit of readers in various countries around the world.

Finally, I need to make one more observation. This is my first book that has been written and published during the COVID-19 pandemic, and that situation has had an impact on my workflow. In particular, I have limited my trips outside my home, where I have remained with my family except for trips to medical appointments and other unavoidable matters. I took only one short trip, to a local park, to take photographs for this book. All other photographs I captured inside my home or in the surrounding yard. I believe the images are sufficient to illustrate the features of the camera, though.

CHAPTER 1: PRELIMINARY SETUP

Then you purchase your Sony a7C, the box should contain the camera itself, battery, charger/AC adapter, shoulder strap, USB type C cable, and instruction pamphlets. Sony also lists as included items the protective cap that is inserted into the accessory shoe and the body cap that covers the area where a lens is attached. There may also be a warranty card and some advertising flyers. Of course, if you purchase the camera as a kit, there will be a lens included as well. With cameras sold outside the United States and Canada, there should be a power cord that connects to the battery charger.

There is no CD with software or a user's guide; the software programs and user's guide supplied by Sony are accessible through the Internet. To install PlayMemories Home, the Sony software for viewing and working with JPEG images, go to the following Internet address: https://www.sony.net/disoft, where the program can be downloaded for Macintosh or Windows-based computers.

At the same site, you also can install Sony's Imaging Edge software. That software suite provides remote shooting, Raw image development, and editing functions. The Sony user's guide and related documents are available at https://helpguide.sony.net/ilc/2020/v1/h_zz/index.html. You also can get access to Sony help and tutorial materials at https://www.sony.com/electronics/support/e-mount-body-ilce-7-series/ilce-7cl/manuals.

One of the other basic requirements for using this camera is to attach a lens. This is a simple operation, but you need to be careful to minimize the possibility of letting any dust or other foreign matter get inside the camera's body. You should arrange the camera and lens together in a safe area, such as on a bed or table, with both caps on the lens and the body cap on the camera. When you are ready, remove all of the caps, and hold the camera with the lens mount pointing downward,

to avoid exposing it to dust or other items from above. Line up the index mark on the lens with the white index mark on the camera's lens mount, press the lens firmly into place against the lens mount, and twist the lens clockwise until it catches and locks into place.

You might want to attach the shoulder strap to the a7C body as soon as possible, so you can support the camera with the strap over your shoulder or around your neck.

Charging and Inserting the Battery

The Sony battery for the a7C is the NP-FZ100. The standard procedure is to charge the battery while it's inside the camera. To do this, you use the supplied USB C cable, which plugs into the camera and into the supplied Sony charger or another power source, such as a USB port on your computer or a standard USB charger.

There are pluses and minuses to charging the battery while it is inside the camera. On the positive side, you don't need an external charger, and the battery can charge automatically when the camera is connected to your computer. You also can find many portable charging devices with USB ports, and many automobiles have USB slots where you can plug in your a7C to keep up its charge.

One drawback is that you cannot charge another battery outside of the camera using this system. A solution to this situation is to purchase at least one extra battery and a device to charge your batteries externally. However, with the a7C, you can use the supplied battery charger as an AC adapter that will power the camera.

So, if your battery runs completely down, you don't have to wait until you have recharged it to start using the camera again. You can plug the charger into the camera and into an AC outlet or USB power supply, and operate the camera directly from that power source, as long as there is a partially charged battery inserted in the camera. However, the battery will not be charged while the camera is being operated. I'll discuss batteries, chargers, and other accessories further in Appendix A.

To insert the battery, open the battery/memory card compartment door on the bottom of the camera. Then look for the rectangular set of connectors on the battery, and insert the battery so those connectors are positioned close to the outside edge of the camera as the battery goes into the compartment, as shown in Figure 1-1. You may have to nudge aside the blue latch that holds the battery in place, as shown in Figure 1-2, to get the battery fully inserted.

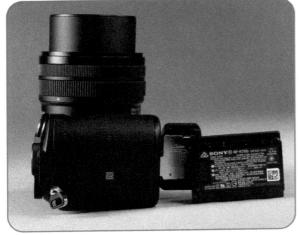

Figure 1-1. Battery Lined Up to Go Into Camera

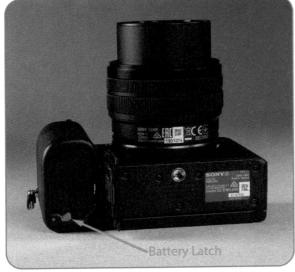

Figure 1-2. Battery Secured by Latch

With the battery inserted and secured by the latch, close the battery compartment door and slide the

ridged latch on the door to the closed position. Then plug the larger, rectangular end of the supplied USB C cable into the corresponding slot on the provided AC charger, which is model number AC-UUD12 in the United States. Plug the smaller end of the cable into the USB C port. This port, which has a USB symbol above it, is located under a small door on the lowest part of the camera's left side as you hold it in shooting position, as shown in Figure 1-3.

Figure 1-3. Charging Cable Connected to Camera

Plug the charger's prongs into a standard electrical outlet. A small orange lamp to the left of the camera's charging port will light up steadily while the battery is charging; when it goes out, the battery is fully charged. The full charging cycle should take about 285 minutes. (If the charging lamp flashes, that indicates a problem with the charger or a problem with the temperature of the camera's environment.) The camera must be turned off for charging to take place; if it is turned on while connected to the charger with a partially-charged battery in place, the camera will operate, but the battery will not charge.

Choosing and Inserting a Memory Card

The a7C does not ship with a memory card. If you turn the camera on with no card inserted, you will see the error message "NO CARD" flashing in the upper left corner of the screen. If you ignore this message and press the shutter button to take a picture, you will be able to capture one image, if the Release w/o Card option on screen 5 of the Camera Settings2 menu is set to Enable. However, even if you can capture an image, don't be fooled into thinking that the camera is storing the image in internal memory, because that is not the case.

Chapter 1: Preliminary Setup

Actually, the camera will temporarily store the image and play it back if you press the Playback button, but the image will not be permanently stored. I did manage to save a NO CARD image by using a video capture device to capture the image from the camera's HDMI port to my computer while it was still on the screen, but that is not a process I would want to do often. You also should be able to operate the camera remotely from a smartphone or computer and save the images to that device, as discussed in Chapter 10, but you probably will not want to rely on that process exclusively.

Some other camera models have a small amount of built-in memory so you can take and store a few pictures even without a card, but the a7C does not have any such safety net.

Therefore, you need to purchase and insert a memory card. The a7C uses SD cards, which come in several capacities and types; some examples are shown in Figure 1-4.

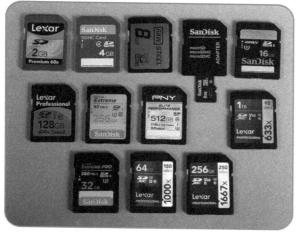

Figure 1-4. Memory Cards of Various Capacities

(The a7C, unlike many prior Sony models, cannot use Sony's proprietary Memory Stick type of memory card.) All of the cards shown in this image worked in my a7C, though the older and slower ones (slower than Speed Class 10) had considerable difficulty in keeping up with continuous shooting; they took a long time to store images from a burst of continuous shots. And, of course, as discussed below, the slower cards could not record video at all. It makes a great deal of difference to your shooting if you use a card rated in a high speed class, such as UHS speed class 3. It also is helpful to use a card that uses the UHS-II data transfer bus, which also speeds up operations.

The standard card, called simply SD, comes in capacities from 8 MB (megabytes) to 2 GB (gigabytes). A higher-capacity card, SDHC, comes in sizes from 4 GB to 32 GB. The newest, and highest-capacity card, SDXC (for extended capacity) comes in sizes of 48 GB, 64 GB, 128 GB, 256 GB, 512 GB, and 1 TB (terabyte); this version of the card can have a capacity up to 2 TB, theoretically, and SDXC cards generally have faster transfer speeds than the smaller-capacity cards.

The a7C also can use micro SD cards, which are smaller cards, often used in smartphones and other small devices. These cards operate in the same way as SD cards, but you have to use an adapter that is the size of an SD card to insert this tiny card in the a7C camera, as shown in Figure 1-4.

The a7C is compatible with SD cards that are rated as UHS-II, a relatively recent rating that can support data transfer at speeds up to 312 megabytes per second. In order to read the data from such a card at that speed, you need to use an SD card reader that is also compatible with the UHS-II rating.

There are some important limitations on your choice of a memory card. If you want to record video with this camera, you have to use an SDHC or SDXC card rated in speed class 10, UHS speed class 1, or faster. If you want to record video using the highest quality of 100 megabits per second, you have to use a card rated in UHS speed class 3. (The speed class is different from the UHS bus designation. A card rated as UHS-I can still be rated in UHS speed class 3.)

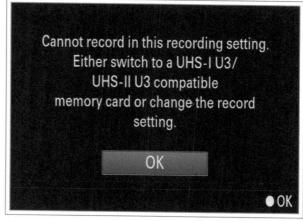

Figure 1-5. Error Message for Using Wrong Card for Video Recording

These specifications are not just recommendations; if you try to record in a video format on a card that does

not meet the requirements for that format, the camera will display an error message, as shown in Figure 1-5, and will not record the video.

If you want to record any video or use continuous shooting, you need to get one of the higher-powered cards that can support that use. Figure 1-6 shows five cards I have tested that can handle all video formats on the a7C—the SanDisk Extreme Plus 32 GB SDHC card, the SanDisk Extreme Pro 32 GB SDHC card, the Sony Tough 64 GB SDXC card, the Lexar Professional 256 GB SDXC card, the PNY Elite Performance 512 GB SDXC card, and the Lexar Professional 1 TB SDXC card, all of which are rated in UHS speed class 3.

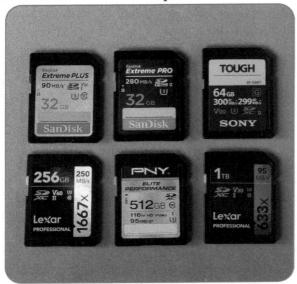

Figure 1-6. Memory Cards Capable of Recording Video in a7C

Once you have chosen a card, open the largest door on the left side of the camera that covers the memory card compartment, and slide the card into the slot until it catches. You insert an SD card with its label facing toward the front of the camera, as shown in Figure 1-7.

Figure 1-7. Memory Card Going into Camera

Push the card firmly into the slot until it catches and stays in place, then close the compartment door and make sure it is firmly latched. To remove the card, push down on its edge until it releases and springs out, so you can remove it.

Although a card may work well when newly inserted in the camera, it's a good idea to format a card when first using it in the camera, so it will have the correct file structure and will have any bad areas blocked off from use. To do this, turn on the camera by moving the power switch to the On position, then press the Menu button on the upper middle edge of the camera's back.

Next, press the Up button (top edge of the control wheel on the camera's back, labeled DISP) one or more times until the orange highlight bar disappears, meaning the line of icons at the top of the screen is now active. Then, press the Right button (right edge of the control wheel, labeled ISO) one or more times (if necessary) until the toolbox icon, the next to last icon at the top right of the screen, is highlighted, as shown in Figure 1-8.

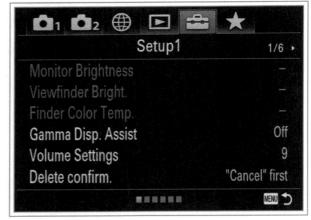

Figure 1-8. Toolbox Icon for Setup Menu Highlighted at Top of Menu Screen

(I will refer to the other three edges of the control wheel as the Left, Up, and Down buttons, and to the button in the middle of the wheel as the Center button.)

Next, press the Down button, or turn the control wheel, so the Monitor Brightness command is highlighted by the orange bar. Then press the Right button four times to reach screen 5 of the Setup menu, and press the Down button twice so the orange bar is on the Format command, as seen in Figure 1-9.

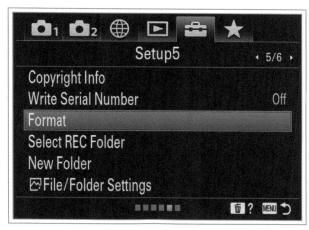

Figure 1-9. Format Option Highlighted on Setup Menu

Press the Center button when the Format line is highlighted. On the next screen, seen in Figure 1-10, highlight Enter and press the Center button again to carry out the command.

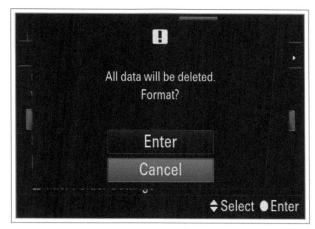

Figure 1-10. Format Confirmation Screen

Setting the Date, Time, and Language

You need to make sure the date and time are set correctly before you start taking pictures, because the camera records that information invisibly with each image and displays it later if you want. It is, of course, important to have the date (and the time of day) correctly recorded with your archives of digital images. The camera should prompt you to set these items the first time you turn it on. If not, or if you need to change the settings, follow these steps:

Turn the camera on, then press the Menu button. Using the procedure described above for the Format

command, display the Setup4 screen while the Setup menu's toolbox icon is highlighted.

Press the Down button to move the orange highlight bar to the Date/Time Setup line on the menu screen, as shown in Figure 1-11, and press the Center button to select that option, which leads to the screen shown in Figure 1-12.

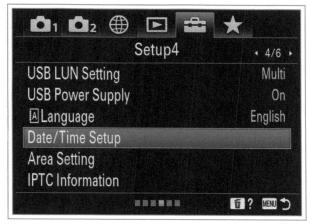

Figure 1-11. Date/Time Setup Menu Options Screen

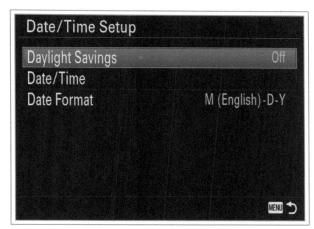

Figure 1-12. Date/Time Setup Highlighted on Setup Menu

Highlight the Date/Time option, press the Center button, and then, by pressing the Left and Right buttons or by turning the control wheel, move left and right through the month, day, year, and time settings, as shown in Figure 1-13.

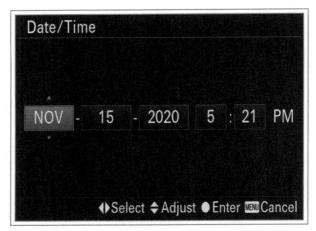

Figure 1-13. Date and Time Settings Screen

Change the values by pressing the Up and Down buttons or by turning the control dial (the ridged dial at the right of the camera's top, above the AF-ON button). When everything is set correctly, press the Center button to confirm. Then use a similar method to adjust the Daylight Savings (On or Off) and Date Format options, if necessary.

If you need to change the language the camera uses for menus and other text, press the Menu button and navigate to the Language item, which is one line above the Date/Time Setup item, as shown earlier in Figure 1-11. Press the Center button to select it. You then can select from the available languages on the menu, as shown in Figure 1-14.

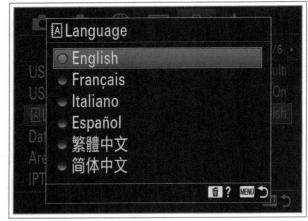

Figure 1-14. Language Selection Screen

CHAPTER 2: BASIC OPERATIONS

ow that the Sony a7C has the correct time and date set and a charged battery inserted along with a memory card, I'll discuss the steps to get your camera into action and to capture a usable image or video to your memory card.

Introduction to Main Controls

Before I discuss settings, I will introduce the camera's main controls to give a better idea of which button or dial is which. I won't discuss the controls in detail here; there is more information in Chapter 6. For now, I will include images showing the buttons, switches, and dials of the a7C. You may want to refer back to these images for a reminder about each control as you go through this book. Some of these illustrations show the camera with the 28mm-60mm kit lens mounted on it. Other lenses will differ in appearance from this one, and may have different controls.

TOP OF CAMERA

On top of the camera are some of the most important controls and dials, as shown in Figure 2-1.

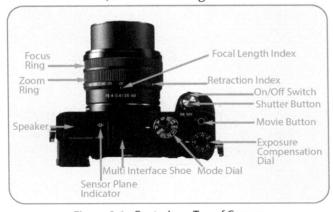

Figure 2-1. Controls on Top of Camera

You use the mode dial to select a shooting mode for still images or video. For basic shooting without making many other settings, turn the dial so the green AUTO

label is next to the white marker; this will set the camera to its most automatic mode.

The shutter button is used to take pictures. Press it halfway to evaluate focus and exposure; press it all the way to take a picture. You can change its behavior through options on the Camera Settings1 and Camera Settings2 menus. The on/off switch, which surrounds the shutter button, turns the camera on and off.

The Multi Interface Shoe functions as a flash shoe to hold an external flash unit, and it also accepts certain other Sony accessories that communicate with the camera through the shoe, such as microphones and flash triggers, as discussed in Appendix A. The sensor plane indicator marks the location of the camera's digital sensor, in case you need to measure the exact distance from the sensor to your subject for a closeup shot.

The red Movie button, at the extreme right side of the camera's top, starts and stops the recording of a video sequence. It also can be assigned to a different function if you prefer, as discussed in Chapter 5.

The exposure compensation dial is used to adjust exposure compensation, to make images brighter or darker than they would be without the adjustment.

The small openings on the left side of the camera's top are where the speaker emits sounds from videos and where the camera's operational sounds are heard.

In Figure 2-1, the a7C camera is shown with a lens attached—the Sony FE 28mm-60mm f/4-5.6 kit lens. This view shows the two ridged rings on the lens. The larger ring, closer to the camera's body, is the zoom ring. You turn that control to zoom the lens in and out between the 28mm (wide-angle) setting and the 60mm (telephoto) setting.

You also have to turn the zoom ring past the focal length numbers (28-60) so the indicator line (called the focal-length index by Sony) meets the white dot (called the retraction index by Sony), in order to retract the lens so you can store the camera safely. You have to turn the ring so those numbers have reached the indicator line, when you are ready to use the camera again. If you don't turn the zoom ring out of the retraction zone, the lens will not perform properly. In fact, when I tried to take a picture with the lens retracted, the camera displayed an error message and would not take any action to record an image.

The smaller ring, closer to the end of the lens, is the focus ring. You turn that control to focus the lens when the camera is using manual focus instead of autofocus.

The minimum focus distance of this lens is 0.99 foot (0.3m) at the 28mm setting and 1.48 foot (0.45m) at the 60mm setting.

BACK OF CAMERA

Figure 2-2 shows the controls on the camera's back. The viewfinder window is where you look into the viewfinder when you want to view the scene at eye level, with your eye shaded from the sun. The diopter adjustment wheel is used to adjust the viewfinder for your vision. The eye sensor, a small slot to the right of the viewfinder, senses when your head is near, and can switch the camera between using the LCD screen and using the viewfinder.

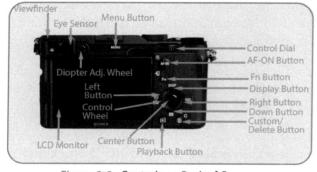

Figure 2-2. Controls on Back of Camera

The Menu button calls up the camera's system of menu screens with settings for shooting, playback, and other options, such as control button functions, audio features, and others.

The ridged control dial, located to the right of the Menu button and close to the exposure compensation dial, is used to adjust shutter speed in Shutter Priority mode and to adjust aperture in Aperture Priority and Manual exposure modes. It makes similar adjustments in Movie mode, when settings are in effect that permit shutter

speed or aperture to be adjusted. The dial's functions of setting aperture and shutter speed can be reversed using the Dial/Wheel Setup option on screen 9 of the Camera Settings2 menu.

In Program mode, the control dial adjusts Program Shift. This dial also is used to navigate through various screens and options for camera settings. It can be programmed to perform other functions using the My Dial Settings option on screen 9 of the Camera Settings2 menu and the Dial/Wheel EV Compensation item on screen 10 of that menu.

The Custom (C) button, located in the lower right corner of the camera's back, can be programmed to perform any one of numerous camera operations when the camera is in shooting mode, such as turning on focus tracking, adjusting ISO, white balance, or activating a drive mode setting, using the Custom Key menu options on screen 9 of the Camera Settings2 menu. In playback mode it always functions as the Delete button, enabling the deletion of recorded images and videos. When a menu screen is displayed, this button calls up a screen with information about the highlighted menu item.

In shooting mode, the Function (Fn) button calls up a menu of camera functions for easy access. Using the Function Menu Settings option on screen 9 of the Camera Settings2 menu, you can select two different sets of functions to be assigned to this menu—one for shooting still images and one for recording movies. This button also helps you navigate through the camera's menu systems. Whenever a menu screen is displayed, you can press this button to move between the main menu systems rapidly; each press of the Function button advances the highlight to the next menu system, without having to scroll through all of its individual screens.

The Function button also can be used to lock the operation of the control wheel and control dial, if it is set to do that using the Dial/Wheel Lock option on screen 10 of the Camera Settings2 menu. In playback mode, pressing this button can send an image to a smartphone or tablet, though you can assign a different option to the button using the Custom Key (Playback) menu option. The Playback button places the camera into playback mode, so you can view your recorded images and videos. If you press it again when

Chapter 2: Basic Operations | 11

the camera is in playback mode, the camera returns to shooting mode.

The control wheel is a rotary dial for navigating through menu screens and other screens with camera settings. In Shutter Priority and Manual modes, it adjusts shutter speed; in Aperture Priority mode, it adjusts aperture. It makes corresponding adjustments in Movie mode, when possible. (As noted earlier, you can reverse those assignments of the control wheel using a menu option.) In Program mode, it adjusts Program Shift. It also can be programmed to adjust one of several settings, such as exposure compensation, white balance, or ISO, using options on screens 9 and 10 of the Camera Settings2 menu. In addition, each of the wheel's four edges acts as a direction button when you press it in, for navigating through menu screens and moving items such as the focus frame.

The button in the center of the wheel (Center button) is used to confirm selections and for some miscellaneous operations. The top edge of the wheel (Up button) also acts as the Display button. You can press this button to choose the various display screens in either shooting or playback mode. The Down button calls up index screens in playback mode. In addition, the Left, Right, Center, and Down buttons can each be programmed through the Custom Key options on screen 9 of the Camera Settings2 menu to handle any one of numerous functions.

The LCD monitor—which displays the scene viewed by the camera along with the camera's settings and plays back your recorded images—swings out to the left and can tilt up or down and rotate to allow you to hold the camera in a high or low position to view a scene from unusual angles. It also can rotate forward approximately 180 degrees for self-portraits or vlogging (video blogging).

In addition, the LCD has limited touch screen capabilities: You can touch the screen to move the focus frame, to set a new focus point, or to take a picture. You can tap the screen twice in playback mode to enlarge an image, and then scroll the enlarged image with your finger. You also can tap twice to enlarge the screen to assist with focusing when using manual focus.

The AF-ON button, located to the right of the upper right corner of the LCD, by default is assigned to turn on autofocus tracking when an autofocus mode is in effect, so the camera will lock on a subject and continue to keep it in focus. However, the AF-ON button can be assigned to any one of numerous other functions instead, as discussed in Chapter 5, using the Custom Key options on screen 9 of the Camera Settings2 menu.

In playback mode, pressing the AF-ON button enlarges a still image that is being displayed on the LCD or in the viewfinder. No other function can be assigned to this button in playback mode.

FRONT OF CAMERA

There are several items to point out on the camera's front, as shown in Figure 2-3.

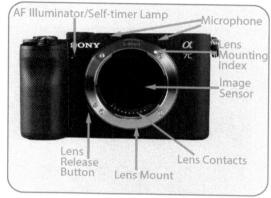

Figure 2-3. Items on Front of Camera

The AF Illuminator/Self-timer Lamp lights up to signal the operation of the self-timer and to provide illumination so the camera can use its autofocus system in dark areas. You can control its operation to some extent using the AF Illuminator item on screen 5 of the Camera Settings1 menu.

The lens mount is where you attach a compatible lens. This camera is designed to use Sony's E mount lenses, but it also can accept other lenses with an appropriate adapter, as discussed in Appendix A. The lens mounting index is a white dot that needs to be lined up with a similar white dot on the lens you are attaching, before twisting the lens into place.

The lens release button is pressed when you need to remove a lens from the camera body. The lens contacts are where the camera communicates electronically with an attached lens. The image sensor, inside the camera's body, is where the image is formed by the light that strikes the sensor. It has an effective resolution of 24 megapixels (MP). It is important to protect the sensor from dust and any other sort of contamination. The two

small openings above the lens mount are where the builtin microphone receives sound to be recorded for videos.

LEFT SIDE OF CAMERA

On the left side of the camera, shown in Figures 2-4 and 2-5, are three small doors that cover various important connections. The smallest door, near the top of the camera's left side, covers the jack for connecting an external microphone for video recording. It accepts a standard 3.5mm stereo microphone plug. The largest door, just below the microphone jack, covers the memory card slot, where you insert an SD card for storing images and videos. The third door, at the bottom of the camera's left side, covers the micro-HDMI port, the USB port, the headphones jack, and the charge lamp.

Figure 2-4. Left Side of Camera: Port Doors Closed

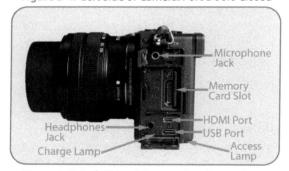

Figure 2-5. Left Side of Camera: Port Doors Open

The headphones jack accepts a standard 3.5mm stereo plug from a set of headphones that you can use to monitor sound while it is being recorded for a video, or when a video is being played back in the camera.

The micro-HDMI port is for connecting the camera to an HDTV with an HDMI cable to view your images and videos. You also can use this port to send a "clean" HDMI signal to an external monitor, video recorder, or computer, as discussed in Chapter 9.

The USB port is where you connect the USB-C cable that is supplied with the camera to charge the battery or power the camera, or to connect the a7C to a computer to upload images. This port accepts a USB Type C connector, the same size used on many modern smartphones and computers.

Using Sony's Imaging Edge (Remote) software, you can connect the camera to a computer using the USB cable, and control the camera from that software, as discussed in Chapter 10.

The charge lamp, located to the left of the USB port, lights up when the battery is charging and turns off when the charge is complete.

The small access lamp near the hinge of the bottom port-cover door glows red when the camera is writing data to a memory card, indicating that you should not interrupt this activity by trying to turn the camera off or remove the memory card.

RIGHT SIDE OF CAMERA

The one item of note on the right side of the camera, shown in Figure 2-6, is the NFC active area, designated by a fancy letter N. You can touch another device that uses near field communication, such as an Android smartphone or tablet, to that spot to activate a wireless connection to the camera, as discussed in Chapter 10.

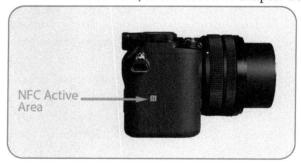

Figure 2-6. Right Side of Camera

BOTTOM OF CAMERA

Finally, as shown in Figure 2-7, on the bottom of the camera are the tripod socket and the battery compartment. The battery compartment door has a small flap that opens to make room for the cord from an AC adapter, if you use that optional accessory, as discussed in Appendix A.

Chapter 2: Basic Operations | 13

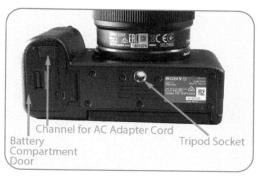

Figure 2-7. Items on Bottom of Camera

Taking Pictures in Intelligent Auto Mode

Now I'll discuss how to use these controls to start recording still images and videos. First, here is a set of steps for taking still photos if you want to let the camera make most decisions for you. This is a good approach for quick snapshots without fiddling with too many settings. I used the Sony 28mm-60mm kit lens for these steps; you may have to make some adjustments if you are using a different lens.

- 1. Remove the lens cap and make sure the LCD screen is unfolded from the camera's back, so it is visible. If you are using the Sony 28mm-60mm kit lens, turn the zoom ring so the number 28 (or a larger number, if you wish) is lined up with, or beyond, the white indicator line behind the numbers, as shown in Figure 2-1. (This procedure moves the lens out of its retracted state, so it can be used properly.)
- 2. Move the on/off switch on top of the camera to the On position. The LCD screen will illuminate to show that the camera has turned on. (If you see a message about creating an image database file, that means the memory card contains some images recorded by another camera. Select Enter to dismiss the message and then proceed.)
- 3. Find the mode dial on top of the camera to the right of the accessory shoe, and turn it so the green AUTO label is next to the white indicator mark, as shown in Figure 2-8. This sets the camera to the Intelligent Auto shooting mode.
- 4. Press the Menu button at the upper middle area on the camera's back to activate the menu system. As I discussed in Chapter 1, navigate through the menu screens by pressing the Right and Left buttons. The

Camera Settings1 and Camera Settings2 menus are headed by a camera icon with a number 1 or 2; the Network menu by the globe icon; the Playback menu by the triangular Playback symbol; the Setup menu by the toolbox icon; and the My Menu option by the star icon.

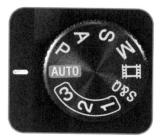

Figure 2-8. Mode Dial at AUTO

The icon for the currently active menu system is highlighted with a color background and is outlined by a gray line. You can tell which numbered screen of that menu system is active by looking at the numbers separated by a slash mark at the upper right corner of the display, such as the numbers 1/14 shown in Figure 2-9, meaning the camera is displaying the first of 14 menu screens. You also can tell what menu screen is currently displayed by looking at the line of dots at the very bottom of the screen. One of those dots will be orange, to indicate which screen is displayed.

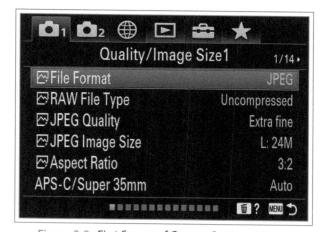

Figure 2-9. First Screen of Camera Settings1 Menu

When a given menu screen is selected, navigate up and down through the options on that screen by pressing the Up and Down buttons or by turning the control wheel right or left. When the orange selection bar is on the option you want, press the Center button to select that item. Then press the Up and Down buttons or turn the control wheel

- to highlight the value you want for that option, and press the Center button to confirm it. You can then continue making menu settings; when you are finished with the menu system, press the Menu button to go back to the live view, so you can take pictures.
- 7. Using the procedure in Step 6, make the settings shown in Table 2-1 for the Camera Settings1 menu. For menu options not listed here, any setting is acceptable for now.

Table 2-1. SUGGESTED SETTINGS FOR CAMERA SETTINGS 1 MENU IN INTELLIGENT AUTO MODE

MENU OPTION	SETTING
FILE FORMAT (STILL IMAGES)	JPEG
JPEG QUALITY	EXTRA FINE
JPEG IMAGE SIZE	L: 24M
ASPECT RATIO	3:2
APS-C/Super 35mm	Аито
COLOR SPACE	sRGB
LENS COMPENSATION	ALL VALUES AT AUTO
DRIVE MODE	SINGLE SHOOTING
BRACKET SETTINGS	No Setting Needed
INTERVAL SHOOTING FUNCTION	INTERVAL SHOOTING OFF
MEMORY	No Setting Needed
REGISTER CUSTOM SHOOTING SETTING	No Setting Needed
Focus Mode	SINGLE-SHOT AF
PRIORITY SET IN AF-S	BALANCED EMPHASIS
PRIORITY SET IN AF-C	BALANCED EMPHASIS
Focus Area	Wide
Focus Area Limit	LEAVE ALL OPTIONS CHECKED
AF ILLUMINATOR	Аито
Face/Eye AF Settings	FACE/EYE PRIORITY IN AF=ON;
	SUBJECT DETECTION=HUMAN;
	RIGHT/LEFT EYE SELECT=AUTO;
	FACE/EYE FRAME DISPLAY=ON;
	ANIMAL EYE DISPLAY=ON
APERTURE DRIVE IN AF	Standard
AF w/Shutter	On
Pre-AF	Off
Eye-Start AF	OFF, UNLESS USING AN A-MOUNT LENS; IN THAT CASE, USE ON IF DESIRED
AF AREA REGISTRATION	Off
DEL. REG. AF AREA	No Setting Needed
FOCUS FRAME COLOR	WHITE OR RED, DEPENDING ON PREFERENCE
AF Area Auto Clear	Off

DISP. CONT. AF AREA	On
CIRCULATION OF FOCUS POINT	Does Not Circulate
AF FRAME MOVE AMOUNT	Standard
AF MICRO ADJUSTMENT	AF ADJUSTMENT SETTING=OFF
ISO SETTING	ISO RANGE LIMIT = 50-204800
SPOT METERING POINT	Center
EXPOSURE STEP	0.3EV
AEL w/Shutter	Аито
EXPOSURE STD. ADJUST	No SETTING NEEDED
Flash Mode	Autoflash
EXPOSURE COMPENSATION SETTING	Ambient & Flash
RED EYE REDUCTION	Off
SHUTTER AWB LOCK	Off
Focus Magnifier	No Setting Needed
Focus Magnification Time	No LIMIT
INITIAL FOCUS MAGNIFICATION	x1.0
AF IN FOCUS MAGNIFICATION	On
MF Assist	On
PEAKING SETTING/DISPLAY	On
Peaking Setting/Level	Mid
PEAKING SETTING/COLOR	YELLOW
ANTI-FLICKER SHOOTING	Off
FACE REGISTRATION	No Setting Needed
REGISTERED FACES PRIORITY	Off

- 8. If you don't want to make all of these settings, don't worry; you are likely to get usable images even if you don't adjust most of these settings at this point. I have not included any recommendations for the Camera Settings2, Setup, or other menus; the default settings should work well in Intelligent Auto mode. I will discuss all of the menu options later in the book.
- 9. Press the Menu button again to make the menu disappear, if it hasn't done so already.
- 10. Aim the camera to compose the picture. If you are using a zoom lens, use the zoom ring or other zooming mechanism to set the focal length of the lens as you want, to include more of the scene or to zoom in for an enlarged view.
- 11. Once the picture looks good on the display, gently press the shutter button halfway and pause in that position. You should hear a beep and see a group of green focus brackets or blocks on the LCD screen indicating that the subject will be in focus, as shown in Figure 2-10.

Chapter 2: Basic Operations 15

You also should see a green dot in the lower left corner of the screen. If that green dot lights up steadily, the image is in focus; if it flashes, the camera was unable to focus. In that case, you can re-aim and see if the autofocus system does better from a different distance or angle.

After you have made sure the focus is sharp, push the shutter button all the way to take the picture.

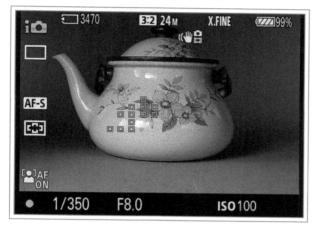

Figure 2-10. Green Blocks Showing Image is in Focus

VARIATIONS FROM FULLY AUTOMATIC

Although the a7C takes care of several settings when it's set to Intelligent Auto mode, the camera still lets you make a number of adjustments to fine-tune the shooting process.

Focus

With some cameras, you have few or no options for focus settings in the most automatic shooting mode. With the a7C, you can make several focus-related settings in this mode, as long as you are using a lens with compatible autofocus capability. I will give a brief overview of focus options here, with further discussion in the chapters that discuss the various menu options and physical controls.

Focus Modes

There are five focus modes available for shooting still images with the a7C, as indicated by the five settings for the focus mode item on screen 4 of the Camera Settings1 menu (AF-S, AF-A, AF-C, DMF, and MF), which are shown in Figure 2-11.

Those settings are single-shot autofocus, automatic autofocus, continuous autofocus, direct manual focus, and manual focus. (For movies, the only usable options are the AF-C and MF settings.)

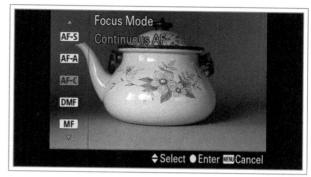

Figure 2-11. Focus Mode Menu

With the AF-S setting, the camera starts to focus when you press the shutter button halfway down. At that point, it tries to achieve sharp focus on an object in the focus area. If it can focus sharply, it beeps and displays one or more green focus frames or blocks and a solid green disk. The focus stays locked at that distance as long as you hold the shutter button halfway down; you can then press the button the rest of the way down to take the picture.

With the AF-A setting, the camera combines the AF-S and AF-C settings. That is, it locks focus and keeps it locked if the subject is not moving, as is the case with the AF-S setting. However, if the subject (or the camera) starts to move, the camera operates as if it were using the AF-C setting, discussed below, and continuously adjusts the focus as necessary to keep the subject in focus.

With the AF-C setting, when you press the shutter button halfway, the camera attempts to focus on an object in the focus area, but it continues to adjust the focus as needed, if the camera or the subject moves. The camera does not lock the focus setting until you press the button all the way down to take the picture. The green dot appears in the lower left of the display when focus is achieved, but it is surrounded by curving lines to indicate that the camera is continuing to adjust focus.

With the DMF setting, the camera lets you use both the autofocus capability of single autofocus and the manual focusing capability. With this combination of two focus modes, you can press the shutter button halfway to let the camera use autofocus, and then continue to adjust focus on the lens manually. You have to keep the shutter button pressed halfway down while you adjust the focus manually. (DMF is not available with all lenses that can be used with this camera.)

Finally, with the MF setting, focusing is entirely up to you. You adjust focus manually on the lens to bring the image into sharp focus. You might use manual focus in a dark or reflective environment where the camera would have difficulty, or in a situation where the camera might not focus on the subject that is most important to you. Another use of manual focus is for extreme closeup shots, when you need to adjust the focus distance very precisely. As I will discuss in Chapter 4, you can set the camera to assist with manual focusing through several menu options.

My preference is to use the AF-S setting for single autofocus in most situations. In tricky focusing environments, such as taking macro images or pictures of the moon, I often use manual focus with the focus-assisting aids provided by the camera. Continuous autofocus is useful when you are taking pictures of subjects that are moving unpredictably, such as birds, other animals, children at play, or sports competitors.

You also can touch the screen to tell the camera where to direct its autofocus. For this feature to work, turn on the touch screen using the Touch Operation option on screen 2 of the Setup menu. Then, on screen 3 of that menu, make sure that either the Touch Panel + Pad option or the Touch Panel Only option is turned on, under the Touch Panel/Pad menu item. On Screen 10 of the Camera Settings2 menu, set Function of Touch Operation to Touch Focus. Then, when you touch an area on the screen, the camera will place a focus frame at that point. Press the shutter button down halfway to focus at that area and press it all the way down to capture the image. I will discuss the Touch Focus option and other touch operations of the LCD monitor in Chapter 6, where I discuss the camera's physical controls.

Tracking Autofocus

One of the outstanding features of the Sony a7C camera is its ability to track a moving subject with its autofocus system. I will discuss the applicable settings for focus tracking in Chapters 4 and 5, but you may want to take advantage of this feature when you first start using the camera, so I will include here a brief introduction to focus tracking. The following steps will let you track a moving subject for still photography, but be aware that there are other ways to turn on tracking, as discussed in the later chapters.

1. Set the mode dial to Intelligent Auto.

- On screen 4 of the Camera Settings1 menu, set Focus Mode to Continuous AF (AF-C).
- 3. On that same screen, set focus area to Tracking (Wide).
- 4. Aim the camera at your subject, and when it appears to be in a good position to start tracking it, press the shutter button halfway down. If the camera fixes its focus on your subject, it will display a green frame that stays on the subject, even as the subject or the camera moves, as shown in Figure 2-12.

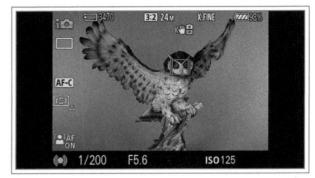

Figure 2-12. Focus Frame for Tracking Autofocus

- 5. The camera will continuously adjust focus, even if the distance to the subject changes.
- 6. When you are ready, press the shutter button all the way down to capture the image.

Other Settings

There are several other items that can be adjusted in Intelligent Auto mode, but not many that will have an immediate and noticeable effect on your photography. For example, you can adjust items such as the aspect ratio (shape) of your images as well as the file format, image size, and quality. Those options are important when you want to have more control over your images, but, for general picture-taking in Intelligent Auto mode, they are not critical. I have set forth recommended menu settings in Table 2-1, and I will discuss details of those options in Chapter 4. However, there are a few menu options you might want to take advantage of when you first use the a7C in Intelligent Auto mode, and I will discuss those briefly.

Flash

The a7C camera does not include a built-in flash unit, presumably a decision Sony made in order to fit a full-frame camera into a compact body. If you need to capture still images in dim lighting or in harsh sunlight

Chapter 2: Basic Operations | 17

that casts deep shadows, you may want to use a flash unit in the camera's hot shoe. That topic is discussed in Chapter 4, where I discuss the flash mode menu options, and in Appendix A, where I discuss compatible flash units. For now, I will discuss briefly the essential steps for using flash with the a7C when the camera is in Intelligent Auto mode.

First, you need to obtain a flash unit that is compatible with Sony's hot shoe, which is not the same as the standard hot shoe used by other camera makers. For this discussion, I used the Sony HVL-F20M, a small unit with basic features. Mount the flash to the camera's accessory shoe, making sure the flash's foot is pushed firmly into the shoe so that proper contact is made. Go to screen 10 of the Camera Settings1 menu and set flash mode to Autoflash, as shown in Figure 2-13.

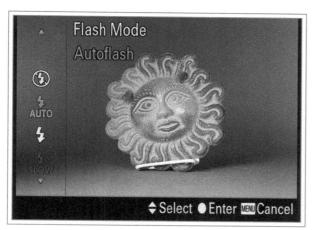

Figure 2-13. Flash Mode Menu in Intelligent Auto Mode

This setting will appear on the shooting screen, as shown in Figure 2-14. (You may have to press the Display button one or more times to display a screen that includes the flash setting icon.)

When you press the shutter button to capture an image, the flash will fire if the camera's metering system senses that flash is needed. I will discuss other flash options in Chapter 4.

Drive Mode: Self-Timer and Continuous Shooting

The drive mode menu option provides more adjustments you may want to make when using Intelligent Auto mode. Select this menu item from screen 3 of the Camera Settings1 menu, and the camera will display a vertical menu for drive mode, as shown in Figure 2-15. You also can select this menu by pressing the Left button on the control wheel, unless that

button has been reset to a different function using the Custom Key (Still Images) menu option.

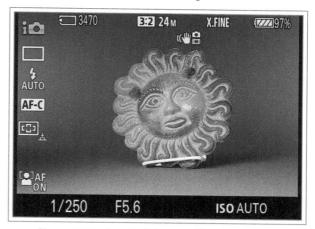

Figure 2-14. Autoflash Icon on Shooting Screen

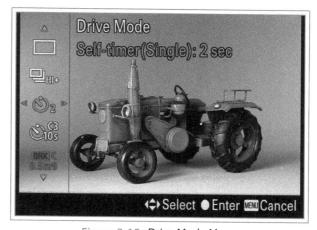

Figure 2-15. Drive Mode Menu

You navigate through the options on this menu by pressing the Up and Down buttons or by turning the control wheel.

I will discuss the drive mode options more fully in Chapter 4. For now, you should be aware of a few of the options. (I will skip over some others.) If you select the top option, represented by a single rectangular frame, the camera is set for single shooting mode; when you press the shutter button, a single image is captured. With the second option, whose icon looks like a stack of images, the camera is set for continuous shooting, in which it takes a rapid burst of images while you hold down the shutter button. Use the Left and Right buttons or turn the control dial to choose Hi+, Hi, Mid, or Lo for the speed of shooting. With the Hi+ setting, the camera can shoot up to 10 frames per second.

If you choose the third option, whose icon is a dial with a number beside it, the camera uses the self-timer. Use

the Left and Right buttons or control dial to choose two, five, or ten seconds for the timer delay and press the Center button to confirm. Then, when you press the shutter button, the shutter will be triggered after the specified number of seconds.

The ten-second delay is useful when you need to place the camera on a tripod and join a group photo; the two-second or five-second delay is useful when you want to make sure the camera is not jiggled by the action of pressing the shutter button. This option helps when you are taking a picture for which focusing is critical and you need to avoid shaking the camera, such as an extreme closeup or a time exposure. I will discuss the use of the self-timer and other drive mode options in more detail in Chapter 4.

Overview of Movie Recording

Now I'll discuss recording a short movie sequence with the a7C. Once the camera is turned on, turn the mode dial to select the green AUTO icon, for Intelligent Auto mode. There is a special Movie mode setting marked by the movie film icon on the mode dial, but you don't have to use that mode for shooting movies; I'll discuss the use of that option and other details about video recording in Chapter 9.

On the first screen of the Camera Settings2 menu, highlight File Format and press the Center button to go to the submenu with two choices for the format of movie recording. For now, be sure the second option, XAVC S HD, is highlighted, as shown in Figure 2-16; that format provides high quality for your videos without getting involved with 4K recording.

Remember that you have to use a memory card in speed class 10 or greater to record using this format, or in the UHS-3 speed class if the 100 Mbps setting is used with this format.

Go to screen 4 of the Camera Settings1 menu, to the focus mode item. Select AF-S for single autofocus, AF-A for automatic autofocus, AF-C for continuous autofocus, or DMF for direct manual focus. With any of those settings, the camera will use continuous autofocus for recording movies.

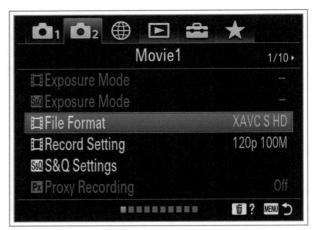

Figure 2-16. XAVC S HD Highlighted for File Format

For the rest of the settings, I will provide a table like the one included earlier in this chapter for shooting still images. The settings shown in Table 2-2 are standard ones for shooting good-quality movies. All of these settings are found on the Camera Settings2 menu.

Table 2-2. Suggested Camera Settings 2 Menu Settings for Movies in Intelligent Auto Mode

FILE FORMAT	XAVC S HD
RECORD SETTING	30 _P 16M
S & Q SETTINGS	No Setting Needed
PROXY RECORDING	Off
AF TRANSITION SPEED	5
AF SUBJECT SHIFT SENSITIVITY	5 (Responsive)
AUTO SLOW SHUTTER	On
Initial Focus Magnification	x1.0
Audio Recording	On
AUDIO LEVEL DISPLAY	On
AUDIO OUT TIMING	Live
WIND NOISE REDUCTION	Off
MARKER DISPLAY	Off
Marker Settings	No Setting Needed
VIDEO LIGHT MODE	POWER LINK
Movie w/ Shutter	Off
RELEASE W/O LENS	ENABLE
RELEASE W/O CARD	ENABLE
STEADYSHOT	On
STEADYSHOT SETTINGS	STEADYSHOT ADJUST.=AUTO
Zоом	No Setting Needed
ZOOM SETTING	OPTICAL ZOOM ONLY
FINDER/MONITOR	Аито
FINDER FRAME RATE	Standard
ZEBRA SETTING	OFF UNLESS NEEDED
GRID LINE	OFF UNLESS NEEDED

EXPOSURE SETTINGS GUIDE

CONTINUOUS SHOOTING LENGTH

AUTO REVIEW

FUNCTION OF TOUCH OPERATION

DIAL/WHEEL LOCK

AUDIO SIGNALS

OFF UNCLESS NEEDED

NOT DISPLAYED

OFF

TOUCH FOCUS

UNLOCK

ON

Settings not listed above can be ignored for present purposes, or set as you want. There are some other settings you can make for still images on the Camera Settings1 menu that will affect movie recording; I will discuss that topic in Chapter 9. You can leave the other items set as they were for shooting still images, as listed earlier in Table 2-1.

After making these settings, aim the camera at your subject, and when you are ready to start recording, press and release the red-ringed Movie button at the right edge of the camera's top.

The screen will display a red REC icon in the lower left corner of the display, above a counter showing the elapsed time in the recording, as shown in Figure 2-17.

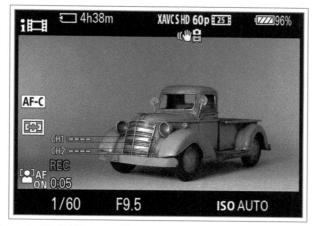

Figure 2-17. REC Icon on Shooting Screen During Video Recording

The camera will also display recording-level indicators to show the volume of sound being recorded for channel 1 and channel 2, if you have set all of the menu options as listed above. Hold the camera as steady as possible (or use a tripod), and pan it (move it side to side) smoothly if you need to. The camera will keep shooting until you press the red Movie button again to stop the recording, or until the camera stops on its own because of overheating. According to Sony, the camera should record in any mode for at least 30 minutes, but that limit is not pre-determined; it could be higher or

lower, depending on factors such as the environment you are working in and the format you are using.

The camera will automatically adjust exposure as lighting conditions change. You can zoom the lens in and out as needed, but you should do so sparingly if at all, to avoid distracting the audience and to avoid recording sounds of zooming the lens on the sound track. If the Touch Operation features are turned on through screen 2 of the Setup menu and the camera is set for autofocus and Touch Focus, you can touch the screen where you want the camera to direct its focus. When you are finished recording, press the Movie button again, and the camera will save the footage.

Those are the basics for recording video clips with the a7C. I'll discuss movie options further in Chapter 9.

Viewing Pictures

Before I cover more advanced settings for taking still pictures and movies, as well as other matters of interest, I will discuss the basics of viewing your images in the camera.

REVIEW WHILE IN SHOOTING MODE

Each time you take a still picture, the image will show up on the LCD screen (or in the viewfinder) for a short time, if you have the Auto Review option on screen 8 of the Camera Settings2 menu set to turn on this function. I'll discuss the details of that setting in Chapter 5. By default, this option is turned off. If you prefer, you can turn on this display to last for two, five, or ten seconds. I usually leave it turned on to display for two seconds, so I can get a quick view of the image that was just captured.

REVIEWING IMAGES IN PLAYBACK MODE

To review images taken previously, you enter playback mode by pressing the Playback button—the one with the small triangle icon to the lower left of the control wheel. To view all still images and movies for a particular date, go to screen 3 of the Playback menu and set the View Mode option to Date View. If you prefer, you can set View Mode to show only stills, only XAVC S HD movies, or only XAVC S 4K movies.

Once you choose a viewing option, you can scroll through recorded images and movies by pressing the Left and Right buttons or by turning the control wheel or control dial. Hold down the Left or Right button to move more quickly through the images. You can enlarge the view of any still image by pressing the AF-ON button, located on the back of the camera under the control dial, and you can scroll around in the enlarged image using the four direction buttons. You also can enlarge an image by selecting the Enlarge Image option on screen 2 of the Playback menu.

In addition, you can enlarge an image by tapping quickly twice on the LCD screen, if the touch screen features of the LCD are enabled through the Touch Operation item on screen 2 of the Setup menu. After double-tapping the screen, you can scroll the enlarged image around with your fingers, and you can return it to normal size by double-tapping again.

If you press the Center button or the Menu button, an enlarged image will return to normal size. If you press the Down button when an image is normal-sized, you will see an index screen with a number of thumbnail images (either 9 or 25, depending on the Playback menu Image Index option). If you move the highlight to the far left of the index screen and press the Center button, the camera will display a calendar screen, with thumbnail images on any date for which images or videos are present on the memory card. You can select images from the index and calendar screens by pressing the Center button on a highlighted thumbnail image. I'll discuss other playback options in Chapter 7.

PLAYING MOVIES

To play movies, move through the files by the methods described above until you find the movie you want to play. You should see a triangular playback icon inside a circle, as shown in Figure 2-18.

Press the Center button to start the movie playing. Then, as seen in Figure 2-19, you will see icons at the bottom of the screen for the controls you can use, including the Center button to pause and resume play. (If you don't see the controls, press the Display button until they appear.) You also can press the Down button to bring up a more detailed set of controls on the screen, as shown in Figure 2-20.

To change the volume, pause the movie and press the Down button to bring up the detailed controls; then navigate to the speaker icon, next to last at the right of those controls, and press the Center button to select it. Then use the control wheel, the control dial, or the Right and Left buttons to adjust the volume. To exit from playing the movie, press the Playback button. I'll discuss other movie playback options in Chapter 9.

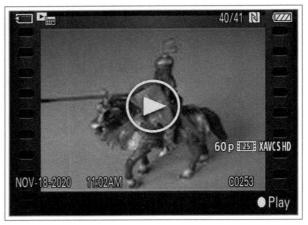

Figure 2-18. Movie Ready for Playback in Camera

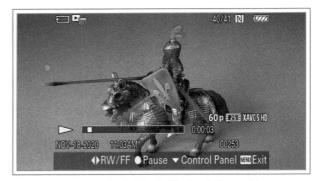

Figure 2-19. Basic Movie Playback Control Icons

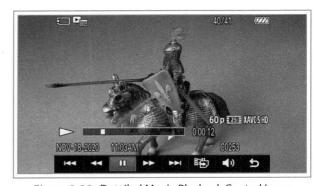

Figure 2-20. Detailed Movie Playback Control Icons

If you want to play movies on a computer or edit them with video-editing software, you can use the PlayMemories Home software that is provided through the Sony web site. You also can use any program that can deal with XAVC S video files, such as Adobe Premiere Elements, Adobe Premiere Pro, Final Cut Pro, iMovie, or Windows Movies and TV, depending on what type of computer you have.

Chapter 3: Shooting Modes for Still Images

ntil now, I have discussed the basics of setting up the camera for quick shots, using Intelligent Auto mode to take pictures and video clips with settings controlled mostly by the camera's automation. As with other advanced cameras, though, with the Sony a7C there is a large range of other options available. To explain this broad range of features, I need to discuss shooting modes and the Camera Settings1 and Camera Settings2 menu options. In this chapter, I'll discuss the shooting modes; in Chapters 4 and 5, I'll discuss the Camera Settings1 and Camera Settings2 menus.

In order to capture still images, you need to select one of the shooting modes available on the mode dial: Intelligent Auto, Program Auto, Aperture Priority, Shutter Priority, Manual exposure, or Memory Recall. (The other two modes on the dial are for movies, which I will discuss in Chapter 9.) So far, I have discussed primarily the Intelligent Auto mode. Now I will discuss the others, after some review of the first one.

Intelligent Auto Mode

I've already discussed this shooting mode in some detail. This is a good choice if you need to take a quick shot and don't have much time to fuss with settings such as ISO, white balance, aperture, shutter speed, or focus. It's also a good mode to select when you hand the camera to someone else to take a photo of you and your companions. For example, I used Intelligent Auto mode for a quick shot of a group of people walking their dog in a local park, as seen in Figure 3-1.

To make this setting, turn the mode dial to the green AUTO label, as shown in Figure 3-2. When you select this mode, the camera makes several decisions for you and limits your options in some ways. The camera will select the shutter speed, aperture, and ISO setting, along with several other settings over which you will have no control.

Figure 3-1. Intelligent Auto Mode Sample Image

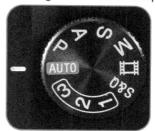

Figure 3-2. Mode Dial at AUTO

For example, you can't set white balance to any value other than Auto, and you can't choose a metering method or use exposure bracketing. You can, however, use quite a few features, as discussed in Chapter 2, including some settings of flash mode, some settings of drive mode, focus mode, and others. You also can use sophisticated options such as the Raw format, which I will discuss in Chapter 4 when I discuss the items on the Camera Settings1 menu.

One interesting aspect of this mode is that the camera tries to figure out what sort of subject or scene you are shooting. Some of the subjects the camera will attempt to detect are Infant, Portrait, Night Portrait, Night Scene, Landscape, Backlight, Low Light, and Macro. It also will try to detect certain conditions, such as whether a tripod is in use, and it will display

appropriate icons for those situations. So, if you see different icons when you aim at various subjects in this shooting mode, that means the camera is evaluating the scene for factors such as brightness, backlighting, the presence of human subjects, and the like, so it can use the best possible settings for the situation.

For Figure 3-3, the camera evaluated a scene with a human face and appropriately used its Portrait setting. A Portrait icon is in the upper-left corner of the screen.

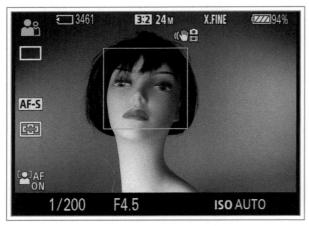

Figure 3-3. Scene Recognition: Portrait

Figure 3-4 shows the use of automatic scene recognition for a toy soldier located closer to the lens. The camera interpreted the scene as a macro, or closeup shot, and switched automatically into macro mode, indicated by the flower icon.

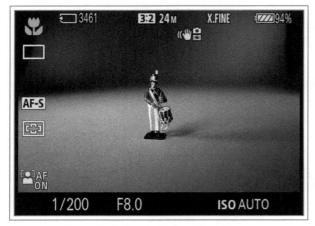

Figure 3-4. Scene Recognition: Macro

Of course, scene recognition depends on the camera's programming, which may not interpret every scene the same way that you would. If that becomes a problem, you may want to make individual settings using one of

the more advanced shooting modes, such as Program, Aperture Priority, Shutter Priority, or Manual.

Program Mode

Choose this mode by turning the mode dial to the P setting, as shown in Figure 3-5.

Figure 3-5. Mode Dial at P for Program Mode

Program mode (sometimes called Program Auto mode) lets you control many of the settings available with the a7C, apart from shutter speed and aperture, which the camera chooses on its own. You still can adjust the camera's automatic exposure to a fair extent by using exposure compensation and bracketing, as discussed in Chapter 4, and Program Shift, discussed later in this section. You don't have to make a lot of decisions if you don't want to, because the camera will make reasonable choices for you as defaults.

The camera can choose a shutter speed as long as 30 seconds or as short as 1/4000 second. If the Silent Shooting option on screen 5 of the Camera Settings2 menu is turned on, the fastest shutter speed available is 1/8000 second.

The Program Shift function, which is available only in Program mode, works as follows. Once you have aimed the camera at your subject, the camera displays its chosen settings for shutter speed and aperture in the lower left corner of the screen. At that point, you can turn the control dial or the control wheel, and the values for shutter speed and aperture will change, if possible under current conditions, to select different values for both settings while keeping the same overall exposure of the scene.

If the Exposure Settings Guide option on screen 7 of the Camera Settings2 menu is turned on, the camera will display two bands graphically showing the aperture and shutter speed values as they change. With this option, the camera "shifts" the original exposure to your choice of any of the matched pairs that appear as you turn the wheel or dial. For example, if the original exposure was f/2.8 at 1/30 second, you may see equivalent pairs of f/3.2 at 1/25, f/3.5 at 1/20, and f/4.0 at 1/15, among others. When Program Shift is in effect, the P icon in the upper left corner of the screen will have an asterisk to its right, as shown in Figure 3-6.

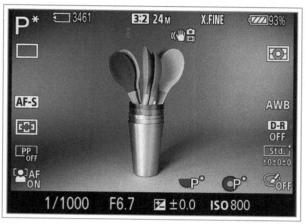

Figure 3-6. Asterisk on Shooting Screen for Program Shift

To cancel Program Shift, turn the control wheel or the control dial until the original settings are in effect or move the mode dial to another shooting mode, then back to Program.

Program Shift is useful if you want a slightly faster shutter speed to stop action or a wider aperture to blur the background, or you might have some other creative reason. This option lets the camera quickly evaluate the exposure, but gives you the ability to tweak the shutter speed and aperture to suit your current needs.

Of course, if you need to use a specific shutter speed or aperture, you probably are better off using Aperture Priority, Shutter Priority, or Manual exposure mode. However, having Program Shift available is useful when you're taking pictures quickly using Program mode, and you want a fast way to tweak the settings somewhat.

Another important aspect of Program mode is that it expands the choices available through the Camera Settings1 menu, which controls many of the camera's settings that directly affect your images. You will be able to make choices involving ISO sensitivity, metering mode, DRO/HDR, Creative Style, Picture Effect, and others that are not available in Intelligent Auto mode.

See the discussion of the Camera Settings1 menu in Chapter 4 for information about the many selections that are available.

Aperture Priority Mode

You select Aperture Priority mode by turning the mode dial to the A setting, as shown in Figure 3-7.

Figure 3-7. Mode Dial at A for Aperture Priority Mode

In this mode, you select the aperture and the camera chooses a shutter speed for proper exposure. With this mode, you can exercise control over depth of field of your shots. When you select a narrow aperture, such as f/16.0, the depth of field will be broad, with the result that more items will appear to be in sharp focus at varying distances from the lens. On the other hand, with a wider aperture, such as f/2.8, the depth of field will be relatively shallow, and you may be able to keep only one subject in sharp focus.

In Figures 3-8 and 3-9, I took two pictures using the Sony SAL5014 50mm f/1.4 lens, which was mounted to the a7C using Sony's LA-EA4 Mount Adaptor because it is an A-mount lens, not designed for the E-mount used by the a7C. The settings for the two images were the same except for aperture values.

Figure 3-8. Aperture Set to f/1.4

For Figure 3-8, I set the aperture to f/1.4, the widest possible for this lens. With this setting, because the

depth of field at this aperture was quite shallow, the items in the background are fairly blurry. I took Figure 3-9 with the aperture set to f/22, the narrowest possible setting, resulting in a broader depth of field, making the background appear considerably sharper.

Figure 3-9. Aperture Set to f/22

These photos illustrate the effects of varying aperture by setting it wide (low numbers) to blur the background or narrow (high numbers) to enjoy a broad depth of field and keep subjects at varying distances in sharp focus. A need for shallow depth of field arises often in the case of outdoor portraits or photographs of subjects such as flowers. If you can achieve a shallow depth of field by using a wide aperture, you can keep the subject in sharp focus but leave the background blurry, as in Figure 3-8.

This effect is sometimes called "bokeh," a Japanese term for a pleasing blurriness of the background. In this situation, the fuzzy background can be an asset, minimizing distraction from unwanted objects and highlighting the sharply focused portrait of the subject.

Here is the procedure for using this shooting mode. With the mode dial at the A setting, use the control wheel or the control dial to select the aperture value. The available settings depend on the lens you are using and the setting of the Exposure Step option on screen 9 of the Camera Settings1 menu. For example, using the Sony 28mm-60mm kit lens with Exposure Step set to 0.5EV, the available settings are f/4.0, f/4.5, f/5.6, f/6.7, f/8.0, f/9.5, f/11.0, f/13.0, f/16.0, f/19.0, and f/22.0.

When you set the aperture, as seen in Figure 3-10, the f-stop (f/13 in this case) will appear at the bottom of the screen next to the shutter speed. If you turn on the Exposure Settings Guide option on screen 7 of the Camera Settings2 menu, you will see a graphic display

of the aperture values on a moving band as you turn the control wheel or control dial, as shown in Figure 3-11.

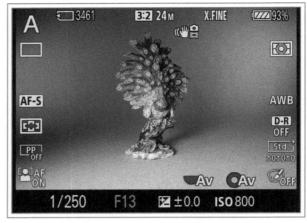

Figure 3-10. Aperture Value on Shooting Screen

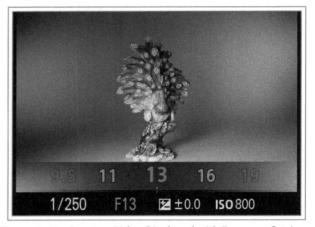

Figure 3-11. Aperture Value Displayed with Exposure Settings
Guide Turned On

The camera will select a shutter speed that results in a normal exposure given the aperture you have set. The camera can choose shutter speeds from 30 seconds to 1/4000 second, or as fast as 1/8000 second if Silent Shooting is turned on.

Although in most cases the camera will be able to select a corresponding shutter speed that results in a normal exposure, there may be times when this is not possible. For example, if you are taking pictures in a very bright location with the aperture set to f/4.0, the camera may not be able to set a shutter speed fast enough to yield a normal exposure. In that case, the fastest possible shutter speed will flash on the display to show that a normal exposure cannot be made using the chosen aperture. The camera will let you take the picture, but it may be too bright to be usable.

Similarly, if conditions are too dark for a good exposure at the aperture you have selected, the slowest possible shutter speed (30", meaning 30 seconds) will flash.

If conditions are too bright or dark for a good exposure, the camera's display may become bright or dark, giving you notice of the problem. This will happen if the Live View Display item on screen 8 of the Camera Settings2 menu is set to Setting Effect On. If that option is set to Setting Effect Off, the display will remain at normal brightness (if there is sufficient ambient light for that purpose), even if the exposure settings would result in an excessively bright or dark image. I will discuss that menu option in Chapter 5.

Depending on the lens you are using, not all apertures may be available at all times. For example, with the 28mm-60mm kit lens, the widest aperture, f/4.0, is available only when the lens is zoomed out to its wideangle setting. As soon as the lens is zoomed in slightly beyond the 28mm focal length, the widest aperture available is f/4.5. At the highest zoom levels, the widest aperture available is f/5.6.

Some zoom lenses, however, are constant-aperture lenses, which maintain their widest aperture at all zoom levels. For example, the Sony E 10-18mm f/4 OSS lens provides a constant aperture of f/4.0 throughout its zoom range. Lenses of that sort tend to be fairly expensive, but it may be worthwhile to have the constant aperture, so you can blur the background and shoot in relatively dim light. Of course, you also may use a prime lens with a fixed focal length, such as 35mm or 50mm, in which case the aperture will be constant because the lens does not zoom.

Shutter Priority Mode

In Shutter Priority mode, you choose the shutter speed you want and the camera will set the corresponding aperture to achieve a proper exposure of the image.

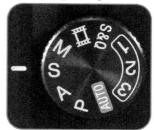

Figure 3-12. Mode Dial at S for Shutter Priority Mode

In this mode, designated by the S position on the mode dial, as shown in Figure 3-12, you can set the shutter to be open for a time ranging from 30 seconds to 1/4000 of a second, or 1/8000 second if Silent Shooting is turned on, which causes the electronic shutter to be used.

If you are photographing fast action, such as a bird in flight, a baseball swing, or a hurdles race at a track meet, and you want to freeze motion with a minimum of blur, you should select a fast shutter speed, such as 1/2000 of a second. For Figures 3-13 and 3-14, I used different shutter speeds for images of a group of colored beads as I poured them into a clear plastic pitcher.

Figure 3-13. Shutter Speed Set to 1/4000 Second

Figure 3-14. Shutter Speed Set to 1/30 Second

In Figure 3-13, I used a shutter speed setting of 1/4000 second. In this image, you can see the individual beads clearly. In Figure 3-14, with the shutter speed set to 1/30 second, the beads blur together into what looks almost like a continuous stream.

You select this shooting mode by turning the mode dial to the S indicator, as shown in Figure 3-12. Then you select the shutter speed by turning the control wheel or the control dial.

If you turn on the Exposure Settings Guide option on screen 7 of the Camera Settings2 menu, you will see a graphic display of the shutter speeds on a moving band as you turn the control wheel or dial, similar to the display of aperture settings, shown earlier in Figure 3-11.

Although the a7C uses the letter "S" to stand for Shutter Priority on the mode dial and to designate this mode on the live view screen, it uses the notation "Tv" on the shooting mode display in Shutter Priority mode, next to the control dial and control wheel icons, as shown in Figure 3-15. Tv stands for time value, a term often used for shutter speed.

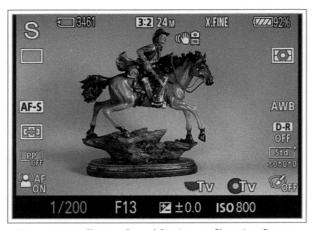

Figure 3-15. Shutter Speed Setting on Shooting Screen

As you cycle through various shutter speeds, the camera will select the appropriate aperture to achieve a normal exposure, if possible. As I discussed in connection with Aperture Priority mode, if you set a shutter speed for which the camera cannot select an aperture that will yield a good exposure, the aperture reading at the bottom of the display will flash. The flashing aperture means that proper exposure at the selected shutter speed is not possible at any available aperture, according to the camera's calculations.

For example, if you set the shutter speed to 1/350 second in a fairly dark indoor environment with a low ISO setting in place (such as 100), the aperture number (which will be the widest setting for the lens in use, if the lens is at its wide-angle setting) may flash, indicating that proper exposure is not possible. As I discussed for Aperture Priority mode, you can still take the picture if you want to, though it may not be usable. A similar situation may take place if you select a slow shutter speed (such as four seconds) in a relatively bright location. (This situation is less likely to happen in Aperture Priority

mode, because of the wide range of shutter speeds the camera can use to achieve a good exposure.)

If the current settings in this mode would result in an image that is excessively dark or bright, the LCD display will grow dark or bright to show that effect, but only if the Live View Display option on screen 8 of the Camera Settings2 menu is set to Setting Effect On. If that option is set to Setting Effect Off, the display will show a normal image even in unusually bright or dark conditions, if possible with the current ambient lighting situation.

Manual Exposure Mode

The technique for using this mode is similar to what I discussed for the Aperture Priority and Shutter Priority modes. To control exposure manually, set the mode dial to the M indicator, as shown in Figure 3-16.

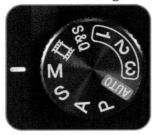

Figure 3-16. Mode Dial at M for Manual Exposure Mode

You now have to control both shutter speed and aperture by setting them yourself. To set the aperture, turn the control dial; to set the shutter speed, turn the control wheel. (You can reverse the roles of the dial and wheel using the Dial/Wheel Setup option on screen 9 of the Camera Settings2 menu.)

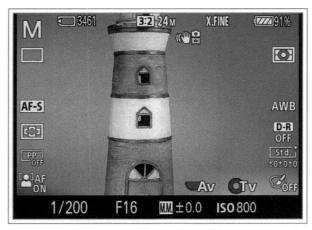

Figure 3-17. Aperture and Shutter Speed Values on Shooting Screen

The values you set will appear at the bottom of the display, as shown in Figure 3-17. You can turn on the Exposure Settings Guide option on screen 7 of the Camera Settings2 menu to display a graphic moving band that shows either the aperture or the shutter speed as either value is adjusted.

As you adjust shutter speed and aperture, a third value, to the right of the aperture, also may change. That value is a positive, negative, or zero number. The meaning of the number is different depending on the current ISO setting.

In Chapter 4, I'll provide more details about the ISO setting, which controls how sensitive the camera's sensor is to light. With a higher ISO value, the sensor is more sensitive and the image is exposed more quickly, so the shutter speed can be faster or the aperture more narrow, or both.

To set the ISO value, from the shooting screen, press the Right button to bring up the ISO menu, as shown in Figure 3-18, and scroll through the selections using the Up and Down buttons or by turning the control wheel or the control dial.

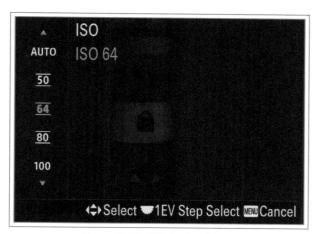

Figure 3-18. ISO Setting Menu

You can scroll through values more rapidly with the control dial, which skips over some values. (The Right button controls ISO by default; if that setting has been changed using the Custom Key (Still Images) menu option, you can bring up the ISO menu through the ISO Setting item on screen 8 of the Camera Settings1 menu.)

Choose a low number like 100 to maximize image quality when there is plenty of light; use a higher number in dim light. Higher ISO settings are likely to cause visual "noise," or graininess, in your images.

Generally speaking, you should try to set ISO no higher than 800 to ensure the highest image quality.

If the ISO value is set to a specific number, such as 125, 200, or 1000, then, in Manual exposure mode, the icon at the bottom center of the display is a box containing the letters "M.M.," which stand for "metered manual," as shown in Figure 3-17.

In this situation, the number next to the M.M. icon represents any deviation from what the camera's metering system considers to be a normal exposure. So, even though you are setting the exposure manually, the camera will still let you know whether the selected aperture and shutter speed will produce a standard exposure.

If the aperture, shutter speed, and ISO values you have selected will result in a darker exposure than normal, the M.M. value will be negative, and vice-versa. This value can vary only by +2.0 or -2.0 EV (exposure value) units; after that, the value will flash, meaning the camera considers the exposure excessively abnormal.

Of course, you can ignore the M.M. indicator; it is there only to give you an idea of how the camera would meter the scene. You very well may want part or all of the scene to be darker or lighter than the metering would indicate to be "correct."

As with the Aperture Priority and Shutter Priority modes, the camera's display will become unusually bright or dim to indicate that current settings would result in an abnormal exposure, but only when the Live View Display option on screen 8 of the Camera Settings2 menu is set to Setting Effect On.

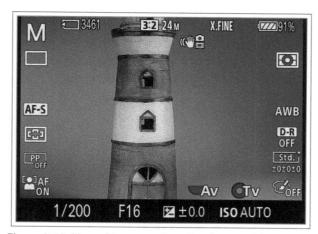

Figure 3-19. Manual Exposure Shooting Screen with Auto ISO

If, instead of a specific value, you have set ISO to Auto ISO, the icon at the bottom center of the screen changes. In this situation, the camera displays the exposure compensation icon, which contains a plus and minus sign, as shown in Figure 3-19.

The reason for this change is that, when you use Auto ISO in Manual exposure mode, the camera can likely produce a normal exposure by adjusting the ISO. There is no need to display the M.M. value, which shows deviation from a normal exposure.

Instead, when ISO is set to Auto ISO, the camera lets you adjust exposure compensation, so you can set the exposure to be darker or brighter than the camera's autoexposure system would produce.

To set exposure compensation in Manual mode, just turn the exposure compensation dial on the top right of the camera. Or, if you prefer, you can assign exposure compensation to the C, Center, Left, Right, Down, AF-ON, Movie, or Focus Hold button (if the lens you are using has a Focus Hold button). You make that assignment using the Custom Key (Still Images) option on screen 9 of the Camera Settings2 menu, as discussed in Chapter 5.

You also can use the Function menu to adjust exposure compensation, if that option has been included in that menu, as also discussed in Chapter 5, or you can adjust it with the Exposure Compensation item on screen 8 of the Camera Settings1 menu. You also can assign it to the control wheel or control dial using the dial settings on screens 9 and 10 of the Camera Settings2 menu.

With Manual exposure mode, the settings for aperture and shutter speed are independent of each other. When you change one, the other one stays unchanged until you adjust it manually. But the effect of this system is different depending on whether you have selected a specific value for ISO as opposed to Auto ISO.

If you select a numerical value for ISO, which can range from 50 to 204800, the camera leaves the creative decision about exposure entirely up to you, even if the resulting photograph would be washed out by excessive exposure or underexposed to the point of near-blackness.

However, if you select Auto ISO for the ISO setting, then, as discussed above, the camera will adjust the ISO to achieve a normal exposure if possible. In this case, Manual exposure mode becomes like a different shooting mode altogether. You might call this the "aperture and shutter speed priority mode," because you are able to set both aperture and shutter speed but still have the camera adjust exposure automatically by changing the ISO value.

The ability to use Auto ISO in Manual exposure mode is very useful. For example, suppose you are taking photographs of a craftsman using tools in a dimly lighted area. You may want to use a narrow aperture such as f/16.0 to achieve a broad depth of field and keep the tools and other items in focus, but you also may want to use a fast shutter speed, such as 1/250 second, to freeze action. If you use Aperture Priority mode, the camera will choose the shutter speed; with Shutter Priority mode, the camera will choose the aperture; and with Program mode, the camera will choose both values. Only by using Manual exposure mode with Auto ISO can you choose both aperture and shutter speed and still have the camera find a good exposure setting automatically.

Even with the ability to use Auto ISO, though, there may be situations in which the camera cannot produce a normal exposure. This could happen if you have limited the scope of the Auto ISO setting by setting a narrow range between the minimum and maximum settings for Auto ISO. It also could happen if you have chosen extreme settings for aperture and shutter speed, such as 1/2000 second at f/16.0 in dark conditions. In such situations, the ISO setting label and the exposure compensation value at the bottom of the display will flash, indicating that a normal exposure cannot be achieved with these settings.

The range of shutter speeds in Manual mode includes the same options as for Shutter Priority mode: 30 seconds to 1/4000 second, or 1/8000 second if Silent Shooting is turned on through screen 5 of the Camera Settings2 menu. However, there is one important addition. In Manual exposure mode, you can set the shutter speed to the Bulb setting, just beyond the 30-second mark, as shown in Figure 3-20. (Exposure Settings Guide was turned on for this image, to show the band of shutter speed settings.)With the Bulb setting, you have to press and hold the shutter button to keep the shutter open. You can use this setting to take photos in dark conditions by holding the shutter open for a minute or more.

One problem is that it is hard to avoid jiggling the camera, causing image blur, even if the camera is on a tripod. One way to avoid this problem is to trigger the camera remotely from the Imaging Edge Mobile app, which supports Bulb shooting. I discuss that process in Chapter 10. Also, in Appendix A, I discuss using a physical remote control to trigger the camera.

After the exposure ends, the camera will process the image for the same length of time as the exposure, to reduce the noise caused by long exposures. You will not be able to take another shot while this processing continues. (You can disable this setting with the Long Exposure Noise Reduction option on screen 2 of the Camera Settings1 menu.)

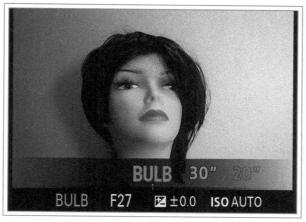

Figure 3-20. Bulb Setting for Shutter Speed in Manual Mode

The Bulb setting is not available when some other options are in use, including Auto HDR, the Rich-tone Monochrome setting for Picture Effect, the drive mode settings of continuous shooting, continuous self-timer, or continuous bracketing, or Silent Shooting.

Another feature available in the Manual shooting mode is Manual Shift, which is similar to Program Shift, discussed earlier. To use Manual Shift, you first have to assign one of the control buttons (Custom, Center, AF-ON, Movie, or Focus Hold) to the AEL (autoexposure lock) Hold or AEL Toggle function using the Custom Key (Still Images) option on screen 9 of the Camera Settings2 menu, as discussed in Chapter 5. (The Left, Right, or Down button can be assigned to AEL Toggle, but not to AEL Hold.)

Then, after making your aperture and shutter speed settings, change the aperture or shutter speed setting while pressing the button assigned to the AEL function.

(If you selected AEL Toggle, you don't hold down the button; just press it and release it.)

When you do this, the camera will make new settings with equivalent exposure, if possible. For example, if the original settings were f/3.5 at 1/160 second, when you select Manual Shift and change the aperture to f/3.2, the camera will reset the shutter speed to 1/200 second, maintaining the original exposure. In this way, you can tweak your settings to favor a particular shutter speed or aperture without affecting the overall exposure. An asterisk will appear in the lower right corner of the display while you activate the button that controls AEL.

I use Manual exposure mode often, for various purposes. One use is to take images at different exposures to combine into a composite HDR (high dynamic range) image. I will discuss that technique in Chapter 4. I also use Manual mode when using a third-party external flash, as discussed in Appendix A. In that case, the flash does not interact with the camera's autoexposure system, so I need to set the exposure manually. Manual mode also is useful for some special types of photography, such as making silhouettes, as shown in Figure 3-21.

Figure 3-21. Manual Exposure Sample Image

Memory Recall Mode

There is one more shooting mode to discuss, apart from Movie mode and S & Q Motion mode, both of which I will discuss in Chapter 9. This last mode, called Memory

Recall, is a powerful tool that gives you expanded options for your photography.

When you turn the mode dial to one of the three numbered MR positions (as shown in Figure 3-22) and then select one of the seven groups of settings that can be stored to the camera, you are, in effect, selecting a custom-made shooting mode that you create with your own favorite settings.

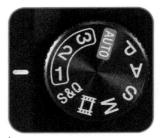

Figure 3-22. Mode Dial at Position 1 of Memory Recall Mode

You can set up the camera as you want it—with stored values for items such as shooting mode, shutter speed, aperture, white balance, ISO, and other settings—and later recall all of those values instantly just by turning the mode dial to one of the three MR positions and selecting one of the stored memory registers on the Memory Recall screen. You can store settings for any shooting mode, including the Intelligent Auto mode.

Here is how this works. First, set up the camera with the settings you want to recall. For example, suppose you are going to do street photography in daylight conditions. You may want to use a fast shutter speed, say 1/250 second, in black and white, at ISO 800, using continuous shooting with autofocus, Large and Extra Fine JPEG images, and shooting in the 1:1 aspect ratio.

The first step is to make all of these settings. Set the mode dial to Shutter Priority and use the control dial to set a shutter speed of 1/250 second. Then press the Menu button to call up the Camera Settings1 menu and, on screen 1, select JPEG for File Format, Extra Fine for JPEG Quality, L for the image size, and 1:1 for Aspect Ratio.

Then move to screen 3 and choose continuous shooting set to Hi speed for drive mode. On screen 8, under ISO Setting, set ISO to 800, then on screen 11 set white balance to Daylight. Next, scroll down three positions below white balance to the Creative Style option and select the B/W setting, for black and white. You can set any other available Camera Settings1 menu options as

you wish, but the ones listed above are the ones I will consider for now.

On the Camera Settings2 menu, go to screen 8 and set the Live View Display item to Setting Effect On.

Once these settings are made, navigate to the Memory item, shown in Figure 3-23, which is the fifth item on screen 3 of the Camera Settings1 menu. After you press the Center button with Memory highlighted, you will see a screen like the one in Figure 3-24, showing icons and values for all of the settings currently in effect.

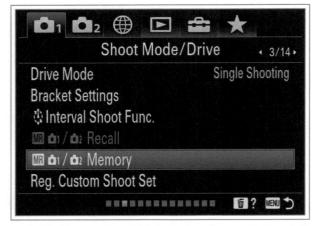

Figure 3-23. Memory Item Highlighted on Camera Settings1 Menu

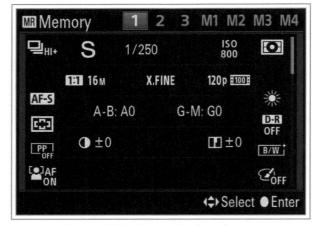

Figure 3-24. Memory Settings Screen

The word Memory appears at the upper left of the screen, and the indicators 1, 2, 3, M1, M2, M3, and M4 at the upper right. In the example shown here, the number 1 is highlighted. Now press the Center button, and you will have selected register 1 to store all of the settings you just made. Registers 1, 2, and 3 are stored in the camera's internal memory. Registers M1, M2, M3, and M4 are stored on the memory card that is currently inserted in the camera.

Note the short gray bar at the right side of the Memory screen shown in Figure 3-24. That bar indicates that you can scroll down through other screens to see additional settings that are in effect, such as High ISO Noise Reduction, Color Space, Interval Shooting, Pre-AF and several others. Use the Up and Down buttons to scroll through those screens.

Next, to check how this worked, try making some very different settings, such as setting the camera to Manual exposure mode with a shutter speed of one second, File Format set to Raw, aspect ratio set to 16:9, continuous shooting turned off, ISO set to Auto ISO, and Creative Style set to Vivid. Then turn the mode dial back to the first MR position, number 1 on the mode dial. You will see that all of the custom settings you made have instantly returned, including the shooting mode, shutter speed, aspect ratio, and other menu settings. You can then continue shooting with those settings.

This is a very useful feature, and it is more powerful than similar options on some other cameras, which can save menu settings but not values such as shutter speed, or can save settings only for the less-automatic shooting modes, but not the most automatic mode. In addition, if you now switch back to Manual exposure mode, the camera will restore the settings that you had in that mode before you turned to the MR-1 mode.

You can store some, but not all, settings from the Camera Settings1 and Camera Settings2 menus,

including items such as white balance, ISO, Live View Display, Zebra, Grid Line, Auto Review, and others, as well as the aperture and shutter speed values, provided, of course, that you are using a lens that communicates properly with the camera. You cannot save Program Shift.

Note that you can recall the M1, M2, M3, or M4 settings only if the memory card that has those settings saved is inserted in the camera. On the positive side, this means that you can build up an inventory of different groups of settings, and store them in groups of four on different memory cards. If those cards are clearly labeled or indexed, you can select a card with the four groups of settings you may need for a particular shooting session. However, whenever you format a card, the stored settings will be lost.

If you call up a group of settings using Memory Recall mode, you need to remember to make any other settings that require the use of a physical control. For example, you would need to make sure the switch on the Sony FE f/2.8~50mm Macro lens is set to the AF position in order to use any autofocus settings.

Overall, though, this feature is powerful and useful. With a twist of the mode dial, you can call up a group of settings tailored for a particular type of shooting. It is worthwhile to experiment with this feature and develop various groups of settings that work well for your shooting needs.

Chapter 4: The Camera Settings1 Menu

The a7C has six menus: Camera Settings1, Camera Settings2, Network, Playback, Setup, and My Menu. The first two contain settings that affect images and videos, as well as some other options that affect the functioning of various controls, such as the buttons, control wheel, and control dial. The Network menu has settings that govern the operation of the camera's Wi-Fi and Bluetooth features for remote control and transferring images. The Playback menu includes items for controlling playback of images and videos. The Setup menu has options that affect the camera's operation but that do not affect the imagemaking and video-recording operations directly, such as settings for camera sounds, monitor brightness, and the formatting of memory cards. Finally, the My Menu system lets you add your most-used menu options to a customized, short menu of favorites.

I will discuss all of these menus in the various chapters of this book. In this chapter, I will discuss only the Camera Settings1 menu, which mainly offers ways to control the appearance of still images and how you capture them. The available options on this menu will change depending on the setting of the mode dial. For example, if the camera is set to Intelligent Auto mode, the Camera Settings1 menu options are limited because that mode is for a user who wants the camera to make many decisions without input. For this discussion, I'm assuming you have the camera set to Program mode, because with that mode you have access to most of the options on the Camera Settings1 menu.

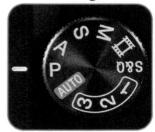

Figure 4-1. Mode Dial at P for Program

Turn the mode dial on top of the camera to P, which represents Program mode, as shown in Figure 4-1. You enter the menu system by pressing the Menu button. I would normally not discuss that obvious point further, but the location of the Menu button on the a7C camera has caused me some problems. I have found that its position at the top center of the camera's back is awkward; it is difficult to reach it and press it when holding the camera. One solution to this problem is to assign a different button to the Menu function, using the Custom Key (Still Images) and/or Custom Key (Movies) options on screen 9 of the Camera Settings2 menu. I have reassigned the Menu function to the Movie button using the Custom Key (Still Images) option, and I have found it much easier to get access to the menu system by pressing that button, rather than the Menu button. I discuss this issue further in Chapter 6, where I discuss the physical controls.

When the orange highlight bar is visible on a menu screen, you can navigate through the various screens of that menu by pressing the Right or Left button or by turning the control dial at the right side of the camera's top edge. As you press either of those buttons or turn the dial, you will see an orange dot at the very bottom of the screen move through a line of gray dots, indicating which screen of the current menu system you are viewing. You also will see a pair of numbers separated by a slash mark at the top right of the menu screen. Those numbers also indicate which screen of the menu is now displayed.

For example, Figure 4-2 shows screen 5 of the Camera Settings1 menu when the camera is in Program mode. The orange dot is in the fifth position from the left at the bottom of the screen, and the numbers at the top right are 5/14, meaning the current screen is the fifth of fourteen screens of this menu system.

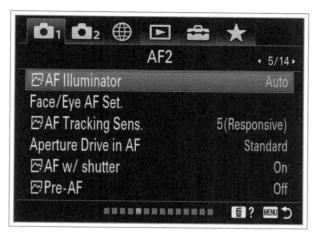

Figure 4-2. Screen 5 of Camera Settings1 Menu

When the menu system first appears, the camera will display the last menu screen that was viewed. If you need to move to a different screen or a different menu, press the Right and Left buttons or turn the control dial to navigate to that screen. As you keep pressing the direction buttons or turning the control dial, the cursor will move through all numbered screens of the various menu systems.

As you move through the menu screens on the a7C, after the Camera Settings1 menu comes the Camera Settings2 menu, then the Network menu, headed by a globe icon. The last three menus are the Playback menu, marked by a triangle icon; the Setup menu, marked by a toolbox icon; and, finally, the My Menu option, marked by a star icon.

To navigate quickly through these six menu systems, you can press the Up button or turn the control wheel to move the highlight block into the line of icons at the top of the screen. When one of those icons is highlighted, and the long, orange highlight bar has disappeared from the screen, you can use the Left and Right buttons or the control dial to move directly from one menu system to another without going through the various screens of each menu.

For example, in Figure 4-3, the Network menu icon is highlighted. From there, you can press the Left button twice or turn the control dial to the left to move the highlight to the camera icon for the Camera Settings1 menu at the far left, as shown in Figure 4-4.

Then you can press the Down button or turn the control wheel to move the highlight into the list of items on screen 1 of the Camera Settings1 menu.

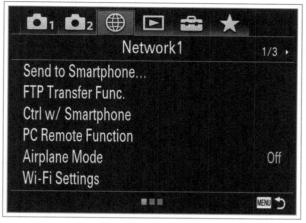

Figure 4-3. Network Icon Highlighted at Top of Menu Screen

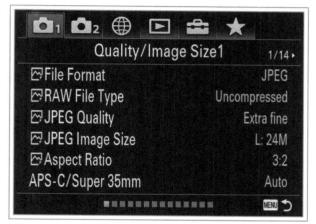

Figure 4-4. Camera Settings1 Icon Highlighted at Top of Menu Screen

Another shortcut for navigating through the main menu systems without going through their individual screens is to press the Function button. When a menu screen is displayed, pressing that button moves through the main menu system tabs in order, without highlighting any items on the various menus.

In this chapter, I will discuss only the Camera Settings1 menu; I will discuss the other five menus in Chapter 5 (Camera Settings2), Chapter 7 (Playback), Chapter 8 (Setup and My Menu), and Chapter 10 (Network).

The Camera Settings1 menu has many options on 14 numbered screens. In most cases, each option (such as JPEG Image Size) occupies one line, with its name on the left and current setting (such as L: 24M) on the right. Some items on the menu screens are dimmed and cannot be selected, such as the Exposure Compensation, Metering Mode, and Face Priority in Multi Metering options on screen 8 of the menu as seen in Figure 4-5, for example. This means those options

are not available for selection in the current context. In this case, the camera was set to Intelligent Auto mode, in which those three options cannot be used.

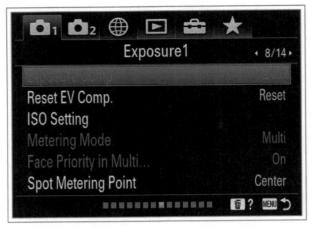

Figure 4-5. Several Items Dimmed on Menu Screen

Some items are preceded by an icon that indicates whether they are used for still images, movies, or Slow & Quick Motion movies, among other items. For example, Figure 4-6 shows screen 5 of the Camera Settings1 menu, on which all but two of the items are preceded by the icon showing they are applicable only for still images.

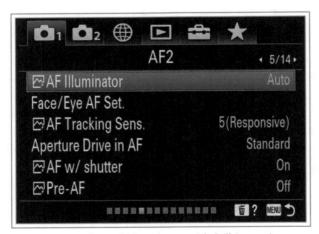

Figure 4-6. Several Menu Items with Still-image Icons

Figure 4-7 shows screen 1 of the Camera Settings2 menu, which has three settings (Exposure Mode, File Format, and Record Setting) that apply only for normal-speed movies, two settings (S & Q Exposure Mode and S & Q Settings) that apply only for Slow & Quick Motion recording, and one setting (Proxy Recording) that applies only for proxy recording, as shown by the icons for items in each of those categories.

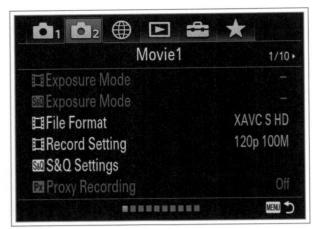

Figure 4-7. Several Menu Items with Movie and Other Icons

To follow the discussion below of the options on the Camera Settings1 menu, leave the shooting mode set to Program, which gives you access to most of the items on that menu. I'll start at the top of screen 1 and discuss all of the options on each of the 14 screens of this menu.

Screen 1 of the Camera Settings1 menu is shown in Figure 4-8.

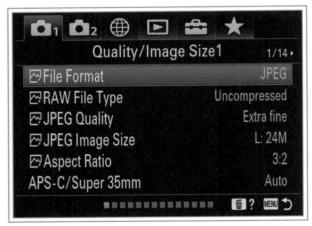

Figure 4-8. Screen 1 of Camera Settings1 Menu

File Format (Still Images)

This first option on the Camera Settings1 menu lets you make the important choice of whether to shoot still images using the Raw format, as JPEG files, or in both formats at the same time, as shown in Figure 4-9.

As is the case with most camera manufacturers, Sony offers its own special Raw format, which is a file type that preserves as much as possible of the raw data received by the camera through its lens for each still image. If you want to shoot images with the highest

possible quality, choose Raw for this menu option. If you want to shoot images that are easier to edit and to share, choose JPEG, which is an industry-standard format that is compatible with a wide range of photo editing programs, email programs, and other software. However, there are some other factors to consider in making this choice.

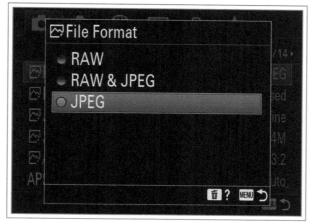

Figure 4-9. File Format (Still Images) Menu Options Screen

Raw files are larger than other files, so they take up more space on your memory card, and on your computer, than JPEG files. But Raw files offer advantages over JPEG files. When you shoot in the Raw format, the camera records as much information as it can about the image and preserves that information in the file it saves to the memory card.

When you open the Raw file later on your computer, your software can process that information in various ways. For example, you can change the exposure or white balance of the image when you edit it on the computer, just as if you had changed your settings while shooting. In effect, the Raw format gives you what almost amounts to a chance to travel back in time to improve some of the settings that you didn't get quite right when you pressed the shutter button.

For example, Figure 4-10 is an image I took with the a7C using the Raw format, with the exposure purposely set too dark and white balance set to Incandescent, even though I took the picture outdoors during daylight hours.

Figure 4-11 shows the same image after I opened it in Adobe Camera Raw software and adjusted the settings to correct the exposure and white balance. The result was an image that looked just as it would have if I had used the correct settings when I shot it.

Figure 4-10. Raw Image Taken with Abnormal Settings

Figure 4-11. Raw Image with Settings Adjusted in Software

Raw is not a cure-all; you cannot fix bad focus or excessive exposure problems. But you can improve some exposure-related issues and white balance with Raw-processing software. You can use Sony's Imaging Edge software to view or edit Raw files, and you also can use other programs, such as Adobe Camera Raw, that have been updated to handle Raw files from this camera.

Using Raw can have disadvantages, also. The files take up a lot of storage space; uncompressed Raw images taken with the a7C are about 48 MB in size and compressed ones are about 24 MB, while Large JPEG images I have taken are between about 3 and 18 MB, depending on the settings used. Also, Raw files have to be processed on a computer; you can't take a Raw image and immediately share it through social media or print it; you first have to use software to convert it to JPEG, TIFF, or some other standard format for manipulating digital photographs. If you are pressed for time, you may not want to take that extra step. Finally, some features of the a7C are not available when you are using the Raw format, such as the Auto HDR, Picture Effect, and Digital Zoom options.

If you're undecided as to whether to use Raw or JPEG, you have the option of selecting Raw & JPEG, the second choice for the File Format (Still Images) menu item. With that setting, the camera records both a Raw and a JPEG image when you press the shutter button.

The advantage with that approach is that you have a Raw image with maximum quality and the ability to do extensive post-processing, and you also have a JPEG image that you can use for viewing, sharing, printing, and the like. Of course, this setting consumes storage space more quickly than saving your images in just Raw or JPEG format, and it can take the camera longer to store the images, so there may be a slowdown in the rate of continuous shooting, if you are using that option. You can reduce the burden of file size by using compressed Raw images, as discussed later in this section. Even if you use the compressed version of Raw, however, you still cannot use some menu options that conflict with the Raw setting.

When you choose Raw & JPEG, you can select a JPEG Quality setting and a JPEG Image Size setting (both discussed below) that will apply only to the JPEG image; the Raw image is always saved at the maximum image size and quality.

The best bet for preserving the quality of your images and your options for post-processing and fixing exposure mistakes later is to choose Raw files. However, if you want to use features such as the Picture Effect menu option, and others, which are not available with Raw files, then choose JPEG. If you choose JPEG, I recommend using Large size and Extra Fine quality, unless you have an urgent need to conserve storage space on your memory card or on your computer. If you want Raw quality and are not concerned about storage space or speed of shooting, choose Raw & JPEG. However, you will still not be able to use Picture Effect and some other options.

Raw File Type

The Sony a7C camera offers a choice of two different versions of the Raw format—uncompressed and compressed. You might have thought that all Raw files are uncompressed, because that is a common understanding. A Raw file is sometimes described as a "digital negative" that contains all of the information

that the camera received through its digital sensor, with no processing or compression.

That is not the case with all Raw files, including the compressed Raw files offered by Sony in this and other cameras. Although compressed Raw files provide the advantages of Raw files, such as wide dynamic range and the ability to correct some settings in post-processing, they are compressed to conserve space on the memory card and on the computer's storage disk. They can also improve speed of burst shooting. As noted earlier, uncompressed Raw files are about 48 MB in file size, whereas compressed ones are about 24 MB.

The obvious question is whether it is worthwhile to choose the uncompressed Raw format for your photography, given that the file sizes are about twice those of compressed Raw files. The answer is that there is some deterioration of details in the compressed Raw files, especially in the area of high-contrast edges, or areas of transition from bright to dark parts of the image. If you need the absolute highest quality for images with areas of heavy contrast, you may want to use the uncompressed Raw option. For general photography of subjects without large differences in contrast, I recommend using the compressed Raw setting. With that option, you will get the benefits of using the Raw format without the double-sized files that consume your storage space rapidly.

JPEG Quality

The next option on this menu, JPEG Quality, is available for selection at any time, though it takes effect only when you are shooting JPEG images. The choices are Extra Fine, Fine, and Standard, as shown in Figure 4-12.

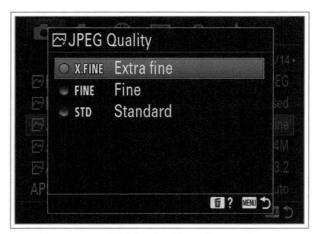

Figure 4-12. JPEG Quality Menu Options Screen

The term "quality" in this context concerns the way in which digital images are processed. In particular, JPEG (non-Raw) images are digitally compressed to reduce their size without losing too much information or detail from the picture. However, the more a JPEG image is compressed, the greater the loss of detail and clarity in the image.

The Extra Fine setting provides the least compression. Images captured with the Fine or Standard setting undergo increasingly more compression, resulting in smaller files with somewhat reduced quality. I recommend always using the Extra Fine setting for JPEG files, unless you have a need to preserve storage space or are taking numerous images that do not need to be of high quality, such as images for photo ID cards or for an inventory of possessions.

JPEG Image Size

This setting controls the size in pixels of a JPEG still image recorded by the camera. (Raw images are always recorded at the maximum image size.) The Sony a7C has a full-frame sensor, which means the sensor is about the same size as a frame of 35mm film, and that sensor has a high maximum resolution, or pixel count. The sensor is capable of recording a still image with 6000 pixels, or individual points of light, in the horizontal direction and 4000 pixels vertically. When you multiply those two numbers together, the result is 24 million pixels, often referred to as megapixels, MP, or M.

The resolution of still images is important mainly when it comes time to enlarge or print your images. If you need to produce large prints (say, 8 by 10 inches or 20 by 25 cm), then you should select a high-resolution setting for JPEG Image Size. You also should choose the largest setting if you may need to crop out a small portion of the image and enlarge it for closer viewing.

For example, if you are shooting photos of wildlife and the animal or bird you are interested in is in the distance, you may need to enlarge the image digitally to see that subject in detail. In that case, you should choose the highest setting (L) for JPEG Image Size.

The available settings for JPEG Image Size are L, M, and S for Large, Medium, and Small, as shown in Figure 4-13.

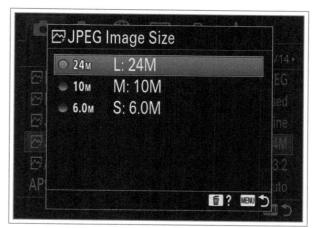

Figure 4-13. JPEG Image Size Menu Options Screen

When you select one of these options, the camera displays a setting such as L: 24M, meaning Large: 24 megapixels. The number of megapixels changes depending on the aspect ratio setting, discussed below. This is because when the shape of the image changes, the number of horizontal or vertical pixels changes also, to form the new shape.

For example, if the aspect ratio setting is 3:2, the maximum number of pixels is used because 3:2 is the aspect ratio of the camera's sensor. However, if you set aspect ratio to 16:9, the number of horizontal pixels (6000) stays the same, but the number of vertical pixels is reduced from 4000 to 3376 to form the 16:9 ratio of horizontal to vertical pixels. When you multiply those two numbers (6000 and 3376) together, the result is about 20 million pixels, which the camera states as 20M, as will be shown on screen 1 of the Camera Settings1 menu.

One of the few reasons to choose a JPEG Image Size setting smaller than L is if you are running out of space on your memory card and need to keep taking pictures in an important situation. Table 4-1 shows approximately how many images can be stored on a 64 GB memory card for various settings.

Table 4-1. Number of Images that Fit on a 64 GB Card (Image Size vs. Quality at 3:2 Aspect Ratio)

	LARGE	MEDIUM	SMALL
UNCOMPRESSED RAW & JPEG (EXTRA FINE)	950	1100	1100
Uncompressed Raw	1300		
EXTRA FINE	3600	6700	8700

FINE	6700	9999+	9999+	
STANDARD	9600	9999+	9999+	

As you can see, if you are using a 64 GB memory card, which is a fairly common size nowadays, you can fit about 950 images on the card even at the maximum settings of 3:2 for Aspect Ratio, Large for Image Size, and (Uncompressed) Raw & JPEG (Extra Fine) for Quality. If you limit the JPEG image quality to Fine, with no Raw images, you can fit about 6700 images on the card. If you reduce the JPEG Image Size setting to Small, you can store more than 10,000 images. I am unlikely ever to need more than about 300 or 400 images in any one session. And, of course, I can use a larger memory card or multiple memory cards.

If space on your memory card is not a consideration, I recommend you use the L setting at all times. You never know when you might need the larger-sized image, so you might as well use the L setting and be safe. Your situation might be different, of course. If you were taking photos purely for a business purpose, such as making photo identification cards, you might want to use the Small setting to store the maximum number of images on a memory card and reduce expense. For general photography, I rarely use any setting other than L for Image Size. (One exception could be when I want to increase the focal length reach of the lens without losing image quality; see the discussion of Smart Zoom and related topics in Chapter 5.)

Aspect Ratio

This next option on the Camera Settings1 menu lets you choose the shape of your still images. The choices are the default of 3:2, as well as 4:3, 16:9, and 1:1, as shown in Figure 4-14. These numbers represent the ratio of the units of width to the units of height. For example, with the 16:9 setting, the image is 16 units wide for every 9 units of height.

The aspect ratio that uses all pixels on the image sensor is 3:2; with any other aspect ratio, some pixels are cropped out. So, if you want to record every possible pixel, you should use the 3:2 setting. If you shoot using the 3:2 aspect ratio, you can always alter the shape of the image later in editing software such as Photoshop

by cropping away parts of the image. However, if you want to compose your images in a certain shape and don't plan to do post-processing in software, the aspect ratio settings of this menu item can help you frame your images in the camera using the appropriate aspect ratio on the display.

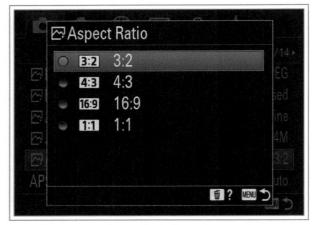

Figure 4-14. Aspect Ratio Menu Options Screen

For each of the aspect ratios discussed below, I am including an image I took using that setting in the same location at the same time, to show what the different aspect ratios look like. The default 3:2 setting, used for Figure 4-15, includes the maximum number of pixels, and is the ratio used by 35mm film. This aspect ratio can be used without cropping to make prints in the common U.S. size of six inches by four inches (15 cm by 10 cm).

Figure 4-15. Aspect Ratio 3:2

The 4:3 setting, shown in Figure 4-16, is in the shape of a traditional (non-widescreen) computer screen, so if you want to view your images on that sort of display, this may be your preferred setting. With this setting, some pixels are lost at the left and right sides of the image.

Figure 4-16. Aspect Ratio 4:3

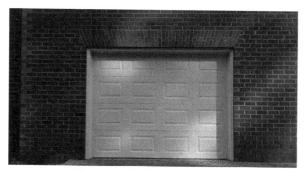

Figure 4-17. Aspect Ratio 16:9

The 16:9 setting, illustrated in Figure 4-17, is the "widescreen" option, like that found on many modern HD television sets. You might use this setting when you plan to show your images on an HDTV set. Or, it might be suitable for a particular composition in which the subject matter is stretched out in a horizontal arrangement. With this setting, some pixels are cropped out at the top and bottom, though none are lost at the left or right.

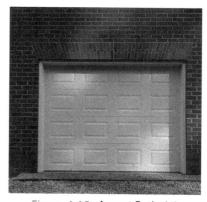

Figure 4-18. Aspect Ratio 1:1

The 1:1 ratio, illustrated in Figure 4-18, produces a square shape, which some photographers prefer because of its symmetry and because the neutrality of the shape leaves open many possibilities for

composition. With the 1:1 setting, the camera crops pixels from the left and right sides of the image.

The aspect ratio setting is available in all shooting modes. However, although you can set aspect ratio when the camera is in Movie mode or S & Q Motion mode (mode dial turned to movie-film icon or S & Q), that setting will have no effect until you switch to a mode for taking still images, such as Program mode. When the mode dial is set to the Movie position or the S & Q position, you cannot take still images.

APS-C/Super 35mm

This next setting lets you optimize the camera for using either a lens designed for full-frame cameras like the a7C, or a lens designed for APS-C cameras like the Sony a6000 series, including the a6000, a6100, a6400, and a6600. As discussed in Appendix A, both of these types of camera can accept Sony E-mount lenses. However, there are two classes of E-mount lenses: the ones intended for full-frame cameras are designed to produce an image that covers the entire area of the full-frame sensor, while the lenses designed for the APS-C cameras, which have the smaller APS-C-sized sensor, are designed to produce an image that fully covers only that smaller-sized sensor.

It is quite possible to attach a lens designed for APS-C cameras to the a7C, as long as the lens has the Sony E-mount. However, with such a lens, the image will not fill the entire area of the sensor, resulting in vignetting, because the lens is not designed to produce an image over the extent of the larger sensor of the a7C camera. Therefore, Sony provides this menu option. If you turn it on, the camera makes an adjustment to allow the lens to produce an image that fills the full extent of the full-frame sensor.

To illustrate, Figure 4-19 is an image taken with an APS-C lens (the Sony 18mm-135mm f/3.5-5.6 OSS) attached to the a7C, with this menu option turned off. As you can see, there is considerable vignetting, because the image from the lens did not fill the area of the full-frame sensor in the A7C camera. Figure 4-20 is a similar image taken with that lens, with this menu option turned on. As you can see, in this case the camera adjusted for the use of the lens, and cropped the image so it could be magnified to fill the area of the sensor.

Figure 4-19. Image from APS-C Lens with APS-C Option Turned Off

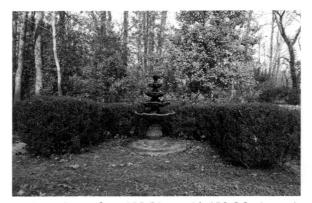

Figure 4-20. Image from APS-C Lens with APS-C Option at Auto

This menu option can be set to On, Auto, or Off. With On, the camera adjusts for using an APS-C (or Super 35mm) lens; with Off, it remains set up for using a full-frame lens. With Auto, the camera adjusts according to the lens that it detects as attached to the camera.

Super 35mm is a classification for lenses for cinema cameras that use the Super 35 format, which is similar in size to APS-C. One example is the Sony E PZ 18-110mm f/4 G OSS lens, designed for use with video cameras.

This menu option is useful because it gives you a way to make use of any APS-C (or Super 35mm) lenses that you happen to own or have access to, without the disadvantage of vignetting. However, you lose resolution in the images you capture with such a lens, because the camera crops the image in order to fill the sensor. Therefore the maximum image size when using the APS-C setting is 10 megapixels, instead of the 24 MP possible with the full-frame setting. I almost always leave this setting at Auto, which gives me the option to attach an APS-C lens and use it with good results.

Note that you can turn this menu option on even when using a lens designed for a full-frame camera. In that case, the camera crops the image, in effect achieving a longer focal length for the lens. That action would have the same effect as selecting a smaller image size and then zooming the lens using the Smart Zoom range of the camera, as discussed in Chapter 5, or cropping the image and enlarging it using software. So, there would be no advantage in using the On setting for this option when using a full-frame lens, other than providing an alternative sort of digital zoom.

Screen 2 of the Camera Settings1 menu is shown in Figure 4-21.

Figure 4-21. Screen 2 of Camera Settings1 Menu

Long Exposure Noise Reduction

This option uses processing to reduce the "noise" that affects images during exposures of one second or longer. This setting is turned on by default. When it is turned on, the camera processes your shot for a time equal to the length of the exposure. So, if your exposure is for two seconds, the camera will process the shot for an additional two seconds after the image is captured, creating a delay before you can shoot again.

In some cases, this processing may remove details from your image. In addition, in certain situations you may prefer to leave the noise in the image because the graininess can be pleasing in some cases. Or, you may prefer to remove the noise using post-processing software. If you want to turn off this option, use this menu item to do so.

This option is not available for adjustment when the camera is set for continuous shooting, continuous

exposure bracketing, silent shooting, or in Intelligent Auto mode.

I recommend you make this setting based on the type of shooting you are doing. If you're taking casual shots or don't want to do post-processing, I suggest you leave this option turned on. But, if you are shooting with Raw quality and want to do processing with software, I recommend turning it off.

High ISO Noise Reduction

This next menu entry has three settings: Normal, Low, or Off; the default is Normal. This option removes noise caused by the use of a high ISO level. One problem with this sort of noise reduction is that it takes time to process your images after they are captured. You may want to set this option to Low or Off to minimize the delay before you can take another picture. If File Format (Still Images) is set to Raw, this option will be unavailable on the menu because this processing is not available for Raw images. It is not available for adjustment on the menu in Intelligent Auto mode; it is always set to Normal in that mode.

Color Space

With this option, you can choose to record your still images using the sRGB "color space," the more common choice and the default, or the Adobe RGB color space. The sRGB color space has fewer colors than Adobe RGB; therefore, it is more suitable for producing images for the web and other forms of digital display than for printing. If your images are likely to be printed commercially in a book or magazine or it is critical that you be able to match a great many color variations, you might want to consider using the Adobe RGB color space. I always leave the color space set to sRGB, and I recommend that you do so as well unless you have a specific need to use Adobe RGB, such as a requirement from a printing company that you are using to print your images.

If you are shooting your images with the Raw format, you don't need to worry so much about color space, because you can set it later using your Raw-processing software.

Lens Compensation

The final item on screen 2 of the Camera Settings1 menu, labeled Lens Comp., provides three suboptions that you can turn on to adjust the appearance of images by correcting for three problems that are inherent in camera lenses: Shading Compensation, Chromatic Aberration Compensation, and Distortion Compensation. This menu option is available only when you are using a lens that permits this sort of automatic compensation. Sony includes this feature with many of its lenses; information from Sony about compliant lenses is available at https://support.d-imaging.sony.co.jp/www/cscs/lens_body/index.php#menu_lens_mount.

Figure 4-22. Lens Compensation Menu Options Screen

Each of this menu item's sub-options, shown in Figure 4-22, can be set to either Off or Auto. When a setting is set to Auto, the camera uses its digital processing to correct the image for that particular type of problem. There are some differences in how these settings operate, as described below.

SHADING COMPENSATION

This problem involves a darkening in the corners of images. If you set this option to Auto, the camera will automatically apply processing to compensate for that darkening. I recommend you leave it set to Auto, unless you have a particular reason to deal with it in post-processing software.

CHROMATIC ABERRATION COMPENSATION

This correction involves the distortion of colors in images because of the characteristics of the lens. I recommend leaving it set to Auto unless you want to address chromatic aberration in post-processing software.

DISTORTION COMPENSATION

This last option corrects for the effect by which the lens bends or curves straight lines. It could not be disabled on my a7C camera when using the 28mm-60mm f/4.0-5.6 kit lens, but it could be disabled with the Sony FE 100-400mm f/4.5-5.6 GM OSS lens and with the Sony FE 50mm f/2.8 Macro lens. Even if you are using a lens for which this option can be disabled, I recommend leaving it set to Auto unless you are certain you want to deal with distortion in post-processing software.

If you generally use a program such as Adobe Photoshop Lightroom to apply lens corrections, you can leave the above options set to Off (except for Distortion Compensation with some lenses) and apply any needed corrections using your post-processing software. According to Sony, if you want to apply corrections to Raw files, you may need to use Sony's Imaging Edge software. See https://www.sony.com.sg/electronics/support/articles/00018031. (This article says to use Image Data Converter software, but that software has been replaced by Imaging Edge.)

The items on screen 3 of the Camera Settings1 menu are shown in Figure 4-23.

Figure 4-23. Screen 3 of Camera Settings1 Menu

Drive Mode

This first option on screen 3 of the Camera Settings1 menu gives access to features of the a7C for shooting bursts of images, bracketing exposures, and using the self-timer.

When you highlight this option and press the Center button, a menu appears at the left of the screen as shown in Figure 4-24, with eight choices represented by icons: Single Shooting, Continuous Shooting, Self-timer (Single), Self-timer (Continuous), Continuous Exposure Bracketing, Single Exposure Bracketing, White Balance Bracketing, and DRO Bracketing.

Figure 4-24. Drive Mode Menu

Scroll through this menu using the Up and Down buttons or the control wheel. When the icon for an option is highlighted, you can select sub-options by pressing the Left and Right buttons or by turning the control dial. (You have to scroll down to see all of the choices on the menu.)

Details for the drive mode settings are discussed below.

SINGLE SHOOTING

This is the normal mode for shooting still images. Select this top choice on the drive mode menu to turn off all continuous shooting. In some cases, having one of the continuous-shooting options selected will make it impossible to make other settings, such as Long Exposure Noise Reduction. If you find you cannot make a certain setting, try selecting single shooting to see if that removes the conflict and fixes the problem.

CONTINUOUS SHOOTING

Continuous shooting, sometimes called burst shooting, is one of the most useful features of the a7C, providing speeds up to 10 frames per second (fps), with focus and exposure adjusted for each shot. This capability is useful in many contexts, from shooting an action sequence at a sporting event to taking a series of shots of a person in order to capture changing facial expressions. I often

use burst shooting for street photography to increase my chances of catching an interesting scene.

To activate burst shooting, scroll down to the second icon on the drive mode menu, which looks like a stack of overlapping frames, as shown in Figure 4-24. When that icon is highlighted, press the Left or Right button or turn the control dial to select the speed of shooting—Hi+, Hi, Mid, or Lo. The Hi+ setting provides speeds up to 10 fps; Hi offers speeds as high as 8 fps; Mid has speeds up to 6 fps; and the Lo setting is rated at up to 3 fps. Once a speed is selected, press and hold the shutter button to fire off a burst of shots. The camera will shoot at the selected speed level until its memory buffer fills up, at which point the shooting will change to a considerably slower pace.

With the Hi+ setting, the camera does not provide a real-time live view of the scene it is shooting, although it does provide images that lag the shooting somewhat. If you need a constantly updated live view, you should choose the Hi option (or Mid or Low) rather than Hi+. Otherwise, I usually choose Hi+ for the added speed of shooting.

If focus mode is set to AF-S for single autofocus, the camera will not adjust its focus during the burst of shots. But, if you set focus mode to AF-C for continuous autofocus or AF-A for automatic autofocus, the camera will adjust focus for each shot, as long as the aperture value is no higher than f/11.0. The reason for this limitation is that the camera's ability to adjust focus during continuous shooting depends on its use of phase-detection autofocus, which uses 693 special autofocus points covering almost the entire area of the image sensor.

This phase-detection system cannot function at apertures more narrow than f/11.0, such as f/12.0 and f/16.0. At those narrower apertures, the camera reverts to using contrast-detection autofocus, which is quite accurate but considerably slower than the phase-detection process. So, if you need to take bursts of continuous shots with autofocus adjustments for all images, you should ensure that the camera is using an aperture of f/11.0 or lower.

In addition, to get the best possible performance for autofocusing during burst shooting, you should check the setting of the Priority Set in AF-C menu option on screen 4 of the Camera Settings1 menu. As discussed later in this chapter, that setting controls whether the camera emphasizes quick release of the shutter as opposed to accurate autofocus, or puts a "balanced emphasis" on both. When I tested continuous shooting using my Sony 28mm-60mm kit lens, I found that, when this option was set to Release or Balanced Emphasis, the camera and lens did not adjust the focus quite as well during continuous shooting as when Priority Set in AF-C was set to AF. With the AF setting, with which the camera emphasizes focus over speed, the speed of shooting slowed down noticeably while the camera focused, but there were fewer out-of-focus images.

I also found that the focus area setting, discussed later in this chapter, can have a definite impact on the quality of autofocus results during burst shooting. I found that the Wide setting worked well in my tests.

Also note that autofocus will not be accurate in all situations during burst shooting. If the subject is one that is difficult to focus on, the camera may not always focus sharply. But when conditions are reasonably good, the autofocus works very well during burst shooting, especially if you use the AF setting for Priority Set in AF-C and a compatible setting for focus area, such as Wide.

If you want the camera to adjust its exposure during the series of continuous shots, you need to go to screen 9 of the Camera Settings1 menu and check the setting of the AEL w/Shutter menu item. If that item is set to On, the camera will lock exposure when you press the shutter button, and exposure will be locked throughout the burst as it was set for the first image, even if the lighting changes dramatically.

However, if you set AEL w/Shutter to Off, the camera will adjust its exposure as needed during the burst of shots. If you set AEL w/Shutter to Auto, the camera will adjust exposure during continuous shooting if focus mode is set to continuous autofocus or automatic autofocus. If it is set to single autofocus, the camera will keep the exposure locked. (Of course, if you want the camera to adjust exposure automatically, you have to use an exposure mode in which the camera normally controls exposure. If you use Manual mode with a fixed ISO value, the exposure will not change.) I recommend setting this menu option to Auto, unless you have a particular reason to use a different setting.

Although you can turn on the flash when the Continuous Shooting option is selected, and the camera will take a series of shots with flash as you hold down the shutter button, the time between shots may be one second or longer, because the flash cannot recycle quickly enough to take a more rapid series of shots. (I was quite surprised, though, to find that the camera shot a continuous burst quite rapidly when using the Sony HVL-F20M flash, which was able to keep up the pace much faster than I expected.)

After taking a burst of shots, it can take the camera a while to save them to the memory card. The access lamp on the bottom left corner of the camera lights up in red while the camera is writing to the card. In addition, the camera will display a series of small vertical lines along with a series of changing numbers in the upper left corner of the display, indicating the number of images remaining to be written from the buffer to the memory card. While the access lamp is illuminated and the buffer-emptying display is active, be sure not to remove the battery or the memory card. While the buffer is being emptied, you can take additional shots, you can enter playback mode to view images that have already been written to the memory card, and you can use the menu system to some extent.

When you have captured a series of continuous shots, the way they are displayed in playback mode depends on a menu setting called Display as Group, on screen 3 of the Playback menu. If that option is turned on, as it is by default, then, once the burst of shots is captured and written to the memory card, the camera will display all of the shots in the group as a single item that appears like a stacked group of images. In the lower right corner of the display, the camera displays the word Expand next to a round icon, as shown in Figure 4-25. These indications mean you can press the Center button to open up the group to see the individual images inside it.

If you don't press the Center button, the group, which may contain hundreds of images, will behave like a single image for purposes of scrolling through images and deleting them. If you press the Center button, the group opens up and you can view each individual image within the group. The camera will display a set of numbers in the upper right corner of the display, such as 1/134, indicating which image is being viewed out of how many total images in the group, as shown in Figure

4-26. To end the expansion and group the images back into a single item, press the Center button again.

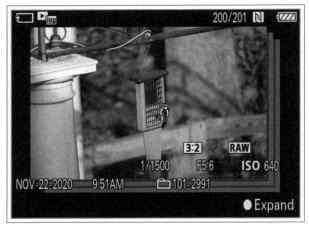

Figure 4-25. Burst of Shots Displayed as Group

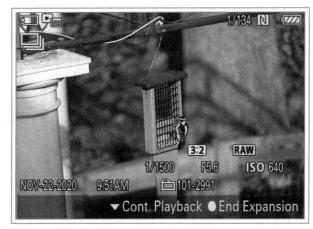

Figure 4-26. Burst of Shots Displayed as Individual Images

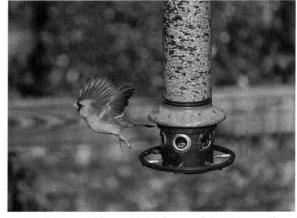

Figure 4-27. Image Taken with High-speed Continuous Shooting

For Figure 4-27, I used continuous shooting to take a series of images of birds at a backyard feeder, with the goal of catching one of them in flight. After capturing many images, I selected this one. It was shot with

the Sony FE 100-400mm f/4.5-5.6 GM OSS lens at 1/1500 second, at ISO 640 and f/5.6. I used high-speed continuous shooting, and continuous autofocus with focus area set to Tracking-Flexible Spot.

Continuous shooting is not available with the Rich-Tone Monochrome Picture Effect setting, or with Auto HDR turned on.

To display a bar indicating the amount of time available for continuous shooting with current settings, use the Continuous Shooting Length menu option on screen 8 of the Camera Settings2 menu, discussed in Chapter 5.

SELF-TIMER

The next icon down on the menu of drive mode options represents the self-timer, as shown earlier in Figure 4-24. The self-timer is useful when you need to be the photographer and also appear in a group photograph. You can place the a7C on a tripod, set the timer for five or ten seconds, and insert yourself into the group before the shutter clicks. The self-timer also is helpful when you don't want to cause blur by jiggling the camera as you press the shutter button.

For example, when you're taking a macro shot very close to the subject, focusing can be critical, and any bump to the camera could cause motion blur. Using the self-timer gives the camera a chance to settle down after the shutter button is pressed, before the image is recorded.

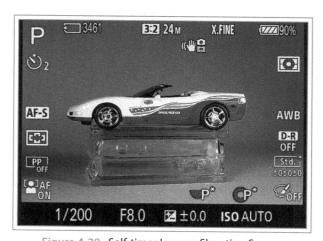

Figure 4-28. Self-timer Icon on Shooting Screen

The self-timer option presents you with three choices: ten seconds, five seconds, or two seconds. When the self-timer icon is highlighted, press the Left or Right button or turn the control dial to highlight one of these

options, and press the Center button to select it. After you make this selection, the self-timer icon will appear in the upper left corner of the display with the chosen number of seconds (10, 5, or 2) displayed next to the icon, as shown in Figure 4-28. (If you don't see the icon, press the Display button until a screen with the various shooting icons appears.)

Once the self-timer is set, when you press the shutter button, the timer will count down for the specified number of seconds and then take the picture. The reddish lamp on the front of the camera will blink, and the camera will beep during the countdown. You can cancel the process by pressing the shutter button again or by pressing the Left button, assuming it is still assigned to drive mode. If you don't want the camera to beep during the countdown, set Audio Signals to Off on screen 10 of the Camera Settings2 menu. (The lamp on the front of the camera will still blink.)

The self-timer is not available for recording a movie, and you cannot select continuous autofocus when the self-timer is turned on. To use the self-timer with bracketing, you need to use the Self-timer During Bracket menu option, discussed later in this chapter.

SELF-TIMER (CONTINUOUS)

The next item down on the drive mode menu, highlighted in Figure 4-29, is another variation on the self-timer.

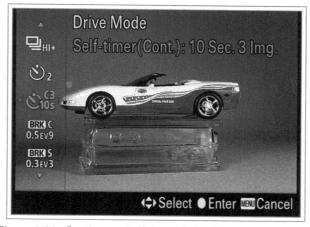

Figure 4-29. Continuous Self-timer Highlighted on Drive Mode Menu

With this option, you can set the timer to take multiple shots after the countdown ends. You can choose any of the three time intervals, and you can set the camera to take either three or five shots after the delay. When you highlight this option, you will see a horizontal triangle indicating that, by pressing the Left and Right buttons or turning the control dial, you can select one of six combinations of the number of shots and the timer interval. For example, the option designated as C3/2s sets the camera to take three shots after the timer counts down for two seconds; C5/10s sets it for five shots after a ten-second delay.

This option is useful for group photos; when a series of shots is taken, you increase your chances of getting at least one shot in which everyone is looking at the camera and smiling. You can choose any settings you want for File Format, JPEG Quality, and JPEG Image Size, including Raw & JPEG, and you will still get three or five rapidly fired shots, though the speed of shooting will decrease slightly when using the Raw format. You cannot use continuous autofocus with this option.

CONTINUOUS EXPOSURE BRACKETING

This next option on the drive mode menu, shown just below the continuous self-timer in Figure 4-29, sets the camera to take three, five, or nine images with one press of the shutter button but with a different exposure level for each image, giving you a greater chance of having one image that is properly exposed.

When you highlight this option, you will see a horizontal triangle meaning that you can use the Left and Right buttons or the control dial to select one of 16 combinations of the difference in exposure value and the number of images in the bracket. The first 12 choices include exposure value (EV) intervals of 0.3, 0.5, 0.7, or 1.0, each with a bracket of three, five or nine exposures. The other four choices are for EV intervals of 2.0 or 3.0 EV, each with a bracket of three or five exposures.

The decimal numbers represent the difference in EV among the multiple exposures (three, five, or nine) that the camera will take. (With the larger EV intervals of 2.0 or 3.0 EV, the available numbers of shots are three or five; there is no option for choosing nine shots, because the overall exposure range would be too great, given the larger EV interval.)

For example, if you select 0.7 EV as the interval for three exposures, the camera will take three shots—one at the metered exposure level; one at a level 0.7 EV (or f-stop) below that, resulting in a darker image; and

one at a level 0.7 EV above that, resulting in a brighter image. If you want the maximum exposure difference among the shots, select 3.0 EV as the interval for the three or five shots.

Once you have set this option as you want it and composed your scene, press and hold the shutter button and the camera will take the three, five, or nine shots in rapid succession while you hold down the button.

If you set this option for three exposures, the first one will be at the metered value, the second one underexposed by the selected interval, and the third one overexposed to the same extent. If you set it for five exposures, the first three shots will have the values noted above, the fourth will have the most negative EV, and the fifth will have the most positive EV. With nine exposures, the pattern will be similar, with the final two exposures having the most negative and positive EV settings, respectively. (You can change this order using the Bracket Settings menu option, discussed later in this chapter.)

You can use exposure compensation, in which case the camera will use the image with exposure compensation as the base level, and then take exposures that deviate under and over the exposure of the image with exposure compensation.

If you attach a flash unit and set it to fire, using the Fill-flash setting for example, the flash will fire for each of the bracketed shots and the exposure will be varied, but you have to press the shutter button for each shot, after the flash has recycled. (The orange dot to the right of the flash icon on the screen shows when the flash is ready to fire again.) With this approach, the camera will vary the output of the flash unit rather than the exposure value of the images themselves.

When using Manual exposure mode with ISO set to Auto, the camera adjusts the ISO setting to achieve the different exposure levels for the multiple images. If ISO is set to a specific value, the camera varies the shutter speeds for the multiple shots.

SINGLE EXPOSURE BRACKETING

The next option is similar to the previous one, except that, with this selection, you have to press the shutter button for each shot; the camera will not take multiple shots while you hold down the shutter button. You have the same 16 choices for combinations of EV intervals and numbers of exposures. You might want to choose this option when you need to pause between shots for some reason, such as if you are using a model who needs to have some costume or makeup adjustments for each exposure. It also could be useful if you want to look at the resulting image after each shot to see if you need to make further adjustments to your settings.

Apart from using individual shutter presses, this option works the same as continuous exposure bracketing. For example, you can use flash and you can change the order of the exposures using the Bracket Settings menu option.

None of the bracketing options—exposure, white balance, or DRO—is available in the Intelligent Auto shooting mode.

WHITE BALANCE BRACKETING

The next option on the drive mode menu, white balance bracketing, whose icon is highlighted in Figure 4-30, is similar to continuous exposure bracketing, except that only three images can be taken and the value that is varied for the three shots is white balance rather than exposure.

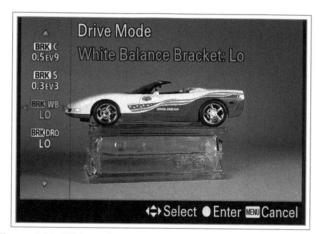

Figure 4-30. White Balance Bracketing Icon Highlighted on Menu

Using the Left and Right buttons or the control dial, select either Lo or Hi for the amount of deviation from the normal white balance setting. Then, when you press the shutter button (you don't have to hold it down), the camera will take a series of three shots—one at the normal setting; the next one with a lower color temperature, resulting in a "cooler," more bluish image; and the last one with a higher color temperature, resulting in a "warmer," more reddish image. When you use this form of bracketing, unlike exposure bracketing.

you will hear only one shutter sound because the camera takes just one image, with one quick shutter press, and then electronically creates the other two exposures with the different white balance values.

You can change the order of the exposures using the Bracket Settings menu option, discussed later in this chapter.

DRO BRACKETING

This final option on the drive mode menu sets the a7C to take a series of three shots at different settings of the DRO (dynamic range optimizer) option. I'll discuss DRO later in this chapter. Essentially, DRO alters the a7C's image processing to even out the contrast between shadowed and bright areas. It can be difficult to decide how much DRO processing to use, and this option gives you a way to experiment with several different settings before you decide on the amount of DRO for your final image.

As with white balance bracketing, you can select Hi or Lo for the DRO interval. Also, as with white balance bracketing, you only need to press the shutter button once, briefly; the camera will record the three different exposures electronically. The order of these exposures is not affected by the Bracket Order menu option.

Bracket Settings

The next option on this menu screen includes two settings for how bracketed exposures are taken. When you select Bracket Settings, you will see two suboptions: Self-timer During Bracket and Bracket Order, as shown in Figure 4-31.

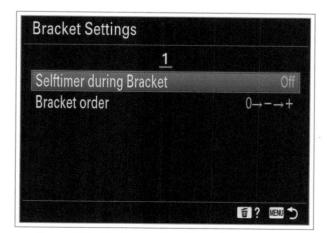

Figure 4-31. Bracket Settings Menu Options Screen

The Self-timer During Bracket option lets you use the self-timer with bracket shooting. Without this option you could not use bracketing and the self-timer at the same time, because they are selected by different options on the drive mode menu.

With this menu item you can have the self-timer set for two, five, or ten seconds before the first bracket shot is triggered, or you can leave the self-timer turned off. This setting turns on the self-timer for any type of bracket shooting you choose from the drive mode menu—exposure, white balance, or DRO.

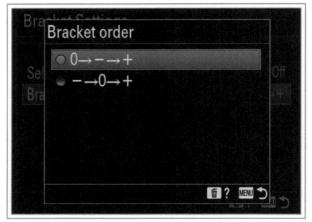

Figure 4-32. First Choice Selected for Bracket Order

The second sub-option, Bracket Order, lets you alter the sequence of the bracketed shots. There are two choices. The first one, shown selected in Figure 4-32, is the default setting, with which the first shot is at the normal setting, the next is more negative (or with lower color temperature), the one after that is more positive (or with higher color temperature), and so on, ending with the most negative setting and, finally, the most positive setting. If you choose the second option, the images are shot in a strictly ascending series, moving from the most negative setting to the most positive setting.

The Bracket Order option affects the order for exposure bracketing and white balance bracketing, but not for DRO bracketing.

Interval Shooting Function

This option lets you set up the camera to shoot a series of still images at a specified interval in order to create a time-lapse sequence that can be played back like a movie. The end result is a movie that is greatly speeded up, usually in order to show a long process, such as the

sun setting, a flower unfolding, a parking lot filling up with cars, or a building being constructed, in a much shorter period of time, such as five or ten seconds.

With the a7C, you can capture the series of shots using the Interval Shooting Function menu option, but you cannot create the final movie in the camera. Instead, you have to use software such as Imaging Edge, which can be downloaded for free from Sony.

Here are the steps to use for this process:

- 1. Select the Interval Shooting Function option on screen 3 of the Camera Settings1 menu and press the Center button to select it.
- 2. On the first screen of sub-options, shown in Figure 4-33, set Interval Shooting to On.

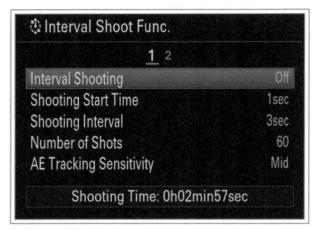

Figure 4-33. First Screen of Interval Shooting Options

- 3. Set Shooting Start Time to a value from 1 second to 99 minutes and 59 seconds. This period of time represents the delay from when you press the shutter button to when the interval shooting series starts. Unless you have a reason to delay the start of shooting, pick 1 or 2 seconds, so the sequence will get started immediately.
- 4. Set Shooting Interval to a value from 1 second to 60 seconds, which represents the time between shots. The larger this value, the faster the action will appear in the final movie. If you choose 1 second, the action will be speeded up about 30 times, if you use the standard 30 frames per second (fps) speed for the final movie. If you choose 10 seconds, it will be speeded up 300 times; if you choose 60 seconds, it will be speeded up 1800 times. So, for a very long process, such as building a house, you may want

- to choose the maximum interval of 60 seconds, to keep the final movie at a reasonable length.
- 5. Set Number of Shots to a value from 1 to 9999. If you set this value to 9999 and use 60 seconds for the interval between shots, the camera can record an event that lasts for about one week. Of course, if you record a sequence for one week, you can then reset the camera to start another sequence, if you are recording an event that lasts more than one week, as long as you are able to continue supplying power to the camera and making sure the memory card does not fill up. If the shooting interval is quite short, such as two or three seconds, it is possible that the camera will overheat after a long period of shooting. You could try using a longer shooting interval or find a way to cool the camera's environment if this problem occurs.
- 6. Set AE Tracking Sensitivity to High, Mid, or Low. This setting controls how readily the camera changes its exposure settings when lighting conditions change. The value you use for this setting depends on the subject you are recording. For example, if you are recording a construction project, you may not want the exposure to change every time a cloud passes over the sun. In that case, set this option to Low. On the other hand, if you are recording the sunset, it is natural for the exposure to change constantly as the sky darkens. In that case, you may want to choose High. As you work with this feature, you may find which setting produces the results you prefer.
- 7. On the second screen of sub-options (reached by pressing the Right button or turning the control dial), set Silent Shooting in Interval to On or Off. This setting depends on your needs. If you are recording a sequence in an area where you want to minimize the sounds of the camera operating, choose On; if you would prefer to hear the shutter being operated for each shot, choose Off. (This option is turned on by default.)
- 8. For the last sub-option, set Shooting Interval Priority to On or Off. This setting controls what happens when the camera is set to Program or Aperture Priority mode, in which the camera selects the shutter speed. In that situation, it is possible that, if the lighting of the subject dims, the shutter speed the camera selects will become longer than

- the shooting interval that is set. For example, if the shooting interval is set to three seconds but the lighting becomes so dim that the camera needs to choose a shutter speed of four seconds, a problem arises. If Shooting Interval Priority is turned on, in that situation the camera will reduce the shutter speed in order to maintain the shooting interval as set. If it is turned off, the camera will use the longer shutter speed, regardless of the shooting interval that was set.
- 9. On screen 1 of the Camera Settings1 menu, set aspect ratio to the desired value: 3:2, 4:3, 16:9, or 1:1. If you are going to be using Sony's Imaging Edge software to create the final movie, you may want to choose 16:9, because that is the aspect ratio of the movie that will be created by that software. If you choose one of the other settings, there will be black bars at the sides of the movie frame.
- 10. Make any other settings you need. For example, you may want to select a preset value for white balance, rather than using Auto White Balance, in order to avoid changes in the coloration of the images as the lighting changes.
- 11. When you are ready, set the camera on a sturdy tripod, and make sure it has a steady supply of power that is sufficient for the planned duration of the sequence. If you are using a zoom lens, adjust the focal length; you cannot change it during the interval shooting. Then press the shutter button to start the sequence of shooting.
- 12. Once the images have been captured, they will appear in the camera as a group, similar to how a group of continuous shots appears, as discussed earlier in this chapter. You can view a preview of how the final movie will look. To do that, go to screen 2 of the Playback menu and select Continuous Playback for Interval. The camera will display a screen with the notation Continuous Playback in the lower right corner, with a white disc to the left, indicating that you press the Center button to activate continuous playback for interval shots.
- 13. Then, navigate to the group of interval shots you just captured, and press the Center button. The camera will play back the group of interval shots quickly, giving you an approximate idea of how the final sequence will look. To play it again, press

the Down button. You can adjust the speed of this playback by turning the control wheel during playback, or by using the Playback Speed for Interval option on screen 2 of the Playback menu. When you have finished previewing the sequence in continuous playback mode, press the Center button to exit to normal playback.

- 14. You also can initiate continuous playback of a group of interval shots from the regular playback screen. To do that, display the group of shots on the screen, press the Center button to expand it, and then press the Down button to play the group continuously. Press the Center button again to end the expansion of the group and return to normal playback mode.
- 15. If you want to create a final time-lapse movie from a group of interval shots, follow these steps:
- 16. Download Sony's free Imaging Edge and PlayMemories Home software packages. The download sites are https://imagingedge.sony.net/en-us/ie-desktop.html and https://www.sony.net/pm/, respectively. Install both of those programs on your computer.
- 17. Using a card reader, load the memory card with the interval shots into the computer. In the Imaging Edge Viewer module, select the images you want to include in the time-lapse movie.
- 18. Go to the Imaging Edge Viewer's Tools menu, and select Create Time-Lapse Movie. Select values as indicated on the computer screen for items such as Output Method, File Settings, and Trimming. If you used the Raw setting for File Format, it may take a while for the program to process the Raw images.
- 19. Once initial processing is complete, click Next at the place indicated on the screen, and the PlayMemories Home software on your computer should start automatically, with the selected images loaded into the video-editing screen. Make any other desired settings, then click Next at the bottom of the screen, and save the movie in the desired format.
- 20. For more detailed instructions on this process, see Sony's support website at https://support.d-imaging.sony.co.jp/support/tutorial/ilc/en/ilce-6400/08.php. (This tutorial is for a different model of Sony camera, but it works for the a7C as well.

21. When you have finished using interval shooting, be sure to set the Interval Shooting menu option to Off, because leaving it on will interfere with your ability to shoot images normally and will conflict with some other settings, such as the drive mode options, DRO/Auto HDR, AEL w/Shutter, Anti-Flicker Shooting, and Picture Effect.

Recall

The Recall option is used only when the mode dial is set to one of the three numbered Memory Recall slots on the mode dial. Using this option, you can recall the camera settings that you stored to one of the registers for Memory Recall mode, as discussed in Chapter 3.

When the mode dial is first turned to MR-1, 2, or 3, this option's main screen appears on the camera's display with one of five indicators at the upper right highlighted, as shown in Figure 4-34. The screen will show only the number of the slot where the mode dial is currently positioned, as well as the four memory registers that can be saved to the memory card.

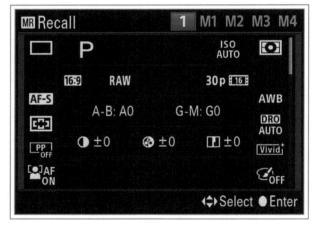

Figure 4-34. Recall Settings Screen

If the mode dial is already at MR-1, 2, or 3 and you want to change to a memory register that was saved to the memory card that is currently in the camera, you can use this menu option. Once the Memory Recall screen is displayed, either by turning the mode dial to MR-1, 2, or 3, or by using this menu option, use the direction buttons, the control wheel, or the control dial to select register M1, M2, M3, or M4 at the upper right of the screen. The settings for registers 1, 2, and 3 are stored in the camera's internal memory and can be recalled by turning the mode dial to the appropriate number; the settings for registers M1 through M4 are stored on

a memory card. Of course, you have to make sure the appropriate memory card is in the camera if you want to use M1 through M4.

When the register whose saved settings you want to recall for use is highlighted, press the Center button, and the new group of settings stored to that register will take effect.

Memory

The next option on screen 3 of the Camera Settings1 menu, Memory, was discussed in Chapter 3 in connection with the Memory Recall shooting mode. Once you have set up the a7C with the settings you want to store to a register of the MR mode, select the Memory option and choose one of the seven numbered registers.

Press the Center button, and the current settings will be stored to that register for the Memory Recall mode. You can recall those settings at any time by turning the mode dial to the appropriate numbered MR position or by selecting the Recall menu option and selecting register M1, M2, M3, or M4. As noted above, the contents of the first three registers are stored to the camera's internal memory and correspond to the three numbers on the mode dial, while the contents of M1 through M4 are stored to a memory card in the camera.

With either the Recall or Memory option, you can scroll to additional screens using the Down button to see other settings currently in effect.

Register Custom Shooting Settings

This final option on screen 3 provides a useful feature for quick recall of a group of shooting settings for the a7C. In order to take advantage of this option, you have to use this menu item as well as the Custom Key (Still Images) option on screen 9 of the Camera Settings2 menu, which I will discuss in Chapter 5. With that option, you can assign a particular control button, such as the Custom, Center, AF-ON, Focus Hold (if any) or Movie button, to carry out one operation of your choice from a long list of options, such as bringing up the ISO, drive mode, or white balance menu, activating Eye AF, or locking exposure or focus.

Among the many options that can be assigned to a control button are three options called Recall Custom Hold 1, 2, and 3. For example, if you assign a control button to the Recall Custom Hold 1 option, then, when you press that button in shooting mode, the camera will immediately put into effect all of the settings that are stored for the Recall Custom Hold 1 option. This feature works only when the camera is set to one of the PASM shooting modes—Program, Aperture Priority, Shutter Priority, or Manual. The Recall Custom Hold options cannot be assigned to the Left, Right, or Down button.

In order to choose what settings are stored for Recall Custom Hold 1, 2, and 3, you use the menu option being discussed here—Register Custom Shooting Settings. With this option, you can, if you want, assign a different group of shooting settings to each of those three slots, and then assign each of those slots to a different control button. In that way, you can press the button assigned to a given group of settings to instantly call up those settings. The settings will stay in effect while you keep the assigned button pressed down, and the camera will revert to the settings that are currently in effect once you release the button.

This feature can be useful if, say, you are photographing scenery or people at an outdoor event, but you want to be ready to take a picture of a bird in flight if you suddenly see that opportunity. When you see the bird flying, you can press the button assigned to the settings stored in the Recall Custom Hold 1 slot, and keep the button pressed while you shoot images of the flying bird. Then release the button, and you can resume your other image-making without having had to change any settings on the camera.

Here is how to use this menu option. When you highlight it and press the Center button, you will see the screen in Figure 4-35, with three options for the Recall Custom Hold slots. Highlight and select one to move to the next screen, which is shown in Figure 4-36.

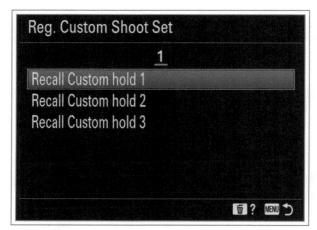

Figure 4-35. Register Custom Shooting Settings - Options Screen

Figure 4-36 shows the first five of the eleven settings that can be stored: shooting mode, aperture, shutter speed, drive mode, exposure compensation, ISO, metering mode, focus mode, focus area, AF Tracking Sensitivity, and AF On. Using the control wheel or the Down button, scroll through these lines. If you want to include a setting for a given item, when its line is highlighted, use the Left button or control dial to highlight the check box at the left and press the Center button to add the check mark. If you want to remove a check mark, press the Center button again.

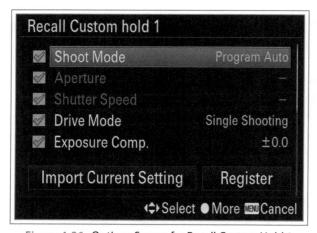

Figure 4-36. Options Screen for Recall Custom Hold 1

To change the setting for a given item, highlight the line itself (rather than the check box) and press the Center button. The camera will then display a screen like that shown in Figure 4-37, which shows the options for shooting mode.

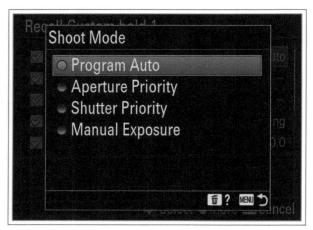

Figure 4-37. Recall Custom Hold 1 - Options for Shooting Mode

Highlight and select the item you want to set for that option, and press the Menu button to return to the list of options. Continue through the list, checking the box for each item you want to include and then selecting the setting for that item. When you have made all of your selections, move the orange highlight bar to the bottom of the list, and highlight and select the Register item, as shown in Figure 4-38.

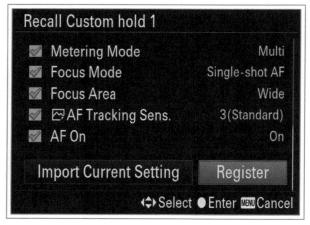

Figure 4-38. Register Block Highlighted for Custom Hold 1

The listed settings will then be registered to the chosen slot, such as Recall Custom Hold 1, and that slot of settings is ready to be assigned to a control button using the Custom Key (Still Images) menu option.

If you prefer, you can make all of the desired settings on the camera itself, and then highlight and select the Import Current Setting block at the bottom of the list of settings. If you do that, the camera will display a screen showing the current settings, with a message asking if you want to import that group of settings, as shown in Figure 4-39.

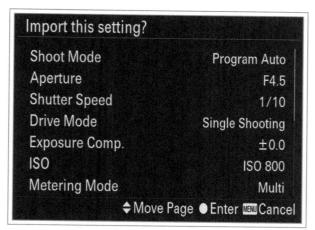

Figure 4-39. Confirmation Screen for Import Settings

Press the Center button to confirm, and those settings will be loaded to the selected Recall Custom Hold slot. However, to store them to that slot so they can be recalled, you still need to go back to the bottom of the screen and select the Register option, as shown in Figure 4-38. Then the settings will be stored and ready to recall with a press of the assigned button.

So, if you see a quick opportunity for an action shot, you can press the button assigned to your group of settings, including, for example, Shutter Priority mode with continuous autofocus and a fast shutter speed, and be ready to shoot very quickly, without having to change a single setting.

You can store settings only for the Program, Aperture Priority, Shutter Priority, and Manual exposure modes, and, as noted earlier, you can recall them only when the camera is set to one of those modes.

You also can change the contents of a registered set of settings when you are using the Custom Key (Still Images) option on screen 9 of the Camera Settings2 menu. To do that, when the Recall Custom Hold option is highlighted on that menu, press the Center button and you will be presented with the screens for changing those settings.

The items on screen 4 of the Camera Settings1 menu are shown in Figure 4-40.

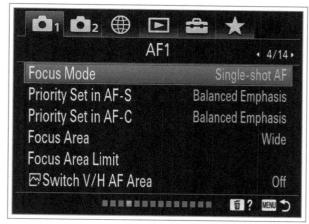

Figure 4-40. Screen 4 of Camera Settings1 Menu

Focus Mode

The focus mode option gives you five choices for the method the camera uses for focusing. This is one of the more important choices you can make for your photography. Following are details about each of the five selections, which are shown in Figure 4-41.

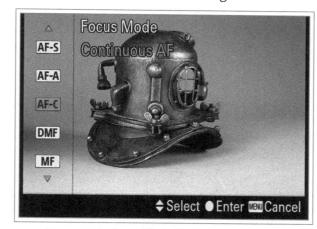

Figure 4-41. Focus Mode Menu Options Screen

SINGLE-SHOT AF

The first focus mode option is single-shot AF, indicated by the AF-S icon. With this option, the camera tries to focus on the scene using the focus area that is selected using the focus area menu option, discussed below. If the Pre-AF option on screen 5 of the Camera Settings1 menu is turned on, the camera will continuously adjust focus, even before you press the shutter button halfway down. When you do press the button halfway down, the camera will lock in the focus and keep it locked as long as you keep the button pressed halfway.

If the Pre-AF menu option is not turned on, the camera will not make any attempt to adjust focus until you press the shutter button halfway down.

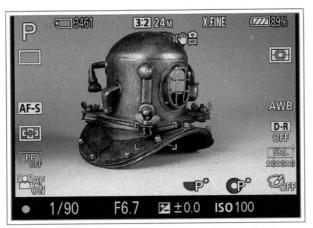

Figure 4-42. Shooting Screen When AF-S Focus Achieved

Once you press the shutter button halfway down, you will see one or more green focus brackets or blocks on the screen indicating the point or points where the camera achieved sharp focus, as shown in Figure 4-42, and you will hear a beep (unless beeps have been turned off through the Audio Signals option on screen 10 of the Camera Settings2 menu, as discussed in Chapter 5).

In addition, a green dot in the lower left corner of the display will light up steadily, indicating that focus is confirmed. If focus cannot be achieved, the green dot will blink and no focus brackets will appear on the screen.

Once you have pressed the shutter button halfway to lock focus, you can use the locked focus on a different subject that is at the same distance as the one the camera originally locked its focus on. For example, if you have focused on a person at a distance of 15 feet (4.6 m), and then you decide you want to include another person or object in the scene, once you have locked the focus on the first person by pressing the shutter button halfway down, you can move the camera to include the other person or object in the scene as long as you keep the camera at about the same distance from the subject. The focus will remain locked at that distance until you press the shutter button the rest of the way down to take the picture.

AUTOMATIC **AF**

The second option for focus mode, automatic AF, designated by the AF-A icon, is a combination of the

first and third options, single-shot AF and continuous AF. With automatic AF, the camera locks focus on the subject as with single-shot AF, but, if the subject or camera then moves in a way that changes the focus point, the camera will continue to adjust focus, as with continuous AF. I generally prefer to use either single-shot AF or continuous AF, so I will know whether the camera is going to be adjusting focus, rather than relying on its electronic judgment as to whether focus needs to be changed. But, in a case where the subject initially is stationary but may be moving, this mode could be useful.

Continuous **AF**

The next option for focus mode, continuous AF, is designated by the AF-C icon on the menu. With this option, as with single-shot AF, the a7C focuses continuously before you press the shutter button if the Pre-AF menu option is turned on. If that option is turned off, the camera does not adjust focus until you press the shutter button halfway.

The difference with this mode is that the camera does not lock in the focus when you press the shutter button halfway. Instead, the focus will continue to be adjusted if the subject moves or the distance to the subject changes through camera motion. You will not hear a beep or see any focus brackets to confirm focus. Instead, the green dot in the lower left corner of the display will change its appearance to show the focus status.

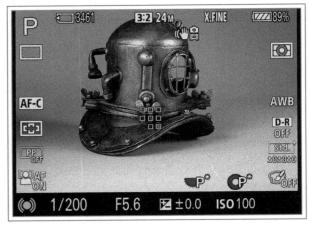

Figure 4-43. Shooting Screen When Focus is Continuing

If the green dot is surrounded by curved lines, as shown in Figure 4-43, that means focus is currently sharp but is subject to adjustment if needed.

If only the curved lines appear, that means the camera is still trying to achieve focus. If the green dot flashes, that means the camera is having trouble focusing.

If you turn on the Display Continuous AF Area option on screen 6 of the Camera Settings1 menu, if focus area is set to Wide or Zone, the camera will display an array of small green boxes that will move around the screen to show where the camera is directing its focus. With other settings for focus area, the camera displays a focus frame that turns green when focus is achieved.

This focusing mode can be useful when you are shooting a moving subject. With this option, you can get the a7C to fix its focus on the subject, but you don't have to let up the shutter button to refocus; instead, you can hold the button down halfway until the instant when you take the picture. In this way, you may save some time, rather than having to keep starting the focus and exposure process over by pressing the shutter button halfway again.

Also, you can use the continuous AF setting in order to take advantage of the camera's excellent tracking capability. If you set the focus area option to Tracking, the a7C will keep focus locked on your subject with its moving focus frame. This capability gives you an excellent system for achieving sharp images of sporting events, of children and pets at play, and the like.

If you want to lock the focus while using Continuous AF, you can assign a button to the Focus Hold option using the Custom Key (Still Images) or Custom Key (Movies) option on screen 9 of the Camera Settings2 menu. If you press and hold the assigned button, the focus position will be held until you release the button.

Continuous AF is the only autofocus option available for recording movies.

DMF

The next option for focus mode is DMF, which stands for direct manual focus. This feature lets you use a combination of autofocus and manual focus. DMF can be helpful if you are shooting an extreme closeup of a small object, when focus can be critical and hard to achieve. With the DMF option, you can start the focusing process by pressing the shutter button halfway down. The camera will make its best attempt to focus sharply using the autofocus mechanism. Then, if you

continue to hold the shutter button halfway down, you can use the camera's manual focusing mechanism to fine-tune the focus, concentrating on the parts of the subject that you want to be most sharply focused.

When DMF is activated, you can turn on Peaking through screen 13 of the Camera Settings1 menu, as discussed below, and that feature will function for autofocus as well as for manual focus. You also can use the MF Assist feature from that same menu screen with DMF. That feature is discussed below in connection with manual focus.

DMF is not available with all lenses that can be used with this camera. For example, it is not available with the Sony DT 50mm f/1.8 SAM lens (SAL50F18).

MANUAL FOCUS

The final selection on the focus mode menu is manual focus. As I indicated in the discussion of DMF, there are situations in which you may achieve sharper focus by adjusting it on your own rather than by relying on the camera's autofocus system. Those situations include shooting extreme closeups; shooting a group of objects at differing distances; or shooting through a barrier such as glass or a wire fence.

The method for setting manual focus mode varies according to the lens you are using. If the lens has an AF/MF switch, you can move that switch to the MF position to activate manual focus mode. You also can turn on manual focus by using the focus mode menu, even if the AF/MF switch is at the AF position, with some lenses, such as the Sony 85mm f/2.8 Macro lens. If the switch is at the MF position, though, you cannot switch the focus mode back to AF using the menu; you have to use the switch on the lens. However, with some lenses, such as the Sony DT 50mm f/1.8 (used with the Mount Adaptor), you have to use the AF/MF switch on the lens to activate manual focus mode.

Once manual focus is selected, use the focusing mechanism on the lens itself, which may be a large, ridged ring like the one on the 28mm-60mm kit lens. There are several functions available to assist with manual focusing. I will discuss those menu options separately later in this chapter, but I will briefly describe them here so you can get started with manual focus.

The first option, MF Assist, is controlled through the fifth item on screen 13 of the Camera Settings1 menu. With MF Assist turned on, whenever you start adjusting manual focus, the image on the display is magnified 5.9 times, as shown in Figure 4-44, so you can more clearly check the focus.

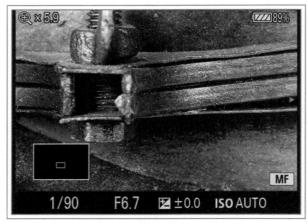

Figure 4-44. MF Assist Option in Use at 5.9x Magnification

Once the magnified image is displayed, if you press the Center button, the image is magnified further to 11.7 times normal. Press the Center button again to return to the 5.9-times view and press the shutter button halfway to return the display to normal size. You can adjust how long the magnified display stays on the screen using the Focus Magnification Time option, also found on screen 13 of the Camera Settings1 menu. I prefer to set the time to No Limit, so the magnification does not disappear just as I am getting the focus adjusted as I want it. With the No Limit setting, the magnification remains on the screen until you dismiss it by pressing the shutter button halfway.

If you don't want the camera to enlarge the image as soon as you start focusing, you can use the Focus Magnifier option instead of MF Assist. You can find Focus Magnifier also on screen 13 of the Camera Settings1 menu, or you can assign it to a control button using the Custom Key (Still Images) or Custom Key (Movies) option on screen 9 of the Camera Settings2 menu.

Once Focus Magnifier is activated, a small orange frame appears on the screen. You can move that frame around the screen with the control wheel, the control dial, or the direction buttons, or by dragging it with your finger if touch screen operations are turned on. The frame represents the area that will be magnified when

you press the Center button. By pressing the Center button, you can switch magnification to various levels, as discussed later in this chapter.

You can use both MF Assist and Focus Magnifier, though I see no need to do so. My preference is to use only the MF Assist option. I prefer not to go through the steps to turn on the Focus Magnifier option, which does not add that much to the focusing options. However, when I am faced with a challenging task such as shooting in dim lighting, I sometimes use the Focus Magnifier option because it is easier to deal with that situation by being able to see the subject clearly at its normal size and selecting the focus point before using magnification and starting to focus. MF Assist is not available when shooting movies or when a Mount Adaptor is attached, for using an A-mount lens, so Focus Magnifier is the only option in those cases.

The a7C provides one more aid to manual focusing, called Peaking, which is controlled using the Peaking Setting option on screen 13 of the Camera Settings1 menu. It has three sub-options: Peaking Display, Peaking Level, and Peaking Color. Peaking Display can be on or off, and Peaking Level can be set to Low, Mid, or High. When Peaking Level is turned on at any of those levels, then, when you are using manual focus or DMF, the camera places bright pixels around the areas of the image that it judges to be in focus, as illustrated in Figure 4-45 (without Peaking) and Figure 4-46 (with Peaking Level set to Mid).

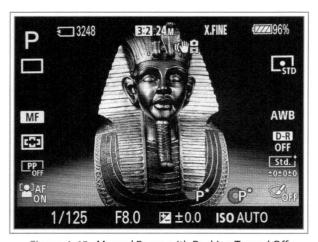

Figure 4-45. Manual Focus with Peaking Turned Off

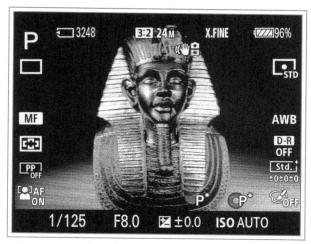

Figure 4-46. Manual Focus with Peaking Level Set to Mid

Besides setting the intensity of this display, you can set its color—white, red, yellow, or blue—using the Peaking Color option. I find Peaking to be especially useful in dark conditions because the Peaking effect contrasts with the dark display. Also, as noted above, Peaking works with both the autofocus and manual focus aspects of the DMF option. I will discuss Peaking further later in this chapter.

Finally, there is another way to customize the use of manual focus with the a7C. On screen 9 of the Camera Settings2 menu, as noted above, you can use one of the Custom Key menu options to assign a button to control any one item from a long list of functions. One of those functions, called AF/MF Control Toggle, is useful if you often need to switch back and forth between autofocus and manual focus.

When this function is assigned to a button, you can press the button to switch instantly between these two focus modes. This is so much more convenient than going back to the Shooting menu and using the focus mode menu option, that it may be worthwhile dedicating a button to this use. Note, though, that this function works to switch from manual focus into autofocus only when the switch on the lens (if there is such a switch) is in the AF position. If that switch is at the MF position, the AF/MF Control Toggle function cannot override the setting of that switch.

Priority Set in AF-S

This next menu option lets you determine how the camera sets its priority between releasing the shutter and making sure focus is sharp when using autofocus.

This first of two similar options governs the camera's behavior when focus mode is set to AF-S, for single autofocus. It also applies when that option is set to AF-A, for automatic autofocus, or to DMF, for direct manual focus. The options are AF, Release, or Balanced Emphasis, as shown in Figure 4-47.

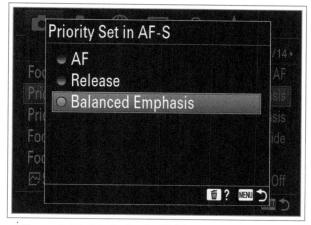

Figure 4-47. Priority Set in AF-S Menu Options Screen

If you choose AF, the camera will not release the shutter when you press the shutter button down, if the subject is not in focus. If you choose Release, the camera will release the shutter regardless of whether the subject is in focus. With the Balanced Emphasis option, the camera will attempt to achieve focus, but will still release the shutter even if focus could not be achieved, though it may delay while it is trying to focus.

The choice you make for this option depends on your needs in a given shooting session. If you are photographing a one-time event, you might want to choose Release, to make sure you don't miss a shot completely. If you are capturing images that need to be in focus when time is not critical, you might choose AF. For many purposes, the Balanced Emphasis selection is a good compromise.

Priority Set in AF-C

This option is similar to the one discussed above, except that it applies only when focus mode is set to AF-C, for continuous autofocus. This setting can be important when you are using continuous shooting. If you are shooting bursts of shots with focus mode set to AF-C, the camera will focus continuously, and the setting you make for Priority Set in AF-C can have a significant impact on the speed of shooting.

If you choose AF, the shots are likely to be in focus, but the speed of shooting may slow down significantly as the camera ensures that focus is sharp before permitting the next shot to take place. To speed up shooting, you can choose Release, but focus is likely to suffer if the subject is moving. Even with Balanced Emphasis, you may find that the shots you take are not optimally focused. So, as with the previous menu option, the choice you make depends on how strongly you value accurate focus versus speed and the number of shots you can capture in a short period of time.

Focus Area

The next option on this menu screen, focus area, lets you choose the area the camera focuses on when using an autofocus setting or DMF, as selected with the focus mode menu option. The three autofocus modes are single, automatic, and continuous. Direct manual focus, or DMF, is a mode that lets you use both manual focus and autofocus. The focus area menu option sets the focus area for all four of those focus modes.

Before I discuss the various choices for the focus area menu option, it is important to note that these settings were originally designed for use with a camera that does not have any touch screen features. If you don't want to use the touch screen for focusing, that is fine—you can just use the focus area setting to control where the camera directs its focus. However, you also can use the touch screen for focusing to some extent, with any of these settings in place.

I will discuss touch screen options in more detail in Chapter 6, where I discuss the LCD screen and other physical features of the camera. Briefly, when shooting still images with an autofocus mode in effect, if focus area is set to Wide or Center (or the Wide or Center setting for Tracking AF), and Function of Touch Operation on screen 10 of the Camera Settings2 menu is set to Touch Focus, you can choose the focus point by touching the screen. Just put your finger on the screen at the chosen point, and the camera will place a focus frame there. You can then drag that frame around the screen if you want. Then press the shutter button to focus and take the picture.

If the conditions mentioned above are in place, but focus area is set to Flexible Spot or Expand Flexible Spot (or the Flexible Spot or Expand Flexible Spot setting for Tracking AF), you can drag the focus frame on the screen to move it, or tap the screen to place the frame at a new location. If focus area is set to Zone, you can touch the screen to move the focus zone. The situation is similar for video recording, with a few variations, as discussed in Chapters 6 and 9.

In the following discussion of focus area options, I will not often mention the Touch Focus feature, but remember that it is available as an alternative way to use autofocus.

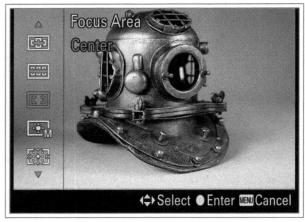

Figure 4-48. Focus Area Menu Options Screen

The choices for focus area are Wide, Zone, Center, Flexible Spot, Expand Flexible Spot, and Tracking AF. Figure 4-48 shows five of these options; you have to scroll down to see the last one.

The ways these selections operate vary somewhat depending on whether you select single-shot autofocus, automatic autofocus, continuous autofocus, or DMF for focus mode on the menu. If you select DMF, you can use autofocus in the same way as with single autofocus, so DMF is the same as single autofocus with respect to focus area. I will discuss the following options assuming at first that you are using single autofocus or DMF for focus mode. I will also assume that Face/Eye Priority in AF, Face/Eye Frame Display, and Animal Eye Display are turned off through the sub-options under the Face/Eye AF Settings item on screen 5 of the Camera Settings1 menu; if those options are turned on and a face or eye is detected, a face or eye detection frame will be seen in addition to any focus area frame that may be visible.

WIDE

With the Wide setting for focus area, the a7C uses multiple focus zones that cover the whole screen, and tries to detect one or more items within the scene to focus on based on their locations. When it has achieved sharp focus on one or more subjects, the camera displays a green frame or a group of small green blocks indicating each focus point. The camera displays frames when focusing on a larger area, and blocks when focusing on a smaller area. You may see one or several green frames or numerous blocks, depending on how many focus points are detected at the same distance. An example with multiple blocks is shown in Figure 4-49.

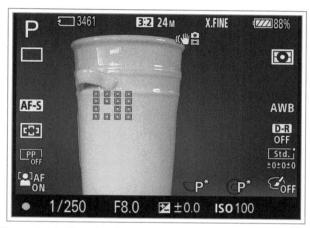

Figure 4-49. Shooting Screen with Wide Setting for Focus Area

With single-shot autofocus, the Wide option is good for shots of landscapes, buildings, and the like. In continuous autofocus mode, the a7C does not display stationary frames or blocks when focus is achieved, as it does with the single-shot AF setting. Instead, it displays small, moving blocks where focus is located, if Display Continuous AF Area is turned on through screen 6 of the Camera Settings1 menu. The camera tries to focus on subjects that appear to be the main ones.

ZONE

The Zone setting is similar to Wide, but the camera displays an area that uses only part of the screen. With this setting, the camera will be limited to focusing on a subject within the designated zone. When you select this option, the camera displays a set of focus frames that outline the overall focus zone, with arrows pointing to the four edges of the display, as shown in Figure 4-50.

Use the four direction buttons to move the focus zone around the display. If touch screen operations are turned on, you can drag the zone around the screen with your finger. If you press the Custom/Delete button while the zone is activated for moving, it will move back

to the center of the display. When the zone is located where you want it, press the Center button to fix it in place. The camera will display a large focus frame in the chosen location. When you press the shutter button halfway to focus, the camera will display green frames or small green blocks that indicate where focus is sharp within the designated zone.

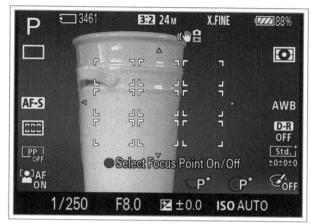

Figure 4-50. Movable Zone with Zone Setting for Focus Area

This setting is useful when you want to focus within a certain area, but the location of the actual subject is not certain. For example, if you are photographing a show in which the performers are located on the right side of the stage, you can set the zone to the right side and let the camera direct its focus to the action within that limited area.

CENTER

If you select Center for the focus area setting, the camera places a focus frame in the center of the display, as shown in Figure 4-51, and focuses on whatever it finds within that frame.

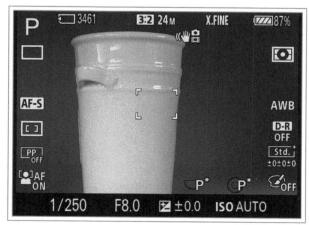

Figure 4-51. Focus Frame for Center Setting for Focus Area

When you press the shutter button halfway, if the camera can focus it will beep and the frame will turn green. This option is useful for an object in the center of the scene.

Even if you need to focus on an off-center object, you can use this setting. To focus on an object at the right, center that object in the focus frame and press the shutter button halfway to lock focus. Keeping the button pressed halfway, move the camera so the object is on the right, and press the button to take the picture.

If you turn on continuous autofocus with the Center setting, the camera still will display a focus frame. When you press the shutter button halfway, the frame will turn green when focus is sharp, but the camera will not beep. As the camera or subject moves, the camera will continue to re-focus as you hold the shutter button halfway down. You can use this technique to carry out your own focus tracking, by moving the camera to keep the center frame targeted on a moving subject.

FLEXIBLE SPOT

The Flexible Spot option gives you more control over the focus area, with a frame you can move around the screen and resize. After you highlight this option on the Camera Settings1 menu, press the Right or Left button or turn the control dial to select the size of the Flexible Spot focus frame: L, M, or S, for Large, Medium, or Small.

After choosing a size, press the Center button and you will see a screen like that in Figure 4-52, with a focus frame of that size with gray arrows pointing to the four edges of the display.

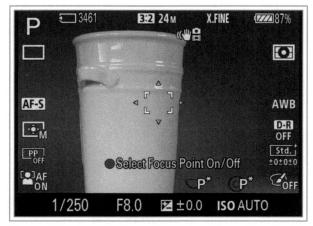

Figure 4-52. Movable Focus Frame for Flexible Spot Setting

Use the four direction buttons to move the frame around the display. When the frame is located as you want it, press the Center button to fix it in place. The camera will display a frame of the chosen size in the chosen location. When you press the shutter button halfway to focus, the focus frame will turn green when focus is sharp.

This frame operates the same way as the frame for the Center option, except for the ability to change the location and select a size. To return the frame quickly to the center of the screen, press the Custom/Delete button while the frame is activated for moving, and it will move back to the center of the display.

This option is useful for focusing on a particular point, such as an object at the far right, without having to move the camera to place a focus frame over that object. This might help if you are using a tripod, for example, and need to set up the shot with precision, focusing on an off-center subject. If the subject is small, using the smallest focus frame can make the process even easier.

If you use continuous autofocus, the Flexible Spot option works the same way as the Center option, discussed above, but with the added ability to select the size and change the location of the frame.

One problem with the Flexible Spot option is that it can be cumbersome to move the frame again once you have fixed it in place. One way to do this is to select the focus area menu option and repeat all of the steps discussed above. There are several quicker ways to move the frame, though.

The easiest way to do this is to have the Touch Operation and Touch Panel items turned on through screens 2 and 3 of the Setup menu. With those settings active, you can touch the LCD screen with your finger to choose a new focus point, or drag the focus frame to a new location. (If the Touch Pad option is also activated through that menu screen, you can move the focus frame by touching the LCD screen when you are using the viewfinder to view the scene.)

Another easy way to move the focus frame, without using the touch screen, is to go to screen 9 of the Camera Settings2 menu and select the appropriate Custom Key menu option. On the next screen, select a button, such as the Center button, and assign the Focus Standard setting to that button. Then, whenever

Flexible Spot is in effect, just press the button assigned to Focus Standard when the shooting screen is displayed, and the screen for moving the focus frame will appear. You can quickly use the direction buttons to move the frame where you want it, and you can press the Custom/Delete button to center it on the display. Press the Center button again to fix the frame in place.

Another option for moving the focus frame is to assign focus area to a control button using the Custom Key (Still Images) menu option. Then, when you press the assigned button, the camera displays the focus area menu, from which you can choose the size and location of the Flexible Spot frame. Or, you can assign focus area to the Function menu, which is called up by pressing the Function button. I will discuss that menu in Chapter 6.

My preference is to use the touch screen, which is simple and does not require using a control button for the Focus Standard option. As an alternative, I recommend assigning the Focus Standard setting to the Center button. Then, to move the focus frame, just press that button and it is an easy matter to adjust the frame's location. I will discuss the Custom Key menu options further in Chapters 5 and 6.

EXPAND FLEXIBLE SPOT

This next option for focus area is a variation of the previous one, Flexible Spot. It operates in the same way, except that the only available frame size is small. You can move it around the display with the direction buttons.

When you use this frame to fix the focus for your shot, the camera will first try to focus on a subject within the frame. If it cannot find a focus point in that small area, it will expand its scope and try to focus on a subject within the area immediately surrounding the frame. That area is outlined by four small brackets outside the corners of the focus frame, as shown in Figure 4-53.

This option can be of use when you want to focus on a small area, but you don't want the focusing to fail if focus can't be achieved in that exact spot.

TRACKING

The final option for focus area is Tracking, which sets up the camera to track a moving object. This menu option is available for selection only when focus mode is set to continuous AF. When you highlight this option on the menu, as shown in Figure 4-54, the camera gives you seven choices for the Tracking focus frame: Wide, Zone, Center, Flexible Spot Small, Flexible Spot Medium, Flexible Spot Large, or Expand Flexible Spot. These frames correspond to the other choices for focus area, discussed above, and they also include the Tracking frame's ability to "lock on" to a subject and track it as it moves.

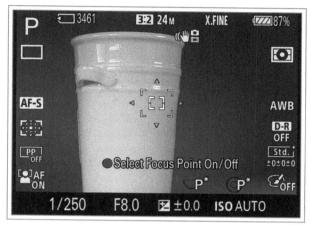

Figure 4-53. Expand Flexible Spot Focus Frame

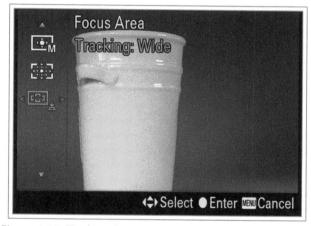

Figure 4-54. Tracking Option Highlighted on Focus Area Menu

After choosing one of these seven settings, aim the camera at the subject, place the focus frame (if there is one) over it, and press the shutter button halfway. The camera will try to keep the subject in focus as the subject or camera moves. The camera will display a small focus frame that moves with the subject. When you are ready to take the picture, press the shutter button all the way. If the autofocus system worked as expected, the image should be in focus.

When you are deciding which of the seven sub-options to choose for Tracking AF, consider the subject that you want the camera to lock on to, and choose accordingly. For example, if the subject is an automobile that is not too far away, you can probably choose Wide. If the subject is a person some distance away, you may want to choose Flexible Spot Small or Medium. Or, you can choose Center and position the central frame over the subject.

Note that this choice affects only how the camera selects the subject to lock on to. Once it has locked on to that subject, the camera will attempt to track whatever subject it has selected, as the subject moves around. So, even if you started with the Flexible Spot Small setting, if the camera locks on to a nearby face, the camera should continue to track the face, even if the face is larger than the initial focus frame.

If you select an option with a movable focus frame or zone, such as Zone, Flexible Spot, or Expand Flexible Spot, you can move that frame around the screen in the same way as described earlier for those focus area options.

If you have turned on the Face/Eye AF Settings options to detect faces and eyes through screen 5 of the Camera Settings1 menu, the camera will lock on to a detected face or eye and track it, even if it started tracking a different subject before it detects the face or eye.

If you assign a control button, such as the AF-ON button, to the Tracking On function, or the Tracking On + AF On function, through the Custom Key (Still Images) option on screen 9 of the Camera Settings2 menu, you can activate the Tracking setting for focus area temporarily by holding down that button.

The Tracking AF option will not give good results if the subject moves too rapidly or erratically, or moves completely out of the frame. But, for subjects that are moving moderately in stable patterns, the Tracking AF system is an excellent feature. This option is not available on the focus area menu when recording movies.

Note, though, that there is another way to activate tracking autofocus with the a7C camera, which works somewhat differently from the Tracking option on the focus area menu. As I will discuss in Chapter 6, you can turn on Touch Tracking through the Function of Touch Operation option on screen 10 of the Camera Settings2 menu. With that option activated, you can touch the screen to initiate focus tracking at the selected point.

That option is similar to the Tracking option on the focus area menu, with two significant differences. First, it works in all autofocus modes—single-shot AF, automatic AF, continuous AF, and DMF, not just continuous AF, as is the case with the Tracking option for focus area. Second, Touch Tracking works when recording movies, unlike the Tracking option for focus area.

The only focus area settings available in Intelligent Auto mode are Wide and Tracking (Wide).

Focus Area Limit

This menu option gives you a way to limit the available selections on the focus area menu. If you know you will only be using a few (or just one) of the various options for a particular shooting session, or in general, you can use this option to hide the settings you won't be needing, so it will be quicker to select a setting that you want.

When you highlight this menu option and move to its selection screen by pressing the Center button, the camera displays a screen like that in Figure 4-55, showing all possible settings for focus area represented by icons, with boxes for check marks above them.

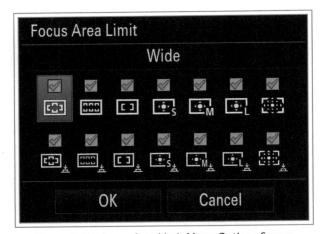

Figure 4-55. Focus Area Limit Menu Options Screen

Move through the icons using the control wheel, the control dial, or the direction buttons. When a setting you want to remove from the menu is highlighted in orange, press the Center button to remove the check mark from its box. To restore it to the list, highlight it and press the Center button again. When you have finished adding or removing options, highlight the OK block at the lower left of the screen and press the Center button to lock in your choices.

I find this menu option quite helpful. I rarely use the Zone or Expand Flexible Spot options, so I remove the check boxes from those items, and from the Tracking versions of those versions, to reduce the clutter on the focus area menu options screen.

This option is especially helpful if you assign the Switch Focus Area option to a control button, using the Custom Key (Still Images) menu option. That option cycles through the available focus area settings when you press the assigned button, so it would be cumbersome to have more than a few options assigned for focus area when using that control button.

Switch Vertical/Horizontal AF Area

This last option on screen 4 of the Camera Settings1 menu is designed for photographers who need to change the orientation of the camera between horizontal and vertical fairly often, and would like to have the camera automatically move the focus point and/or the focus area when that happens. For example, this feature could be useful for a person who is shooting sporting events or weddings, and often uses a focus point in the upper middle of the LCD screen when shooting horizontally. If the camera is then rotated to the left, with the side with the shutter button held up in the right hand, that focus point will have moved to the left side of the screen. To compensate for that effect, you can use this menu option, which causes the camera to memorize the focus points and sizes of focus frames that you specify for each orientation.

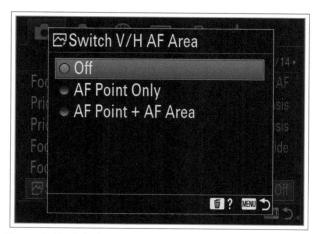

Figure 4-56. Switch Vertical/Horizontal AF Area Menu Options Screen

To do this, select either AF Point Only or AF Point + AF Area, as shown in Figure 4-56, then press the Menu button to return to the shooting screen. Then, assuming you chose AF Point + AF Area, first, with the camera in its normal, horizontal orientation, select a setting for the focus area menu option (Wide, Center, Flexible Spot, etc.). Also, if you selected a setting with a movable focus frame, such as Flexible Spot, move the frame where you want it on the display. (Use any technique available to move the focus frame—the touch screen, the Focus Standard option assigned to a control button, or the focus area menu option, as discussed in connection with the focus area menu option.)

Then, tilt the camera to a different orientation (90 degrees to the left or right). Select the focus area setting you want for that orientation, and, if applicable, move the focus frame where you want it. Finally, tilt the camera to the third orientation (right or left), and again select a focus area setting and, if applicable, a location for the focus frame.

Then, as long as this menu option is turned on, the camera will automatically use the focus area setting you selected for a given orientation when you move the camera between the vertical and horizontal orientations, and it will move the focus point if that was selected as well. If you later change the setting for this menu option, the focus area settings and focus frame positions you selected will not be retained. However, they are retained when the camera is powered off and back on, as long as the menu option setting has not been changed.

This option does not work with Intelligent Auto mode, video recording, Digital Zoom, continuous shooting, and in several other situations.

I don't do enough shooting in different orientations that I would find this feature useful, but it is available if you need it.

The options on screen 5 of the Camera Settings1 menu are shown in Figure 4-57.

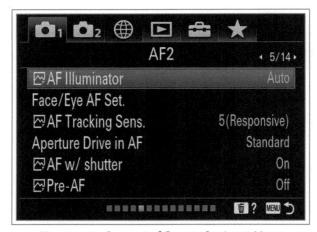

Figure 4-57. Screen 5 of Camera Settings1 Menu

AF Illuminator

The AF Illuminator item lets you disable the reddish lamp on the front of the camera for autofocusing. By default, this option is set to Auto, which means that when you are shooting a still image in a dim area, the camera will turn on the lamp briefly if needed to light the subject and assist the autofocus mechanism in gauging the distance to the subject. If you want to make sure the light never comes on for that purpose to avoid causing distractions in a museum or other sensitive areas, or to avoid alerting a subject of candid photography—set this option to Off. In that case, the lamp will never light up for focusing assistance, though it will still illuminate if the self-timer is activated. You cannot use this option when a Mount Adaptor is attached to the camera. (When I tested it with the LA-EA5 Mount Adaptor attached to the camera, the menu option was available for adjustment, but the AF Illuminator lamp itself would not operate.)

Face/Eye AF Settings

This option has five sub-options for controlling how the camera uses its abilities to detect faces and eyes, as shown in Figure 4-58.

The first sub-option, Face/Eye Priority in AF, determines whether or not the camera uses face and eye detection when using autofocus. If this option is turned on and the next setting, Subject Detection, is set to Human, the camera will detect any human faces, up to eight in total, and select one as the main face to concentrate its settings on. If the next option is set to

Animal, the camera will detect animal eyes and display a white detection frame for the eye.

The second sub-option, Subject Detection, determines whether the camera looks for human eyes or animal eyes. It cannot look for both at the same time. For most purposes, you will probably want to choose Human for this setting, but if you are on a safari, at the zoo, or photographing the family dog or cat or a bird, choose Animal. The camera does not detect animal faces, only animal eyes.

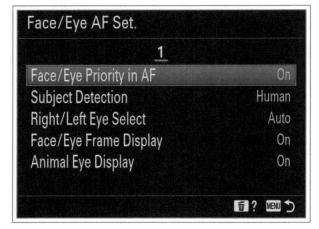

Figure 4-58. Face/Eye AF Settings Menu Options Screen

The third sub-option, Right/Left Eye Select, determines whether the camera focuses on the subject's right or left eye, or, with the Auto setting, decides for itself which eye to focus on. (The subject's right eye is the eye to the left, from the photographer's point of view.) This setting is available only when face and eye detection is turned on and Subject Detection is set to Human.

The fourth sub-option, Face/Eye Frame Display, determines whether the camera displays a frame when it has detected a human face or eye, even before you press the shutter button halfway down to evaluate focus. Even if this option is turned off, the camera will display a green frame over a face or an eye that is in focus.

The final sub-option, Animal Eye Display, determines whether the camera displays an eye detection frame when it has detected an animal's eye, even before you press the shutter button halfway down to check the focus. As with the previous sub-option, the camera will display a green frame for an animal eye that is in focus, even if this sub-option is turned off.

If you have the first four of these sub-options turned on, with the second one set to Human and the third one to Auto, the camera will display white or gray frames around any human faces it finds, as shown in Figure 4-59. When you press the shutter button halfway to lock focus and exposure, the camera will place a small block on the eye it has chosen to focus on.

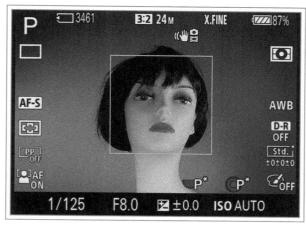

Figure 4-59. Face Detection in Use

When using face/eye detection, you need to be aware of the setting for focus area on screen 4 of the Camera Settings1 menu. If focus area is set to Wide, the camera will find a face and focus on it. However, if focus area is set to an option such as Center, Flexible Spot, or Expand Flexible Spot, the camera will not focus on a face unless the face is within the area of the focus frame. So, if you want to rely on the camera to find and focus on faces, you should set focus area to Wide. Of course, you can always use Touch Focus to touch a face you want the camera to focus on, no matter what focus area setting is in use, as long as touch operations are enabled. You also can assign a control button to Eye AF, and press that button to cause the camera to focus on a human eye.

Face detection does not work when some other settings are in use. For example, it does not work when Picture Effect is set to Posterization, when Digital Zoom or Clear Image Zoom is in use, or when using the Focus Magnifier option. It also does not function when recording a video with Record Setting set to 120p (100p if the PAL system is in use), or when recording an S & Q Motion video with the 120p/100p setting for S &Q Frame Rate. Eye AF does work when recording 4K video, but I had difficulty getting it to work at first. I eventually turned off all settings that might interfere, including PC Remote and Bluetooth connections, and Eye AF worked as expected with 4K video recording.

Face/Eye Priority in AF is automatically turned on in Intelligent Auto mode.

AF Tracking Sensitivity (Still Images)

This option can be set to a numeric value from 1 to 5. With a setting of 1, the camera's autofocus stays locked on to the subject you have focused on, so it will not go out of focus even if a person or other object moves in front of your camera.

This setting helps avoid disruptions to focus, when you are using automatic AF or continuous AF and you want to keep the focus on a particular subject. With a setting of 5, the autofocus system is at its most responsive, and will readily shift focus to another subject that comes within its focusing area. This setting is useful if you are photographing various subjects, such as children at play, and want the camera's focus to shift as different subjects come within its focusing area. The intermediate settings are available for various degrees of responsiveness, with 3 being the standard setting.

Sony has produced a chart for another camera model with similar features, setting forth suggested settings for this option and others when focusing, for photographing various sports. The link is at http://support.d-imaging.sony.co.jp/support/ilc/autofocus/ilce9/en/index.html.

This setting, as indicated in the heading, applies only to autofocus for still images. To adjust the focus tracking sensitivity for movies, use the AF Subject Shift Sensitivity option on screen 2 of the Camera Settings2 menu, discussed in Chapter 9.

Aperture Drive in AF (Still Images)

This setting, like the previous one, applies only for shooting still images. This option is provided for situations when you want to shoot as silently as possible. It has three possible settings: Focus Priority, Standard, and Silent Priority. If you select Focus Priority, the camera may adjust the aperture by opening it to a wider setting in order to achieve better focus. With that setting, the aperture movement may create a sound. With Silent Priority, the camera avoids adjusting

the aperture for focusing, to reduce the sounds made by the camera. With Standard, the camera is less likely to adjust the aperture setting. I recommend leaving this setting at Standard unless you are striving for silent operation and find the other settings make excessive noise, in which case you may want to use the Silent Priority setting.

AF w/Shutter (Still Images)

Normally, when you press the camera's shutter button halfway down, the camera uses its autofocus system, assuming focus mode is set to AF-S, AF-A, AF-C, or DMF. With this menu option, you can disable that function, so that a half-press of the shutter button does not cause any autofocus activity. You may want to do this if you prefer to use "back button focus," a system by which you activate the autofocus system using a button other than the shutter button, such as the AF-ON button or one of the direction buttons. In order to use that system, you have to assign one of the control buttons to the AF-ON option using the Custom Key (Still Images) option on screen 9 of the Camera Settings2 menu.

With the back button focus system, you are free to compose and shoot your images without having the camera refocus every time you press the shutter button.

If you want to disable the shutter button's action of evaluating exposure when you press it halfway down, there is a separate menu option for that: AEL w/ Shutter, on screen 9 of the Camera Settings1 menu.

Pre-AF (Still Images)

The Pre-AF setting affects the way the a7C uses autofocus for capturing still images. When this option is turned on and focus mode is set to AF-S, AF-A, AF-C, or DMF, the camera continuously tries to focus on a subject, even before you press the shutter button halfway. With this setting, the camera's battery is depleted more quickly than normal, but the final focusing operation may be speeded up because the camera can reach an approximate focus adjustment before you press the shutter button to evaluate focus and take the picture.

If this setting is turned off, the camera makes no attempt to use its autofocus mechanism until you press

the shutter button halfway to check focus. I usually leave this setting off to avoid running the battery down too soon. But, if I were taking pictures of moving subjects, I might activate this setting to speed up the focusing process.

When the camera is recording movies, it always uses the equivalent of the Pre-AF setting; this menu option has no effect for movie recording. Pre-AF works only when an E-mount lens is attached to the camera.

The options on screen 6 of the Camera Settings1 menu are shown in Figure 4-60.

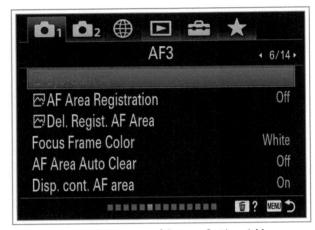

Figure 4-60. Screen 6 of Camera Settings1 Menu

Eye-Start AF (Still Images)

This option is available only when you have an A-mount lens attached to the a7C, which requires the use of an adapter, as discussed in Appendix A. If you have such a lens on the camera, and you turn this feature on while focus mode is set to an autofocus option, the camera will make its initial autofocus attempt when you raise the camera to your eye to look through the viewfinder. In this way, the camera gets a head start on focusing. This option might be of use in situations when you need to focus quickly on a sporting event or other quickly unfolding action, without wasting time making an initial focus adjustment.

AF Area Registration

This option lets you register a location for a movable focus frame, so you can assign a button to instantly place the frame on the display at that location. This is a multi-step process. First, you have to set this menu option to On. Then, go to the shooting screen and

position a movable focus frame, such as Flexible Spot, in the location where you want it on the display. Then, press and hold the Function button for a second or two. The camera will display a message saying the AF area has been registered.

Next, go to the Custom Key (Still Images) option on screen 9 of the Camera Settings2 menu and assign a control button, such as the AF-ON button, to the option called Registered AF Area Hold. Then, when the camera is in shooting mode, you can press the assigned button (AF-ON in this example) and the focus frame will appear at the registered location as long as you hold down the button.

If you don't want to have to hold down the assigned button, you can choose the Registered AF Area Toggle option, in which case you only need to press and release the button. Or, you can select Registered AF Area + AF On, in which case, when you press the assigned button, the camera will place the frame at the registered location and also will use its autofocus at that point. You cannot assign the Left, Right, or Down button to the Registered AF Area Hold function, but any of those buttons can be assigned to Registered AF Area Toggle.

You cannot call up a registered AF area when the mode dial is at the Auto, Movie, or S & Q position.

This option can be convenient if, for example, you are at a baseball game and you are focusing on the action at first base, but you occasionally need to switch quickly to focusing on third base. You can position a Flexible Spot focus frame over third base and register it there. Then, while you are focusing on first base, you can press the assigned button to instantly bring the focus point to third base and catch the action there.

Delete Registered AF Area

This option lets you delete an AF area registration that you set up using the previous menu option. Although you can always register a new location, you might want to delete the current registration, because, even if the registered AF area is not assigned to a control button, the camera causes the registered area to flash on the shooting screen, as a reminder that there is a registered AF area available for assignment to a button. The flashing can be quite distracting, so I am glad to be able to delete the registration.

Focus Frame Color

With this option, you can select either white or red for the color of the camera's focus frame, to make it stand out more clearly against the subjects you are photographing. This setting applies to the focus frame that appears before focus has been adjusted. Once focus is achieved, the focus frame, if any, turns green.

AF Area Auto Clear

This option controls whether or not the camera continues to display one or more green focus frames or small green blocks after it has achieved sharp focus when focus mode is set to AF-S, AF-A, or DMF. By default, this option is turned off, so the autofocus area is not cleared from the display when focus is achieved; the frames or blocks remain on the display until you press the shutter button all the way down to capture an image.

If you turn this option on through the menu, the frames or blocks will disappear from the display about one second after you press the shutter button halfway down to focus, so you can have a clear view of the subject before you press the shutter button all the way down to take the picture. If focus mode is set to AF-C, the focus frames or blocks will stay on the screen even if this option is turned on, because the camera continues to evaluate focus in that mode. If the AF-A setting is in effect, the frame will disappear if focus is achieved, but it will reappear if the subject or camera continues to move so that focus needs to continue.

The setting you use for this option is a matter of personal preference. I usually don't mind seeing the green focus indicators on the display, so I leave this option turned off most of the time. There could be situations, though, when you want to confirm focus by viewing the green frames or blocks but then want to see the subject clearly without the frames or blocks, before you actually capture an image.

Display Continuous AF Area

This option can be turned either on or off. When it is turned on, it causes the camera to display small, green focus blocks to show what area of the scene is in focus, when focus mode is set to continuous autofocus and the focus area option is set to Wide or Zone. (It also operates if focus area is set to automatic AF, and the subject or

camera is moving, so the camera uses continuous AF.) If this option is turned off, the camera does not display any focus frames or blocks under those conditions.

I find this option useful, because, without it, there is no obvious way to tell what part of the scene or subject is currently in focus. With continuous autofocus in effect and focus area set to Wide or Zone, the camera's autofocus mechanism adjusts constantly as you half-press the shutter button, and there is no frame or other indicator that shows where the focus is being set, other than judging with your eyes what parts of the image look sharper than others. When this menu option is turned on, the camera displays a constantly changing set of focus blocks, as the autofocus mechanism selects a main subject to focus on within the boundaries of the Wide or Zone focus area setting.

The options on screen 7 of the Camera Settings1 menu are shown in Figure 4-61.

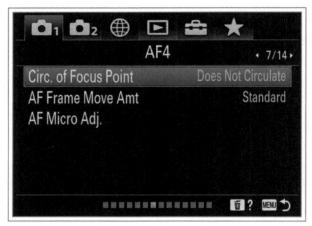

Figure 4-61. Screen 7 of Camera Settings1 Menu

Circulation of Focus Point

With this menu option, you can control how the camera displays the focus point when you are setting up the location of a movable focus frame for the Zone, Flexible Spot, or Expand Flexible Spot setting for focus area, or for the Tracking variations of those settings. If this option is left at its default setting of Off, you can move the zone or focus frame only to the edges of the monitor or viewfinder. If you turn this option on, when you move the zone or frame to the edge of the screen, it "circulates" back through the opposite edge of the screen, as if there were a continuous wraparound effect. This setting can let you move the frame from, say, the right side of the screen back to the left side

very quickly. If you need to move the focus frame fairly often, it is convenient to leave this option turned on. Remember that you also can cause the movable frame to jump back to the center of the screen by pressing the Custom/Delete button.

AF Frame Move Amount

This setting lets you specify how far the focus frame moves when you have selected a movable focus area setting, such as Flexible Spot. The normal setting is Standard. If you select Large instead, the frame moves a greater distance as you move it, so you can adjust its position more quickly.

This is a useful option for some situations, when you are photographing a variety of subjects at different distances from the camera and you need to keep adjusting the focus frame to a new position. The ability to move the frame a larger distance with each motion can be of considerable help in those cases.

This setting can be overridden through the use of two other options. First, you can assign the Switch AF Frame Move Hold to a control button using the Custom Key menu options. If you do that, the setting for the AF Frame Move Amount menu option is toggled to the opposite setting while you hold down that button. Second, you can use the My Dial Settings menu option to assign either the control dial or the control wheel to move the AF frame either vertically or horizontally using the Standard or Large setting. Any setting you make using that option takes priority over the AF Frame Move Amount menu setting. This option has no effect when the LA-EA4 Mount Adaptor is in use.

AF Micro Adjustment

This menu option is for use when you have attached an A-mount lens to the a7C using the Sony LA-EA4 Mount Adaptor. As discussed in Appendix A, that adapter lets you attach to the a7C Sony lenses that use the A-mount system, which are designed for cameras such as the Sony a99 and other cameras.

If you are using one of those lenses with that adapter, you can use this option to make adjustments to the autofocusing distance of the lens, to compensate for any differential in the lens's focusing behavior.

To use this option, first set the AF Adjustment Setting option to On, then use the Amount option to make the actual adjustment on a scale from minus 20 to plus 20 units, using the control wheel, the control dial, or the Up and Down buttons. The camera will register the settings for up to 30 lenses. After that point, you will have to use the Clear option to clear the value for one of the previously adjusted lenses before you can adjust and register another lens.

The options on screen 8 of the Camera Settings1 menu are shown in Figure 4-62.

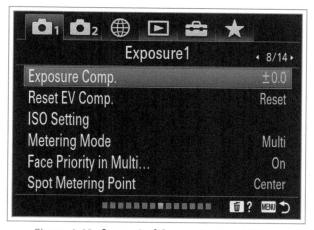

Figure 4-62. Screen 8 of Camera Settings1 Menu

Exposure Compensation

This first option on screen 8 of the Camera Settings1 menu adjusts exposure compensation. Another way to adjust that setting is by using the exposure compensation dial, on the right side of the top of the camera. You also can use the Custom Key menu options, the My Dial Settings menu option, or the Dial/Wheel EV Compensation menu option to assign one of the other control buttons or dials to adjust exposure compensation, as discussed in Chapter 5, or you can use the Function menu or Quick Navi menu for that purpose, as discussed in Chapter 6.

Using the exposure compensation dial, you can adjust the EV (exposure value) setting within the range of plus or minus 3 units. With the Exposure Compensation menu option, you can adjust it within the range of plus or minus 5 units.

In order to adjust exposure compensation using this menu option, the exposure compensation dial must be at the zero setting. If any negative or positive value is selected with the dial, that value will override the menu setting, and make the menu option unavailable.

Once you select this menu option, the EV (exposure value) scale appears on the display, as shown in Figure 4-63. Use the Left and Right buttons, the control wheel, or the control dial to set the amount of positive or negative compensation, to make the image brighter or darker than it would be otherwise.

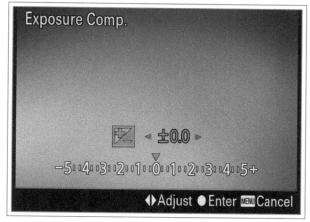

Figure 4-63. Exposure Compensation Adjustment Scale

Here is an example of the use of this setting. In Figure 4-64, I aimed the camera at a red lantern in Program shooting mode. The lantern was somewhat dark, but the background was white. The camera's autoexposure system measured the light from the overall scene, and, because of the white background, it decreased the exposure setting, making the lantern appear too dark.

I adjusted the setting on the scale to apply 1.7 EV of positive exposure compensation, as shown in Figure 4-65, making the lantern appear at a normal brightness.

Figure 4-64. Exposure Compensation Example - Before Adjustment

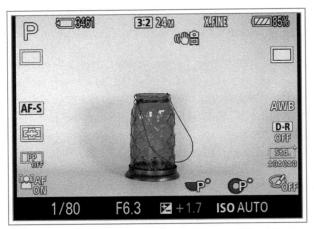

Figure 4-65. Exposure Compensation Example - After Adjustment

With a negative value, the image will be darker than it otherwise would; with a positive value, it will be brighter. The camera's display will change to show the effect of the adjustment, if you have set the camera to show the effect. To see the effect as you adjust exposure compensation, go to screen 8 of the Camera Settings2 menu, select Live View Display, and choose Setting Effect On. If you choose the other possibility, Setting Effect Off, you will not see the effect of exposure compensation on the shooting screen, though it will appear in the final image.

You might consider using exposure compensation on a routine basis. Some photographers generally leave exposure compensation set at a particular amount, such as negative 0.7 EV. You could do this if you find your images often look slightly overexposed or if you see that highlights are clipping in many cases. (You can tell if highlights are clipping by checking the playback histogram, as discussed in Chapter 7. If the histogram chart is bunched to the right, with no space between the graph and the right side of the chart, the highlights are clipping, or reaching the maximum value.) It is difficult to recover details from images whose highlights have clipped, so it can be a safety measure to underexpose your images slightly to avoid that situation.

You can control whether exposure compensation set through this menu option remains in place after the camera has been powered off, using the Reset EV Compensation menu option, discussed immediately below.

In Manual exposure mode, exposure compensation has no effect unless ISO is set to Auto ISO. Exposure compensation is not available in Intelligent Auto mode.

In Movie mode and S & Q Motion mode, exposure compensation can be adjusted only up to 2.0 EV positive or negative, instead of the 5.0 EV available for still images. You can control whether this menu option adjusts flash output as well as exposure settings by using the Exposure Compensation Setting option on screen 10 of the Camera Settings1 menu, as discussed later in this chapter.

If you want to program the camera to use a small amount of exposure compensation for all shots taken with a particular metering mode setting, you can do so using the Exposure Standard Adjustment option on screen 9 of the Camera Settings1 menu, as discussed later in this chapter.

Reset EV Compensation

This option controls how the camera handles exposure compensation values that are set using the Camera Settings1 menu option or a control button, as opposed to the exposure compensation dial. The two choices for this menu option are Reset or Maintain. If you choose Reset, then, when you have set exposure compensation using the menu or a control button, that value will be reset to zero when the camera is turned off and then back on. If you choose Maintain, then the exposure compensation value you set will be retained in memory and will remain in effect after the camera is turned off and back on.

There is one complication to be aware of, though. This menu option takes effect only if the exposure compensation dial remains set at its zero point. If that dial is set to any other value, then the value on the dial controls the exposure compensation, and this option will have no effect.

This option is important because, with the a7C, you can adjust exposure compensation as much as 5.0 EV positive or negative using the Exposure Compensation menu option, as opposed to only 3.0 EV in either direction using the exposure compensation dial. So, if you need to make an adjustment greater than 3.0 EV, you may want to control whether that adjustment remains in effect when the camera is powered off. It might be useful to assign exposure compensation to one of the control buttons, and then set this option to Reset. With that setup, any exposure compensation set with the control button will be reset to zero after the camera is powered off, so you do not have to

worry about resetting the value yourself. In that way, you can make a temporary adjustment to exposure compensation and not worry about remembering to reset it to zero later. (Adjustments made using the exposure compensation dial are always maintained when the camera is powered off.)

ISO Setting

ISO is a measure of the sensor's sensitivity to light. When ISO is set to higher values, the camera's sensor needs less light to capture an image and the camera can use faster shutter speeds and narrower apertures. The problem with higher values is that their use produces visual "noise" that can reduce the clarity and detail in your images, adding a grainy, textured appearance.

In practical terms, shoot with low ISO settings (around 100) when possible; shoot with high ISO settings (800 or higher) when necessary to allow a fast shutter speed to stop action and avoid motion blur, or when desired to achieve a creative effect with graininess.

With that background, here is how to set ISO on this camera. As is discussed in Chapters 5 and 6, with the a7C you can get quick access to the ISO setting using the Right button, which is assigned by default to control ISO. You also can use the Function menu, the Quick Navi system, or you can assign a control button or dial to this function. However, you can also set ISO from the Camera Settings1 menu, and you can get access to some additional ISO settings only from this menu, so it's important to understand how to use this menu item.

ISO

The main menu option, called ISO Setting, is the gateway to the three sub-options that provide the actual settings. The first sub-option, called simply ISO, lets you choose the ISO value for your shots. After you highlight it, press the Center button to bring up the vertical ISO menu at the left of the screen, as seen in Figure 4-66.

Scroll through the options by turning the control wheel or by pressing the Up and Down buttons to select a value ranging from the top option—Auto ISO—through 50, 64, 80, 100, 125, 160, 200, and other specific values, to a maximum of 204800 at the bottom of the scale. You can scroll through this menu more

quickly, skipping over two values at a time, by using the control dial.

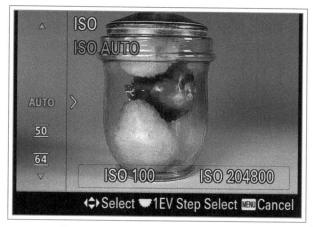

Figure 4-66. ISO Menu Options Screen

If you choose Auto ISO (the first option on the menu, highlighted in Figure 4-66), the camera will select a numerical value automatically depending on the lighting conditions and other camera settings. You can select both the minimum and maximum levels for Auto ISO. In other words, you can set the camera to choose the ISO value automatically within a defined range such as, say, ISO 200 to ISO 1600. In that way, you can be assured that the camera will not select a value outside that range, but you will still leave some flexibility for the setting.

To set minimum and maximum values, while the orange highlight is on the Auto ISO option, press the Right button to move the highlight to the right side of the screen, where there are two rectangles that are labeled (when highlighted) ISO Auto Minimum and ISO Auto Maximum, as shown in Figure 4-67.

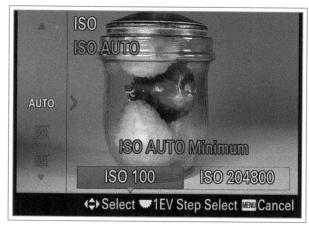

Figure 4-67. Minimum Block for ISO Auto Highlighted

Move the highlight to each of these blocks in turn using the Right button and change the value as you wish, by pressing the Up and Down buttons or turning the control wheel, which scrolls through all values in increments of 1/3 EV, or the control dial, which skips over some values for quicker scrolling, moving in increments of 1 EV. You can set both the minimum and the maximum to values from 100 to 204800. When both values have been set, press the Center button to move to the shooting screen.

Once the minimum and maximum values are set, the camera will keep the ISO level within the range you have specified whenever you select Auto ISO. Of course, you can always set a specific ISO value at any other level by selecting it from the ISO menu.

As I discussed in Chapter 3, with the a7C, you can select Auto ISO in Manual exposure mode. In that way, you can set both the shutter speed and aperture, and still have the camera set the exposure automatically by varying the ISO level. In Intelligent Auto mode, Auto ISO is automatically set, and you cannot adjust the ISO setting. The available ISO settings for movie recording are different from those for stills; I will discuss that point in Chapter 9. If you find you cannot select an ISO value lower than 500, check the Picture Profile setting on screen 11 of the Camera Settings1 menu. If you are using a setting that includes S-Log2 or S-Log3 for Gamma, the ISO must be set to at least 500.

Also, note that the settings for ISO 64000 and higher are surrounded by lines on the menu, as shown in Figure 4-68, as are the settings for ISO 50, 64, and 80, as shown for the first two values in Figure 4-66.

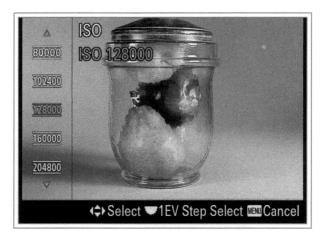

Figure 4-68. Higher Values for ISO, with Lines Around Them

The lines indicate that those settings are not "native" to the a7C's sensor, whose native ISO values range

from 100 to 51200. So, although using the extreme low and high settings appears to provide a wide range of sensitivity to light, in reality those settings are achieved with internal processing by the camera. However, they are certainly worth experimenting with, and they may produce the results you need.

My recommendation is to use Auto ISO for general photography when the main consideration is to have a properly exposed image. When you know you will need a fast shutter speed, select a high ISO setting as necessary. When you need to use a wide aperture to blur the background or a slow shutter speed to smooth out the appearance of flowing water, use a low ISO setting.

ISO RANGE LIMIT

The second sub-option for ISO Setting, ISO Range Limit, lets you limit the settings that the camera displays on the ISO menu. If you know you will never want to use certain settings, such as those above 51200, you can use this menu option to remove those from the ISO menu display, so you don't have to scroll through a long list that includes values you will never use. If you later decide you need to use one or more of the excluded values, return to this menu option and restore those settings to the list.

Note that this menu option does not set the limit for values the camera chooses when Auto ISO is in effect. That setting is made by pressing the Right button when Auto ISO is highlighted on the ISO menu, and then setting values for minimum and maximum for Auto ISO. So, for example, if you set ISO Range Limit to a range from 100 to 16000, the effect will be that you cannot set ISO manually to values above 16000. However, if you set ISO to Auto ISO, and set the maximum ISO value to, say, 64000, the camera will still be able to set ISO to values up to 64000 if the lighting conditions call for such a value.

ISO AUTO MINIMUM SHUTTER SPEED

This final sub-option under the ISO Setting menu item lets you set a minimum shutter speed, or shutter speed range, for the camera to use when ISO is set to Auto. This option is available for selection only when the shooting mode is set to Program or Aperture Priority, the only two advanced shooting modes in which the camera chooses the shutter speed. The purpose of this setting is to

ensure that the camera uses a shutter speed fast enough to stop the action for the scene you are shooting.

For example, if you are shooting images of children at play with the camera set to Program mode and ISO Auto in effect with a range from 200 minimum to 1600 maximum, the camera ordinarily may choose a relatively low ISO setting in order to maintain high image quality and low noise. However, using that setting may result in the use of a fairly slow shutter speed, such as 1/30 second, in order to provide enough light for the exposure. With the ISO Auto Minimum Shutter Speed setting, you can set the minimum shutter speed you want the camera to use, such as, say, 1/125 second, to avoid motion blur. You also can specify a more general range of shutter speeds, using several categories, as discussed below.

To use this option, make sure the shooting mode is set to Program or Aperture Priority and that ISO is set to Auto ISO. Then, highlight this option and press the Center button. You will see a menu with numerous options as you scroll down through several screens, as shown in Figure 4-69.

Figure 4-69. ISO Auto Minimum Shutter Speed Menu Options Screen

All but one of the options are specific shutter speeds, ranging from 1/8000 second to 30 seconds. If you select one of those values, the camera will try to use a shutter speed at least that fast for each shot while maintaining the minimum ISO setting. Once the camera has found it necessary to lower the shutter speed to the minimum value, it will start raising the ISO level as needed. If the camera has set the ISO value to the upper range specified for maximum ISO and still cannot expose the image properly at the ISO Auto Minimum Shutter Speed, the

camera will set a shutter speed slower than the minimum value, in order to achieve a proper exposure.

For example, in the situation discussed above, using ISO Auto with a range from 200 to 1600, if there is plenty of light, the camera may select shutter speeds such as 1/250 second or 1/500 second. It will maintain the ISO at 200 if possible, and it will never select a shutter speed slower than 1/125 second. If the lighting conditions become such that the camera needs to lower the shutter speed all the way to the minimum setting of 1/125 second, the camera will raise the ISO as needed. If the light becomes too dim, the camera may set the ISO to the top of its Auto ISO range at 1600 but still find it impossible to get a good exposure using 1/125 second for the shutter speed. In that case, the camera will use a slower setting, such as 1/60 second or 1/30 second, as needed.

The item at the top of the menu for this option lists settings that are not specific shutter speeds: Standard, Fast, Faster, Slower, and Slow. You can use one of these if you don't need to specify a particular shutter speed but just want to set general guidance for the camera to use. If you choose Standard, the camera tries to maintain a normal shutter speed based on its programming, taking into account the current focal length of the lens.

So, if you use a zoom lens at a 24mm wide-angle setting, the camera will try to maintain a shutter speed faster than 1/24 second. If the lens is zoomed in to 100mm, the camera will try to use a shutter speed faster than 1/100 second. If you choose Fast or Faster, the camera attempts to maintain a faster shutter speed than with Standard; Slow or Slower has the opposite effect.

I generally leave this setting at Standard, unless I am faced with a situation in which I definitely need a particularly fast shutter speed.

Metering Mode

This option lets you choose among the five patterns of exposure metering offered by the a7C—Multi, Center, Spot, Entire Screen Average, and Highlight—as shown in Figure 4-70.

Figure 4-70. Metering Mode Menu Options Screen

This choice tells the camera's automatic exposure system what part of the scene to consider when setting the exposure. With Multi, the camera uses the entire scene that is visible on the display, but it divides that area into segments and analyzes the pattern of the segments in order to determine the optimum exposure.

With Center, the camera still measures all of the light from the scene, but it gives additional weight to the center portion of the image on the theory that your main subject is in or near the center.

With Spot, the camera evaluates only the light that is found within the spot metering zone. You can change the size of that zone between Standard and Large by pressing the Left and Right buttons or turning the control dial when the Spot icon is highlighted.

With the Spot option, particularly with the Standard setting, you can see the effects of the exposure system clearly by selecting Program exposure mode and aiming the small circle at various points, some bright and some dark, and seeing how sharply the brightness of the scene on the camera's display changes. If you try the same experiment using Multi, Center, or Entire Screen Average mode, you will see more subtle and gradual changes.

If you choose Spot metering, the circle you will see is different from the rectangular frames the camera uses to indicate the Center or Flexible Spot focus area mode settings. If you make either of those focus area settings at the same time as the Spot metering setting, you will see both a Spot metering circle and an autofocus frame in the center of the LCD screen, as in Figure 4-71, which shows the screen with the Spot metering and Center focus area settings in effect.

Figure 4-71. Spot Metering and Center Focus Area Both in Use

Be aware of which one of these settings is in effect, if a circle or a frame is visible in the center of the screen. Remember that the circle is for Spot metering, and the rectangular bracket is for Center or Flexible Spot autofocus (or an equivalent Tracking AF setting). You can use the Spot Metering Point menu option, discussed later in this chapter, to set the Spot metering point to track with the Flexible Spot or Expand Flexible Spot focus frame.

The next choice for metering mode, Entire Screen Average, bases the exposure on the overall brightness of the entire screen, without regard to where the subject is located. This option may be useful if the scene is uniform in its brightness or if you know from past experience that basing the exposure on the average brightness will yield a good result.

The last option, Highlight, causes the camera to base the exposure on the brightest point in the scene, regardless of its location. This setting is especially useful for a situation such as a stage performance that is illuminated by one or more spotlights, to avoid overexposure.

In Intelligent Auto mode, the only metering method available is Multi. That method also is the only one available when Clear Image Zoom or Digital Zoom is in use. (The conflict arises only when the lens is actually zoomed beyond the limit of optical zoom; at that point, the camera will change the metering method to Multi, and will change it back when the lens is zoomed back within the optical zoom limit.)

The Multi setting is best for scenes with relatively even contrast, such as landscapes, and for action shots, when the location of the main subject may move through different parts of the frame. The Center setting is good for sunrise and sunset scenes, and other situations with a large, central subject that exhibits considerable contrast with the rest of the scene. The Spot setting is good for portraits, macro shots, and other images in which there is a relatively small part of the scene where exposure is critical. Spot metering also is useful when lighting is intense in one portion of a scene, such as when a concert performer is lit by a spotlight. However, the Highlight option may be preferable for scenes with stage lighting, because the camera will expose for the brightest part of the scene, even if it changes position.

Face Priority in Multi Metering

This option works in a way similar to the Set Face Priority in AF feature, discussed earlier in this chapter under the Face/Eye AF Settings menu option. The Face Priority in Multi Metering option lets you set whether or not the camera optimizes exposure for a detected face, when metering mode is set to Multi. If it is turned on, the camera ignores the overall exposure reading and concentrates the exposure setting based on the highestpriority face. If it is turned off, the camera ignores the faces, and uses the standard algorithm for metering based on the overall scene. In Intelligent Auto mode, this option is turned on and cannot be disabled. If the Face/Eye Priority in AF option under Face/Eye AF Settings on screen 5 of the Camera Settings1 menu is turned on and Subject Detection under that option is set to Animal, the Face Priority in Multi Metering setting has no effect.

This feature can be quite useful if, for example, you are photographing a person against a window with bright sunshine outside. With this option turned off, with Multi metering activated, the camera would expose for the bright window, and leave the person's face too dark. With the option turned on, the camera would expose for the face, and let the window area be overexposed. So, if you are photographing people in a variety of lighting conditions, it can be a good idea to leave this option turned on.

Spot Metering Point

When Spot metering is in effect, you can use the Spot Metering Point menu option to set the Spot circle to move along with the Flexible Spot or Expand Flexible Spot focus frame, whenever either of those frames is in use for focus area. This menu option has two choices—Center or Focus Point Link. If you choose Center, the Spot circle will always stay in the center of the frame. If you choose Focus Point Link, the Spot Circle will move as you move the Flexible Spot or Expand Flexible Spot focus frame.

If focus area is set to Tracking AF with the Flexible Spot or Expand Flexible Spot sub-option, with the Focus Point Link option the Spot metering circle will be located where the focus frame is before focus tracking begins, but the metering area will not move as focus is tracked.

The options on screen 9 of the Camera Settings1 menu are shown in Figure 4-72.

Figure 4-72. Screen 9 of Camera Settings1 Menu

Exposure Step

This option lets you set the size of the exposure interval between settings when you are setting the aperture, shutter speed, or exposure compensation on the camera. The choices are either 0.3EV (exposure value) or 0.5EV. If you choose the smaller step of 0.3EV, you will have more choices for both aperture and shutter speed. For example when using the Sony 28mm-60mm kit lens, with the 0.3EV setting, the choices for aperture include f/4.0, f/4.5, f/5.0, f/5.6, f/6.3, f/7.1, f/8.0, and f/9.0, among others. With the 0.5EV setting, the choices include f/4.0, f/4.5, f/5.6, f/6.7, f/8.0, and f/9.5, among others.

For shutter speed, with the 0.3EV setting the choices include 1/40, 1/50, 1/60, 1/80, 1/100, and 1/125. With the 0.5EV setting, the choices include 1/45, 1/60, 1/90, and 1/125.

For exposure compensation, with the 0.3EV setting, the choices include 0.3, 0.7, 1.0, 1.3, 1.7, and so on, and with the 0.5 EV setting, the choices include 0.5, 1.0, 1.5, 2.0, and so on, but only for adjustments made using this menu option (or assigned to a control button or dial). Adjustments made with the dedicated exposure compensation dial on top of the camera are always in increments of 0.3 EV, regardless of the setting of the Exposure Step menu option.

If you don't want to limit the choices that can be made for these exposure values, choose the 0.3EV setting. If you want to make it slightly quicker to scroll through the settings, choose the 0.5EV setting. I don't find the increased speed of making settings very significant, so I leave this setting at 0.3EV, to preserve the option for making finer adjustments.

AEL with Shutter

This menu item controls how the shutter button handles autoexposure lock. There are three possible settings for this feature: Auto, On, and Off.

With the default option, Auto, pressing the shutter button halfway locks exposure when focus mode is set to AF-S for single-shot autofocus or DMF for direct manual focus. When focus mode is set to AF-C for continuous autofocus or MF for manual focus, pressing the shutter button halfway does not lock exposure. When focus mode is set to AF-A for automatic autofocus, pressing the shutter button halfway locks exposure as long as the subject does not move and burst shooting is not taking place. If the subject starts to move or you start to shoot a continuous burst of images, the exposure will no longer be locked.

If AEL with Shutter is set to On, pressing the shutter button halfway locks exposure in all situations, regardless of what focus mode is in place. So, for example, if focus mode is set to AF-C for continuous autofocus, pressing the shutter button halfway locks exposure, though the focus mechanism will continue adjusting focus. If focus mode is set to MF for manual focus, pressing the shutter button halfway locks exposure, even though focus is not adjusted.

If this menu option is set to Off, pressing the shutter button halfway never locks exposure, in any focus mode. You may want to use this setting when you need to press the shutter button halfway to lock focus and then move the camera to change the composition somewhat. You might want the camera to re-evaluate the exposure, even though you have already locked the focus.

Another important use for the Off setting is when you are using the continuous shooting settings of drive mode. As I discussed earlier in this chapter, if you want the camera to adjust its exposure for each shot in a continuous burst, you need to set AEL with Shutter to Off, or set it to Auto with focus mode set to continuous AF or automatic AF. Otherwise, the camera will lock exposure with the first shot, and will not adjust it if the lighting changes during the burst.

Of course, you may not want to use the Off or Auto setting in that scenario, because it can slow down the burst of shots, and, depending on the situation, it may not be likely that the lighting will change during a brief burst of shots. But this option is available for those times when you want the camera to keep evaluating and adjusting exposure while you take a burst of shots.

Exposure Standard Adjustment

This third and final item on screen 9 of the Camera Settings1 menu is provided so you can fine-tune the exposure settings for the various metering modes. You can use this option to program in an adjustment of up to one stop of EV (exposure value) for each of the camera's five metering modes: Multi, Center, Spot, Entire Screen Average, and Highlight.

This adjustment ordinarily should not be necessary, but it is included for photographers who know that, when they use a particular metering mode, their exposure generally needs a particular adjustment. For example, a photojournalist who covers rock concerts may have found that her shots need to be adjusted upward by 0.5 EV so the non-highlighted areas on the stage are not lost in shadows when she is using the Highlight setting for metering mode. She can use this menu option to set a positive adjustment in that amount.

To make this adjustment, select this menu option and press the Center button to move to a screen with a message saying this adjustment is usually not necessary; then select the OK block to move to the screen listing the metering modes, shown in Figure 4-73. On that screen, select the metering mode you

want to adjust, and move to the adjustment screen, shown in Figure 4-74, where you can select the adjustment you want. Then press the Menu button repeatedly, or just press the shutter button halfway, to return to the shooting screen.

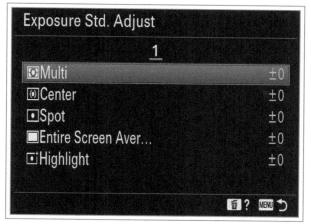

Figure 4-73. Exposure Standard Adjustment - Main Options Screen

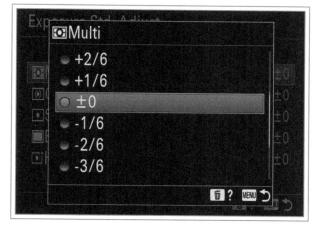

Figure 4-74. Exposure Standard Adjustment - Adjustments Screen

I consider this option to be a somewhat esoteric one, which I don't recommend using unless you have a definite need for it.

The items on screen 10 of the Camera Settings1 menu are shown in Figure 4-75.

Flash Mode

This menu option controls the behavior of any compatible flash unit that is attached to the camera's Multi Interface Shoe. There are five choices for this setting—Flash Off, Autoflash, Fill-flash, Slow Sync, and Rear Sync, as shown in Figure 4-76. Flash Off and Autoflash are dimmed on this screen, because those settings are not available for selection in the Program

shooting mode, illustrated here. There is no shooting mode in which all five options are available.

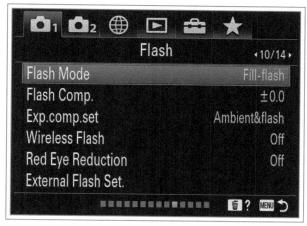

Figure 4-75. Screen 10 of Camera Settings1 Menu

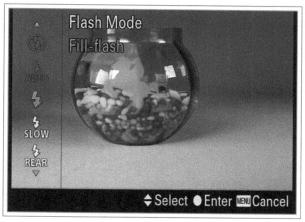

Figure 4-76. Flash Mode Menu

FLASH OFF

This option is available for selection only in Auto mode, and it is not likely to be of much use, because you can always just turn off a flash unit or not attach one to the camera. However, you might want to use this setting if you are in a museum or other place where you don't want the flash to fire, and you don't want to bother with turning off the flash or removing it from the camera.

The following settings apply when you do want to use flash. With any of the flash modes discussed below, the camera will synchronize with the flash at shutter speeds up to 1/160 second, provided you are using a compatible flash unit.

AUTOFLASH

With Autoflash, you leave it up to the camera to decide whether to fire the flash. The camera will analyze the lighting and other aspects of the scene and decide whether to use flash without further input from you. This selection is available only in Intelligent Auto mode.

FILL-FLASH

With Fill-flash, you are making a decision to use flash no matter what the lighting conditions are. If you choose this option, the flash will fire every time you press the shutter button, if the flash is popped up. This is the setting to use when the sun is shining and you need to soften shadows on a subject's face, or when you need to correct the lighting when a subject is backlit.

Figure 4-77. Fill-flash Example: Flash Off

Figure 4-78. Fill-flash Example: Flash On

For example, for Figures 4-77 and 4-78 I took two shots of a mannequin head on a sunny day: one without flash and one using Fill-flash, using the Sony HVL-F45RM flash unit. In Figure 4-78, for which flash was used, the harsh shadows are largely eliminated, providing more even lighting for the face.

Fill-flash is available with all shooting modes except Movie and S and Q Motion.

SLOW SYNC

The Slow Sync option is designed for use when you are taking a flash photograph of a subject at night or in dim lighting, when there is some natural light in the background.

With this setting, the camera uses a relatively slow shutter speed so the ambient (natural) lighting will have time to register on the image. In other words, if you're in a fairly dark environment and fire the flash normally, it will likely light up the subject (such as a person), but because the exposure time is short, the surrounding scene may be black. If you use the Slow Sync setting, the slower shutter speed allows the surrounding scene to be visible also.

Figure 4-79. Slow Sync Example: Normal Flash

Figure 4-80. Slow Sync Example: Slow Sync Flash

I took the images in Figures 4-79 and 4-80 with identical lighting and camera settings, except that I took the first image with the flash set to Fill-flash and shutter speed at 1/60 second, and I took the second image with the flash set to Slow Sync, resulting in a longer shutter speed of 1/4 second.

In Figure 4-79, the flash illuminated the mannequin head in the foreground, but the background is dark. In

Figure 4-80, the room behind the figure is illuminated by ambient light because of the slower shutter speed.

When you use Slow Sync, you should use a tripod, because the camera may choose a very slow shutter speed, such as three seconds or longer. Note that you can choose Slow Sync even in Shutter Priority mode. If you do so, you should select a slow shutter speed because the point is to use a long exposure to light the background with ambient light. With Shutter Priority mode you can choose any shutter speed, but it would not make sense to select a relatively fast one, such as, say, 1/30 second. The same considerations apply for Manual exposure mode, in which you also can select Slow Sync.

Slow Sync can be selected only in the Program, Aperture Priority, Shutter Priority, and Manual exposure modes.

REAR SYNC

The next setting for Flash Mode is Rear Sync. You should not need this option unless you encounter the special situation it is designed for. If you don't activate this setting (that is, if you select any other flash mode in which the flash fires), the camera uses the unnamed default setting, which could be called "Front Sync." In that case, the flash fires very soon after the shutter opens to expose the image. If you choose the Rear Sync setting instead, the flash fires later—just before the shutter closes.

Rear Sync helps avoid a strange-looking result in some situations. This issue arises, for example, with a relatively long exposure, say 1/2 second, of a subject with lights, such as a car or motorcycle at night, moving across your field of view. With normal (Front) sync, the flash will fire early in the process, freezing the vehicle in a clear image. However, as the shutter remains open while the vehicle keeps going, the camera will capture the moving lights in a stream extending in front of the vehicle.

If, instead, you use Rear Sync, the initial part of the exposure will capture the lights in a trail that appears behind the vehicle, while the vehicle itself is not frozen by the flash until later in the exposure. With Rear Sync in this particular situation, if the lights in question are taillights that look more natural behind the vehicle, the final image is likely to look more natural than with the Front Sync (default) setting.

The images in Figures 4-81 and 4-82 illustrate this concept using a flashlight. I took both pictures using a Sony flash unit, with a shutter speed of 1/2 second. For each shot, I waved the flashlight from right to left. In Figure 4-81, using the normal (Fill-flash) setting, the flash fired quickly, making a clear image of the flashlight at the right of the image, and the light beam continued on to the left during the long exposure to make a light trail in front of the flashlight's path of movement.

In Figure 4-82, using Rear Sync, the flash did not fire until the flashlight had traveled all the way to the left, and the trail of light from its beam appeared behind the flashlight's path of motion. If you are trying to convey a sense of natural movement, the Rear Sync setting, as seen here, is likely to give you better results than the default setting.

Figure 4-81. Rear Sync Example: Normal Flash

Figure 4-82. Rear Sync Example: Rear Sync Flash

A good general rule is to use Rear Sync only when you have a definite need for it. Using this option makes it harder to compose and set up the shot, because you have to anticipate where the main subject will be when the flash finally fires late in the exposure process. But, in the relatively rare situations when it is useful, Rear Sync can make a dramatic difference. Rear Sync is not available in Intelligent Auto mode.

Flash Compensation

This menu item lets you control the output of an external flash unit if a compatible one is attached to the flash shoe. This function works similarly to exposure compensation, discussed earlier in this chapter, which is available in the more advanced shooting modes. The difference between the two options is that flash compensation varies only the brightness of the light emitted by the flash, while exposure compensation varies the overall exposure of a given shot, whether or not flash is used. (You can control whether the exposure compensation setting adjusts flash output as well as camera settings by using the Camera Settings1 menu's Exposure Compensation Setting option, discussed immediately below.)

Flash compensation is useful when you don't want the subject overwhelmed with light from the flash. I sometimes use this setting when I am shooting a portrait outdoors with the Fill-flash setting to reduce shadows on the subject. With a bit of negative flash compensation, I can keep the flash from overexposing the image or casting a harsh light on the subject's face.

To use this option, highlight it on the menu screen and press the Center button. On the next screen, press the Left and Right buttons or turn the control dial or the control wheel to set the amount of positive or negative compensation you want.

When a compatible flash unit is in use, an icon in the upper right corner of the shooting screen shows the amount of flash compensation in effect, even if it is zero. Be careful to set the value back to zero when you are done with the setting, because any setting you make will stay in place even after the camera has been powered off and back on again.

The Flash Compensation option is not available in Intelligent Auto mode.

Exposure Compensation Setting

This next option has two possible settings: Ambient & Flash, or Ambient Only.

With Ambient & Flash, the default setting, when you adjust exposure compensation, the camera will adjust not only its exposure settings, but also the intensity of the flash. If you choose Ambient Only, adjusting

exposure compensation will control only the exposure settings, and not the flash.

To give the a7C flexibility in adjusting exposure compensation, leave the setting at Ambient & Flash. However, results can be different using the Ambient Only setting, so you may want to experiment with both options to see which one you prefer in a given situation. Remember that the camera has a separate adjustment for Flash Compensation on the Camera Settings1 menu, and you can set that value separately if you need to adjust the output of the flash. I recommend using the Ambient & Flash setting unless you have a particular reason for using the Ambient Only option.

Wireless Flash

The next option on screen 10 of the Camera Settings1 menu, Wireless Flash, gives you the ability to control one or more off-camera flash units using Sony flash equipment. Because this option is separate from the flash mode menu option, you can turn on wireless flash capability and also use one of the other settings for flash mode, such as Slow Sync or Rear Sync.

Sony offers two different types of wireless flash. One system, which is built into some Sony flash units, uses pulses of light to communicate between a flash attached to the camera and one or more remote flashes. The other system, which is available in the form of a transmitter unit and a receiver unit, and also is built into some Sony flash units, uses radio signals to transmit information from the camera to one or more off-camera flash units. I will provide information about both of these systems here, with more emphasis on the light-based process.

Using Sony's Light-Based Wireless Protocol

In order to use the light-based flash system, you need to have at least two flash units that are compatible with this Sony wireless system—one attached to the camera's accessory shoe and another one (or multiple units) positioned off the camera.

A flash unit attached to the camera's hot shoe acts as the controller. One option for this purpose is the Sony HVL-F20M, a small and relatively inexpensive unit, which I discuss in Appendix A. One negative point about this unit is that it cannot act as a remote unit using the Sony wireless protocol, only as the controller. That is not much of a problem, though; you can just dedicate this unit as your controller and use other, larger units as the remote flash units. Another option I have used as a controller is the Sony HVL-F32M.

One remote unit I have used is the Sony HVL-F43M, also discussed in Appendix A. This full-sized flash has features such as a rotating head and a built-in video light. For wireless purposes, it can serve as either the controller or the remote unit for the Sony protocol.

I will describe how to set up a shot using the Sony optical wireless flash protocol in Aperture Priority mode using the HVL-F20M flash as the controller and the HVL-F43M flash as the remote unit; the procedure would be similar with other compatible Sony flash units.

- As a preliminary matter, go to the Custom Key (Still Images) option on screen 9 of the Camera Settings2 menu and assign one of the camera's control buttons to the Wireless Test Flash function. (I chose the Custom button for this option, but you can choose any control you prefer.)
- 2. Attach the HVL-F43M to the a7C, turn the camera and flash on, and set the camera to Aperture Priority mode, which is one of the modes that permit the use of the Wireless Flash option. On the Camera Settings1 menu, set the Wireless Flash menu option to On and press the shutter button halfway. Make sure the flash's display shows that it is now set to Wireless mode, on Channel 1. If necessary, press the Mode button on the flash to set the flash to RMT (remote) mode.
- 3. Remove the HVL-F43M flash from the camera and set it up aiming at your subject, on a light stand, on its own plastic stand, or handheld by the subject or other person. The red AF Illuminator light on the flash unit should now be blinking, indicating that the remote unit is ready to receive a signal from the controller unit.
- 4. Attach the HVL-F20M to the a7C and turn the flash on by pulling it up into a vertical position. On the a7C, set up your shot using Aperture Priority mode.
- 5. On the camera, make sure the Wireless Flash option is still turned on. When the camera is aimed at the subject, make sure that the flash from the HVL-F20M can be seen by the remote flash. (The

line of sight can be indirect, from bouncing off a wall or ceiling.) To test the setup, press the button on the camera that you assigned to the Wireless Test Flash function in Step 1. This should trigger the remote flash.

6. When the shot is set up as you want it, press the shutter button to take the picture.

The flash unit on the camera sends a coded signal to the remote flash telling it to fire a pre-flash. The camera then evaluates that pre-flash and sets the remote flash to fire the flash at the proper intensity for the actual exposure. You will see the pre-flash, followed fairly quickly by the actual flash for the exposure.

Figure 4-83. Image Taken Using Wireless Flash

Figure 4-83 shows an image taken with a setup similar to this one, using flash from the HVL-F43M. This image was taken with a single remote flash. I used Aperture Priority mode with the 28mm-60mm kit lens, and the camera exposed the image for 1/60 second at f/22 with ISO set to 250. I experienced difficulty using this system with ISO set to Auto ISO. With that setting, in a darkened room, the camera overexposed the shots, setting ISO to the high level of 25600. Setting the ISO to a specific value of 250 solved this problem for me.

There are other Sony flash units that work with the optical wireless protocol, including the HVL-F32M and the HVL-F60RM. You can use multiple external flash units if you want.

Using Sony's Radio-Based Flash System

The other system offered by Sony for remote flash control with the a7C involves sending radio signals from a transmitter attached to the a7C to a remote receiver with a compatible flash unit attached to it. I

will set forth the basic steps for using this system with the Sony transmitter and receiver. (You also can use certain Sony flash units as the transmitter or receiver.) These units are discussed further in Appendix A.

- Attach the Sony Wireless Radio Commander, model number FA-WRC1M, to the accessory shoe on top of the a7C, and attach the Sony Wireless Radio Receiver, model number FA-WRR1, to a light stand or other support. Attach a compatible flash, such as the Sony HVL-32M, to the flash shoe on top of the receiver.
- Turn on the Wireless Radio Commander, press its Menu button, select Pairing from the menu, then scroll to Add, and press the center button in the device's controller.
- 3. Make sure the Wireless Radio Receiver is turned off. Then, after selecting Add on the Commander, press and hold the on/off button on the Receiver for about seven seconds. The Commander should display a message saying Added: 1.
- 4. At this point, the Commander and Receiver should be paired, and two green lights should illuminate on the back of the Receiver. Press the center button on the Commander's controller to exit from the pairing process. Make sure the Commander is set to TTL, with the TTL indicator on the screen. If it is not, press the Fn button on the Commander to highlight the current setting, such as Release, Group, or Manual, then press the center button on the controller, and select TTL from the menu that appears by highlighting it and pressing the center button.
- 5. Turn on the a7C and set the Wireless Flash menu option to On. Turn on the Flash that is attached to the Receiver, and put that flash into TTL mode. You can now shoot images with the a7C, and the remote flash should fire each time you press the shutter button. As with the optical-based wireless system, I have found that it is advisable to set ISO to a specific value, such as 200, rather than to Auto ISO, to avoid abnormal exposure.

Red Eye Reduction

This next option on screen 10 of the Camera Settings1 menu is designed to combat "red-eye"—the eerie red

glow in human eyes that appears in images when oncamera flash lights up the blood vessels on the retinas. This menu item can be set to either On or Off. If it is turned on, then, whenever the flash is used, it fires a few times before the actual flash that illuminates the image. The pre-flashes cause the subject's pupils to narrow, reducing the ability of the later, full flash to enter the pupils, bounce off the retinas, and produce the unwanted red glow in the eyes.

I prefer to leave this option turned off and deal with any red-eye effects using editing software. However, if you will be taking flash photos at a party, you may want to use this menu option to minimize the occurrence of red-eye effects in the first place. This option is not available if the Wireless Flash menu option is turned on.

External Flash Setting

This menu option lets you adjust the settings of a compatible Sony flash unit or the Sony Wireless Radio Commander unit that is attached to the camera's flash shoe. The first thing to note about this option is that not all Sony flash units are compatible with it. The first unit I tried it with, the Sony HVL-F43M, was not compatible. I then found that another flash I had, the Sony HVL-F45RM, is compatible, but only if it has its software updated.

I went to the following site to find out what units are compatible: https://www.sony.net/dics/7c. I then went to another site to download the software needed to update the software in the flash: https://www.sony.com/electronics/support/camera-camcorder-accessories-flashes-and-lights/hvl-f45rm/downloads/00016696. After I downloaded the new software to the flash using a USB cable, the flash unit became compatible with the External Flash Setting menu option and I could test its functioning, as set out below.

I also found that the Sony Wireless Radio Commander, model number FA-WRC1M, needed to have its firmware updated before the camera would recognize it for use with the External Flash Setting menu option. I updated the firmware from https://www.sony.com/electronics/support/camera-camcorder-accessories-flashes-and-lights/fa-wrc1m/downloads/00016702. Once the firmware was updated, this unit was recognized and a few settings could be adjusted from the camera.

Once the camera and flash (or Wireless Radio Commander) are turned on, this menu item provides two sub-options: External Flash Firing Settings and External Flash Custom Settings. You can use the camera's control wheel to scroll through the available options for the flash or transmitter unit you are using, and select them as you wish.

For example, with the Sony HVL-F45RM flash with updated firmware attached to the camera's hot shoe, selecting the External Flash Firing Settings option produced the screen shown in Figure 4-84, with options for Flash Control Mode including Flash Off, TTL Flash Firing, Manual Flash Firing, Multi Flash Firing, and Group Flash Firing. The Memory Recall option included choices of Off, MR1, and MR2. The High Speed Sync (HSS) option included choices for turning HSS on or off. Finally, the menu included an option for adjusting flash compensation, displaying a scale from -3 to +3 EV units, similar to the scale used with the Flash Compensation on the camera's menu system.

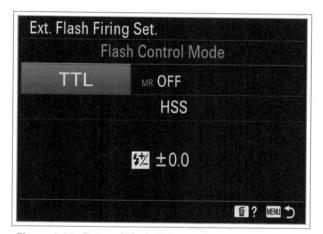

Figure 4-84. External Flash Firing Settings Options Screen

In short, the External Flash Setting option offers a way to make several useful settings on the flash or transmitter unit attached to the camera, but only if you have a compatible flash or transmitter unit.

The options on screen 11 of the Camera Settings1 menu are shown in Figure 4-85.

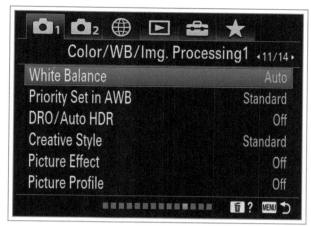

Figure 4-85. Screen 11 of Camera Settings1 Menu

White Balance

The White Balance menu option is needed because cameras record colors of objects differently according to the color temperature of the light illuminating those objects. Color temperature is a value expressed in Kelvin (K) units. A light source with a lower K rating produces a "warmer," or more reddish light. A source with a higher rating produces a "cooler," or more bluish light. Candlelight is rated about 1,800 K, indoor tungsten light (ordinary light bulb) is rated about 3,000 K, outdoor sunlight and electronic flash are rated about 5,500 K, and outdoor shade is rated about 7,000 K. If the camera is using a white balance setting that is not designed for the light source that illuminates the scene, the colors of the recorded image are likely to be inaccurate.

The a7C, like most cameras, has an Auto White Balance setting that chooses the proper color correction for any given light source. The Auto White Balance setting works well, and it will produce good results in many situations, especially if you are taking snapshots whose colors are not critical.

If you need more precision in the white balance of your shots, the a7C has settings for common light sources, as well as options for setting white balance by color temperature and for setting a custom white balance based on the existing light source.

Once you have highlighted this menu option, press the Center button to bring up the vertical menu at the left of the screen, as shown in Figure 4-86.

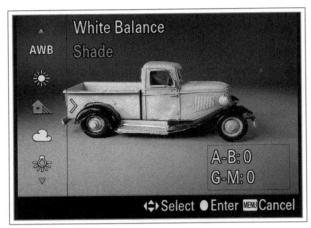

Figure 4-86. White Balance Menu

Press the Up and Down buttons or turn the control wheel to scroll through the choices: Auto White Balance (AWB); Daylight (sun icon); Shade (house icon); Cloudy (cloud icon); Incandescent (round light bulb icon); Fluorescent Warm White (bulb icon with -1); Fluorescent Cool White (same, with 0); Fluorescent Day White (same, with +1); Fluorescent Daylight (same, with +2); Flash (WB with lightning icon); Underwater Auto (AWB with fish icon); Color Temperature/Filter (K and filter icon); and three numbered custom choices. It takes several screens to scroll through all of these choices.

To select a setting without making any further adjustments, highlight it and press the Center button. Most of the settings describe a light source in common use. There are four settings for fluorescent bulbs, so you should be able to find a good setting for any fluorescent light, though you may need to experiment to find the best setting for a given bulb. For settings such as Daylight, Shade, Cloudy, and Incandescent, select the setting that matches the dominant light in your location. If you are indoors and using only incandescent lights, this decision will be easy. If you have a variety of lights turned on and sunlight coming in the windows, you may want to use either the Color Temperature/ Filter setting or the custom option.

The Color Temperature/Filter option lets you set the camera's white balance according to the color temperature of the light source. One way to determine that value is with a color meter like the Sekonic C-700.

Such meters work well when you need accuracy in white balance settings. If you don't want to use a meter, you can still use the Color Temperature/Filter option, but you will have to do some guesswork or use your own

sense of color. For example, if you are shooting under lighting that is largely incandescent, you can use the value of 3,000 K as a starting point, because, as noted earlier in this discussion, that is an approximate value for the color temperature of that light source. Then you can try setting the color temperature figure higher or lower, and watch the camera's display to see how natural the colors look.

As you lower the color temperature setting, the image will become more "cool," or bluish; as you raise it, the image will appear more "warm," or reddish. Once you find the best setting, leave it in place and take your shots. (The Live View Display option on screen 8 of the Camera Settings2 menu must be set to Setting Effect On for these changes to appear on the display, as discussed in Chapter 5.)

To make this setting, after you highlight the icon for Color Temperature/Filter, press the Right button to move the orange highlight to the right side of the camera's screen so that it highlights the color temperature value bar, as shown in Figure 4-87.

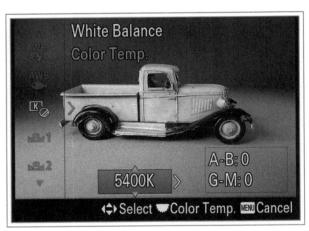

Figure 4-87. Color Temperature/Filter Setting Screen

Raise or lower that number by pressing the Up and Down buttons or by turning the control wheel or control dial, and press the Center button to select that value. Or, when the icon for Color Temperature/Filter is highlighted, you can just start turning the control dial to adjust the color temperature value.

If you don't want to use the Color Temperature/Filter option, you can set a custom white balance. The three custom icons, just below the Color Temperature/Filter icon, are used to set the camera to one of three currently stored custom white balance settings. Before

you can use any of the three custom icons, you need to set the custom white balance value as you want it and store it to one of those icons.

To set and store a custom white balance, highlight any one of the three custom icons and press the Right button to move the highlight to the Set icon. Press the Center button to select this option, and the camera will display a screen like that shown in Figure 4-88, with a small yellow frame in the center of the display. Using the direction buttons, control wheel, or control dial, move that frame so it is filled with a gray or white surface that is lit by the light source you are measuring. To return the frame to the center of the screen, press the Custom/Delete button. Once the frame is located properly, press the Center button, and the camera will capture the color information and set the custom white balance accordingly.

The lower area of the screen will show the measured color temperature along with letters and numbers indicating variations along two color axes. If there is some variation, you will see an indication such as G-M: G1, meaning one unit of variation toward green along the green-magenta axis. If there is no variation, it will say A-B: 0 and G-M: 0.

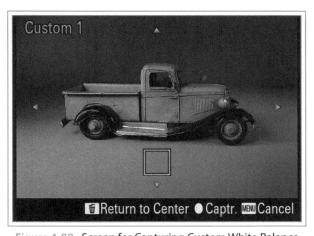

Figure 4-88. Screen for Capturing Custom White Balance

Press the Center button to return to the shooting screen. To use the custom white balance setting you saved, select the 1, 2, or 3 custom icon on the white balance menu, depending on the slot you used to save the setting. You can change any of the custom settings whenever you want to, if you are shooting under different lighting conditions.

There is one more way to adjust the white balance setting by taking advantage of the two color axes discussed above. If you want to tweak the white balance setting to the nth degree, when you have highlighted your desired setting on the white balance menu (whether a preset, Auto, or a custom setting), press the Right button, and you will see a screen for fine adjustments, as shown in Figure 4-89.

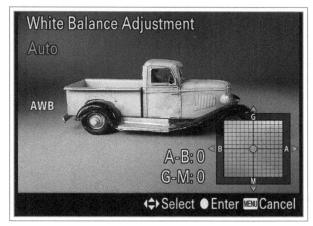

Figure 4-89. Color Axes Screen for Fine-tuning White Balance

This screen has a pair of axes that intersect at a zero point marked by an orange dot. The axes are labeled G, B, M, and A for green, blue, magenta, and amber.

You can use all four direction buttons to move the orange dot along either of the axes to adjust these four values until you have the color balance exactly how you want it. You also can use the control wheel to adjust the G-M axis and the control dial to adjust the B-A axis. Press the Center button to confirm the setting.

Be careful to undo any adjustments using these axes when they are no longer needed; otherwise, the adjustments will alter the colors of all of your images that are shot with this white balance setting in a shooting mode for which white balance can be adjusted, even after the camera has been powered off and then back on.

Some final notes about white balance: First, if you shoot using Raw quality, you can always correct the white balance after the fact in your Raw software. So, if you are using Raw, you don't have to worry so much about what setting you are using for white balance. Still, it's a good idea always to check the setting before shooting to avoid getting caught with incorrect white balance when you are not using the Raw format, and to avoid having to adjust white balance unnecessarily for Raw images.

Second, before you decide to use the "correct" white balance in every situation, consider whether that is the best course of action to get the results you want. For example, I know of one photographer who generally keeps his camera set for Daylight white balance even when shooting indoors because he likes the "warmer" appearance that comes from using that setting. I don't necessarily recommend that approach, but it's not a bad idea to give some thought to straying from a strict approach to white balance, at least on occasion.

The white balance setting is fixed to Auto White Balance in Intelligent Auto mode.

Before I leave this topic, I am including a chart in Figure 4-90 that shows how white balance settings affect images taken by the a7C. I took the photos in the chart under daylight-balanced light using each available white balance setting, as indicated on the chart.

Most of the settings yielded acceptable results. The only ones that clearly look incorrect for this light source are the Incandescent, Fluorescent Warm White, and Fluorescent Cool White settings. The other settings produced variations that might be appropriate, depending on how you plan to use the images.

Priority Set in Auto White Balance

This next menu option gives you a way to tweak the white balance of shots taken using the Auto White Balance setting. You can leave it set to its default setting of Standard, or set it to Ambience or White. It is intended for use when you are shooting a scene illuminated by incandescent lighting. If you set this option to Standard, the camera makes no change to its normal Auto White Balance setting.

With Ambience, the camera adjusts white balance to the warmer side, making the shot a bit more yellowish than it would otherwise be. With the White setting, the camera adjusts to the cooler side, producing a more icetinged white. I generally leave this option at the Standard setting, but if you are doing extensive shooting under incandescent lighting using the Auto White Balance setting, this menu item gives you a way to make a mild adjustment to the color balance of your images.

White Balance Chart for Sony a7C

Auto White Balance

Daylight

Shade

Cloudy

Incandescent

Fluorescent Warm White

Fluorescent Cool White

Fluorescent Day White

Fluorescent Daylight

Flash

AWB Underwater

Color Temp: 5400K

Custom

Figure 4-90. White Balance Comparison Chart

DRO/Auto HDR

The next option on the Camera Settings1 menu lets you control the dynamic range of your shots using the DRO/HDR (dynamic range optimizer/high dynamic range) processing of the a7C. These settings can help correct problems with excessive contrast in your images. Such issues arise because digital cameras cannot easily process a wide range of dark and light areas in the same

image—that is, their "dynamic range" is limited. So, if you are taking a picture in an area that is partly lit by bright sunlight and partly in deep shade, the resulting image is likely to have some dark areas in which details are lost in the shadows, or some areas in which highlights, or bright areas, are excessively bright, or "blown out," so, again, the details of the image are lost.

One way to deal with this situation is to use high dynamic range (HDR) techniques, in which multiple photographs of the same scene with different exposures are combined into a composite image that has clear details throughout the entire scene. The a7C can take HDR shots on its own, or you can take separate exposures yourself and combine them in software on a computer into a composite HDR image. I will discuss those HDR techniques later in this chapter.

The a7C's DRO setting gives you another way to deal with the problem of uneven lighting, with special processing in the camera that can boost details in dark areas and reduce overexposure in bright areas at the same time, resulting in a single image with better-balanced exposure than would be possible otherwise. To do this, the DRO setting uses digital processing to reduce highlight blowout and pull details out of the shadows.

To use the DRO feature, press the Menu button and highlight this option, then press the Center button to bring the DRO/Auto HDR menu up on the camera's display, as shown in Figure 4-91. Scroll through the options on that menu using the Up and Down buttons or by turning the control wheel.

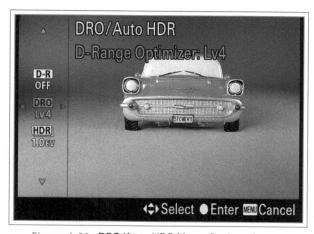

Figure 4-91. DRO/Auto HDR Menu Options Screen

With DRO Off, no special processing is used. With the second choice, press the Right and Left buttons or turn

the control dial to move through the DRO choices: Auto, or Level 1 through Level 5. With the Auto setting, the camera analyzes the scene to pick an appropriate amount of DRO processing. Otherwise, you can pick the level; the higher the number, the greater the processing to even out contrast between light and dark areas.

Figures 4-92 through 4-94 are examples of images captured using various levels of DRO processing, ranging from Off to Level 5.

As you can see, the greater the level of DRO used, the more evenly the a7C processed lighting in the scene, primarily by enhancing details in the shadowy areas.

There is some risk of increasing visual noise in the dark areas with this sort of processing, but the a7C does not seem to do badly in this respect; I have not seen increased noise levels in images processed with the DRO feature.

Figure 4-92. DRO Series: DRO Off

Figure 4-93. DRO Series: DRO Set to LV3

Figure 4-94. DRO Series: DRO Set to LV5

The final option for this menu item, HDR, involves in-camera HDR processing. With traditional HDR processing, the photographer takes two or more shots of a scene with contrasting lighting, some underexposed and others overexposed, and merges them using Photoshop or HDR software to blend differently exposed portions from all of the images. The end result is a composite HDR image with clear details throughout all parts of the photograph.

Because of the popularity of HDR, many makers have incorporated some degree of HDR processing into their cameras in an attempt to help the cameras even out areas of excessive brightness and darkness to preserve details. With the a7C, Sony has provided an automatic method for taking multiple shots that the camera combines internally to achieve one HDR composite image. To use this feature, highlight the bottom option on the DRO/Auto HDR menu.

Press the Right and Left buttons or turn the control dial to scroll through the various options for the HDR setting until you have highlighted the one you want, then press the Center button to select that option and exit to the shooting screen. The available options are Auto HDR and HDR with EV settings from 1.0 through 6.0.

If you select Auto HDR, the camera will analyze the scene and the lighting conditions and select a level of exposure difference on its own. If you select a specific level from 1.0 to 6.0, the camera will use that level as the overall difference among the three shots it takes.

For example, if you select 1.0 EV for the exposure difference, the camera will take three shots, each 0.5 EV level (f-stop) different in exposure from the next—one shot at the metered EV level, one shot at 0.5 EV lower, and one shot at 0.5 EV higher. If you choose the

maximum exposure difference of 6.0 EV, then the shots will be 3.0 EV apart in their brightness levels.

When you press the shutter button, the camera will take three shots in a quick burst; you should either use a tripod or hold the camera very steady. When it has finished processing the shots, the camera will save the composite image as well as the single image that was taken at the metered exposure.

For Figure 4-95 through Figure 4-98, I took shots of a model lighthouse in conditions of mixed sunlight and shadow, to illustrate the effectiveness of the HDR settings. For Figure 4-95, HDR was turned off; for Figure 4-96, it was set at 3.0EV; for Figure 4-97, HDR was set to its highest value, 6.0EV. The image using HDR at 6.0EV gave the best results in terms of pulling details out of the shadows.

For comparison, I took several shots of the subject using a range of exposure levels in Manual exposure mode. I merged those images together in Photoshop and tweaked the result until I got what seemed to be the optimal dynamic range.

Figure 4-95. HDR Series: HDR Off

Figure 4-96. HDR Series: HDR Set to EV3.0

Figure 4-97. HDR Series: HDR Set to EV6.0

Figure 4-98. HDR Series: Composite Image from Photoshop

In my opinion, the HDR image done in software, shown in Figure 4-98, did a better job of evening out the contrast than the Auto HDR images processed in the camera. However, these images were taken under fairly extreme conditions. The in-camera HDR option is an excellent option for subjects that are partly shaded and partly in sunlight, when you don't have the time or inclination to take multiple pictures and combine them later with HDR software into a composite image.

My recommendation is to leave the DRO Auto setting turned on for general shooting, especially if you don't plan to do post-processing. If the contrast in lighting for a given scene is extreme, then try at least some shots using the Auto HDR feature.

If you are planning to do post-processing, you may want to use the Raw setting for file Format, so you can work with the shots later using software to achieve evenly exposed final images. You also could use Manual exposure mode or exposure bracketing to take shots at different exposures and merge them with Photoshop, Photomatix, or other HDR software. The a7C provides high levels of dynamic range in its Raw files, particularly if you shoot with low ISO settings.

Therefore, you very well may be able to bring details out of the shadows and reduce overexposure in highlighted areas using your Raw processing software.

Note that the Auto HDR setting cannot be used if you are using the Raw format for your images. The other DRO settings do work with Raw images, but they will have no effect on the Raw images unless you process them with Sony's Imaging Edge software or some other software that has been programmed to recognize the DRO settings embedded in the Raw files. When I used Adobe Camera Raw to open a Raw file taken by the a7C with DRO set to LV5, the image did not show any effects of the DRO processing, although the effects were apparent in Imaging Edge.

You cannot adjust DRO and Auto HDR settings in Intelligent Auto mode; DRO is automatically turned on in that mode. DRO/HDR cannot be used when Picture Effect or Picture Profile is active on screen 11 of the Camera Settings1 menu. You can use flash with the DRO/HDR settings, but it will fire only for the first HDR shot, and it defeats the purpose of the settings to use flash, so you probably should not do so.

Creative Style

The Creative Style setting provides options for altering the appearance of your images with in-camera adjustments to their contrast, saturation (color intensity), and sharpness. Using these settings, you can add or subtract intensity of color or make subtle changes to the look of your images, as well as shoot in monochrome. Of course, if you plan to edit your images on a computer using software such as Photoshop, you can duplicate these effects readily at that stage. But if you don't want to spend time processing your images in that way, having the ability to alter the look of your shots using this menu option can add a good deal to the enjoyment of your photos.

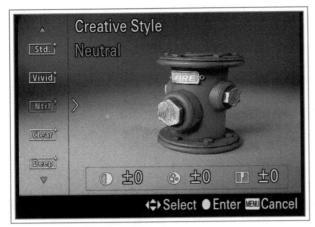

Figure 4-99. Creative Style Menu Options Screen

To use this feature, highlight Creative Style on screen 11 of the Camera Settings1 menu and press the Center button to go to the next screen, as shown in Figure 4-99. Using the Up and Down buttons or turning the control wheel, scroll through the 13 main settings: Standard, Vivid, Neutral, Clear, Deep, Light, Portrait, Landscape, Sunset, Night Scene, Autumn Leaves, Black and White, and Sepia. If you want to choose one of these settings with no further adjustment, just press the Center button when your chosen option is highlighted.

If you use an option other than Standard, you may see a change on the display in shooting mode. For example, if you choose Sepia or Black and White, the screen will have that coloration.

This effect will be visible, though, only if the Live View Display option on screen 8 of the Camera Settings2 menu is set to Setting Effect On. If that menu option is set to Setting Effect Off, the display will not show any change from the Creative Style setting. You will still see an icon showing which setting is in effect, in the lower right of the screen. For example, when the Sepia setting is active but Setting Effect is off, a VIEW indicator in the upper middle of the display indicates that Setting Effect is turned off, but the display is in full color, not sepia, as shown in Figure 4-100.

Adjusting Contrast, Saturation, and Sharpness

To adjust contrast, saturation, or sharpness for a Creative Style setting, move the highlight bar to the setting, such as Portrait, and press the Right button or turn the control dial to put a new highlight bar on the right of the

screen. You will see a label above a line of icons at the bottom of the screen, as shown in Figure 4-101.

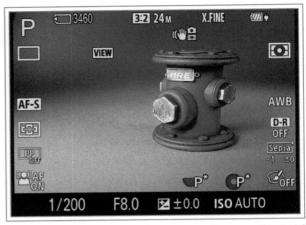

Figure 4-100. VIEW Icon on Screen When Setting Effect is Off

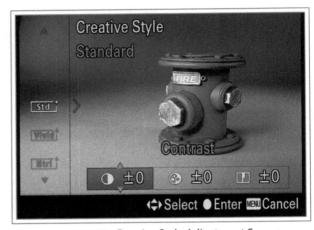

Figure 4-101. Creative Style Adjustment Screen

As you move the highlight bar over each icon with the Left and Right buttons or the control dial, the label will change to show which value is active and ready to be adjusted. When the chosen value (contrast, saturation, or sharpness) is highlighted, use the Up and Down buttons or turn the control wheel to adjust the value upward or downward by up to three units for contrast or saturation, and by up to five units for sharpness. When the Black and White or Sepia setting is active, there are only two adjustments available—contrast and sharpness. Saturation is not available because it adjusts the intensity of colors and there are no colors to adjust for those two settings.

By varying the amounts of these three parameters, you can achieve a range of different appearances for your images. For example, by increasing saturation, you can add punch and make colors stand out. By adding contrast and/or sharpness, you can impose a "harder"

appearance on your images, making them look grittier and more realistic.

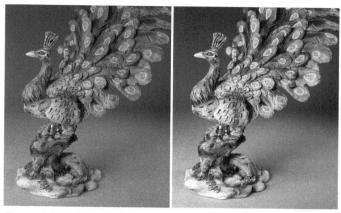

Figure 4-102. Creative Style Minimum and Maximum Adjustments

Figure 4-102 is a composite image. The left image was taken with the Standard setting with all three parameters adjusted to their minimums, and the right image was taken with the same main setting, but with the contrast, sharpness, and saturation all adjusted to their maximum levels. As you can see, the right image is noticeably brighter, with a crisper look than that in the left image.

If you want to save the adjusted settings for future use, you can create and save six different custom versions, using any of the 13 basic settings with whatever adjustments you want. To do this, scroll down on the Creative Style menu to the numbered items, starting just below the Sepia item, as shown in Figure 4-103.

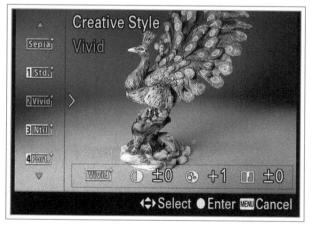

Figure 4-103. Numbered Icons for Custom Creative Style Settings

There are six numbered icons, of which the first four are visible on the screen shown here. They all work in the same way. Highlight a numbered icon, then, using the Right button or the control dial, move the highlight to

the right side of the screen, on the name of the setting (Vivid, Neutral, Deep, etc.). Use the control wheel or the Up and Down buttons to select any one of the 13 basic Creative Style settings. Then, scroll to the right and adjust contrast, saturation, and sharpness as you want them. When all the adjustments are made, press the Center button to accept them. Whenever you want to recall that customized setting for use, call up the Creative Style menu and scroll to the numbered icon for the style you adjusted.

The Creative Style option works with all shooting modes except Intelligent Auto mode. You can use it with the Raw format, but the results will vary depending on the Raw-conversion software you use. For example, when I shot a Raw image in Program mode using the Black and White setting, the image showed up in black and white on the camera's screen. However, when I opened the image in Adobe Camera Raw software, the image was in color; that software ignored the information in the image's data about the Creative Style setting.

When I opened the image using Sony's Imaging Edge software, though, the image appeared in black and white, because Sony's software recognized the Creative Style information. So, if you want to use this menu option with Raw files, be aware that not all software will use that data when processing the images.

The Creative Style menu option cannot be used when the Picture Effect or Picture Profile option is in use.

Figures 4-104 and 4-105 include comparison photos showing each Creative Style setting as applied to the same subject under the same lighting conditions to illustrate the different effects you can achieve with each variation. General descriptions of these effects are provided after the comparison charts.

Creative Styles Chart for Sony a7C- Part 1

Standard Clear

Deep

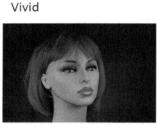

Neutral

STANDARD

Light

Figure 4-104. Creative Style Comparison Chart - Part 1

The Standard setting uses what Sony considers to be appropriate processing to give a pleasing overall appearance for everyday photographs, with some

enhancements to make color photographs appear bright and sharp. This option is intended to be a good default setting for general purposes.

VIVID

The Vivid setting increases the saturation, or intensity, of all colors in the image, as well as the contrast. As you can see from the samples, it calls attention to the subject, though it does not produce dramatic effects. The Vivid setting might work well to emphasize the colors in images taken at a birthday party or at a carnival.

NEUTRAL

With the Neutral setting, the a7C leaves images with reduced saturation and sharpness, so you can process them to your own taste using software.

Creative Styles Chart for Sony a7C - Part 2

Portrait

Landscape

Sunset

Night Scene

Autumn Leaves

Black and White

Sepia

Figure 4-105. Creative Style Comparison Chart - Part 2

CLEAR

The Clear option emphasizes the highlighted areas in an image, giving them added intensity. Some users feel this setting yields images with more intensity than the Vivid setting.

DEEP

Sony says that this setting is intended to show the "solid presence" of the subject. In effect, it emphasizes the shadow tones and lowers the overall brightness of the image.

LIGHT

This setting is the opposite of Deep; it emphasizes the highlight tones and results in a brighter, lighter appearance.

PORTRAIT

The main feature of the Portrait setting is a reduction in the saturation and sharpness of colors to soften the appearance of skin tones. You might want to use this setting to take portraits that are flattering rather than harsh and realistic. Because this setting provides midrange values for the colors and contrast, some photographers find this to be their favored Creative Style setting for general photography.

LANDSCAPE

With the Landscape setting, the a7C increases all three values—contrast, saturation, and sharpness—to make the features of a landscape, such as trees and mountains, stand out with clear, sharp outlines. It is similar to Portrait in its processing of colors, but the sharper outlines and contrast might be too strong for portraits.

SUNSET

With the Sunset option, the camera increases the saturation to emphasize the red hues of the sunset. In my opinion, this setting produces more changes in color images than any of the others.

NIGHT SCENE

Night Scene lowers contrast in an attempt to soften the harsh effect that may result from shots taken in dark surroundings, without affecting the saturation or hues of the colors.

AUTUMN LEAVES

This setting, designed for enhancing shots of fall foliage, increases the intensity of existing red and yellow tones in the image, but does not alter the color balance or introduce new reddish shades, as the Sunset setting does.

B/W

This setting removes all color, converting the scene to black and white. Some photographers use this setting to achieve a realistic look for their street photography.

SEPIA

This second monochrome setting also removes the color from the image, but adds a sepia tone that gives an oldfashioned appearance to the shot.

I don't often use the Creative Style settings, because I prefer to shoot with the Raw format and process my images in software such as Photoshop. I occasionally use the Sunset setting to enhance an evening view. The Creative Style settings are of value to a photographer who needs to take numerous photographs with a certain appearance and process them quickly.

For example, a wedding or sports photographer may not have time to process images in software; he or she may need to capture hundreds of images in a particular visual style and have them ready for a client or a publication without delay. For this type of application, the Creative Style settings are invaluable. The settings also are useful for any photographer who wants to maintain a consistent appearance of his or her images and is not satisfied with how the JPEG files look when captured with the factory-standard settings.

Picture Effect

The Picture Effect menu option includes a variety of settings for shooting images or videos with in-camera special effects. The Sony a7C gives you several ways to add creative touches to your shots, and the Picture Effect settings can produce excellent results.

The Picture Effect settings are not available in Intelligent Auto mode and do not work with Raw images, Creative Style, DRO/Auto HDR, or Picture Profile in use. If you set a Picture Effect option and then select Raw (or Raw & JPEG) for Quality, the Picture Effect setting will be canceled. You cannot use the Rich-Tone Monochrome setting with continuous shooting or video recording. However, with a Picture Effect setting turned on, you still have control over many of the most important settings, including JPEG Image Size, white balance, ISO, and even, in most cases, drive mode. So, when you select a Picture Effect option, you are still free to control the means of taking your images as well as other aspects of their appearance.

To use these effects, select the Picture Effect menu option as seen in Figure 4-106, and scroll through the

choices at the left using the control wheel or the Up and Down buttons.

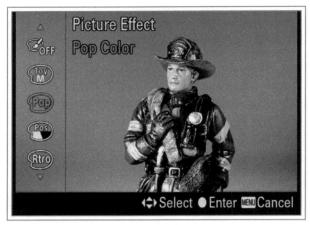

Figure 4-106. Picture Effect Menu Screen

Some selections have no other options, and some have sub-settings that you can make by pressing the Left and Right buttons or by turning the control dial when their icon is highlighted on the menu.

I will discuss each option in turn and then provide a chart showing the effects of each setting on the same subject.

Off

The top setting on the Picture Effect menu is used to cancel all Picture Effect settings. When you are engaged in ordinary picture-taking or video shooting, you should make sure the Off setting is selected so that no unwanted special effects interfere with your images.

Toy Camera

The Toy Camera option is an alternative to using one of the "toy" film cameras such as the Holga, Diana, or Lomo, which are popular with hobbyists and artists who use them to take photos with grainy, low-resolution appearances. With all of the Toy Camera settings, the a7C processes the image so it looks as if it were taken by a camera with a cheap lens: The image is dark at the corners and somewhat blurry.

The several sub-settings for Toy Camera, reached by pressing the Right and Left buttons or turning the control dial, act as follows:

Normal: No additional processing.

Cool: Adjusts color to the "cool" side, resulting in a bluish tint.

Warm: Uses a "warm" white balance, giving a reddish hue.

Green: Adds a green tint, similar to dialing in an adjustment on the green axis for white balance.

Magenta: Similar to the Green setting, but adjustment is along the magenta axis.

POP COLOR

This setting, according to Sony, is meant to give a "vivid look" through emphasis on bright colors. As you can see in Figure 4-107, this setting is another way to add "punch" and intensity, along with added brightness, to color images.

POSTERIZATION

This is a dramatic effect. Using the Right and Left buttons or the control dial when its icon is highlighted, you can choose to apply this effect in color or in black and white. In either case, the camera places extra emphasis on colors (or dark and light areas if you select black and white) and uses a high-contrast, pastellike look. It is somewhat like an exotic type of HDR processing. The number of different colors (or shades of gray) used in the image is decreased to make it look as if the image were created from just a few poster paints; the result has an unrealistic but dramatic effect, as you can see in Figure 4-107.

Remember that with all Picture Effect options, you can adjust other settings, including white balance, exposure compensation, and others. With Posterization, you might use exposure compensation, which can change the appearance of this effect dramatically. I have found the results with this setting often are improved by using negative exposure compensation to avoid excessive brightness. I recommend using Posterization to achieve a striking effect, perhaps for a distinctive-looking poster or greeting card.

RETRO PHOTO

With this setting, the a7C uses sepia tint and reduced contrast to mimic the appearance of an aging photo. This effect is not as pronounced as the sepia effects I have seen on other cameras; with the a7C, a good deal

of the image's original color still shows up, but there is subtle softening of the image with the sepia coloration.

SOFT HIGH-KEY

"High key" is a technique that uses bright lighting throughout a scene for an overall look with light colors and few shadows. With the a7C, Sony has added softness to give the image a light appearance without the harshness that might otherwise result from the unusually bright exposure.

Partial Color

The Partial Color effect lets you choose a single color to retain in an image; the camera reduces the saturation of all other colors to monochrome, so that only objects of that single hue remain in color in the image. I really enjoy this setting, which can be used to isolate a particular object with dramatic effect.

The choices for the color to be retained are red, green, blue, and yellow; use the Left and Right buttons or the control dial to select one of those colors. When you aim the camera at your subject, you will see on the display what objects will show up in color, if the Live View Display menu option is set to Setting Effect On.

There is no direct way to adjust the color tolerance of this setting, so you cannot, for example, set the camera to accept a broad range of reds to be retained in the image. However, if you change the white balance setting, the camera will perceive colors differently.

So, if there is a particular object that you want to depict in color, but the camera does not "see" it as red, green, blue, or yellow, you can try selecting a different white balance setting and see if the color will be retained. You also can fine-tune the white balance using the color axes to add or subtract these hues if you want to bring a particular object within the range of the color that will be retained.

By choosing a color that does not appear in the scene at all, you can take a straight monochrome photograph.

HIGH CONTRAST MONOCHROME

This setting lets you take black and white photographs with a stark, high-contrast appearance. You might want to consider this setting for street photography or any

other situation in which you are not looking for a soft or flattering appearance.

RICH-TONE MONOCHROME

With this option, the a7C takes a triple burst of shots at different exposures and combines them digitally into a single composite photo with a broader dynamic range than would otherwise be possible. Unlike the camera's Auto HDR setting, though, this one does not let you select the intensity of the effect, and it produces images in monochrome only. Because of its multiple-shot processing, this setting conflicts with some other settings, such as movie recording, continuous shooting, and the Bulb setting for shutter speed.

Figure 4-107 includes images of a firefighter figurine taken with each of the Picture Effect settings, to illustrate their characteristics.

Picture Effect Off Retro Photo Soft High Key Pop Color Posterization High Contrast Monochrome

Figure 4-107. Picture Effect Comparison Chart

Rich-tone Monochrome

Picture Profile

Picture Profile, the final item on the eleventh screen of the Camera Settings1 menu, provides powerful tools for adjusting the appearance of your files, particularly video footage. This option is similar in some ways to the Creative Style option, which provides a separate set of preset adjustments that affect image processing, as discussed earlier in this chapter. Like Creative Style, the Picture Profile option includes several presets from which you can easily choose the one that best suits your current needs and instantly apply it to all of the videos and images you record using that setting. You also can make adjustments to several parameters within any of the Picture Profile settings, just as you can with the Creative Style settings, and you can save the adjusted settings for future use.

However, apart from those similarities, the Picture Profile option is considerably different from the Creative Style feature. Creative Style is straightforward in the adjustments it provides, both in its 13 preset options (Standard, Vivid, Neutral, etc.) and in the adjustments you can make to those settings (contrast, saturation, and sharpness). It is easy to understand what is being adjusted for the presets and to see the resulting differences in the appearance of your images and videos.

The Picture Profile option does not provide such easily categorized adjustments. These adjustments are technical ones intended for use by experienced videographers, to produce footage that is ready for post-processing, or that matches footage from other cameras using the same profile.

In this section, I will explain how to apply a Picture Profile setting and how to adjust one, and I will discuss parameters that can be tweaked for each profile. I will not try to give a detailed explanation of all possible adjustments for the various settings involved, such as gamma, knee, and detail.

To use this setting, highlight Picture Profile on the menu screen and press the Center button to display the vertical menu of settings, as shown in Figure 4-108.

Use the control wheel, the control dial, or the Up and Down buttons to scroll through the eleven settings, including PP Off and PP1 through PP10.

If you don't need or want to bother with setting a profile, just leave this item set to PP Off and you won't have to deal with it further. To use one of the ten preset profiles, scroll to that setting and press the Center button to choose it. That profile will then be displayed in an icon in the lower left corner of the detailed shooting screen.

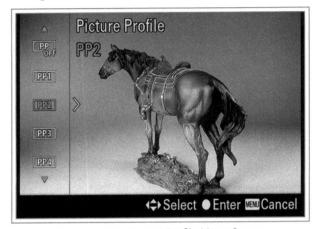

Figure 4-108. Picture Profile Menu Screen

The basic characteristics of the ten preset profiles that come with the camera are as follows:

PP1 Uses the standard gamma curve for movies.

PP2 Uses the standard gamma curve for still images.

PP3 Uses ITU709 gamma curve for natural color tone. The ITU709 standard is the normal set of specifications for HD television. This is a good profile to use for shooting that won't need extensive post-processing. This is also good for matching footage with that of other cameras.

PP4 Uses the ITU709 standard for color tone. Should not need much post-processing for color tone.

PP5 Uses Cine1 gamma curve to reduce contrast in dark areas and modify bright areas to produce a "relaxed" color effect. Good for sunny days and conditions with high contrast.

PP6 Uses Cine2 gamma curve, optimized for editing with up to 100% video signal; generally similar to Cine1, for use with less need for post-processing to avoid clipping highlights.

PP7 Uses S-Log2 gamma curve, designed to yield increased dynamic range, for footage that will be adjusted with post-processing software.

PP8 Uses S-Log3 gamma curve, which is similar to S-Log2 but has some technical differences. See the links in Appendix C for a discussion of the differences between those two settings. This profile has Color Mode set to S-Gamut3.Cine, as opposed to PP9, which has a different setting for Color Mode.

PP9 Uses S-Log3 gamma curve with Color Mode set to S-Gamut3.

PP10 Uses HLG2 gamma curve, which can be used as the basis for recording HDR footage or images.

You should be able to get good results for general footage with any of the first four Picture Profile settings. On a particularly bright day or in contrasty conditions, you might try PP5, which uses the Cine1 gamma, designed to compress the dynamic range to avoid clipping highlights, or PP6, which uses the Cine2 gamma, which compresses the range even more.

If you will be doing post-processing to correct the color of your footage, you may want to use PP7, PP8, or PP9, which use the S-Log2 or S-Log3 gamma curve settings. With any of these options, your footage will look dull and somewhat dark as shot, but its dynamic range will be considerably greater than normal, so you will have excellent options for producing good-looking footage with your post-processing software. However, because of the way these settings expand dynamic range, they require the use of an ISO setting of 500 or greater. So, if you use PP7, PP8, PP9, or any profile that includes S-Log2 or S-Log3 gamma, the camera will not set the ISO any lower than 500, and will reset a lower ISO value to 500. (There also are some limits on ISO settings available with a few other gamma settings, but those limits are not as severe as for the S-Log settings.)

If you want to record HDR video footage, you can use PP10, which includes a gamma setting of HLG2. For HDR recording, the Picture Profile setting has to include a gamma setting of HLG1, HLG1, HLG2, or HLG3. PP10 is provided as a preset option that is ready to use for HDR recording. Or, you can modify it to use one of the other HLG settings for gamma.

The chart in Figure 4-109 shows the effects of the ten preset Picture Profile settings, as well as the same image with no Picture Profile in place, to give a general idea of how these settings affect an image.

As you can see, PP7, PP8, and PP9, which use S-Log2 or S-Log3 gamma, and PP10, which uses HLG2 gamma, produce a dark image on the camera's display. When you are using any of those four settings, you can activate the Gamma Display Assist feature, which sets the camera's display to a higher level of contrast, so you can compose your shot accurately. That feature is found on screen 1 of the Setup menu. You also can assign it to a control button using the Custom Key (Still Images) or Custom Key (Movies) option on screen 9 of the Camera Settings2 menu, as discussed in Chapter 5.

Picture Profile Comparison Chart

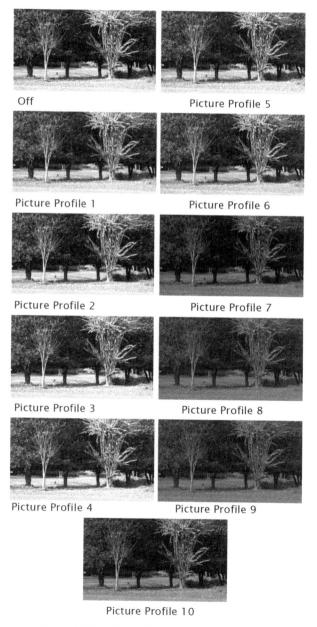

Figure 4-109. Picture Profile Comparison Chart

If you are serious about video production, you may not be content with any of the ten preset Picture Profile settings. You can easily modify any of them in the camera. I don't recommend that you do this unless you are knowledgeable about video production, but the option is available. I will discuss the mechanics of how to adjust the various parameters for the Picture Profile settings, but I will not engage in a technical discussion of when and why to adjust them. (Appendix C has links to resources with further information.)

To adjust a Picture Profile setting, first highlight the Picture Profile menu option and press the Center button to display the menu of Picture Profile options, as shown in Figure 4-108. Scroll to the one you want to adjust and press the Right button. You will then see a screen like that in Figure 4-110, listing the first six parameters that can be adjusted: black level, gamma, black gamma, knee, color mode, and saturation.

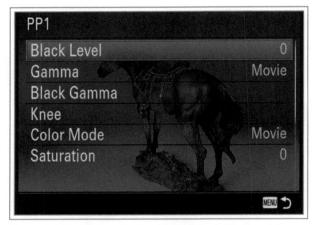

Figure 4-110. Picture Profile - Parameter Adjustment Screen

Turn the control wheel or dial, or press the Up and Down buttons, to scroll through this list and on to the remaining parameters: color phase, color depth, and detail. The last two options, copy and reset, are for copying the settings or restoring the default settings.

When you have highlighted a parameter to adjust, such as gamma, press the Right button or the Center button to bring up the adjustment screen, as shown in Figure 4-111.

Use the control wheel or dial or the Up and Down buttons to choose the value to set, and press the Center button to set the value and return to the previous screen. Continue scrolling through the parameters to set each as you want it. Once you have made the adjustments, the

Picture Profile number you adjusted will retain those changes, even if the camera is turned off and back on. If you want to copy the settings from one Picture Profile slot to another, use the copy item near the bottom of the list of parameters. Use the reset option to restore the Picture Profile setting to its default values.

Figure 4-111. Picture Profile Adjustment Screen for Gamma

Following are general descriptions of the nine parameters that you can adjust for each Picture Profile setting:

Black Level. Default 0; adjustment from -15 to +15. Adjusting in the negative direction strengthens the black color in the image; adjusting in the positive direction fades or weakens it.

Gamma. No default. Choices are Movie, Still, Cine1, Cine2, Cine3, Cine4, ITU709, ITU709 (800%), S-Log2, S-Log3, HLG, HLG1, HLG2, or HLG3. The gamma curve is an adjustment to the video signal to account for the difference between recorded video and the output characteristics of various display devices, such as cathode ray tubes, HDTVs, etc. The first two choices are self-explanatory. Cine1 has the signal compressed to avoid clipping of highlights; Cine2 is compressed further for the same purpose. Cine3 increases contrast between light and dark areas. Cine4 is similar to Cine3, but increases contrast more intensely. The ITU709 setting is a standard one for HDTV. The ITU709 (800%) option provides greater dynamic range than ITU709. It applies standard contrast and color levels to the video signal and turns off the knee circuit. It can be used as the finished product for video production. You may need to use this standard or S-Log2 when recording to certain external recorders. The S-Log2 standard, which provides greater-than-normal dynamic range, produces a flat, somewhat dark signal. This standard is for use when you will adjust the appearance of the video file with post-processing software. S-Log3 is similar to S-Log2 with some technical differences; see Appendix C for further information. The HLG options are variations of an industry standard setting known as Hybrid Log-Gamma. These settings are designed to provide a wider dynamic range than other settings, in a way similar to the function of the HDR setting for still images. HLG is the basic setting. Each of the other three options provides additional dynamic range, but also introduces more possibility of visual noise in the scene because of the use of lesser amounts of noise reduction. As noted earlier, PP10 includes the HLG2 setting by default.

Black Gamma. Range default is Middle; can be set to Wide or Narrow. Level default is 0; can be set from -7 to +7. Increasing Level brightens the image and decreasing Level darkens it. Adjusting Range determines whether the Level adjustment affects only blacks (Narrow) or a wider range of grays. The black gamma value is fixed at 0 when gamma is set to HLG, HLG1, HLG2, or HLG3.

Knee. The knee adjustment sets a curve for compressing the signal in the brightest parts of the video image to avoid clipping or washing out of highlights. The Mode can be set to Auto or Manual. If you select Auto, then you need to use the Auto Set option to choose the Max Point and Sensitivity. If you choose Manual, you need to use the Manual Set option to set the Point and Slope.

Color Mode. No default. Can be set to Movie, Still, Cinema, Pro, ITU709 Matrix, Black & White, S-Gamut, S-Gamut3.Cine, S-Gamut3, BT.2020, or 709. Movie is designed for use with the Movie setting for Gamma; Still for the Still setting; Cinema for the Cine1 or Cine2 setting; Pro for the gamma curve of Sony professional video cameras; ITU709 Matrix for use with the ITU709 gamma curve; Black & White for shooting in monochrome; S-Gamut for shooting with the S-Log2 gamma curve; S-Gamut3.Cine and S-Gamut3 for use with the S-Log3 gamma curve. BT.2020 and 709 are the only color mode settings available when gamma is set to HLG, HLG1, HLG2, or HLG3. If you select the Black & White setting, the video will be shot in black and white.

Saturation. Default 0. Can be set from -32 to +32. This adjustment is similar to the saturation adjustment available with the Creative Style menu option. A negative setting lowers the intensity of colors, reducing

them almost completely to black and white at the -32 level, while a positive value increases their intensity.

Color Phase. Default 0. Can be set from -7 to +7. Adjusting in the negative or positive direction makes the colors shift their hues. You can use this setting to match the color output of the a7C to that of another camera you are using for video production.

Color Depth. Default 0. Can be set from -7 to +7 for each of six colors: red, green, blue, cyan, magenta, and yellow. A higher number makes the color darker and richer; a lower number makes it brighter and paler.

Detail. There are two main settings: Level and Adjust. Level has a default of 0 and can be adjusted from -7 to +7. This setting affects the sharpness of edges in the image. A lower number softens the image and a higher number gives it sharper contrast. The other main setting, Adjust, has several settings, starting with Mode, which can be set to Auto or Manual. If you set Mode to Auto, you can ignore the other settings. If you set it to Manual, you can adjust V/H Balance, B/W Balance, Limit, Crispening (misspelled on the camera's menu), and Hi-Light Detail. Sony's user's guide recommends changing only the Level setting, at least at first, but the guide provides details on the other settings. You can see those details at Sony's website, http://helpguide.sony. net/di/pp/v1/en/index.html. If you are planning to use software to process your video, you may want to reduce Level to -7 so you can determine the proper amount of sharpening on your own.

The good news about the Picture Profile setting is that you do not need to worry about it if you don't want to. If you are shooting primarily still images or videos for your own use, you don't have to select any Picture Profile setting. However, if you are using the a7C for professional video production, perhaps as a second camera, you may need to set the Picture Profile so the camera's output will match that of your other cameras.

Picture Profile cannot be used when DRO/HDR, Creative Style (other than Standard), or Picture Effect is in use. Picture Profile settings affect Raw files, but the black level, black gamma, knee, and color depth settings are not reflected in Raw images.

As indicated earlier, some settings for gamma restrict the ability to use the lower ISO settings. With ITU709 (800%), S-Log2, and S-Log3, the lowest ISO available is

500. With Cine4, the lowest ISO available is 200. With HLG and HLG3, the lowest setting available is 125. If you want to explore Picture Profile in greater detail, check out the resources listed in Appendix C.

Screen 12 of the Camera Settings1 menu, with its single item, is shown in Figure 4-112.

Figure 4-112. Screen 12 of Camera Settings1 Menu

Shutter Auto White Balance Lock

This option lets you control whether or not the camera locks white balance while the shutter is pressed halfway down, or during continuous shooting, when white balance is set to Auto White Balance or Underwater Auto White Balance. The reason for using this option is to avoid having the camera alter the white balance setting during a series of shots because of flickering of the lights, a cloud passing over the sun, or some other unexpected circumstance.

The available settings are Shutter Halfway Down, Continuous Shooting, or Off. If you choose the first option, the camera locks white balance when you press the shutter halfway down, and keeps it locked as long as the shutter stays in that position. In addition, the camera locks white balance during continuous shooting.

With the second setting, the camera locks white balance only during continuous shooting. With the third setting, the camera does not lock white balance, and may adjust it at any time before the image is captured.

Another way to lock white balance using Auto White Balance is to assign AWB Lock Hold or AWB Lock Toggle to a control button, using the Custom Key (Still Images) option on screen 9 of the Camera Settings2 menu. If you use that approach, you can keep white balance locked

for as long as you hold down the assigned button, or, if you use the AWB Lock Toggle option, until you press the assigned button a second time to release the lock.

The items on screen 13 of the Camera Settings1 menu are shown in Figure 4-113.

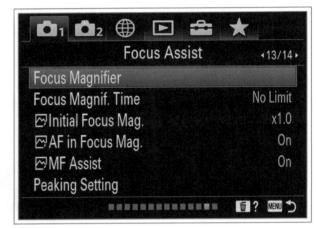

Figure 4-113. Screen 13 of Camera Settings1 Menu

Focus Magnifier

The Focus Magnifier option gives you a way to enlarge a small portion of the display so you can check the focus of that area. It is useful primarily when using manual focus or direct manual focus (DMF), but it can also be used when focus mode is set to AF-S or AF-A. It cannot be used when focus mode is set to AF-C. This option works somewhat differently when recording movies, as discussed later in this section. For this discussion, I'm assuming the Initial Focus Magnification menu option, discussed later in this section, is set to x1.0.

When you select this menu option, the camera places an orange frame on the display, as seen in Figure 4-114.

Figure 4-114. Focus Magnifier Frame on Shooting Screen

You can move the frame to any position on the display using the direction buttons, the control wheel, or the control dial. When the frame is over the area where you want to check focus, press the Center button. The camera will then enlarge the area within the frame to 5.9 times normal, as shown in Figure 4-115. (The enlargement factor is different when shooting movies; see discussion below.)

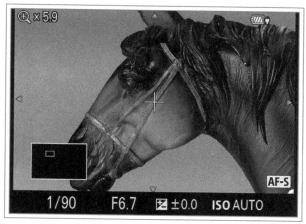

Figure 4-115. Focus Magnifier Screen Magnified to 5.9x

An inset square will show the position of the Focus Magnifier frame. You can continue to move the frame around the screen while the display is enlarged, and you can return the frame to the center of the display by pressing the Custom/Delete button. Press the Center button again, and the focus area will be magnified to 11.7 times normal. A final press will restore the display to normal size and dismiss the magnifier frame. (If you have the APS-C/Super 35mm option set for using an APS-C type of lens, the magnification amounts are 3.8 and 7.7, rather than 5.9 and 11.7.)

When you have activated the Focus Magnifier frame, you can also move it around the screen by dragging it with your finger, if the Touch Operation features are turned on through screen 2 of the Setup menu. The dragging action works in any focus mode, including autofocus. When the camera is set to manual focus mode, you can activate Focus Magnifier at the x5.9 magnification factor just by tapping twice quickly on the screen. Then you can drag the magnified area around the screen; tap twice quickly again to dismiss the magnification.

The Focus Magnifier option can be a bit confusing because it acts in a similar way to another option, which is activated from an item further down on the same menu screen, called MF Assist. As I will discuss later in this chapter, when you turn on MF Assist with manual focus in effect when using a full-frame lens, the focus area is enlarged to 5.9 times normal as soon as you start turning the focus ring to adjust the focus. Then, once the focus area is enlarged with that option, pressing the Center button will magnify the focus area to 11.7 times normal. You can toggle between the 5.9 and 11.7 magnifications using the Center button, and exit to the shooting screen by half-pressing the shutter button. (The magnification amounts are different if the APS-C/Super 35 option is active, as discussed above.)

In other words, if the MF Assist menu option is active, pressing the Center button magnifies the focus area once you have started to adjust focus in manual focus mode. If you select the Focus Magnifier menu option, the difference is that pressing the Center button magnifies the display before you start focusing.

The advantage of using the Focus Magnifier menu option is that you can select the position of the enlarged focus area before you start adjusting focus. If you use the MF Assist option, the camera will enlarge the display as soon as you start turning the lens ring to adjust focus, and you will not be able to choose the location of the enlarged focus area until the display is already enlarged.

The MF Assist option works well for me, because it operates as soon as I start adjusting focus. However, if you prefer to be able to adjust the location of the frame for the enlarged focus area before starting to adjust focus, the Focus Magnifier option is useful.

In addition, as noted earlier, you can use Focus Magnifier even with autofocus (though not with continuous autofocus). The way Focus Magnifier operates in autofocus modes depends on the setting for the AF in Focus Magnifier menu option, three items below Focus Magnifier on the same menu screen. If that option is set to On, when you activate Focus Magnifier in an autofocus mode, the screen stays magnified so you can evaluate the focus and, if necessary, move the focus point around and continue to re-focus until you have the scene focused exactly how you want it. The screen will remain magnified until you press the shutter button all the way down to take the picture.

If, on the other hand, you set AF in Focus Magnifier to Off, when you use Focus Magnifier in an autofocus

mode, the magnification stops as soon as you press the shutter button halfway down to evaluate focus.

The Focus Magnifier feature is easier to use if you assign it to one of the control buttons. For example, you can use the Custom Key (Still Images) option on screen 9 of the Camera Settings2 menu to assign Focus Magnifier to the Left button. Then, you can just press that button to bring the enlargement frame up on the display. You can quickly adjust the position of the frame, press the Center button once or twice to enlarge that area, and then adjust the focus and take the picture.

You can adjust the length of time the screen stays enlarged with this feature by using the Focus Magnification Time option, discussed immediately below. I prefer to set the time to No Limit so the magnification lasts as long as I need it. You also can set the Focus Magnifier option to use an initial magnification factor of x1.0 or x5.9 using the Initial Focus Magnification item, discussed below.

As noted above, Focus Magnifier works slightly differently for movies than for still images. If you assign this option to a control button, you can call it up while recording a movie to check the focus of the area within the frame. The only magnification factor for shooting movies is x4.0, rather than x5.9 and x11.7 (or 3.8 and 7.7, for APS-C shooting), the factors for still images.

Focus Magnification Time

This option lets you select how long the display stays magnified when you use either the Focus Magnifier option, discussed above, or the MF Assist option, discussed later in this chapter. The choices are two or five seconds or No Limit. The default option is No Limit. With that setting, the image will stay magnified until you press the shutter button all the way to take the picture, or press it halfway to dismiss the enlarged view. When using MF Assist, the time limit of two or five seconds starts once you stop adjusting focus with the focus ring. My preference is to use the No Limit option, so I can take my time in adjusting manual focus precisely, even if I stop turning the ring.

Initial Focus Magnification

This menu option lets you select either x1.0 or x5.9 as the initial magnification factor for the Focus Magnifier frame when it first appears on the screen. (As noted earlier, the initial factor is x1.0 or x3.8 if you have the APS-C/Super 35mm menu option on screen 1 of the Camera Settings1 menu set to APS-C/Super 35mm.)

If you select the default of x1.0 for this menu option, the Focus Magnifier frame will appear on the display with no magnification until you press the Center button. The first press magnifies the area within the frame to 5.9 times, and a second press magnifies it to 11.7 times; a third press removes the frame from the display. If you select x5.9 for this option, the frame will appear with the 5.9 times magnification already in effect. (As noted above, the factors are different when shooting with the APS-C crop setting turned on.)

Note: If you use the In-Camera Guide help system, which is permanently assigned to the Custom/ Delete button, and press that button when this menu item is highlighted, the help system says that this option controls the initial magnification for the Focus Magnifier option and for the MF Assist option. However, this option controls the initial magnification only for the Focus Magnifier option. The MF Assist screen always displays initially at the x5.9 (or x3.8) magnification, regardless of the setting for this option.

AF in Focus Magnifier

I discussed this option in connection with the Focus Magnifier option, above. This option determines whether the Focus Magnifier screen remains magnified while you use autofocus to adjust focus, or not. If this option is turned off, the screen reverts to its non-magnified display as soon as you press the shutter button halfway down to evaluate focus. If the option is turned on, you can adjust autofocus multiple times by pressing the shutter button halfway, even while the Focus Magnifier screen retains its magnification. When this option is in effect, the camera places a black plus sign in the center of the screen, to indicate the point where autofocus will be directed. This option lets you direct the focus to an area smaller than what is possible with the Flexible Spot setting for focus area.

MF Assist

The MF Assist option is available to assist with focusing when manual focus or DMF is in use. When MF Assist

is turned on in manual focus mode, the a7C enlarges the image on the display screen to 5.9 times normal size as soon as you start turning the focusing ring on the lens, as shown in Figure 4-116.

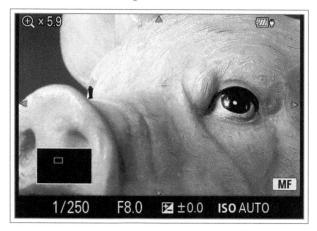

Figure 4-116. MF Assist Screen at 5.9x Magnification

To increase magnification to 11.7 times, press the Center button; press that button again to return to the 5.9 times enlargement factor. Press the shutter button halfway down to return the image to normal size. This feature is helpful in judging whether a particular area is in sharp focus. If you turn this option off, you can use another focusing aid, such as Focus Magnifier, discussed above, or Peaking, discussed immediately below. (As noted earlier in connection with the Focus Magnifier discussion, the magnification factors are 3.8 and 7.7 when you have the APS-C/Super 35mm menu option set for shooting with an APS-C lens.) Or, you can use this option and Peaking at the same time, to provide even more assistance.

When DMF is in effect, you have to keep the shutter button pressed halfway down while turning the focusing ring to use the MF Assist enlargement feature.

As discussed above in connection with the Focus Magnifier option, when the camera is in manual focus mode, you can tap twice on the screen to magnify the image to 5.9 times normal, and drag the magnified area around the screen with your finger; tap twice again to return the size to normal.

I find MF Assist helpful, especially when I set the camera to leave the enlarged screen in place indefinitely using the Focus Magnification Time option, discussed earlier in this chapter. However, the Focus Magnifier option also is helpful, and may be preferable in one way because the screen does not become magnified until

you select the area to be magnified using the orange frame and press the Center button to magnify the screen. (You can change that behavior with the Initial Focus Magnification menu option, discussed above.)

In some cases, where a subject (like the moon) does not have clear edges or other features to focus on, enlarging the view may not be that much help. In those situations, Peaking may be more useful. Or, you may find that using Peaking in conjunction with MF Assist is the most useful approach of all. You should experiment with the various options to find what works best for you.

MF Assist is not available when recording movies or when using a lens with a Mount Adaptor. You can use Focus Magnifier in those situations. While recording movies, Focus Magnifier would have to be assigned to a control button, because you cannot get access to the menu system during the recording process.

Peaking Setting

The Peaking Setting menu option controls the use of the Peaking display to assist with manual focus. When Peaking is turned on with focus mode set to manual focus or DMF, the camera displays bright pixels at areas where focus is sharp, to help you adjust focus. The Peaking Display option controls whether the Peaking feature is activated or not; the Peaking Level option controls the intensity of the display; and Peaking Color determines the color of the pixels that are displayed.

You can set the level to Low, Mid, or High and the color to red, yellow, blue, or white. Figures 4-45 and 4-46 illustrated this feature earlier in this chapter.

The idea is that these areas of bright pixels provide a more definite indication that the focus is sharp than just relying on your judgment of sharpness. Some photographers set Creative Style to black and white while focusing so the Peaking color will stand out, and some set Peaking Level to Low so the color is not overwhelming, letting them see when the color just starts to appear. Some turn on MF Assist to enlarge the screen when using Peaking. You should experiment to find what approach works best for you.

Peaking also works with DMF, even if you are using the autofocus function of that setting.

The items on screen 14 of the Camera Settings1 menu are shown in Figure 4-117.

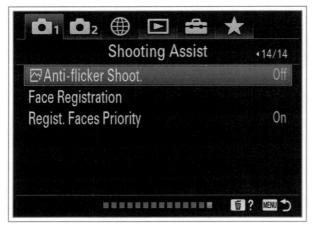

Figure 4-117. Screen 14 of Camera Settings 1 Menu

Anti-Flicker Shooting

This option can be turned either on or off. When it is turned on, the camera detects flickering from artificial lights, if the frequency of the flickering is either 100 Hz or 120 Hz (that is, 100 or 120 cycles per second). When the shutter button is pressed halfway down, the camera checks for such flickering. If it detects flickering, it attempts to time its shots so as to reduce the impact of flickering on the colors or tones of the images.

This setting can cause lag in the operation of the shutter and some degradation of the live view on the display screen, so I recommend leaving it turned off unless you are shooting under fluorescent lights or other sources of potential flicker, and see a need for this setting. It is not available when shutter speed is set to Bulb; when Silent Shooting is turned on; or in Movie mode.

Face Registration

This next option on screen 14 of the Camera Settings1 menu lets you register human faces so the a7C can give those faces priority when it uses face detection. You can register up to eight faces and assign each one a priority from one to eight, with one being the highest. The camera will try to detect the registered faces in the order you have assigned them, if you have turned on the Face Priority in AF option under the Face/Eye AF Settings item on screen 5 of the Camera Settings1 menu, and you have turned on the Registered Faces Priority option, which is directly below Face Registration on screen 14 of the menu. This feature

could be useful if, for example, you take pictures at school functions and you want to make sure the camera focuses on your own children rather than on other kids.

To use this setting, select this menu option, and on the next screen, select New Registration. Press the Center button, and the camera will place a square on the screen. Compose a shot with the face to be registered in that frame, as shown in Figure 4-118, and press the shutter button to take a picture of the face. If the process succeeds, the camera will display the face with the message "Register face?" Highlight the Enter bar on that screen and press the Center button to complete the registration process.

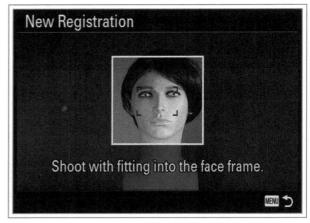

Figure 4-118. Screen to Register Face

Later, you can use the Order Exchanging option to change the priorities of the registered faces, and you can delete registered faces using other menu options.

Registered Faces Priority

When you activate this menu option, the camera searches for faces that you have previously registered using the Face Registration option, discussed above. If the camera detects a registered face, it should consider that face to have priority, in which case it will place a white frame on the face and adjust the focus for that face. If there are multiple faces, some of which are registered, the camera should place a white frame over the one with the highest priority and purple frames over registered faces with lower priorities. For this option to be available, you have to have Face/Eye Priority in AF turned on under the Face/Eye AF Settings option on screen 5 of the Camera Settings1 menu, and you also have to have Subject Detection set to Human on that menu.

Chapter 5: The Camera Settings2 Menu

The second menu that is represented by a camera icon deserves a separate chapter, because its settings are not just a continuation of those on the Camera Settings1 menu. The Camera Settings2 menu contains all of the camera's settings that directly affect video recording, such as video file formats, audio recording options, and the like. This menu also includes a number of settings that affect still photography as well as video recording, such as options for Digital Zoom and switching between the LCD screen and viewfinder. Each of these items is discussed below. However, I do not discuss in this chapter the details of options that are strictly used for video recording. I will mention those items below, but I will discuss them in more detail in Chapter 9, where I discuss movie making. Screen 1 of this menu is shown in Figure 5-1.

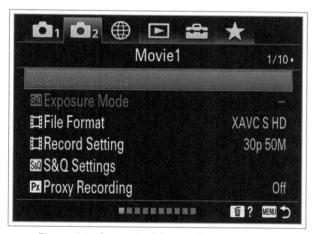

Figure 5-1. Screen 1 of Camera Settings2 Menu

Exposure Mode (Movies)

This first menu item on this screen is available for selection only when the mode dial is set to Movie mode (the position marked by a movie-film icon). It lets you select one of the four available exposure settings for recording movies in that mode: Program Auto, Aperture Priority, Shutter Priority, or Manual Exposure. The Movie mode is for recording movies at normal speeds,

as opposed to the different frame rates used for slow-motion and fast-motion movies recorded in the S & Q mode. I will discuss this option in Chapter 9.

Exposure Mode (S & Q)

This second item on the Camera Settings2 menu is another mode-specific one. It is available for selection only when the mode dial is set to S & Q, for slow and quick motion movie recording. This option lets you choose one of the four exposure modes for recording slow-motion or fast-motion movies, which are similar to the modes mentioned above for Movie mode. I will discuss those settings, as well as other aspects of S & Q Motion recording, in Chapter 9.

File Format (Movies)

This next option applies only for normal-speed movies, which can be recorded in any shooting mode other than S & Q. I will discuss the details of this setting in Chapter 9. For now, you should know that the only two options available are XAVC S HD and XAVC S 4K, both of which yield high-quality video files. The 4K setting provides higher resolution than the HD setting, and results in larger files, which need greater computer resources for processing.

Record Setting

This option is related to the File Format option, discussed above. I will discuss the details of this option in Chapter 9. The available settings are different depending on whether you choose XAVC S 4K or XAVC S HD for File Format. They also will be different if you have set the NTSC/PAL selector, on screen 2 of the Setup menu, to PAL, the TV system used in much of Europe and some other locations. In this book, I will discuss the video options that are applicable for the

NTSC system, as used in the United States, Japan, and elsewhere.

S & Q Settings

This menu option controls the settings for S & Q Motion mode, which enables slow and quick video recording, when the mode dial is set to the S & Q position. I will discuss this option and other aspects of S & Q Motion recording in Chapter 9.

Proxy Recording

This option can be used to set the camera to record a smaller-sized video file at the same time as a high-quality version, so you can share the smaller file quickly or use it for proxy editing. I will discuss this option in Chapter 9.

The items on screen 2 of the Camera Settings2 menu are shown in Figure 5-2.

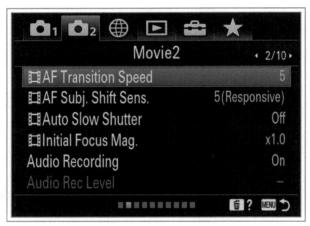

Figure 5-2. Screen 2 of Camera Settings2 Menu

AF Transition Speed

This option controls the speed at which the camera's autofocus system changes focus when recording video. I will discuss it in Chapter 9.

AF Subject Shift Sensitivity

This option, located after AF Transition Speed on the menu, controls how quickly the autofocus system tracks a moving subject when recording video. I will discuss it in Chapter 9.

Auto Slow Shutter

This option lets the camera automatically set a slower shutter speed than normal when shooting a movie, in order to compensate for dim lighting. I will discuss this option in Chapter 9.

Initial Focus Magnification (Movies)

This option is similar to the Initial Focus Magnification item for still images, which was discussed in Chapter 4. This option sets the magnification factor to either x1.0 or x4.0 when you are using the Focus Magnifier option for recording movies. As discussed in Chapter 4, the magnification factor for movies is different from that for still images, so this separate menu option is needed in order to set the initial magnification for movies.

Audio Recording

The Audio Recording item on the Camera Settings2 menu can be set either on or off. If you are certain you won't need the sound recorded by the camera, then you can turn this option off. I never turn it off, because I can always turn down the volume of the recorded sound when playing the video. Or, if I am editing the video on a computer, I can delete the sound and replace it as needed—but there is no way to recapture the original audio from the camera after the fact if this option was turned off during the recording.

Audio Recording Level

This option is available for selection only when the mode dial is set to Movie mode. If you record movies by pressing the Movie button in any other shooting mode, the camera will set the level for recording sound, and you cannot control it. If the mode dial is set to Movie mode, you can control the sound level using this menu option. I will discuss its use in Chapter 9.

The items on screen 3 of the Camera Settings2 menu are shown in Figure 5-3.

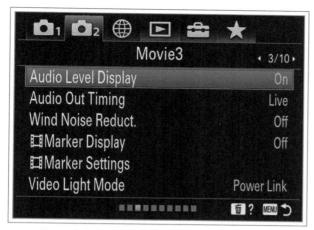

Figure 5-3. Screen 3 of Camera Settings2 Menu

Audio Level Display

This option controls whether audio level meters appear during movie recording in any shooting mode and before recording a video when the camera is set to Movie mode. The meters have green indicators that extend to the right to indicate increases in the volume of audio, as shown in Figure 5-4.

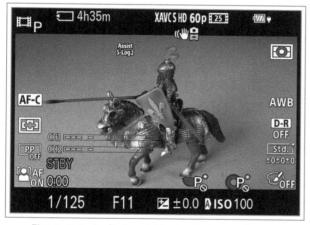

Figure 5-4. Audio Level Display Meters on Screen

The meters appear on detailed information screens; if this option is on and you don't see the meters when recording a video, press the Display button to call up one of the other screens. Also, check to see if the Audio Recording option, discussed above, is turned on; if that option is turned off, the meters will not be displayed. I generally leave this option turned on; seeing the movement of the audio levels on the meters reassures me that the audio is being recorded successfully.

Audio Out Timing

This option controls how audio is output to the headphones jack when you are monitoring audio while recording a video. It can be set to either Live or Lip Sync. With the Live setting, the camera outputs the sound immediately, without delay. With Lip Sync, the camera delays the output of audio slightly, to synchronize the audio and video. The Lip Sync setting is worth trying if you are experiencing a problem with synchronization of the audio and video when monitoring a video recording.

Wind Noise Reduction

This option also is one that applies only to movies. I will discuss it in Chapter 9.

Marker Display

This option, which can be turned either on or off, determines whether or not various informative guidelines, called "markers," are displayed on the camera's screen for movie recording. I will discuss the details of this option in Chapter 9.

Marker Settings

This menu option works together with the Marker Display option, discussed above. This option lets you activate any or all of the four available markers—Center, Aspect, Safety Zone, and Guideframe. I will discuss this setting in Chapter 9.

Video Light Mode

This menu option is of use only when the camera has a compatible video light attached to the Multi Interface Shoe. Because that accessory is primarily of use when recording video clips, I will discuss it in Chapter 9.

The single option on screen 4 of the Camera Settings2 menu is shown in Figure 5-5.

Figure 5-5. Screen 4 of Camera Settings2 Menu

Movie w/Shutter

This only option on screen 4 of the Camera Settings2 menu can be turned either on or off. If it is turned on, you can start and stop movie recording by pressing the shutter button when the camera is set to Movie mode, or to S & Q Motion mode, for slow and quick motion movies. I will discuss this option in Chapter 9.

The options on screen 5 of the Camera Settings2 menu are shown in Figure 5-6.

Figure 5-6. Screen 5 of Camera Settings2 Menu

Silent Shooting (Still Images)

This option gives you a convenient way to silence the sounds of the camera's operation when capturing still images by activating the electronic shutter rather than the mechanical shutter. It is available only in the four PASM modes. This option turns off the sound of the shutter operating, but it does not silence the beep that is emitted when the camera achieves sharp autofocus.

If you want to silence that sound also, go to the Audio Signals option on screen 9 of the Camera Settings2 menu.

When you activate Silent Shooting, you cannot use the flash, Auto HDR, Picture Effect, Picture Profile, Long Exposure NR, or the Bulb setting for shutter speed. However, it gives you access to the 1/8000 second setting for shutter speed, which is not available otherwise.

This feature is useful for continuous shooting in an environment where the steady clicking of the shutter might attract attention or startle your subject, such as when capturing images of birds or pets.

Release without Lens

This menu option lets you enable the camera to release its shutter when no lens is attached. This feature is needed, for example, if you are shooting images or video with the camera attached to a telescope or other device other than a lens that has standard contacts through which it communicates with the camera. If you are using a device that does not have those contacts, the camera will not sense that any lens is attached, and ordinarily will not allow the shutter to be operated. In that case, set this option to On, so the shutter will operate even without a standard lens attached.

Release without Card

This option can be set to either Enable or Disable. If it is set to Enable, you can operate the camera's shutter release button even if there is no memory card inserted in the camera. In that case, the camera will display a NO CARD warning message, but it will let you operate the shutter and an image will be saved temporarily. This setting is useful if the camera is on display in a retail store, so customers can operate the controls and see how a saved image would look, without having to have an expensive memory card left in the camera. As I noted in Chapter 1, there is no way to save an image to the camera's memory with no memory card present, although in an emergency you may be able to send the image through the HDMI port to a video capture device, and you may be able to send images wirelessly to a smart device.

If you select Disable for this item, the NO CARD warning is still displayed. In addition, if you try to press the shutter button, the camera will display a warning message advising that the shutter cannot be operated with no memory card inserted, as shown in Figure 5-7. This setting is the safest one to use, because it protects you against operating the camera when there is no card inserted to save images or videos.

Figure 5-7. Warning Message for Pressing Shutter with No Card

Note, though, that if you have the camera connected to a computer using the PC Remote feature with Sony's Imaging Edge software, you can capture images with the camera through the software controls, even if there is no card in the camera and Release without Card is set to Disable. In that situation, you have to go to the PC Remote Function option on screen 1 of the Network menu, then go to screen 2 of that menu option and set the Still Image Save Destination to PC Only. If that option is set to PC + Camera, you cannot capture images using Sony's Imaging Edge software with no memory card installed in the camera. Remote shooting is discussed in Chapter 10.

SteadyShot

SteadyShot is Sony's optical image stabilization system, which compensates for small movements of the camera to avoid motion blur, especially during exposures of longer than about 1/30 second. This stabilization is built into the body of the a7C camera, which is an important feature for hand-held photography. The inclusion of stabilization in the body is called in-body image stabilization, or IBIS.

The SteadyShot menu setting is turned on by default, and I recommend leaving it on at all times, except when

the camera is on a tripod. In that case, SteadyShot is not needed, and there is some chance it can "fool" the camera and cause it to try to correct for motion that does not exist, resulting in image blur.

You may at times use a Sony lens that has optical stabilization built into it, with the designation OSS, for Optical SteadyShot, included in its name. When you are using a lens of that type, the camera senses the OSS, and the IBIS and OSS coordinate their stabilization techniques in many cases. In some cases, though, particularly when using a lens that has a switch to control OSS, you have to use that switch to control stabilization; the menu option is disabled on the camera. That is the case, for example, with the Sony FE 100mm-400mm f/4.5-5.6 GM OSS lens.

SteadyShot Settings

The sub-settings for this menu option are available for adjustment only when the previous option, SteadyShot, is turned on. This option is for use when you are using a lens with SteadyShot built into it. As noted above, those lenses have the OSS designation, for Optical SteadyShot. This option has two possible settings: Auto or Manual. With Auto, the camera obtains information from the lens and sets the stabilization automatically based on that information. With Manual, you have to enter information about the focal length of the lens in use. For a zoom lens, you need to check the zoom scale or otherwise obtain this information. I always leave this option set to Auto unless there is a specific reason to use Manual.

The options on screen 6 of the Camera Settings2 menu are shown in Figure 5-8.

Figure 5-8. Screen 6 of Camera Settings2 Menu

Zoom

The Zoom menu option is provided to give you a way to zoom the lens beyond the normal optical focal length range, when the lens attached to the camera is not a PZ (power zoom) lens. For example, if you have a prime (non-zoom) lens, such as the Sony FE f/2.8 50mm Macro lens, attached to the a7C, there is no way to zoom the lens itself. However, the camera has the ability to zoom the lens electronically to focal lengths beyond the normal focal length of the lens, using the Clear Image Zoom, Digital Zoom, and Smart Zoom features.

So, if you are using a lens of that sort, you can use the Zoom menu option to "zoom" the lens electronically, but only if one or more of those three non-optical zoom settings is enabled. (ClearImage Zoom, Digital Zoom, and Smart Zoom are discussed below, in connection with the Zoom Setting menu option.)

The Zoom menu option also can be used when you are using a zoom lens that is not a PZ lens, such as the Sony FE 28mm-60mm kit lens. That lens can be zoomed manually using its zoom ring, but the zoom ring will not zoom it beyond its optical zoom limit of 60mm.

If you are using a PZ lens, you can use the zoom lever on the lens to zoom the lens beyond the optical zoom range. With that sort of lens, the Zoom menu option is dimmed and unavailable for selection.

Assuming one or more of the non-optical zoom settings is active and you are using a prime lens or a non-PZ zoom lens, you can use the Zoom menu option to carry out the actual zooming of the lens beyond the optical zoom range. There are several ways to do this. First, you can highlight this menu option and select it by pressing the Center button. You will then see the screen shown in Figure 5-9, with a zoom scale in the lower right corner.

The initial view will show a magnifying glass icon at the left and a zoom factor of 1.0 at the right. To enlarge the view through the lens, press the Right button or turn the control wheel or control dial to the right. To reduce the zoom factor, press the Left button or turn the wheel or dial to the left.

As soon as you start to zoom the lens, the icon at the left of the scale will change. If you are using Smart Zoom (based on the JPEG Image Size setting), the letter S will appear. If you are using Clear Image Zoom,

a C will appear. If you are using Digital Zoom, a D will appear. In addition, the zoom factor will change at the right of the scale as the zoom level increases or decreases. If you are using S for Image Size and have Digital Zoom turned on, the maximum zoom level available is 8.0 times normal.

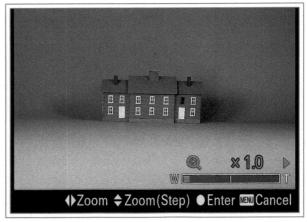

Figure 5-9. Zoom Scale when Zoom Menu Option is in Use

An easier way to use the Zoom menu option is to assign it to a control button. As discussed later in this chapter, using the Custom Key (Still Images) option on screen 9 of the Camera Settings2 menu, you can assign this option any one of several buttons. If you do that, then, when you press the assigned button, the zoom screen appears and you can proceed to zoom the lens using the Right and Left buttons or the control wheel or control dial. (The Left or Right button will still change the zoom factor of the lens, even if it has been assigned to activate the Zoom function. It is convenient to assign the Right button to the Zoom option, so you can press the button to turn on Zoom, and then keep pressing that button to increase the zoom factor.)

Another way to use the Zoom option is to use the Sony RMT-P1BT, a Bluetooth remote control that includes a zoom control. You can press that control to zoom the lens, assuming the non-optical zoom function is currently available because of the Zoom Setting menu option or the Image Size setting on the a7C. You then do not have to use any controls on the camera, such as the Left and Right buttons or the control wheel or dial; just use the zoom control on the remote, once the remote is paired with the camera via Bluetooth. You also can use the Sony GP-VPT2BT, a combination grip and Bluetooth remote control grip that includes a zoom button. Both of those accessories are discussed in Appendix A.

It's important to remember that the Zoom menu option is useful only for zooming the lens in its non-optical zoom range. If you are using a zoom lens, you need to use the lens's normal zooming control to zoom it within its optical zoom range.

Zoom Setting

The next option on screen 6 of the Camera Settings2 menu, Zoom Setting, provides two ways to give the a7C extra zoom range, using features called Clear Image Zoom and Digital Zoom. To explain these features in context, I will discuss all three zoom methods the camera can use, depending on the lens that is attached—optical zoom, Clear Image Zoom, and Digital Zoom. (I will also discuss a fourth feature related to these, called Smart Zoom.)

Optical zoom is the camera's "natural" zoom capability—moving the lens elements so they magnify the image, just as binoculars do. You can call optical zoom a "real" zoom because it increases the amount of information that the lens gathers. The optical zoom of the a7C depends on what lens is attached. If a prime lens, with only a single focal length such as 50mm, is attached, then the lens has no optical zoom ability. If a zoom lens is attached, the optical zoom capability is stated in the model designation of the lens. For example, my camera came with a kit lens, the Sony 28mm-60mm zoom lens; it has an optical zoom capability of 60mm.

The Digital Zoom feature on the a7C magnifies the image electronically without any special processing to improve the quality. This type of zoom does not really increase the information gathered by the lens; rather, it just increases the apparent size of the image by enlarging the pixels within the area captured by the lens.

The other option on the a7C, Clear Image Zoom, is a special type of digital zoom developed by Sony. With this feature, the a7C does not just magnify the area of the image; rather, the camera uses an algorithm based on analysis of the image to add pixels through interpolation, so the pixels are not just multiplied. The enlargement is performed in a way that produces a smoother, more realistic enlargement than the Digital Zoom feature. Therefore, with Clear Image Zoom, the camera achieves greater quality than with Digital Zoom, though not as great as with the "pure" optical zoom.

Finally, there is another way the a7C can have a zoom range greater than the normal range of an attached lens, with no reduction in image quality. The standard optical zoom range (if any) is available when JPEG Image Size is set to Large. However, if JPEG Image Size is set to Medium or Small, the camera needs only a portion of the pixels on the image sensor to create the image at the reduced size. It can use the "extra" pixels to enlarge the view of the scene. This process, which Sony calls Smart Zoom, is similar to what you can do using editing software such as Photoshop. If the final image does not need to be at the Large size, you can crop out some pixels from the center (or other area) of the image and enlarge them, thereby retaining the same final image size with a magnified view of the scene.

So, with Smart Zoom, if you set JPEG Image Size to M or S, the camera can zoom to a greater range than with Image Size set to L and still retain the full quality of the optical zoom. You will, of course, end up with lower-resolution images, but that may not be a problem if you are going to post them on a website or share them via email.

In short, optical zoom provides the best quality for magnifying the scene; Clear Image Zoom gives excellent quality; and Digital Zoom produces magnification accompanied by deterioration of the image. Smart Zoom lets you get greater zoom range with no image deterioration, but at the expense of resolution.

Here is how to use these settings. I will assume for now that you are leaving JPEG Image Size set to L, because that is the best setting for excellent results in printing and editing your images. I also will assume that you are using a lens with some optical zoom capability.

As I discussed in connection with the Zoom menu option, above, the a7C uses the non-optical zoom range of a lens differently for different types of lenses. With a PZ (power zoom) lens, you can press the zoom lever on the lens to get access to all parts of the zoom range, both optical and non-optical. With any other type of lens, you have to use the Zoom menu option or a compatible remote control device to get access to the non-optical areas of zoom.

When you select the Zoom Setting menu option and press the Center button, the camera displays the screen shown in Figure 5-10, giving you the choice of Optical Zoom Only; On: Clear Image Zoom; or On: Digital

Zoom. If you turn on Digital Zoom, Clear Image Zoom will automatically be activated also. Optical Zoom is always available, no matter what settings are used, if you are using a lens that has an optical zoom range.

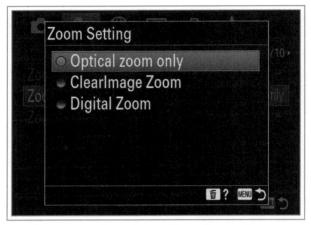

Figure 5-10. Zoom Setting Menu Options Screen

If you turn on only Clear Image Zoom, you will have greater zoom range than normal, as discussed above, with minimal quality loss. If you also turn on Digital Zoom, you will get even greater zoom range, but quality will suffer as the lens is zoomed past the Clear Image Zoom range. When these various settings are in effect, you will see different indications on the camera's display, though the types of indications you see will vary according to the type of lens you are using.

For Figures 5-11 through 5-15, I used the 28mm-60mm kit lens, with JPEG Image Size set to L and with Clear Image Zoom and Digital Zoom turned on. With this sort of lens, which does not have power zoom capability, the camera does not ordinarily display a zoom scale indicator when using optical zoom only. However, when you activate the Zoom menu option, with one or more of the non-optical zoom options in effect, the camera displays the zoom scale. For these illustrations, I activated the Zoom option so the zoom scale is visible at the bottom of the camera's display.

In Figure 5-11, for which I set the optical zoom at 60mm, the zoom indicator at the bottom of the screen has not moved at all, indicating that the lens is still within the optical zoom range.

In Figure 5-12, Clear Image Zoom is in use, using the same lens. The lens can be zoomed up to two times the normal range, as seen in this example, where the lens is zoomed to 1.8 times the optical zoom range.

The magnifying glass icon with the "C" above the scale means Clear Image Zoom is turned on.

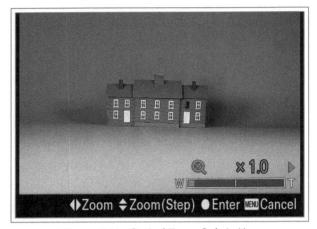

Figure 5-11. Optical Zoom Only in Use

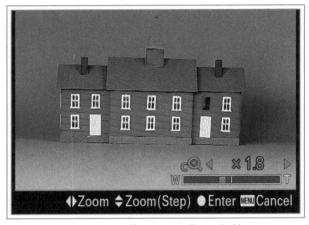

Figure 5-12. Clear Image Zoom in Use

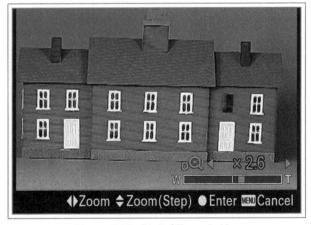

Figure 5-13. Digital Zoom in Use

In Figure 5-13, Digital Zoom is in use and the lens has been zoomed to 2.6 times the optical zoom range. The magnifying glass icon above the scale has a "D" beside it, indicating that Digital Zoom is now in effect.

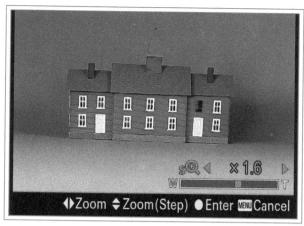

Figure 5-14. Smart Zoom in Use

With a JPEG Image Size setting smaller than Large, the camera will display an S to show that it is using Smart Zoom, as the zoom range extends beyond the standard optical zoom range (if you are using a lens that has an optical zoom capability).

For example, in Figure 5-14, using the 28mm-60mm kit lens (with no power zoom) with JPEG Image Size set to Small, the lens is zoomed in to 1.6 times the optical range, and the zoom indicator displays an S to indicate that Smart Zoom is in effect. With image sizes smaller than Large, the ranges of Clear Image Zoom and Digital Zoom also are expanded.

My preference is to limit the camera to optical zoom (when using a zoom lens) and thereby avoid any deterioration. However, many photographers have found that Clear Image Zoom yields good results, and it is worth using when you cannot get close to your subject. I do not like to use Digital Zoom to take a picture. However, it can be useful to zoom in to meter a specific area of a distant subject, or to check the composition of your shot before zooming back out and taking the shot using Clear Image Zoom or optical zoom.

Smart Zoom, Clear Image Zoom, and Digital Zoom are not available in connection with some other settings, including Raw images, Face/Eye AF settings, tracking focus, metering modes other than Multi, Face Priority in Multi Metering, and Scene Recognition in Intelligent Auto mode. Smart Zoom is not available for recording movies.

When the lens is zoomed in to the range of Clear Image Zoom or Digital Zoom and autofocus is in use, the focus area menu option is disabled and the camera uses a broad focus frame, which is represented by a dotted area like that seen in Figure 5-15.

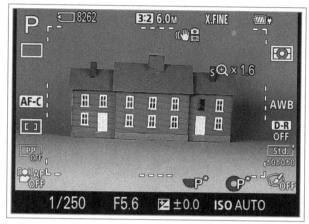

Figure 5-15. Dotted Focus Area for Non-optical Zoom

Zoom Ring Rotate

This menu option is available for use only when the attached lens has power zoom capability and supports this function. If it is available, it lets you reverse the direction of rotation for zooming in and out. Sony lenses with power zoom capability have PZ in their model names, such as the E PZ 18-105mm f/4 G OSS. However, not all PZ lenses are compatible with this menu option. For example, it is not possible to use the Zoom Ring Rotate feature with the E PZ 16-50mm f/3.5-5.6 OSS lens, which is a standard kit lens for the a6000 series of APS-C camera models.

The items on screen 7 of the Camera Settings2 menu are shown in Figure 5-16.

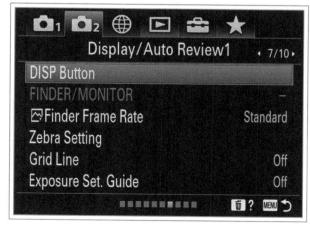

Figure 5-16. Screen 7 of Camera Settings 2 Menu

Display Button

This option lets you choose what screens appear in shooting mode as you press the Display button. There are sub-options for the monitor (LCD) and viewfinder, as seen in Figure 5-17.

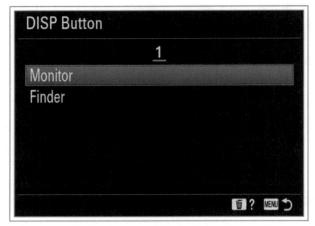

Figure 5-17. Display Button Main Menu Options Screen

You can make different choices for the LCD screen and viewfinder, so pressing the Display button when you are using the monitor may bring up different screens than when you are using the viewfinder. After you decide to choose screens for the monitor or the viewfinder, you will see a screen like that shown in Figure 5-18.

This screen shows the six display screens you can select for the monitor, as well as a seventh choice, Monitor Off. The selection screen for the viewfinder is similar to this one, except that the sixth and seventh choices, For Viewfinder and Monitor Off, are not available.

The For Viewfinder screen is designed to display shooting information on the monitor when you are viewing the live view through the viewfinder, so it would not be useful when you are using the viewfinder. The Monitor Off setting also is intended for use when you are using the viewfinder and don't need to see additional shooting information on the monitor. The screen displaying just the image with no information is not shown here, nor is the screen with the monitor turned off. Using that option does not turn off the monitor for playback mode, only for shooting mode.

Figure 5-19 shows the screen with the Graphic Display in the lower right corner; that display is supposed to illustrate the use of faster shutter speeds to stop action and the use of wider apertures to blur backgrounds. I

find it distracting and not especially helpful, but if it is useful to you, by all means select it.

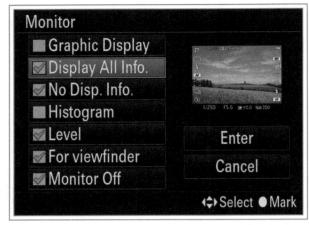

Figure 5-18. Display Screen Selection Options for Monitor

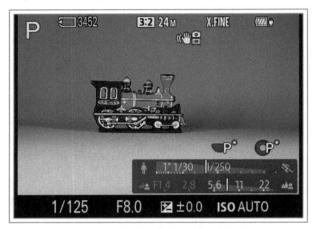

Figure 5-19. Graphic Display Screen

I find the Display All Information screen, shown in Figure 5-20, to be cluttered, but it has useful information. You can always move away from this screen by pressing the Display button (if there is at least one other display screen available), and I like to have it available for times when I need to see what settings are in effect.

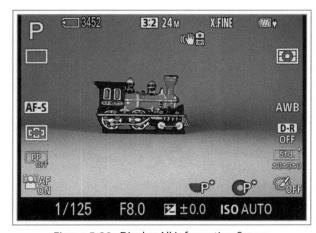

Figure 5-20. Display All Information Screen

The third option, displaying only the image, is not shown here. That display is useful for focusing and composing your shots. I always include it in the cycle of screens.

Figure 5-21. Histogram Screen

The fourth screen, shown in Figure 5-21, displays the histogram. This shooting-mode histogram, unlike the one displayed in playback mode, shows only basic exposure information with no color data. However, it gives you an idea of whether your image will be well exposed, letting you adjust exposure compensation and other settings as appropriate while watching the live histogram on the screen. If you can make the histogram display look like a triangular mountain centered in the box, you are likely to have a good result.

You should try to keep the body of the histogram away from the right and left edges of the graph, in most cases. If the histogram runs into the left edge, that means shadow areas are clipping and details in those areas are being lost. If it hits the right edge, you are losing details in highlights. If you have to choose, it is best to keep the graph away from the right edge because it is harder to recover details from clipped highlights than from clipped shadows.

The fifth available display screen, shown in Figure 5-22, includes the a7C's level, which is a useful tool for leveling the camera both side-to-side and front-to-back. Watch the small orange lines on the screen; when the outer two ones have turned green, the camera is level side-to-side; when the inner two lines are green, the camera is level front-to-back.

The sixth choice, shown in Figure 5-23, which is available only for the monitor, is called For Viewfinder. This option does not include the live view in shooting

mode. Instead, it displays a black screen with detailed information about the camera's settings, so you can check your settings after (or before) you look at the live view in the viewfinder.

Figure 5-22. Level Screen

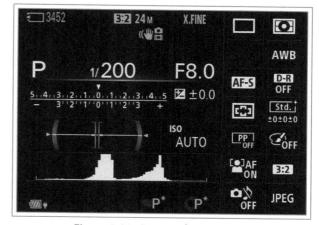

Figure 5-23. For Viewfinder Screen

In addition, as I will discuss in Chapter 6, this screen includes the Quick Navi system. When you press the Function button, the settings on the screen become active. You can navigate through the settings using the direction buttons and adjust them using the control wheel and the control dial.

The For Viewfinder screen does not display when the camera is set to Movie mode or S & Q Motion mode.

The seventh choice, Monitor Off, is available only for the monitor. It produces a completely blank screen.

Once you select the Display Button option and choose whether to select screens for the monitor or viewfinder, you can scroll through the seven (monitor) or five (viewfinder) choices using the control wheel, control

dial, or direction buttons. When a screen you want to have displayed is highlighted, press the Center button to put an orange check mark in the box to the left of the screen's label, as seen earlier in Figure 5-18.

You can also press that button to unmark a box. The camera will let you uncheck all seven of the items (or all five for the viewfinder), but if you do that, you will see an error message as you try to exit the menu screen. You have to check at least one box so that some screen will display when the camera is in shooting mode. (Though you can select only the Monitor Off option, and the camera will not display any error message.)

After you select from one to seven screens for the monitor and from one to five for the viewfinder, highlight the Enter block and press the Center button. Then, whenever the camera is in shooting mode, the selected screens will be displayed; you cycle through them by pressing the Display button (Up button). If you have selected only one screen, pressing the Display button will have no effect in shooting mode when the live view is displayed.

If you select only the one screen that includes the live view but no shooting information, the camera will still display the shutter speed, aperture, exposure compensation, and ISO; all of those values are displayed on a line at the bottom of the screen. In Movie mode and S & Q Motion mode, the camera will also display the counter or other video tracking indicator, as well as the REC/STBY indicator.

Finder/Monitor

This next option, shown in Figure 5-24, lets you choose whether to view shooting, menu, and playback displays on the a7C's LCD screen or in the viewfinder.

The viewfinder provides the same information as the LCD screen, but its display is viewed inside an eye-level window that is shaded from daylight, giving you a clear view of the shooting, playback, and menu screens.

By default, this menu option is set to Auto, which means the camera switches to the viewfinder automatically when you move your head near the eye sensor to the right of the viewfinder. The camera turns on the viewfinder display and blacks out the LCD.

If you prefer to use either the viewfinder or the LCD screen at all times, set this menu option to Viewfinder (Manual) or Monitor (Manual), according to your preference. With either of those settings, the camera will not switch to the other method of viewing unless you go back to this menu option and change the setting. You also can assign a control button to the Finder/Monitor Select option, using the Custom Key (Still Images) or Custom Key (Movies) option on screen 9 of the Camera Settings2 menu. Then you can just press the assigned button to switch between the LCD and the viewfinder.

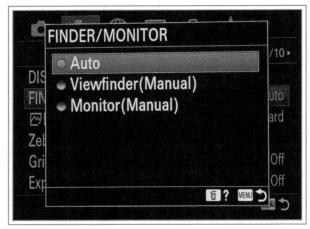

Figure 5-24. Finder/Monitor Menu Options Screen

For me, the Auto option works well, and I rarely change that setting. But if you will be using the LCD while working with your head (or another object) very close to the camera's viewfinder, you might want to use the Monitor (Manual) option so the screen does not blank out unexpectedly.

Finder Frame Rate

This option lets you set the rate at which the electronic viewfinder's screen refreshes when you are shooting still images. If you set this option to High, the motion of subjects in the viewfinder may appear smoother, but the resolution (number of megapixels in the display) is lowered to compensate for the increased frequency of the refreshing. The Standard setting is the normal choice, and it provides sufficient speed for most purposes. The value is fixed at Standard during playback, when an HDMI cable is connected to the camera, and when the camera's temperature has risen to a certain point.

Zebra Setting

This next Camera Settings2 menu option gives you a tool for measuring the exposure level of an image or video when you are composing your shots. This menu item has two sub-options, Zebra Display and Zebra Level, as shown in Figure 5-25.

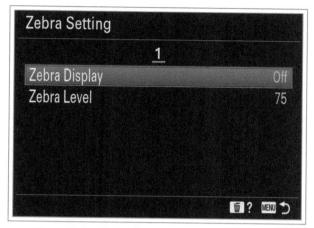

Figure 5-25. Zebra Setting Menu Options Screen

Zebra Display can be turned either on or off, to determine whether the Zebra stripes are displayed on the shooting screen. The Zebra Level option can be set to a value from 70 to 100 IRE in five-unit increments, or 100+ for values greater than 100. The IRE units are a measure of relative brightness or exposure, with 0 representing black and 100 representing white.

You also can save and later use two custom values, C1 and C2, as discussed below. Figure 5-26 shows the screen for selecting values up to 90.

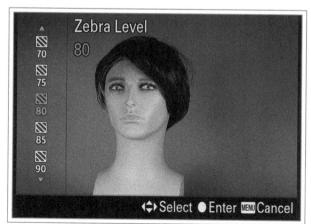

Figure 5-26. Screen to Select Zebra Setting Value

When you turn Zebra Display on at any level, you very likely will see, in some parts of the display, the black-

and-white "zebra" stripes that give this feature its name.

Zebra stripes originally were created as a feature for professional video cameras, so the videographer could see whether the scene would be properly exposed. This tool often is used in the context of recording an interview, when proper exposure of a human face is the main concern.

There are various approaches to using these stripes. Some videographers like to set the zebra function to 90 IRE and adjust the exposure so the stripes barely appear in the brightest parts of the image. Another recommendation is to set the option to 75 IRE for a scene with Caucasian skin, and expose so that the stripes barely appear in the area of the skin.

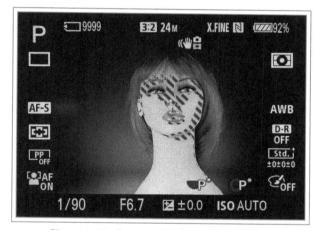

Figure 5-27. Screen with Zebra Set to IRE 75

In Figure 5-27, I set IRE to 75 and exposed to have the stripes appear clearly on the mannequin's face and neck.

As the brightness of the lighting increases for a subject, there may be no stripes at first, then they will gradually appear until they cover the subject, then they will seem to disappear, because the exposure is so bright that the subject is surrounded by an outline of "marching ants" rather than having stripes in its interior.

If you want to save customized values for Zebra, you can save settings to the C1 and C2 slots. A standard way to use these two values is to set C1 to a value for exposure confirmation and C2 to a value for flare confirmation.

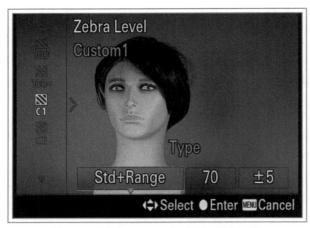

Figure 5-28. Screen to Set Zebra Value C1

To set C1 for exposure confirmation, select Zebra Level, scroll down to the C1 block and press the Right button. You will see a screen like that in Figure 5-28, with the Std+Range block highlighted in orange. (Press the Up or Down button or turn the control wheel or control dial if necessary to bring that label into the block.)

With the Std+Range block highlighted, press the Right button to move to the next block, and use the Up and Down buttons or the control wheel or dial to set a value, which can be from zero to 109, in one-unit increments. Then press the Right button to move to the next block and select a range, which can be from ± 1 to ± 10 .

For example, you might set the first block to 77 and the second block to ± 5 , so the Zebra pattern would appear when the brightness of the scene was within five units of 77, plus or minus. You could then set Zebra to C1 to confirm that the scene's exposure is within that range.

To set the C2 value for flare confirmation, scroll down to that block and press the Right button. Make sure the highlighted block contains the Lower Limit label, as shown in Figure 5-29.

Then press the Right button to move to the second block and select a setting from 50+ to 109+ in one-unit increments. That value represents the brightness level that you don't want to exceed. You can then set Zebra to the C2 block and check the scene to make sure the lighting stays within that limit, to avoid flare. The Zebra pattern will appear if that limit is exceeded.

Zebra is a feature to consider, especially for video recording, but the a7C has an excellent metering system, including both live and playback histograms, so

you can manage without this option if you don't want to deal with its learning curve.

Figure 5-29. Screen to Set Zebra Value C2

Grid Line

With this option, you can select one of four settings for a grid to be superimposed on the shooting screen. By default, there is no grid. If you choose one of the grid options, the lines will appear in your chosen configuration whenever the camera is showing the live view in shooting mode, whether the detailed display screen is selected or not. Of course, the grid does not appear when the For Viewfinder display, with its black screen full of shooting information, is displayed. The four options are seen in Figure 5-30.

Figure 5-30. Grid Line Menu Options Screen

Here are descriptions of these choices, other than Off, which leaves the screen with no grid.

RULE OF THIRDS GRID

This arrangement has two vertical lines and two horizontal lines, dividing the screen into nine blocks, as shown in Figure 5-31.

Figure 5-31. Rule of Thirds Grid in Use on Shooting Screen

This grid follows a rule of composition that calls for locating an important subject at an intersection of these lines, which will place the subject one-third of the way from the edge of the image. This arrangement can add interest and asymmetry to an image.

SOUARE GRID

With this setting, the grid has five vertical lines and three horizontal lines, dividing the display into 24 blocks. In this way, you can still use the Rule of Thirds, but you have additional lines available for lining up items, such as the horizon or the edge of a building, that need to be straight.

DIAGONAL PLUS SQUARE GRID

The last option gives you a square grid of four blocks in each direction and adds two diagonal lines.

The idea is that placing a subject or, more likely, a string of subjects along one of the diagonals can add interest to the image by drawing the viewer's eye into the image along the diagonal line.

Exposure Settings Guide

This option places a display on the screen to simulate one or two sliding bands showing the settings for aperture, shutter speed, or both. The display varies according to the shooting mode. In Program mode, the bands move to display the current aperture and shutter speed when you activate Program Shift. In Shutter Priority, Aperture Priority, and Manual exposure modes, and in Movie mode or S & Q Motion mode when the exposure mode is set to Shutter Priority, Aperture Priority or Manual Exposure, a single band displays the shutter speed or aperture as you adjust it. In Manual mode, the bands show aperture and shutter speed when you use Manual Shift. In other shooting modes, this menu option has no effect. Figure 5-32 shows the display when shutter speed is being adjusted.

Figure 5-32. Exposure Settings Guide for Shutter Speed

I find this display distracting so I leave it turned off, but it might be useful to see this large display to let you know what value is being set, in some circumstances.

The items on screen 8 of the Camera Settings2 menu are shown in Figure 5-33.

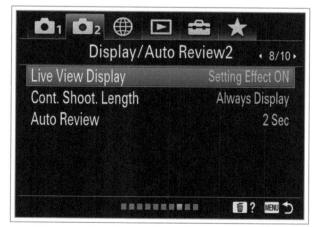

Figure 5-33. Screen 8 of Camera Settings2 Menu

Live View Display

This menu option can be important for getting results that match your expectations. It lets you choose whether or not the camera displays the effects that certain settings will have on your final image, while you are composing the image.

When you select this option, you will see two suboptions on the next screen: Setting Effect On and Setting Effect Off, as shown in Figure 5-34.

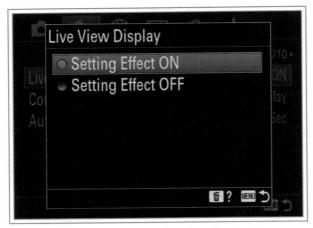

Figure 5-34. Live View Display Menu Options Screen

If you select Setting Effect On, then, when you are using Program, Aperture Priority, Shutter Priority, or Manual exposure mode, the camera's display in shooting mode will show the effects of exposure compensation, white balance, Creative Style, and Picture Effect, with some limitations. In addition, it will show the effects of exposure changes in Manual exposure mode and other advanced modes, to some extent.

In some cases, it may be helpful to see what effect a particular setting will have on the final image, and in other cases that feature might be distracting or might even make it difficult to take the shot.

For example, when you are setting white balance, it can be helpful to see how the various options will alter the appearance of your final images. If you have selected Setting Effect On, then, as you scroll through the white balance menu options, you will instantly see the effect of each setting, such as Daylight, Cloudy, Shade, and Incandescent. That change in the display is not distracting; it is actually very informative.

However, if you are using the Picture Effect option and experimenting with a setting such as Posterization,

which drastically alters the appearance of your images, you might find it difficult to compose the image with Setting Effect On selected.

There is one particular use for the Live View Display menu option that I find very useful. On occasion, I use the a7C to trigger external, non-Sony flash units, with the camera set to Manual exposure mode. For some of these shots, I use settings such as f/16.0, 1/200 second, and ISO 100. This shot will be exposed properly with the flash units I am using, but, with Setting Effect On selected, the camera's screen is quite dark as I compose the shot. That is because the camera's programming does not account for the fact that flash units will be fired.

If I use the Setting Effect Off setting, then the camera displays the scene using the available ambient light, ignoring the exposure settings I have made. In this way, I can see the scene on the camera's display in order to compose the shot properly.

The Setting Effect On option, though, can be useful when using Aperture Priority, Shutter Priority, or Manual exposure mode when you are shooting in unusually dark or bright conditions, because the camera's display screen will change its brightness to alert you that a normal exposure may not be possible with the current settings. (You should see the aperture, shutter speed, M.M., ISO, or exposure compensation value flashing to alert you to this situation, also.)

With the Picture Effect setting of Rich-tone Monochrome, if you choose Setting Effect On, the live view will be in black and white, but it will not show the full effect of the setting. You can see the full effect of that setting in playback mode, after you have captured an image using the setting.

When Setting Effect Off is selected, the camera will display a VIEW icon on the screen, as shown in Figure 5-35, to remind you that the camera's display is not showing the effects of all your settings.

My recommendation is to leave this option at Setting Effect On unless you are faced with a situation in which it is difficult to compose a shot, either because the display is too dark or light, or because a setting such as Picture Effect interferes with your ability to view the subject clearly.

In the Intelligent Auto, S & Q Motion, and Movie modes, this option is forced to Setting Effect On and cannot be changed.

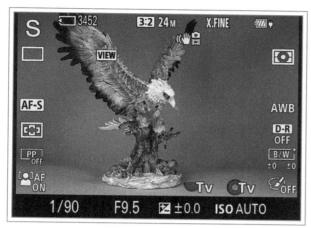

Figure 5-35. VIEW Icon on Display When Setting Effect is Off

Continuous Shooting Length

This option lets you turn on or off a graphic indicator that shows a rough estimate of how long the camera can perform continuous (burst) shooting of still images with the current settings for continuous shooting, under the drive mode options.

As shown in Figure 5-36, this indicator is a narrow white bar placed vertically at the left side of the display. Once you start holding down the shutter button to trigger a burst of shots, the bar starts to turn black, starting at the top. It turns black progressively further down the bar as the capacity for further continuous shooting decreases. If the bar turns completely black, continuous shooting will slow down drastically and the word SLOW will appear on the display near the bottom of the black bar.

I have not found this display to be particularly helpful for ordinary shooting, because I can tell from the speed of the shutter sounds when continuous shooting is starting to slow down. However, if you have turned on Silent Shooting through the option on screen 5 of the Camera Settings2 menu, this display can be helpful to warn you when continuous shooting will be slowed down or stopped.

This option has three possible settings: Always Display, Shoot-Only Display, or Not Displayed. With Always Display, the indicator appears on the screen whenever drive mode is set to continuous shooting. With Shoot-

Only Display, it is displayed only when continuous shooting is actually in progress. With Not Displayed, it is never displayed.

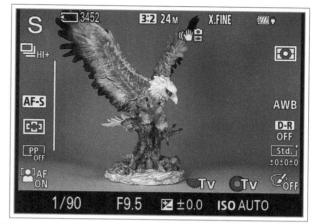

Figure 5-36. Continuous Shooting Length Indicator on Display

Auto Review

The Auto Review option, shown in Figure 5-37, sets the length of time that an image appears on the display screen immediately after you take a still picture.

The default is to have Auto Review turned off, or you can set the time to two, five, or ten seconds. If it is turned off, the camera returns to shooting mode as soon as it has saved a new image to the memory card. When this option is in use, you can always return to the live view by pressing the shutter button halfway. The Auto Review option does not apply to movies; the camera does not display the beginning frame of a movie that was just recorded until you press the Playback button.

Figure 5-37. Auto Review Menu Options Screen

While the new image is being displayed, you can use the various functions of playback mode, such as enlarging

the image, bringing up index screens, moving to other images, or pressing the Delete button to delete the image. If you start one of these actions before the camera has reverted to shooting mode, the camera will stay in playback mode until you return it to shooting mode.

The items on screen 9 of the Camera Settings2 menu are shown in Figure 5-38.

Figure 5-38. Screen 9 of Camera Settings2 Menu

Custom Key (Still Images)

As I will discuss in Chapter 6, several of the camera's control buttons and dials can have their functions changed through menu options. In particular, seven buttons on the camera and one button on the lens (if the lens has a Focus Hold button) can each be assigned to carry out one operation when the button is pressed in shooting mode. The Custom Key (Still Images) menu option is the mechanism for assigning these operations to buttons for shooting still images; there are other options for movies and playback, discussed later in this chapter.

When you select this option, you will see the screen shown in Figure 5-39, which shows graphically the first six buttons that can be assigned; the other two controls are listed on later screens of this menu option.

Move through the three main screens of this menu item using the control dial or the Right and Left buttons. When you have reached the screen that includes the button you want to assign to a function, use the Up and Down buttons or the control wheel to navigate to the line for that button. For example, Figure 5-39 shows the first screen, with the line for the AF-ON button

highlighted. The current assignment for the highlighted control, in this case, AEL Toggle, is listed on that line.

Figure 5-39. Custom Key (Still Images) Main Options Screen

Figure 5-40. Screen Showing Possible Assignments for AF-ON Button

With the line for the AF-ON button highlighted, press the Center Button. You will see one of several screens (for this button, 27 screens) that list all the options that can be assigned to that button, as shown in Figure 5-40. You can scroll quickly from screen to screen using the Left and Right buttons or the control dial; once you have located the screen with the feature you want to assign, you can scroll within that screen using the Up and Down buttons or the control wheel. Scroll to the feature you want to assign to the selected button and press the Center button. An orange dot will appear to the left of the assignment and the button will now control that operation in shooting mode when the camera is set to a mode for shooting still images. If you want more information about an item that can be assigned to a button, press the Custom/Delete button

while the item is highlighted, and the camera will display a help screen that explains the feature.

In most cases, the available assignments are self-explanatory. When you assign an option, such as ISO, to a button, pressing the button calls up the menu screen for ISO, which lets you set the ISO just as if you had selected ISO (under ISO Setting) on the Camera Settings1 menu. However, there are differences for some options, and there are some items that can be assigned through this menu option that are not available for selection on any other menu. I will discuss these details below, as I provide information about each of the items for this menu option.

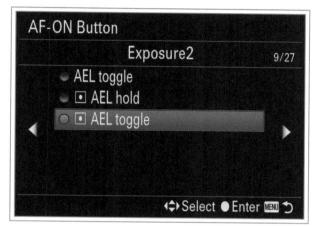

Figure 5-41. One Screen of Options for AF-ON Button

AF-ON BUTTON

If you select the AF-ON Button from the Custom Key (Still Images) menu screen, the camera will display a screen like that shown in Figure 5-41, one of 27 screens of options that can be assigned to this button. This button is assigned by default to Tracking On + AF On, but it can be assigned to any one of the following items instead:

The complete list includes the following choices:

- File Format (Still Images)
- [°] JPEG Quality
- JPEG Image Size
- Aspect Ratio
- APS-C S35/Full Frame Select
- Drive Mode

- Self-timer During Bracket
- Interval Shooting
- Memory
- Recall Custom Hold 1
- Recall Custom Hold 2
- Recall Custom Hold 3
- Focus Mode
- AF/MF Control Hold
- AF/MF Control Toggle
- Focus Standard
- Focus area
- Switch focus area
- Register AF Area Hold
- Register AF Area Toggle
- Register AF Area + AF On
- Tracking On
- Tracking On + AF On
- Face/Eye Priority in AF
- Eve AF
- Subject Detection
- Switch Right/Left Eye
- Face/Eye Frame Display Select
- AF Tracking Sensitivity (Still Images)
- Aperture Drive in AF
- Switch AF Frame Move Hold
- AF On
- Focus Hold
- Exposure Compensation
- ISO
- ISO Auto Minimum Shutter Speed

0	Metering Mode	۰	Frame Rate (S & Q Motion)
0	Face Priority in Multi Metering	٥	AF Transition Speed (Movies)
0	AEL Hold	٥	AF Subject Shift Sensitivity (Movies)
0	AEL Toggle	0	Audio Recording Level
0	Spot AEL Hold	0	Audio Level Display
0	Spot AEL Toggle	0	Marker Display Select
0	Flash Mode	0	Silent Shooting
0	Flash Compensation	0	SteadyShot
0	Wireless Flash	0	SteadyShot Adjustment
0	Wireless Test Flash	0	SteadyShot Focal Length
0	FEL Lock Hold	0	Zoom
0	FEL Lock Toggle	0	Aperture Preview
0	FEL Lock/AEL Hold	0	Shot Result Preview
٥	FEL Lock/AEL Toggle	٥	Finder/Monitor Select
٥	External Flash Firing Settings	0	Finder Frame Rate
0	White Balance	0	Zebra Display Select
0	Priority Set in Auto White Balance	0	Zebra Level
0	AWB Lock Hold	0	Grid Line
0	AWB Lock Toggle	0	Live View Display Select
٥	DRO/Auto HDR	٥	Bright Monitoring
0	Creative Style	0	My Dial 1 During Hold
0	Picture Effect	o	My Dial 2 During Hold
0	Picture Profile	0	My Dial 3 During Hold
0	Focus Magnifier	0	My Dial 1—2—3
٥	Peaking Display Select	0	Toggle My Dial 1
0	Peaking Level	0	Toggle My Dial 2
٥	Peaking Color	0	Toggle My Dial 3
0	Anti-Flicker Shooting	0	Audio Signals
0	In-Camera Guide	۰	Send to Smartphone

FTP Transfer

Movie Shooting [start or stop recording]

- Playback
- Monitor Brightness
- Gamma Display Assist
- Touch Operation Select
- TC/UB Display Switch
- ° MENU
- Display My Menu
- ° Not Set

Scroll through this list and press the Center button to make your selection. The dot next to the chosen option will turn orange to mark the choice.

Many of these options are self-explanatory because, when the button has the option assigned, pressing the button simply calls up the menu screen for that option, if the option is available in the current shooting mode. For example, if the Custom button is assigned to drive mode, then, when you press the button, the camera displays the drive mode menu, just as if you had used the Menu button to get access to that option. I will not discuss those options here; see Chapter 4 for discussion of the Camera Settings1 menu, Chapter 5 for discussion of the Camera Settings2 menu, Chapter 8 for discussion of the Setup menu, and Chapter 10 for discussion of the Network menu.

In a few cases, the assigned button switches between menu options without first calling up a menu screen. For example, this is the case with the APS-C S35/Full Frame Select, Switch Focus Area, Marker Display Select, Finder/Monitor Select, and TC/UB Display Switch options, among others. (I will discuss Switch Right/Left Eye separately below, because it is somewhat more involved than the other options listed here.)

There are some other selections for the AF-ON button (and the other buttons) that do not call up a menu screen or switch between menu items. Instead, they perform a function that does not come from any menu option. I will discuss those selections below.

Recall Custom Hold 1, 2, and 3

These options work together with the Register Custom Shooting Settings option on screen 3 of the Camera Settings1 menu, which I discussed in Chapter 4. In order to use that option, you first select a set of shooting settings, including items such as shooting mode, shutter speed, drive mode, exposure compensation, ISO, and others. You then store them to slots called Custom Hold 1, 2, and 3. When you assign the Recall Custom Hold 1, 2, or 3 option to a control button, that button will call up that complete set of shooting settings instantly when it is pressed in shooting mode. You have to hold down the button while you are using those settings. When you release the button, the camera reverts to the settings that were in effect before you pressed the button.

AF/MF Control Hold

If you select AF/MF Control Hold for the assigned button's function, pressing the button switches the camera between autofocus and manual focus, but only while you hold down the button. If the camera is set to any autofocus mode, pressing and holding the button will switch the camera into manual focus mode. Releasing it will switch to the autofocus mode that was originally set.

If the camera is set to manual focus mode, pressing and holding the button will switch to single-shot AF mode. However, if you are using a lens with an AF/MF switch, that switch must remain in the AF position for this option to work. If the physical switch on the lens is in the MF position, the AF/MF Control Hold option will not override the MF setting. This option will override the camera's focus mode menu setting to MF, but not the physical setting of the switch on the lens to MF.

In this situation, with the camera set to MF through the menu system, when you press the assigned button, the camera will also evaluate the focus and lock focus, if possible. With this option, the assigned button can be used for "back button focus," letting you focus the camera without having to half-press the shutter button. Releasing the button will switch back to manual focus mode. If the camera is set to DMF mode, the button will toggle between DMF and manual focus.

This function is useful in situations when it is difficult to use autofocus, such as dark areas, extreme close-ups, or areas where you have to shoot through obstructions such as glass or wire cages. You can switch very quickly into manual focus mode and back again, as conditions warrant.

Also, this capability is helpful if you want to set "zone" focusing, so you can shoot quickly without having to wait for the autofocus mechanism to operate. For example, if you are doing street photography, you can set the camera to single-shot autofocus mode and focus on a subject at about the distance you expect to be shooting from—say, 25 feet (7.6 meters). Then, once focus is locked on that subject, press and hold the button to switch the camera to manual focus mode, and the focus will be locked at that distance in manual focus mode. You can then take shots of subjects at that distance without having to refocus. If you need to set another focus distance, just release the button to go back to autofocus mode and repeat the process.

Finally, it is convenient to be able to quickly get the camera to use autofocus when it is set to manual focus mode. With this function, as noted above, when you press and release the button, the camera will quickly focus using autofocus, and then go back to manual focus mode for any further adjustments you want to make.

AF/MF Control Toggle

If you select AF/MF Control Toggle for the setting of the assigned button's function, pressing the button switches the camera between autofocus and manual focus. This option works the same as AF/MF Control Hold, except that you do not hold down the control button; you just press it and release it. The switched focus mode then stays in effect until you press the button again. However, when the camera is set to manual focus mode, pressing the assigned button does not cause the camera to evaluate focus. To get that capability, you have to use AF/MF Control Hold, discussed above.

Focus Standard

The Focus Standard option can be assigned to any one of several buttons. That button can then be used to perform focus-related functions in two situations when autofocus is in use. First, when focus area is set to Zone, Flexible Spot, Expand Flexible Spot, or Tracking AF with either of the Flexible Spot options, pressing the button assigned to Focus Standard instantly makes the focus area active, ready to be moved by pressing the direction buttons.

Second, when autofocus is in effect and focus area is set to Wide or Center, or to the Wide or Center option for Tracking, pressing the button assigned to Focus Standard causes the camera to focus in the center of the screen.

Registered AF Area Hold/Registered AF Area Toggle/Registered AF Area + AF On

These three options work in conjunction with the AF Area Registration option on screen 6 of the Camera Settings1 menu, which I discussed in Chapter 4. With that option, you can register a particular point on the camera's display as the point where you want the camera to use its autofocus. Once that area is registered, you can assign the Register AF Area Hold option to a control button. When you press that button in shooting mode, the camera will place the autofocus frame at the registered area on the display. Then, while you hold down the assigned button, you can cause the camera to focus at that area.

If you assign the button to the Registered AF Area Toggle option, you don't have to hold down the assigned button; just press it and release it, and the autofocus area will be placed at the registered point. You then have to press the assigned button again to remove the autofocus area frame from the display.

If you assign the button to the Registered AF Area + AF On option, when you press the button, the camera places the autofocus frame at the registered location and immediately focuses at that position also, so you don't have to use the shutter button (or some other button assigned to AF-On) to cause the camera to autofocus.

It's useful to remember that the registered AF Area will be flashing on the screen in shooting mode, to remind you of its location, so you can compose the shot with that frame at the proper position.

This function works only in the Program, Aperture Priority, Shutter Priority, and Manual shooting modes.

Tracking On

This option turns on the Tracking setting for focus area temporarily when you press the assigned button. When you press the button assigned to Tracking On, focus mode switches to continuous AF and focus area switches from the current setting to the corresponding Tracking setting. For example, if focus area is set to Center, pressing the assigned button will temporarily turn on AF-C (if it wasn't already active) and switch the focus area to Tracking (Center). You have to hold down

the button to keep tracking turned on. It is probably best to assign Tracking On to a button on the back of the camera so you can press it with your thumb and use your index finger to press the shutter button halfway down to lock tracking on your subject.

If you press the shutter button halfway before pressing the Tracking On button, the tracking will lock on to the currently focused subject as soon as the assigned button is pressed. The camera must be set to an autofocus mode for this option to work; it does not work if manual focus is active.

Tracking On + AF On

This option is similar to the previous one, except that this option causes the camera to use its autofocus on the subject being tracked, so you do not have to press the shutter button (or other button assigned to focus) to carry out the focusing operation. By default, the AF-ON button is assigned to this option, and I recommend leaving that assignment in place if you expect to be tracking moving subjects.

Eye AF

If you assign Eye AF to a control button, then, if the camera is set to an autofocus mode, when you press that button the camera will look for human eyes and focus on them if possible. If the camera detects an eye, it will display a small green frame to show that it has focused on the eye, as shown in Figure 5-42.

Continue to hold down the assigned button to lock focus on the eye while you press the shutter button to take the picture. The camera does not have to have Face/Eye Priority in AF turned on for this option to work, and it functions with all focus modes (S, A, C, and DMF) other than manual focus, and with all settings for focus area. However, Subject Detection, an option under Face/Eye AF Settings, must be set to Human rather than Animal. If there are multiple faces in the scene, move the focus frame (if any) over the face you want to focus on before pressing the button assigned to Eye AF; the camera will then use that face for the Eye AF focus.

There is a difference between using Eye AF as assigned to a control button and just relying on the Face/Eye Priority menu option settings. With the menu option, the camera looks first for faces and eyes within the area selected for the focus area menu option. If it does not find any, it focuses on some other object within that

area. With the Eye AF option activated by a control button, the camera looks anywhere in its entire field of view for faces and eyes, even outside the focus area bounds. If it does not find any, it does not look for any other object to focus on.

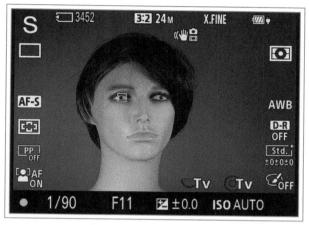

Figure 5-42. Eye AF in Use

This option can be useful to give you an instant way to focus on a face when you were not expecting to take a portrait and do not have the camera set up for face and eye detection. You can just press and hold the assigned button to focus on the nearest eye, which should result in a well-focused portrait.

Eye AF is also available when recording movies, but you have to use the Custom Key (Movies) menu option to assign it to a button for use during movie recording, if you are using Movie mode rather than recording a movie in a still-shooting mode. Eye AF works during 4K video recording, with some restrictions. Proxy Recording must be turned off, and, if Record Setting is set to a 30p setting, 4K Output Select cannot be set to Memory Card + HDMI. In addition, I have found that settings on the Network menu such as PC Remote and Bluetooth connections interfere with the use of Eye AF during 4K recording.

Subject Detection

This item actually does duplicate a menu option, but I will list it here because it might not be obvious what it involves. This option lets you choose between humans and animals for purposes of face and eye detection. The camera cannot recognize both types of subjects with a single setting, so you must tell it which kind to look for. The Subject Detection menu option is found under Face/Eye AF Settings on screen 5 of the Camera Settings1 menu.

Switch Right/Left Eye

This option works in conjunction with the Right/Left Eye Select option, which is found under the Face/Eye AF Settings option on screen 5 of the Camera Settings1 menu. That option, which can be set to Auto, Right, or Left, determines how the camera chooses a human eye to focus on. (That option is not available if Subject Detection is set to Animal.) If that option is set to Right or Left, pressing a button assigned to the Switch Right/Left Eye option changes to the opposite eye, left or right. If that option is set to Auto, pressing the assigned button temporarily switches to the eye other than the one the camera has chosen to focus on. If you press the button again, the camera will switch back to the other eye.

Switch AF Frame Move Hold

This option is related to the AF Frame Move Amount item on screen 7 of the Camera Settings1 menu. With that item, you can set the autofocus frame to move a standard amount or a larger amount when you are using a movable frame with the Flexible Spot or Expand Flexible Spot setting. If you assign the Switch AF Frame Move Hold option to a control button, you can press that button when you need to adjust the frame, to change the current setting to the other one—that is, from Standard to Large, or vice-versa, while you hold down the button.

AF On

If you assign the AF On option to a control button, when you press the button in shooting mode the camera will use its autofocus immediately, without your having to press the shutter button halfway. The camera will use the current focus settings, including the settings for focus mode and focus area. However, if manual focus is in effect, pressing the assigned button will have no effect.

You can use this button assignment to set up the camera for "back button focus." To do that, assign a button to AF On, and then go to screen 5 of the Camera Settings1 menu and set AF w/Shutter to Off, so the camera will not focus when you press the shutter button halfway down. In addition, you may want to turn off the Pre-AF option on that same menu screen, so the camera does not use its autofocus automatically, before you press the button to cause it to autofocus.

Focus Hold

Some lenses have one or more Focus Hold buttons, and the diagram within the a7C's menu system shows a Focus Hold button on the fourth page of diagrams of button locations. But you can assign the Focus Hold feature to any one of several buttons, regardless of whether the lens you are using has a Focus Hold button. (And you can assign any one of numerous options to the Focus Hold button, if the lens has one, not just the Focus Hold option.)

Once you have used the camera's autofocus system to achieve sharp focus, press the button assigned to Focus Hold and hold the button down. As long as the button is held down, the camera will not adjust focus again, even if focus mode is set to continuous AF. So, if you need to adjust the angle of your shot or re-frame the composition, you can then press the shutter button while holding down the assigned button, to take the picture without disturbing the original focus setting.

This is not a function you may need often, but it can be useful if you have focused the camera on a particular subject and are waiting for that subject to appear in the frame again. If you hold the focus with the assigned button, that subject will be in focus when it appears again. If you didn't hold focus, the camera might refocus on some other subject when you pressed the shutter button to take the picture. In addition, you can use this feature for a pull-focus effect when recording movies, by holding the focus on a subject in the distance, for example, with the button assigned to Focus Hold, and then releasing the button so the camera will change its focus to a closer subject.

AEL Hold

If you set a control button to the AEL (autoexposure lock) Hold option, then, when the camera is in shooting mode, pressing the button will lock exposure at the current setting as metered by the camera, as long as you hold down the button.

If the camera is set to Manual exposure mode with ISO set to ISO Auto, pressing the button to activate AEL Hold will lock the ISO setting. Also, if you press the button in Manual exposure mode, you can use the Manual Shift feature by adjusting the aperture or shutter speed to a different value; the camera will then select a matching shutter speed or aperture value to maintain the current exposure as locked by AEL Hold.

When exposure is locked in this way, a large asterisk will appear in the lower right corner of the display and remain there until the assigned button is released.

For example, you might want to use AEL Hold to make sure your exposure is calibrated for an object that is part of a larger scene, such as a dark painting on a light wall. You could lock exposure while holding the camera close to the painting, then move back to take a picture of the wall with the locked exposure ensuring the painting will be properly exposed.

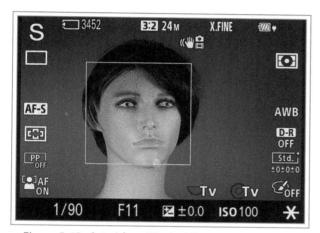

Figure 5-43. Asterisk on Display When AEL is Activated

To do this, assuming the camera is in Program mode, hold the camera close to the painting until the metered aperture and shutter speed appear on the screen. Press and hold the AEL button and an asterisk (*) will appear on the screen, as shown in Figure 5-43, indicating that exposure lock is in effect.

Now you can move back (or anywhere else) and take your photograph using the exposure setting that you locked in. Once you have finished using the locked exposure setting, release the AEL button to make the asterisk disappear. The camera is now ready to measure a new exposure reading.

AEL Toggle

If you set a control button to the AEL Toggle option, then, in shooting mode, pressing the button will lock exposure just as with AEL Hold. The difference with this setting is that you just press and release the AEL button; the exposure will remain locked until you press the button again to cancel the exposure lock.

Spot AEL Hold

The next option for assignment to a control button is listed on the menu as AEL Hold with a spot icon before the name. The icon means that, with this setting, when you press the button and hold it, the camera will lock exposure as metered by the spot-metering area in the center of the display, no matter what metering method is currently in effect. It will use whichever size for the metering spot was last set with the metering mode menu option, either Standard or Large.

This option can be useful if you think you will want to switch to spot metering just for one or two shots. You can press the assigned button to make sure the center of the display covers the area that you want to use for evaluating the exposure, and take the shot with the exposure adjusted for that spot.

Spot AEL Toggle

The Spot AEL Toggle option is similar to the AEL Toggle option, except that the camera meters in the spot area in the very center of the display. As with the previous option, the camera uses the size of the spot as it was last set through the metering mode menu option.

Wireless Test Flash

This option lets you assign a control button that you can press to test the operation of the light-based wireless flash system that is built into the a7C camera and certain Sony flash units. The procedure for using this system is discussed in Chapter 4, under the heading of Wireless Flash.

FEL Lock Hold/FEL Lock/AEL Hold/FEL Lock/AEL Toggle

These next four possible button assignments can be discussed together. They all involve FEL Lock, or flash exposure level lock. FEL functions in a way similar to AEL, or autoexposure lock, discussed earlier, except that it locks the output of the flash, rather than the exposure settings. To use it, assign it to a button, attach a compatible flash unit to the camera's hot shoe, and take a picture with the main subject filling the frame as much as possible, so the camera will evaluate the light for that subject. Then press the assigned button, and the camera will fire a pre-flash from the flash unit and record the amount of light that was needed for the exposure. Then, while still holding down the assigned button, recompose the shot with the subject off to the

side, or however you need it, and shoot using the locked flash exposure.

As with AEL Hold and AEL Toggle, there are multiple versions of this setting. If you choose the Hold option, you have to hold the assigned button down to keep the flash value locked; with Toggle, you just press and release the button, and the value will stay locked until the picture is taken. If you choose FEL Lock/AEL Hold or FEL Lock/AEL Toggle, the camera will evaluate the light whether or not the flash fires. So, if, for example, you turn off the flash for some shots, the camera will still measure the exposure and lock it for you.

It appears that the FEL Lock feature works best when the camera's ISO is set to a specific value rather than to Auto ISO.

AWB Lock Hold/AWB Lock Toggle

These two related functions are similar in function to the Shutter AWB Lock option on screen 12 of the Camera Settings1 menu, discussed in Chapter 4. If you assign AWB Lock Hold to a control button while Auto White Balance or Underwater Auto White Balance is selected, the camera will stop adjusting white balance while the button is held down. With the Toggle option, the adjustments will stop until the button is pressed a second time. As with the menu option, you can use this feature to ensure that the Auto White Balance setting will not change during continuous shooting or during any series of shots for which you want the color balance of the shots to remain consistent.

In-Camera Guide

If you assign In-Camera Guide to a control button, the camera provides a convenient help system for explaining menu options. Once this assignment is made, whenever the camera is displaying a menu screen, including a Function menu or Quick Navi screen, you can press the assigned button to bring up a brief message with guidance or tips about the use of the option that is currently highlighted. For example, if you go to screen 8 of the Camera Settings2 menu and highlight the Live View Display item, then press the button assigned to In-Camera Guide, the camera displays the message shown in Figure 5-44.

If you select a sub-option for a menu item and then press the In-Camera Guide button, the camera will display a different message providing details about that sub-option. For example, Figure 5-45 shows the screen that was displayed when I pressed the assigned button after highlighting the Toy Camera-Magenta option for the Picture Effect item.

Figure 5-44. Help Screen for Live View Display Menu Option

This help system is quite detailed; for example, it has guidance for different ISO settings such as ISO 100, 160, and 6400, with tips about what shooting conditions might call for a given setting. The system operates with all of the menu systems, including Camera Settings2, Playback, Setup, and Network, not just the Camera Settings1 menu. It also operates for items on the Function menu and the Quick Navi menu system.

There is an undocumented quirk with this option, though, that you should be aware of. The In-Camera Guide function appears to be permanently assigned to the Custom button, even if that button is assigned to some other option through the Custom Key menu settings. For example, if you assign that button to call up drive mode, it still brings up the In-Camera Guide when a menu screen is displayed.

So, as far as I can determine, there is no need to assign this option to the C button, because it is always available anyway. With my camera, I have assigned the Silent Shooting option to the C button, so when the camera is in shooting mode I can press that button to activate silent shooting, but when the camera is displaying a menu screen, I can still use the C button to display the help system if I need it. Of course, you may find it more convenient to press another button to call up the help screens, and you can certainly do that if you want to; just be aware that the C button will still serve that purpose also.

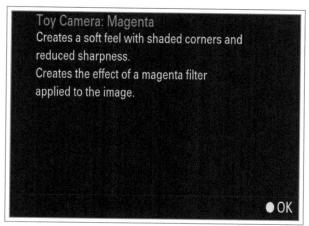

Figure 5-45. Help Screen for Toy Camera Magenta Picture Effect Setting

Movie (Shooting)

The Movie setting does not call up a menu option. Instead, when you assign a button to this setting, the button takes on the same role as the camera's red Movie button. This option gives you another way to start and stop the recording of a video. As I discuss later in this section, I have used this option to reassign movie shooting to the Down button, so I can use the Movie button to gain access to the camera's menu system.

Aperture Preview

When using an A-mount lens with a Sony Mount Adaptor, the a7C does not stop down its aperture to the value that has been set until the image is captured. However, if you assign a button to the Aperture Preview option, you can press and hold the assigned button to see a preview of how the current aperture setting will affect the final image, before the image is captured. In this way, you can judge the depth of field, which is likely to be affected by the aperture setting when the set aperture is a narrow one, such as f/16 or higher. (This function is not needed if you are using an E-mount lens, because that type of lens provides a view of the scene with the aperture stopped down at all times.)

Shot Result Preview

This next option is similar to the Aperture Preview option, discussed above, but this one is supposed to let you preview the DRO setting, shutter speed, and ISO setting, as well as the aperture setting, to see how the final shot will look with all of those settings applied. I tried it with various combinations of settings, with both an A-mount and an E-mount lens, and found that it did not give a reliable view of the final shot when Live

View Display on screen 8 of the Camera Settings2 menu is set to Setting Effect On. However, when that option is set to Setting Effect Off, the Shot Result Preview does provide a reasonably good preview of the final shot.

Some photographers have found this function to be useful when using a Sony flash in the camera's flash shoe, because the Setting Effect On option for Live View Display does not show the view under the ambient light conditions. They use Shot Result Preview instead in that situation. Overall, I have not found a use for this option.

Bright Monitoring

This option is intended for a specific situation: when you are shooting in one of the PASM shooting modes, using manual focus in dark conditions that make it difficult to evaluate the focus on the LCD screen or in the viewfinder. In that situation, when you press the button assigned to the Bright Monitoring option, the camera changes the display to increase its brightness and sets the Live View Display option to Setting Effect Off, if it was not already set that way. With Setting Effect Off, the display does not darken or brighten to show the effects of exposure settings; instead, it maintains a normal brightness if possible.

If you have focus mode set to any option other than manual focus, this key assignment will have no effect. It works only with manual focus, and it does not work if either MF Assist or Focus Magnifier is turned on and in use. When you have finished using this feature, press the assigned button again to turn it off.

This setting is designed for use when you can't see well enough to compose your shot on the LCD screen or in the viewfinder, such as when you are trying to make a long exposure outdoors at night or you need to take a portrait in very dim light.

My Dial 1/2/3 During Hold

These three settings are used in conjunction with the My Dial Settings option on screen 9 of the Camera Settings2 menu, discussed later in this chapter. With that menu option, you can assign any one of several settings, such as aperture, shutter speed, exposure compensation, ISO, white balance, moving the autofocus point, and others, to the control wheel and the control dial, to be used temporarily when you activate them with the assigned control button.

You can store three different combinations of settings in slots labeled My Dial 1, My Dial 2, and My Dial 3. So, for example, you might use the My Dial Settings menu option to set up the My Dial 1 slot with exposure compensation adjusted by the control wheel and ISO adjusted by the control dial. Next, you can assign My Dial 1 During Hold to the C button. Then, when shooting images, if you press and hold down the C button, you can adjust exposure compensation and ISO using the wheel and the dial.

Figure 5-46. Icons on Shooting Screen for My Dial Settings

The shooting screen's icons will change to show the current assignments of the wheel and dial, as shown in Figure 5-46. You can store different sets of settings to the My Dial 2 and My Dial 3 slots, and assign each of those to a different control button if you want. Or, you can use the My Dial 1—2—3 option, discussed immediately below.

Because the My Dial assignments are only temporary, the control wheel and control dial will still retain their default assignments of adjusting shutter speed and aperture in Aperture Priority, Shutter Priority, and Manual exposure modes.

My Dial 1—2—3

This next option is similar to the My Dial 1/2/3 During Hold options, discussed above, but it permits you to assign all three of the My Dial slots of settings to a single control button. So, for example, if you have assigned three sets of options for the control wheel and control dial to the My Dial 1, My Dial 2, and My Dial 3 slots using the My Dial Settings menu option, instead of assigning each of those sets to a different control button, you can assign the My Dial 1—2—3 option to, say, the C button.

Then, when you press that button in shooting mode, the wheel and dial assignments for My Dial 1 are called up. Press the button a second time to call up the My Dial 2 assignments, a third time for the My Dial 3 assignments, and a fourth time to return to the default assignments. With this option, you do not need to hold down the control button; the My Dial settings remain active until you press the assigned button again.

Toggle My Dial 1/2/3

With these next three options, you can assign Toggle My Dial 1, 2, or 3 to a control button. This option is similar to the My Dial 1/2/3 During Hold options, except that you do not have to hold down the assigned button for the My Dial assignments to stay active. Just press and release the assigned button, and the My Dial settings will remain in effect until you press the assigned button again.

Playback

With this option, you can assign a control button to act like the Playback button, which places the camera into playback mode. I'm not sure why you would want to use a control button for this purpose, since the camera has a dedicated Playback button that cannot be reassigned to any other purpose. But this possibility exists, and you can do this if you want.

MENU

With this option, you can set one of the control buttons to perform the function of the Menu button, giving you access to the camera's menu system. I am glad to have this option, because I find the camera's Menu button to be difficult to reach and press, being located in the center of the extreme upper edge of the camera's back, and having a stiff feel. So, I have assigned a different button to the MENU option, which is a great improvement for me, because that button is easy to reach and press whenever I need to get access to a menu screen.

I initially assigned MENU to the C button, but I encountered a problem. That button, when assigned to this function, will provide access to the menu system, but it cannot perform the other function of the Menu button—to back out of a menu screen. So, when I had to back up one screen in the menu system, or exit from it, pressing the C button was of no use. I tried assigning MENU to other buttons, with similar problems.

The Center, Left, Right, and Down buttons don't work well, because, once a menu screen is displayed, each of those buttons will act as a direction button to navigate through the menu system. The only buttons that work just like the Menu button are the AF-ON button, the Focus Hold button, if one is present on the lens you are using, and the Movie button. When either of those buttons is assigned to the MENU option, it will act just like the Menu button, entering the menu system and then backing up through that system as needed.

If you are like me and don't like the feel of the normal Menu button, you might want to assign the MENU option to the Movie button and assign movie shooting to the Down button, which does not have any assignment by default, so you won't be missing out on its normal function. (Of course, if you rarely if ever record movies, you can just not assign movie shooting to any button and use the Movie button for whatever option you choose.)

Display My Menu

If this item is assigned to a control button, when you press the button the camera will display the My Menu screen. As discussed in Chapter 8, you can set up the My Menu system with up to 30 of your most-used options from the various menu systems. Ordinarily, you would have to press the Menu button and then navigate to My Menu to get access to those settings. If you assign a button to this option, you can press that button and immediately have the My Menu options available.

Not Set

The last option that can be assigned to a control button is called Not Set. If you choose this option, the button will not be assigned any special function. This option is useful if you will be using a limited number of settings and don't want to risk activating a different setting by pressing a button accidentally.

Custom (C) Button

The next button that appears on the first page of control assignments is the C button. This control is assigned by default to white balance, but it can be assigned to any of the same options as the AF-ON button, listed earlier, except Switch Focus Area.

CENTER BUTTON

You can assign the Center button to any of the same options as for the AF-ON and C buttons, except for Switch Right/Left Eye and In-Camera Guide. It is assigned by default to the Focus Standard option.

LEFT BUTTON

For the Left button, which is assigned by default to drive mode, the choices of assignment are the same as for the AF/MF and AEL buttons, except that the following choices are not available:

- Recall Custom Hold 1, 2, and 3
- ^o AF/MF Control Hold
- ° Focus Standard
- [°] Switch Focus Area
- Register AF Area Hold
- Register AF Area + AF On
- Tracking On
- Tracking On + AF On
- ° Eye AF
- Switch AF Frame Move Hold
- AF On
- ° Focus Hold
- ° AEL Hold
- Spot AEL Hold
- FEL Lock Hold
- FEL Lock/AEL Hold
- AWB Lock Hold
- In-Camera Guide
- Aperture Preview
- Shot Result Preview
- My Dial 1/2/3 During Hold

RIGHT BUTTON

The choices of assignment for the Right button are the same as those for the Left button. It is assigned by default to ISO.

DOWN BUTTON

The assignment choices for the Down button are the same as those for the Left and Right buttons. It is assigned by default to the Not Set option, meaning it has no function, unless you assign one to it using the Custom Key menu options.

FOCUS HOLD BUTTON

Finally, the Focus Hold button is assigned by default to the Focus Hold option, but you can assign it to any of the functions listed above for the other buttons. Of course, this button is located on a lens and not on the camera, so you will not have this button available if you are using a lens that does not have it. Some lenses have multiple Focus Hold buttons. In that case, any assignment for the Focus Hold button will be active with all of those buttons.

Custom Key (Movies)

This next option on screen 9 of the Camera Settings2 menu lets you assign a function to any of the same control buttons as for the Custom Key (Still Images) option, discussed above. The choices are similar to those for that menu option, but there are some differences. First, the assignment will take effect only if the mode dial is set to the Movie mode or the S & Q Motion mode position. So, if you shoot a movie in a still-shooting mode, pressing a control button may call up an assignment to that button made with the Custom Key (Still Images) option, but it will not call up an assignment made with the Custom Key (Movies) option.

Next, for each of the buttons, the last option in the list of choices for assignment to the control is called Follow Custom (Still Images). If you assign that option to a control, the control will have the same function as was assigned to that control using the Custom Key (Still Images) menu option.

That assignment will be in place even if it cannot take effect. For example, if the Left button is assigned to the JPEG Image Size option with the Custom Key (Still Images) option, and you then choose Follow Custom (Still Images) for the assignment of the Left Button with the Custom Key (Movies) option, that assignment will be in place, even though the JPEG Image Size option is not compatible with movie recording.

The other difference from the Custom Key (Still Images) option is that the lists of possible assignments for the various controls are in most cases shorter for the Custom Key (Movies) option. The lists are as follows:

AF-ON, Custom (C), Movie, and Focus Hold Buttons:

The list of possible assignments for these buttons for Movie mode is as follows:

- APS-C S35/Full Frame Select
- ° Memory
- Focus Mode
- AF/MF Control Hold
- AF/MF Control Toggle
- Focus Standard
- Focus Area
- Switch Focus Area
- Face/Eye Priority in AF
- Eye AF
- Switch Right/Left Eye
- * Face/Eye Frame Display Select
- Switch AF Frame Move Hold
- AF On
- Focus Hold
- Exposure Compensation
- ISO
- Metering Mode
- Face Priority in Multi Metering
- AEL Hold

- ° AEL Toggle
- [°] Spot AEL Hold
- Spot AEL Toggle
- White Balance
- Priority Set in Auto White Balance
- ° AWB Lock Hold
- ° AWB Lock Toggle
- DRO/Auto HDR
- ° Creative Style
- Picture Effect
- Picture Profile
- Focus Magnifier
- Peaking Display Select
- Peaking Level
- Peaking Color
- ° In-Camera Guide
- Movie Shooting
- Frame Rate (S & Q)
- AF Transition Speed (Movies)
- AF Subject Shift Sensitivity (Movies)
- * Audio Recording Level
- Audio Level Display
- Marker Display Select
- ° SteadyShot
- SteadyShot Adjustment
- SteadyShot Focal Length
- Zoom
- Finder/Monitor Select
- Zebra Display Select
- [°] Zebra Level

- ° Grid Line
- My Dial 1/2/3 During Hold
- ° My Dial 1—2—3
- ° Toggle My Dial 1/2/3
- * Audio Signals
- Send to Smartphone
- FTP Transfer
- ° Playback
- Monitor Brightness
- Gamma Display Assist
- Touch Operation Select
- TC/UB Display Switch
- MENU
- Display My Menu
- Not Set
- Follow Custom (Still Images)

CENTER BUTTON

The Center button can be assigned any of the same options as the other buttons, except for Switch Right/ Left Eye and In-Camera Guide.

LEFT, RIGHT, AND DOWN BUTTONS

The Left, Right, and Down buttons can be assigned any of the same options as the other buttons, except for AF/MF Control Hold, Focus Standard, Switch Focus Area, Eye AF, Switch AF Frame Move Hold, AF On, Focus Hold, AEL Hold, Spot AEL Hold, AWB Lock Hold, In-Camera Guide, and My Dial 1/2/3 During Hold.

Custom Key (Playback)

This next menu option lets you assign two of the camera's control buttons to each handle a single function when the camera is in playback mode. The main screen for this option is shown in Figure 5-47.

As shown on the two screens of this menu option, the buttons that can be assigned a function for playback mode are the Function (Fn) button and the Movie button.

Figure 5-47. Custom Key (Playback) Menu Options Screen

The options that can be assigned to the Function button are the following:

- ° Finder/Monitor Select
- Send to Smartphone
- FTP Transfer
- FTP Transfer (1 image)
- ° Protect
- Rotate
- Delete
- ° Rating
- ° Photo Capture
- Enlarge Image
- ° Image Index
- * Touch Operation Select
- * TC/UB Display Switch
- ° Not Set

The Movie button can be assigned to any option from the same list, and, in addition, it can be assigned to Follow Custom (Still Images or Movie). With that last setting, the Movie button will switch into shooting mode and carry out either the assignment for Still Images or Movie, depending on the current position of the mode dial.

For example, suppose you have assigned the Movie button as follows, using the Custom Key options: Picture Effect for Still images, Audio Signals for Movies, and Follow Custom (Still Images or Movie) for Playback. Then, with the mode dial at P for Program mode and the camera in playback mode, when you press the Movie button, the Picture Effect menu will appear. If you then turn the mode dial to the Movie position and put the camera into playback mode, when you press the Movie button the Audio Signals menu will appear.

Function Menu Settings

As I will discuss in Chapter 6, when you press the Function button in shooting mode with the live view on the display, the camera displays up to 12 options in two lines of blocks at the bottom of the display, with an orange highlight indicating the single block that is currently selected, as shown in Figure 5-48.

Figure 5-48. Function Menu in Use on Shooting Screen

Move the selection highlight through the options, using the direction buttons. Adjust main settings with the control wheel, and adjust some secondary settings with the control dial. Use the Function Menu Settings menu item to assign options to the 12 blocks of the Function menu. When you select this option, the camera displays the screen shown in Figure 5-49, showing the assignments for all twelve blocks of the Function menu.

This screen is divided into two parts: the top part shows the twelve assignments that are on the Function menu when the mode dial is set to a mode for shooting still images, and the bottom part shows the assignments when the mode dial is set to the Movie or S & Q position. The assignments for still-image modes appear on the Function menu even when the camera is

recording video, as long as the mode dial is set to a still-shooting mode.

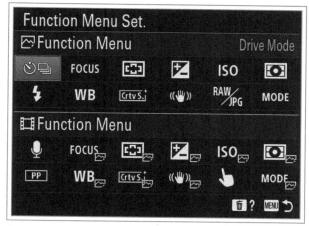

Figure 5-49. Function Menu Settings - Main Options Screen

To change the assignments for the still-image or movie version of the Function menu, use the control wheel, the control dial, or the four direction buttons to navigate through the blocks. When you press the Center button when one of the blocks is highlighted, you will see a screen like that in Figure 5-50, listing the options that can be assigned to that block.

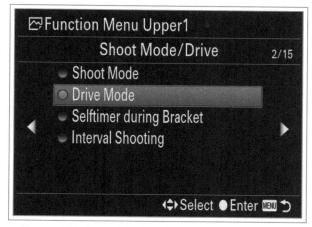

Figure 5-50. List of Options for a Function Menu Block

For each block of the still-shooting menu, the options that can be assigned are:

- File Format (Still Images)
- ^o JPEG Quality
- JPEG Image Size
- [°] Aspect Ratio
- APS-C/Super 35mm

- Shooting Mode
- ° Drive Mode
- Self-timer During Bracketing
- ° Interval Shooting
- Focus Mode
- ° Focus Area
- Face/Eye Priority in AF
- Subject Detection
- Right/Left Eye Select
- Face/Eye Frame Display
- AF Tracking Sensitivity (Still Images)
- Aperture Drive in AF
- [®] Exposure compensation
- ° ISO
- [°] ISO Auto Minimum Shutter Speed
- ^o Metering Mode
- Face Priority in Multi Metering
- ° Flash Mode
- * Flash Compensation
- Wireless Flash
- ° White Balance
- Priority Set in Auto White Balance
- DRO/Auto HDR
- ° Creative Style
- ° Picture Effect
- Picture Profile
- Peaking Display
- Peaking Level
- Peaking Color
- Anti-Flicker Shooting

- Frame Rate (S & Q)
- ^o AF Transition Speed (Movies)
- * AF Subject Shift Sensitivity (Movies)
- ^o Audio Recording Level
- * Audio Level Display
- Marker Display
- ° Silent Shooting
- ° SteadyShot
- SteadyShot Adjustment
- SteadyShot Focal Length
- Finder Frame Rate
- ° Zebra Display
- [°] Zebra Level
- ° Grid Line
- Live View Display
- Audio Signals
- Gamma Display Assist
- * Touch Operation
- ° Not Set

For the movie-oriented blocks of the menu, the list is similar, but it omits several still-related options, such as File Format (Still Images), aspect ratio, drive mode, and several others.

Press the Center button when the option you want to assign to a given block is displayed, and the Function Menu will include that option in place of the one that was previously selected.

Remember that you can use the AF-ON, Custom, Center, Left, Right, Down, and Movie buttons for your most important settings, such as, perhaps, ISO, AEL Toggle, drive mode, white balance, and focus mode, so you can reserve these 12 blocks for other options, one set for shooting still images and one for recording videos.

My Dial Settings

As I discussed earlier in connection with the Custom Key (Still Images) and Custom Key (Movies) menu options, there are various My Dial settings that can be assigned to control buttons, including My Dial 1/2/3 Hold and several others. With each of those options, the assigned button calls up one of three possible slots that are available for storing settings for the control wheel and control dial. The My Dial Settings menu option is the mechanism you use for storing wheel and dial settings to those three slots.

When you highlight this option and press the Center button, the camera displays the screen shown in Figure 5-51, which has two lines—one for the control wheel and one for the control dial, with the settings for the slots numbered 1, 2, and 3 in three columns at the right side of the display. Use the control wheel or the Up and Down buttons to move between the two lines, and use the control dial or the Left and Right buttons to move among the three columns.

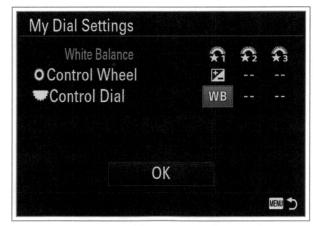

Figure 5-51. My Dial Settings Menu Options Screen

When the highlight is on the slot you want to change for the wheel or dial, press the Center button and the camera will display a screen like that shown in Figure 5-52, which is one of five screens of options for that slot. Scroll through that list and select the option you want to assign to that slot. Once all of the slots are assigned as you want (with Not Set selected for any that you don't want to assign), move the highlight down to the OK block at the bottom of the initial options screen and select it, to lock in your choices. Then you can use the various My Dial options under the Custom Key menu items, as discussed earlier.

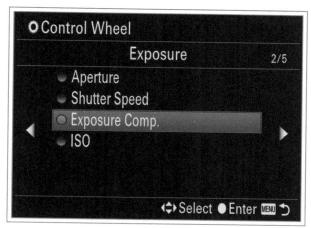

Figure 5-52. Screen With Options for a My Dial Settings Slot

As a brief reminder, here is an example. You can use this menu option to assign exposure compensation to the control wheel and white balance to the control dial, which will result in the menu screen looking like Figure 5-51, showing those two assignments. Then assign My Dial 1 During Hold to the C button, using the Custom Key (Still Images) menu option. If you then press the C button from the live view shooting screen, the display screen will look like Figure 5-53, with icons for the control dial and control wheel showing the options that they control. As long as you keep the button held down, you can use the dial and wheel to adjust the white balance and exposure compensation, respectively.

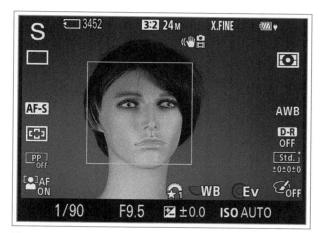

Figure 5-53. My Dial Settings Activated on Shooting Screen

Dial/Wheel Setup

This menu item lets you change the assignments of the control wheel and control dial for adjusting aperture and shutter speed in Manual exposure mode, and in the Movie and S & Q Motion modes when the Exposure Mode setting is Manual Exposure.

By default, the control wheel adjusts shutter speed and the control dial adjusts aperture, as indicated on the top line of the choices for this option, shown in Figure 5-54.

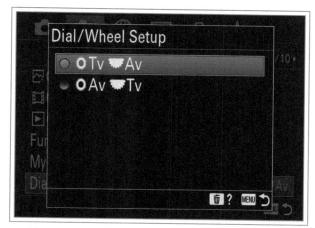

Figure 5-54. Dial/Wheel Setup Menu Options Screen

If you choose the second option, the roles are reversed, so the control wheel adjusts aperture and the control dial adjusts shutter speed. This is strictly a matter of personal preference. Note that this option has no effect on the controls for the Aperture Priority and Shutter Priority modes. In those modes, either the control wheel or the control dial can be used to adjust the one value that can be adjusted in that mode—either aperture or shutter speed.

The options on screen 10 of the Camera Settings2 menu are shown in Figure 5-55.

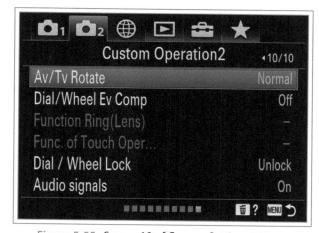

Figure 5-55. Screen 10 of Camera Settings2 Menu

Av/Tv Rotate

This menu item lets you change the direction of rotation when you use the control wheel or control dial to adjust aperture or shutter speed in Aperture Priority, Shutter Priority, or Manual exposure mode, or in Movie mode or S & Q Motion mode with Exposure Mode set to A, S, or M. The choices are normal or reverse. This is strictly a matter of personal preference, which I have never found a need to use.

Dial/Wheel EV Compensation

This menu item gives you the option of setting either the control dial or the control wheel to adjust exposure compensation, when the camera is set to a mode in which exposure compensation can be adjusted, except for Manual exposure mode. This feature, in effect, adds one more control to those that can be assigned an option for shooting mode. In addition, with this option, you can adjust exposure compensation in a range of plus or minus 5 EV, unlike the situation with the exposure compensation dial on top of the camera, which can only adjust it in a range of plus or minus 3 EV. (You also can adjust within the plus or minus 5 EV range using the Exposure Compensation menu option.)

If you use this option in Aperture Priority, Shutter Priority, or Program mode, in which either the control dial or the control wheel adjusts aperture, shutter speed, or Program Shift, using one of those dials to adjust exposure compensation will not be a problem, because there will still be one dial left to adjust those other values. In Manual exposure mode, where you need both the control wheel and control dial to adjust aperture and shutter speed, the Dial/Wheel EV Compensation option does not operate, although the menu option will still be accessible and can be set through the menu system.

If you need to adjust exposure compensation often, this feature is quite convenient, because you can adjust it to its maximum extent by just turning a dial located on the back of the camera.

Function Ring (Lens)

This menu option is available only if you have attached a lens that has a function ring, such as the Sony FE 400mm f/2.8 GM OSS. (That lens costs about \$12,000, so I did not test this option.) With this setting, you can select one of two possible settings for the ring: Power Focus, or APS-C 35/Full Frame Select. The Power Focus setting enables smooth autofocusing with the ring; the other setting lets you switch the angle of view of

the lens between the APS-C/Super 35mm setting and the full-frame setting. Power focus is a feature that is of most use to video shooters, so it may be of more use to choose the APS-C 35/Full Frame Select option if you are shooting still images with a lens of this sort.

Function of Touch Operation

This menu option has three sub-options—Touch Shutter, Touch Focus, and Touch Tracking—which control how the camera uses the touch screen for focusing and for capturing still images. For all three of these features, Touch Operation must be turned on through screen 2 of the Setup menu. You can select only one of the three options, because only one of them can be in effect at any given time.

TOUCH SHUTTER

This first sub-option lets you turn on the Touch Shutter function, which is available for capturing images in still image shooting modes. When Touch Shutter is turned on, you will see a special icon with a finger in the upper right corner of the monitor, as shown in Figure 5-56.

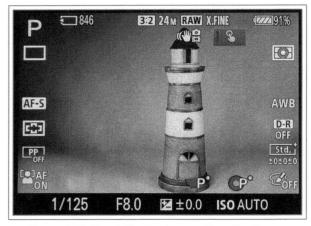

Figure 5-56. Touch Shutter Icon on Shooting Screen

When you touch that icon with your finger, the camera will add a small orange bar at the icon's left side, indicating that the Touch Shutter option is active. Then, the next time you touch the screen, the camera will focus on the spot you touched and take a picture at the same time. You can then keep touching the screen to take more pictures. To cancel the Touch Shutter function, touch the Touch Shutter icon again. If burst shooting or bracketing is turned on, you can press the icon to activate those operations. For burst shooting or continuous bracketing, keep your finger pressed on the

icon for as long as you want the burst to continue, or as long as the bracketing requires.

The Touch Shutter option is not available when using the viewfinder or in the Movie or S & Q Motion modes. It also is not available with manual focus, Digital Zoom, Clear Image Zoom, or when focus area is set to Flexible Spot, Expand Flexible Spot, or the Tracking varieties of those settings.

Touch Focus

This option is similar to the previous one, except that it sets the camera only to focus at the spot where you touch the monitor, not to take a picture also. For still images, touch the subject on the monitor where you want the camera to focus. The camera will place a focus frame there. When you press the shutter button halfway down, the camera will focus on the subject within that frame. If you are using the viewfinder, you can move the focus area around by dragging your finger on the monitor.

If you have Pre-AF turned on through screen 5 of the Camera Settings1 menu, the camera will focus automatically on the spot where you touch the monitor, without your having to press the shutter button halfway down to activate autofocus.

In its user guide, Sony says you need to select a setting other than Flexible Spot or Expand Flexible Spot for focus area, to use Touch Focus. However, if you have focus area set to one of those options, you can still focus by touching the monitor where you want the camera to focus. In that case, though, Sony does not consider this action to amount to Touch Focus; instead, it amounts to moving the existing focus frame. So, in effect, if Touch Focus is turned on, you can touch the screen to focus where you want, regardless of the focus area setting.

If you are recording a movie, touch the monitor where you want focus to be directed. The camera will focus at the spot you touched and will activate manual focus temporarily to lock the focus at the current distance. (Sony calls this function "spot focus.") You can cancel the spot focus operation by pressing the hand icon with an X, or by pressing the Center button. (If focus area is set to Flexible Spot or Expand Flexible Spot, spot focus does not work; instead, the camera lets you move the focus frame.)

Touch Focus is not available when using manual focus or when actually using Clear Image Zoom or Digital Zoom. It also is not available if you are using an A-mount lens with the Sony LA-EA4 Mount Adaptor.

TOUCH TRACKING

The third and final setting for the Function of Touch Operation option sets the camera up to track a subject when you touch the image of that subject on the monitor, for still images or movies. When you touch the screen, the camera places a tracking frame on the subject, and will attempt to keep that subject in focus while the subject or camera moves. The camera displays a message advising you to press the Center button to cancel tracking. You also can cancel it by pressing the X next to a tracking icon at the top of the display.

It is worth noting that Touch Tracking is available with any autofocus mode: single-shot autofocus, continuous autofocus, automatic autofocus, or direct manual focus, unlike the Tracking setting for focus area, which is available only when focus area is set to continuous autofocus. So, if you need to track a subject while using single-shot autofocus, for example, if you have this menu option enabled you can just touch the screen to start the tracking.

Touch Tracking is not available when focus area is set to manual focus, when using non-optical zoom, when the Record Setting option on screen 1 of the Camera Settings2 menu is set to any of the 120p settings (100p for cameras using the PAL video system), or when File Format (Movies) is set to XAVC S 4K and Proxy Recording is turned on.

Note that Touch Tracking is available for recording movies, even though tracking AF is not available as a selection for focus area for recording movies. So, if you want to track a moving subject when recording a movie, you can use the Touch Tracking feature to do so.

Dial/Wheel Lock

This next option on screen 10 of the Camera Settings2 menu has two possible settings, Lock and Unlock. If you select Lock, you can lock the functioning of the control wheel and control dial. To engage the actual lock, after this menu item is set to Lock, press and hold the Function button for several seconds when the

shooting screen is displayed, until a Locked message appears on the screen.

After that, you will see an icon in the lower right corner of the display indicating that the lock is in effect, as shown in Figure 5-57. Once the lock is in effect, turning the control wheel or control dial will not have any effect on the camera's settings.

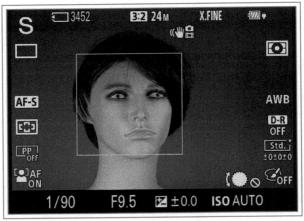

Figure 5-57. Icon on Shooting Screen When Lock in Effect

For example, if the control wheel has been set to adjust exposure compensation using the Dial/Wheel EV Compensation menu option, turning the dial will not adjust exposure compensation while the lock is in effect. Similarly, when the camera is in Shutter Priority or Manual exposure mode, turning the control dial will not change the shutter speed, as it normally would. However, the dial and wheel will still carry out their functions of navigating through menu screens, even with the lock in effect.

This option can prevent these dials from accidentally changing your settings. If you make an important adjustment to your settings, you can lock the dials so the settings will stay in place. If you need to change settings, press and hold the Function button again to remove the lock.

I have not had occasion to use this feature myself, but I can see its value for situations in which you need to keep a setting locked in and want to guard against accidental slipping of the wheel or dial.

Even when the Lock option is turned on, the Function button can be used to call up the Function menu. A quick press of the button will call up that menu, and a longer press-and-hold will lock or unlock the wheel and dial.

Audio Signals

This last option on the Camera Settings2 menu lets you choose whether to activate the sounds the a7C makes when operations take place, such as pressing the shutter button halfway down to focus, pressing the Movie button (or other assigned button) to start a video recording, or using the self-timer. By default, these sounds are turned on, but it can be helpful to silence them in a quiet area, during a religious ceremony, or when you want to avoid alerting your subjects that a camera is being used.

To silence the shutter operation sound for shooting still images, use the Silent Shooting option on screen 5 of the Camera Settings2 menu.

CHAPTER 6: PHYSICAL CONTROLS

he Sony a7C, having a compact body, does not have as many physical controls as a larger camera. But the a7C has more controls than most compact cameras, and the ones it has provide many options for customizing. You can assign the most-used functions to buttons and dials.

In this chapter, I'll discuss each of the camera's physical controls and how they can be used to best advantage, starting with the controls on the top of the camera, as shown in Figure 6-1.

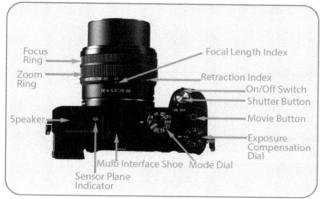

Figure 6-1. Controls on Top of Camera

Shutter Button

The shutter button is the single most important control on the camera. When you press it halfway, the camera evaluates exposure and focus (unless you're using manual exposure with a fixed ISO value, or manual focus, or have disabled either of those functions for the button, as discussed below). Once you are satisfied with the settings, press the button all the way to take the picture. When the camera is set for continuous shooting, you hold this button down while the camera fires repeatedly. You also can press this button halfway to exit from playback mode, menu screens, and help screens to get the camera set to take its next picture. You can half-press this button to wake the camera up after it has powered down because of the Power Save Start Time option on the Setup menu.

You can disable the use of the shutter button to cause the camera to use autofocus by turning off the AF w/ Shutter option on screen 5 of the Camera Settings1 menu. You can disable the use of this button to evaluate exposure by turning off the AEL w/Shutter option on screen 9 of that menu.

When the mode dial is set to Movie mode or S & Q Motion mode, the behavior of this button depends on the setting of the Movie w/Shutter option on screen 4 of the Camera Settings2 menu. If that option is turned off, pressing the shutter button in either of those modes has no effect. If the Movie w/Shutter option is turned on, pressing the shutter button in Movie mode or S & Q Motion mode will start or stop the recording of a movie.

On/Off Switch

This switch surrounding the shutter button is used to turn the camera on and off.

Mode Dial

The mode dial, the larger dial on the right side of the camera's top, has just one function—to set the shooting mode for capturing still images or videos. I discussed those modes in Chapter 3. To take a quick still picture, turn this dial to the green AUTO label and fire away. To take a quick video sequence, turn the dial to that position and then press the red Movie button, at the far right of the camera's top, in front of the exposure compensation dial. You can record a normal-speed movie with the mode dial set to any position except S & Q, which is used for slow-motion or speeded-up movies. There is a Movie mode on this dial, marked by a movie film icon, but you do not have to use that mode to record movies.

If the mode dial is set to Movie mode or S & Q Motion mode, the camera cannot take still images. In those modes, you can only record videos.

Exposure Compensation Dial

The dial at the far right of the camera's top has just one function—to adjust exposure compensation. As is shown in its markings, it can adjust the EV value only within a range of 3 units positive or negative, unlike the Exposure Compensation option on screen 8 of the Camera Settings1 menu, which can adjust it within a range of 5 units in either direction. Any adjustment made with this dial takes precedence over an adjustment made with the menu option or with a control button or dial that is assigned to adjust exposure compensation. Those other adjustments can be made only if this dial is set to its zero position.

Movie Button

The red-ringed button at the right edge of the top of the camera has one primary function by default—to start and stop the recording of movie sequences. However, unlike the situation with some other Sony cameras, the Movie button on the a7C can be reassigned to another option using the Custom Key (Still Images) or Custom Key (Movies) item on screen 9 of the Camera Settings2 menu. As I discussed in Chapter 5, I found it useful to reassign this button to operate the menu system in both still-image and video shooting modes, because I found the location and feel of the Menu button to be difficult to deal with. I then assigned the Down button (which has no assignment by default in shooting mode) to take on the movie-recording function.

There are differences in how the camera operates for video recording in different shooting modes. I will discuss movie-making in detail in Chapter 9.

Multi Interface Shoe

The accessory shoe on top of the a7C, called the Multi Interface Shoe by Sony, comes with a protective cap; slide that cap out, and the shoe is ready to accept several accessories. The most obvious accessory for this shoe is an external flash. I will discuss some available flash units, as well as a radio flash trigger, in Appendix A, where I discuss accessories.

This shoe has special circuitry built into it so it can accept certain other accessories that are designed to interact with the camera. Sony makes microphones that can work with the shoe, including models ECM-

B1M, ECM-XYST1M, and ECM-W1M. Sony also offers an accessory kit, model XLR-K2M, that lets you use professional-level, balanced microphones with XLR connections. I will discuss those items in Appendix A. Sony undoubtedly will release other accessories that can take advantage of this interface as time goes by.

Sensor Plane Indicator

This small symbol located to the left of the Multi Interface Shoe shows the position of the digital sensor within the a7C. This indicator is provided in case you need to measure the exact distance from the sensor plane to your subject for macro photography.

Speaker

The speaker where the camera plays audio from movies and operational sounds is located on the left side of the camera's top. Be sure not to block the speaker's openings if you want to hear that audio clearly.

The items on the back of the camera are shown in Figure 6-2.

Viewfinder and Eye Sensor

The viewfinder window lets you view the live scene and shooting information displays in shooting mode, as well as the playback of images and videos in playback mode, the same as on the LCD monitor. You can control what display screens are available in the viewfinder in shooting mode with the Display Button option on screen 7 of the Camera Settings2 menu.

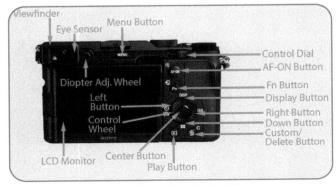

Figure 6-2. Controls on Back of Camera

The eye sensor is a small window in the viewfinder eyepiece to the right of the main viewfinder window. When your head approaches this small slot and blocks Chapter 6: Physical Controls

the light that reaches it, the camera automatically switches from using the LCD screen to using the viewfinder, if a menu option is set for that behavior. To enable this automatic switching, go to screen 7 of the Camera Settings2 menu, select the Finder/Monitor item, and choose Auto. If you don't want the automatic switching, choose Viewfinder (Manual) or Monitor (Manual), to keep either one of those viewing options as the permanent setting. If you want to switch manually between the viewfinder and the LCD screen, assign a button to the Finder/Monitor Select option using the Custom Key menu options on screen 9 of the Camera Settings2 menu.

Diopter Adjustment Wheel

The diopter adjustment wheel is a small, ridged wheel to the right of the viewfinder. You can turn this wheel to adjust the viewfinder according to your vision. If you wear eyeglasses, you may find that you can adjust the setting of the viewfinder so you can see it clearly without your glasses.

Menu Button

The Menu button, located in the center of the camera's upper edge, has a straightforward function. Press it to enter the menu system and press it again to exit to the mode the camera was in previously (shooting or playback). The button also cancels out of sub-menus, taking you to the previous menu screen. You can press the Menu button to wake the camera up into the menu system when it has powered down from the Power Save Start Time option. It also is used to confirm some operations, such as the Protect and Delete options on the Playback menu. You can press this button to return an image to normal size when it has been enlarged in playback mode.

As I discussed in Chapter 5, I do not like the location or feel of this button; I find it hard to reach and press while I am working with the camera. I eventually reassigned its function to the Movie button and reassigned the movie-shooting function to the Down button. But if you have no problem using the Menu button, you certainly can work with it as it is. It cannot be assigned to any other function.

Control Dial

The control dial is the unmarked black dial that sticks out on the right side of the camera's back, near the top edge. One important function of this dial is to adjust the camera's aperture or shutter speed in the shooting modes in which those values can be adjusted. The dial also can be set to control other settings through certain menu options, such as Dial/Wheel EV Compensation and the various My Dial settings, discussed in Chapter 5.

This dial also is used for selecting sub-options in some cases. For example, when you choose Picture Effect from the shooting menu or the Function menu, some settings, such as Toy Camera, have sub-settings that can be selected by turning the control dial. In Program mode, turning the dial activates Program Shift, which causes the camera to pick a new pair of shutter speed and aperture settings to match the current exposure.

When the control dial is set to adjust a particular setting, the camera displays an icon for the dial next to a label or icon for that setting. For example, in Figure 6-3, the display shows that the dial controls shutter speed (indicated by Tv, which stands for time value).

In playback mode, you can turn the control dial to navigate through the images and videos stored on the camera's memory card. Turning the dial will move to another image at the same enlargement factor when an image has been enlarged using the AF-ON button, the Enlarge Image menu option, or the touch screen. The dial also will move through movies slowly when paused or rapidly when they are playing.

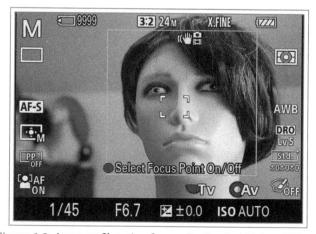

Figure 6-3. Icons on Shooting Screen For Control Dial and Wheel

AF-ON Button

Located just below the control dial is the AF-ON button. By default, it is assigned to the Tracking On + AF On function, which causes the camera to track and focus on a subject you aim the camera at when you press the button while taking still images. The AF-ON button can be reassigned to a different function for shooting still images or videos, as discussed in Chapter 5, using the Custom Key options on screen 9 of the Camera Settings2 menu.

In playback mode, pressing the AF-ON button enlarges a still image that is being displayed on the LCD monitor or in the viewfinder. No other function can be assigned to this button in playback mode.

Function Button

The button marked Fn, for Function, located just below the AF-ON button, has several roles, depending on whether the camera is in shooting mode, playback mode, or displaying the menu system.

MENU SYSTEM NAVIGATION

When the camera is displaying any screen of the menu system, you can press the Function button to navigate quickly through the camera's menu system. Just press this button to move through the menu tabs, rather than just through individual screens. In other words, by pressing this button, you can move directly from the Camera Settings1 menu to the Camera Settings2 menu, then the Network menu, and so on, without having to move through each screen of a given menu system. This action is equivalent to moving the menu highlight to the line of menu tabs at the top of the screen and pressing the Right button, but if you press this button you avoid having to move the highlight up to the line of menu tabs before moving through them.

FUNCTION MENU

When the camera is in shooting mode, the Function button gives you options for setting up the a7C according to your own preferences. With the Function Menu Settings option on screen 9 of the Camera Settings2 menu (discussed in Chapter 5), you can assign up to 12 functions to the Function menu for shooting still images from numerous choices, including items such as ISO, drive mode, white balance, metering

mode, and Picture Effect. An additional option is Not Set, which leaves a slot on the Function menu blank.

You also can assign another set of 12 options to the Function menu that appears when the mode dial is at the Movie or S & Q Motion position, from a pool of somewhat fewer choices, plus Not Set and Follow Function Menu (Still Images).

Scroll through the lines from Function Upper1 through Function Upper6 on the first sub-screen of this menu option and Function Lower1 through Function Lower6 on the second screen. On each line, press the Center button and then scroll through the screens of options to highlight the one you want, and press the Center button to confirm that selection.

Once you have assigned up to 12 options to this menu for still-image shooting and for shooting in Movie or S & Q Motion mode, it is ready for action. To use an option, press the Function button when the camera is in shooting mode, and a menu will appear at the bottom of the display in two rows with six choices each, as shown in Figure 6-4, which shows the menu for still-image shooting.

Use the four direction buttons to move to and highlight an option to adjust. Then turn the control wheel to change the value of that option. For example, if you have moved the orange highlight block to the File Format (Still Images) item, turn the control wheel until the setting you want to make appears, as shown in Figure 6-5, where Raw & JPEG is selected. For some settings, such as drive mode, you turn the control dial when a setting that has further adjustments is highlighted. For example, when self-timer is highlighted for drive mode, you can turn the control dial to select the number of seconds for the countdown.

Then, press the Function button to confirm the setting and exit from the Function menu screen. Or, if you want to make multiple settings from the Function menu options, after changing one setting you can press the Center button to go back to the Function menu and make more settings before you press the Function button to exit to the shooting screen.

If the setting you are adjusting needs to have a suboption set, you can press the Center button to go directly to the menu screen for that setting. For example, suppose you want to set a particular color temperature for white balance. First, from the shooting screen press the Function button to bring up the Function menu, and use the four direction buttons to scroll to the white balance block. Then, instead of choosing a value with the control wheel, press the Center button, and the camera will display the regular white balance menu screen.

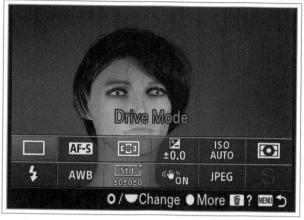

Figure 6-4. Function Menu for Still-image Shooting

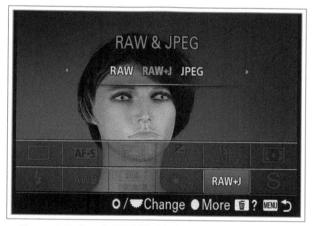

Figure 6-5. Raw & JPEG Highlighted on Function Menu

From that screen, you can navigate to the Color Temperature/Filter option and select the color temperature you want to set. When you have finished, you can press the Center button to confirm your selection and return to the shooting screen. From there, you can press the Function button to return to the Function menu if you wish.

There may be items on the Function menu whose icons are dimmed because the item is unavailable for selection in the current context. If you move the highlight to one of those items and then try to change the setting, the camera will display an error message.

Also, the selections I discussed above may not be available because they have not been assigned to the Function menu. If that is the case, you can use the Function Menu Settings menu option to assign them if you want to follow the examples.

QUICK NAVI SYSTEM

In shooting mode, the Function button also gives you access to the Quick Navi system for changing settings rapidly. This system is similar to the Function menu system I just discussed, but there are significant differences.

The Quick Navi system comes into play only in one situation—when you have called up the special display screen shown in Figure 6-6, which Sony calls the "For Viewfinder" display.

This is the only shooting-mode display screen that includes shooting information but does not include the live view. It is called "For Viewfinder" because the idea is that you will select this display when using the viewfinder, so you can have an unobstructed live view through the viewfinder and see details of your settings on this display, which appears only on the LCD screen.

The For Viewfinder display screen is summoned by pressing the Display button, but only if you have selected it for inclusion in the cycle of display screens. You select it using the Display Button option on screen 7 of the Camera Settings2 menu. From that option, select the sub-option for Monitor, then check the box for the For Viewfinder item on the next screen, as discussed in Chapter 5.

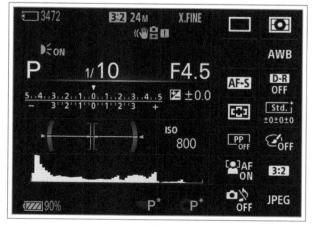

Figure 6-6. For Viewfinder Display Screen

As seen in Figure 6-6, the For Viewfinder screen displays a lot of information at the right, including drive mode, white balance, focus area, DRO, Picture Effect, Picture Profile, Creative Style, and several others.

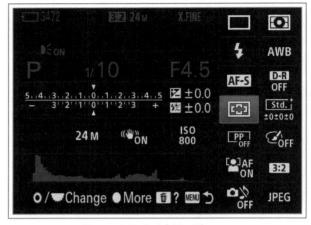

Figure 6-7. Quick Navi Screen

Normally, these items are displayed only for your information; you cannot adjust them. But, if you press the Function button, an orange highlight appears at the right, as shown in Figure 6-7. You can then use the direction buttons to navigate through the settings. This screen then becomes what Sony calls the Quick Navi screen, which permits adjustments. You also can move the orange highlight block to the left, to the settings for options such as ISO, SteadyShot, exposure compensation, and JPEG Image Size.

When you have highlighted a setting to adjust, turn the control wheel to scroll through the available values and make the adjustment quickly. When you adjust certain settings, such as Aspect Ratio, a secondary window opens in the top part of the display, as shown in Figure 6-8, showing the various options available for the setting.

For sub-settings, make the main setting with the control wheel and the sub-setting with the control dial. For example, move the highlight to Picture Effect, turn the control wheel to highlight Partial Color, and turn the control dial to highlight Yellow, as shown in Figure 6-9.

Or, if you prefer, you can press the Center button when the main setting is highlighted to get access to a menu with the sub-options for that setting.

After changing a setting, you can move to other settings using the direction buttons. Once you have made all of your changes, press the Function button again to exit to

the static For Viewfinder display, which will now show the new settings in place.

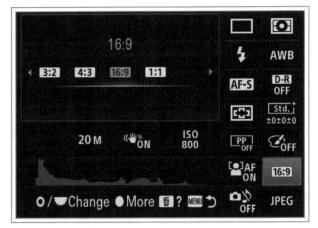

Figure 6-8. Quick Navi Window for Aspect Ratio Setting

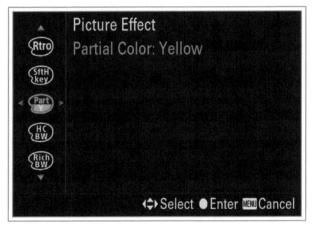

Figure 6-9. Quick Navi Window for Partial Color-Yellow

DIAL/WHEEL LOCK

The Function button can carry out one other operation in shooting mode, depending on how a Camera Settings2 menu option is set. The next-to-last item on screen 10 of that menu is the Dial/Wheel Lock option, which I discussed in Chapter 5. If that option is set to Lock, then, when you press and hold the Function button for several seconds when the shooting screen is displayed, the shooting-related operations of the control wheel and control dial are locked. The wheel and dial will still operate to navigate through menu screens and menu settings, but they will not set items such as exposure compensation, aperture, and shutter speed. The Function button will still operate to use the Function menu and the Quick Navi system, because those features involve short presses of the button.

Chapter 6: Physical Controls | 149

SEND TO SMARTPHONE

When the camera is in playback mode, by default, pressing the Function button brings up a screen allowing you to send the current image or multiple images to a smartphone or tablet, if that function is available. I will discuss this option in Chapter 10, where I discuss the camera's Wi-Fi functions.

You can change the assignment of the Function button, for playback mode only, using the Custom Key (Playback) option on screen 9 of the Camera Settings2 menu, as discussed in Chapter 5.

Playback Button

This button to the lower left of the control wheel, marked with a small triangle, is used to put the camera into playback mode, which allows you to view recorded images and videos on the LCD screen or in the viewfinder. When the camera is in playback mode, pressing this button will switch the camera to shooting mode. When the camera has powered down because of the Power Save Start Time menu option, you can press this button to wake the camera up into playback mode.

Custom/Delete Button

The Custom/Delete button, located at the extreme lower right of the camera's back, can be assigned to one of many functions for use in shooting mode using the Custom Key (Still Images) or Custom Key (Movies) menu option. Whenever a menu screen is displayed, pressing this button calls up the In-Camera Guide help screens, even if that option has not been assigned to this button using the Custom Key menu options.

In playback mode, when an image or video is displayed, this button acts as the Delete button, as indicated by the trash can icon on the button. If you press the button, the camera displays the message shown in Figure 6-10, prompting you to select Delete or Cancel. If you highlight Delete and press the Center button, the camera will delete the image or video that was displayed. If you choose Cancel, the camera will return to the playback mode screen.

This button also has a specialized function that is not obvious. When you have used a focus area menu option such as Zone or Flexible Spot to activate a movable focus zone or frame, and have moved that zone or frame to a new position on the camera's display, you can press the Custom/Delete button to return the zone or frame immediately to the center of the display.

Figure 6-10. Confirmation Screen from Pressing Custom/Delete

Control Wheel and Its Buttons

Several important controls are within the perimeter of the control wheel, the ridged wheel with a large button in its center. The four edges of the wheel (Up, Down, Left, and Right) as well as the middle portion (Center) function as buttons. That is, if you press the wheel at any of those five areas, you are, in effect, pressing a button.

On the a7C, the Up button is permanently assigned as the Display button, which you can press to cycle through the various display screens for the LCD monitor or the viewfinder. The Right and Left buttons have default assignments, but each of them also can be programmed to handle a different function through the Custom Key menu options, as discussed in Chapter 5. The Down button does not have an assignment in shooting mode by default, but it is used to call up index screens in playback mode. It can be assigned to a function for still-image shooting and for movie recording, using the Custom Key menu options. The Center button has various general duties, and also can be assigned to one particular function. Following are details about the control wheel and each of its buttons.

CONTROL WHEEL

In many cases, to choose a menu item or a setting, you can turn this wheel, which is centrally located on the camera's back. In some cases, you have the choice

of using this wheel or pressing the direction buttons. In others, you can turn this wheel or the control dial, located at the upper right of the camera's back.

When the camera is in Shutter Priority mode, this wheel adjusts shutter speed; in Aperture Priority mode, it adjusts aperture. In Manual exposure mode, by default it adjusts shutter speed; you can change that setting so it adjusts aperture using the Dial/Wheel Setup option on screen 9 of the Camera Settings2 menu. The same settings apply when Exposure Mode is set to A, S, or M in Movie or S & Q Motion mode.

You can set this wheel to adjust exposure compensation using the Dial/Wheel EV Compensation option on screen 10 of the Camera Settings2 menu. (That setting does not work in Manual exposure mode. It also does not work in Intelligent Auto mode, in which exposure compensation is not available.)

You can set this wheel to operate a chosen function temporarily when you press an assigned control button to call up a set of My Dial settings that are assigned to this wheel and the control dial, using the My Dial Settings option on screen 9 of the Camera Settings2 menu.

When you are viewing a menu screen, you can navigate up and down through the lists of options by turning the wheel. When you are adjusting items using the Function menu or the Quick Navi menu, you can change the value for the highlighted setting by turning the control wheel. When you are using manual focus and you have the Focus Magnifier or MF Assist option turned on, you can turn the control wheel to choose the area of the scene that is being magnified.

In playback mode, you can turn the control wheel to browse through images and to adjust magnification when an image has been enlarged. When a video is being played on the screen and has been paused, you can turn the control wheel to move the video either forward or in reverse. While a movie is playing, you can use the wheel to fast-forward or fast-reverse the footage.

CENTER BUTTON

The large button in the center of the control wheel has many uses. On menu screens that have additional options, such as the JPEG Image Size screen, this button takes you to the next screen to view the other

options. It also acts as a selection button when you choose certain options. For example, after you select Flash Mode from screen 10 of the Camera Settings1 menu and navigate to your desired option, you can press the Center button to confirm your selection and exit from the menu screen back to the shooting screen.

When the camera is set to manual focus and the MF Assist option is turned on, once you turn the focusing ring on the lens to start focusing, pressing the Center button roughly doubles the magnification of the display: from 5.9 times to 11.7 times. Pressing the button again toggles the display back to the 5.9 times magnification level. (Those values are different when using the APS-C 35mm menu option.) When the Focus Magnifier menu option is turned on, pressing the Center button magnifies the screen when the orange magnifier frame is on the display.

The Center button also has several other possible uses, depending on how it is set up in the menu system. The Custom Key (Still Images) and Custom Key (Movies) options on Screen 9 of the Camera Settings2 menu let you assign a function to the Center Button for either still-shooting or movies, or both.

If you select the Focus Standard option, if focus area is set to a movable setting such as Flexible Spot, pressing the Center button re-activates the screen to adjust the location of the focus frame. Also, when autofocus is in effect and focus area is set to Wide or Center, or to the Wide or Center option for Tracking, pressing the button assigned to Focus Standard causes the camera to focus in the center of the screen.

If you prefer not to use the Focus Standard option, you can assign this button to carry out any one of numerous functions. I discussed those functions in Chapter 5, in connection with the Camera Settings2 menu.

The button also has several miscellaneous functions. For example, in playback mode, you press the Center button to start playing a video whose first frame is displayed on the camera's screen. Once the video is playing, press the Center button to pause the playback and then to toggle between play and pause. When you have enlarged an image in playback mode, you can return it immediately to its normal size by pressing the Center button. When you are selecting images for deletion or protection using the appropriate Playback menu option, you use the Center button to mark or unmark an image for that

Chapter 6: Physical Controls | 151

purpose. When you are setting a custom white balance, you press this button to evaluate the lighting and lock in a new white balance setting.

DIRECTION BUTTONS

Each of the four edges of the control wheel—Up, Down, Left, and Right—is also a "button" you can press to get access to a setting or operation, if the button has had one assigned to it. Sometimes it can be tricky to press in exactly the right spot, but these four buttons are important to control of the camera. You use them to navigate through menus and through screens for settings, whether moving left and right or up and down.

You also can use them in playback mode to move through your images and, when you have enlarged an image, to scroll around within the magnified image.

In addition to the above duties, the direction buttons have functions in connection with various settings. For example, when a movie is being played, pressing the Down button opens the control panel for controlling playback of the movie. In playback mode, pressing this button brings up an index screen showing thumbnails of images and videos. And, as with the Center button, the Right, Left, and Down buttons (but not the Up button) can be assigned to carry out other functions through the Custom Key options on the Camera Settings2 menu, as discussed in Chapter 5.

Finally, one of the direction buttons, the Up button, comes pre-assigned as the Display button, as discussed below.

Up Button: Display

The Up button, marked "DISP," is used to switch among the displays of information on the camera's LCD screen and in the viewfinder, in both shooting and playback modes. As discussed in Chapter 5, you can change the contents of the shooting mode screens using the Display Button option on screen 7 of the Camera Settings2 menu. The display screens that are available in playback mode are discussed in Chapter 7. Because it is dedicated to display duties, the Up button cannot be programmed to perform any other functions.

Left Button

The Left button is assigned by default to bring up the drive mode menu, but it can be assigned to carry out any one or two out of a number of functions for both still shooting and movies, using the Custom Key (Still Images) and Custom Key (Movies) options on screen 9 of the Camera Settings2 menu, as discussed in Chapter 5.

Right Button

The Right button is assigned to adjust ISO by default, but it can be re-assigned to other duties using the Custom Key menu options.

Down Button

The Down button has no assignment for shooting mode by default, but it has the same options as the Left button for having other functions assigned to it. As noted above, in playback mode it calls up index screens.

LCD Monitor

TILTING AND SWIVELING FEATURES

The camera's LCD monitor is not really a "control," but it does allow some physical adjustment. This screen, even without its tilting ability, is a notable feature of the camera. It has a diagonal span of 2.95 inches (7.5 cm) and provides a resolution of 921,600 dots.

The screen can swing outward from the camera's back as much as about 176 degrees. Once it is swung out to the left, it can be rotated up to 270 degrees around its horizontal access, letting it be aimed upward, downward, or forward. It also can be rotated and folded inward against the camera, to protect it from damage.

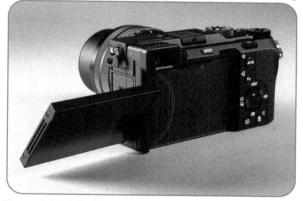

Figure 6-11. LCD Screen Rotated Down for Overhead Shots

When the LCD screen is swiveled out and rotated downward, as shown in Figure 6-11, you can hold the camera high above your head and view the scene as if you were an arm's length taller or were standing on a small ladder. If you attach the camera to a monopod or other support and hold it up in the air, you can extend

the camera's height even farther and still view the screen quite well. You can activate the self-timer before raising the camera up in the air.

You also can use a smartphone or tablet connected to the camera by Wi-Fi to trigger the camera by remote control while it is raised overhead, as discussed in Chapter 10, or you can use one of Sony's remote controls, as discussed in Appendix A.

Figure 6-12. LCD Screen Rotated Up for Low-level Shots

If you need to take images from near ground level, you can rotate the screen so it tilts upward, as shown in Figure 6-12, and hold the camera down as far as you need to get a low-angle view of the scene.

It can be helpful to shoot upward like this when your subject is in an area with a busy, distracting background. You can hold the camera down low and shoot with the sky as your background to reduce or eliminate the distractions. Similarly, you may be able to shoot from a high angle to frame your subject against the ground or floor to have a less-cluttered background. This angle for the display also can be useful for street photography: You can rotate the screen upward and look down at the camera while taking photos of people on the street without drawing undue attention to yourself, especially if you are using a lens with a long telephoto reach.

Figure 6-13. LCD Screen Swiveled Forward for Self-portraits

The screen can also swivel forward, as shown in Figure 6-13, so you can take a self-portrait.

TOUCH SCREEN FEATURES

The second category of special features of the LCD monitor is its limited functionality as a touch screen. I have discussed these features to some extent in earlier chapters, and I will provide a summary of these features here.

For touch screen features to work, you first have to make sure the Touch Operation item on screen 2 of the Setup menu is turned on. To have all touch functions working, go to the Touch Panel/Pad item on screen 3 of that menu and choose Touch Panel + Pad for the setting.

Also, on screen 10 of the Camera Settings2 menu, go to the Function of Touch Operation option and select Touch Shutter, Touch Focus, or Touch Tracking. (For this discussion, I will assume that Touch Focus is chosen, not Touch Shutter or Touch Tracking.)

The camera's touch focus capability when shooting still images works in any shooting mode for stills, and it works with all focus modes except manual focus. The way it works depends on the focus area setting on screen 4 of the Camera Settings1 menu. If that option is set to Wide, Zone, or Center, or to the Wide, Zone, or Center setting for Tracking AF, you can touch the screen where you want the camera to focus, and it will place a small focus frame at that point.

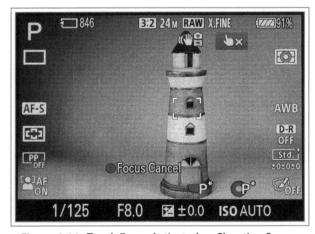

Figure 6-14. Touch Focus Activated on Shooting Screen

You can then proceed to press the shutter button halfway to focus and all the way down to shoot as you would normally, with the focus point at that location. The camera also places a pointing-finger icon and an X

Chapter 6: Physical Controls

on the screen, as shown in Figure 6-14; you can touch that icon, or press the Center button, to cancel the touch focus operation. At that point, the camera will resume its focusing operations as it would with no touch screen in use, though you can always touch the screen again to set a new focus point. You also can drag the focus frame (if any) around the screen with your finger.

If focus area is set to Flexible Spot or Expand Flexible Spot (or the Flexible Spot or Expand Flexible Spot setting for Tracking AF), if you touch the screen, you can drag the focus frame to a new location or set a new focus point outside of the existing frame. In this situation, the camera does not place a cancel icon on the screen.

When Tracking AF is in effect, once the tracking frame has been activated, you can touch the screen to set a new location for the frame. After tracking is canceled, you can touch the screen to start it again.

With Face Priority in AF turned on, you can touch the screen to move the focus point to a different face, or to a point that is not on any face. If Touch Shutter is turned on through the Function of Touch Operation option, you can touch the screen to capture an image.

When the camera is shooting movies, the touch screen operation works somewhat differently than it does with stills. When you touch the screen, the camera uses what Sony calls "spot focus." The camera directs its focus to that point, and it switches the camera into manual focus mode to lock the focus there; you will see the Spot Focus and MF labels appear on the screen, as shown in Figure 6-15.

The camera will stay in manual focus mode until you touch the screen again to choose a new focus point, or you touch the finger icon with the X (or press the Center button) to cancel the spot focus feature and let the camera continue with its normal autofocus system. The camera does not display any focus frame at the point where it directs its focus, but you should be able to see that the focus has become sharp at the selected point.

If you want to create a nice "pull focus" effect for a movie, touch one subject to focus on it. Then, when you are ready to switch the focus to the other subject, touch it, and the camera will change its focus point to the new subject. You can control the speed of the pull-focus transition using the AF Transition Speed option on screen 2 of the Camera Settings2 menu. There is a

considerable difference in the effects produced by using the Slow or Fast setting for that option. If you want a quick, possibly startling focus change, choose Fast (7); for a leisurely, relaxed transition, choose Slow (1) (The default value is 5.)

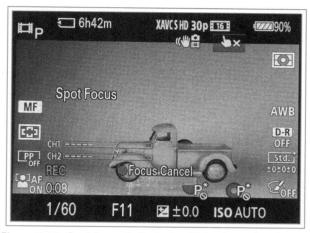

Figure 6-15. Spot Focus Activated on Video Recording Screen

If focus area is set to Flexible Spot or Expand Flexible Spot when recording video, the touch focus operation is somewhat different. In that case, you can still touch a point on the screen to cause the camera to focus at that point, but the camera does not switch into manual focus mode. You can also drag the focus frame to a new position, and the camera will focus at that new location. You can use this dragging action to carry out a "pull focus" effect, as discussed above for the spot focus feature.

You also can use the LCD screen as a touch pad to control focus operations when you are viewing the scene through the viewfinder. The touch focus features can work as described above in that case, but you can change their behavior to some extent with a menu option, Touch Pad Settings, on screen 3 of the Setup menu. If you set the Touch Position Mode option of that menu item to Absolute Position, you can touch any point on the operational area of the screen and the focus will be set there. You also can drag the focus frame, depending on the focus area setting. However, if you set Touch Position Mode to Relative Position, you cannot select a new focus point just by touching the screen; you can only drag an existing focus frame to a new point.

Besides focusing, the a7C offers a couple of other touch screen features. First, when the camera is in playback mode, you can tap the screen twice to enlarge an individual still image. You can then scroll the enlarged

image around with your finger, and tap twice again to return it to normal size. Sometimes it can be difficult to tap at the right speed to get this function to work, but it does work fairly well.

Also, when the camera is in shooting mode with manual focus in use, you can tap the screen twice to call up the Focus Magnifier feature, which enlarges the screen so you can judge the focus. You can scroll the screen around with a finger, and tap twice again to reduce it to normal size.

Ports for Audio, HDMI, and Other Functions

Several important jacks and ports are located on the left side of the camera. Figure 6-16 shows this side of the camera with the protective doors closed. When those doors are opened, the jacks and ports are readily accessible, as seen in Figure 6-17.

Figure 6-16. Left Side of Camera - Port Doors Closed

The top item is the microphone jack, which accepts a standard stereo 3.5mm plug from an external microphone, to upgrade the camera's audio recording for video. If the microphone needs plug-in power, this jack supplies it.

The next item down, under the largest of the three protective doors, is the SD card slot, which was discussed in Chapter 1. This slot accepts standard SD, SDHC, or SDXC memory cards, or micro-SD cards if an adapter is used.

The top item under the lowest protective door is the HDMI port, where you plug in an optional micro-HDMI cable to connect the camera to an HDTV for viewing images and videos. You also can view the shooting display from the camera through this connection, so

you can connect the camera to an HDTV to act as a monitor for your shooting of still images or videos. In addition, you can use this port to output a "clean" HDMI video signal for video production. For example, you can output the video signal to an external video recorder. I discuss that process in Chapter 9.

The next item under the lowest door is the headphones jack, which accepts a standard stereo 3.5mm plug from headphones for monitoring audio during a video recording or for listening to playback of a video.

The bottom-most opening under the lowest protective door is the USB port, where you plug in the USB-C cable that comes with the camera, for charging the battery, powering the camera, or connecting to a computer to upload images and videos. You can also connect the camera to a computer for tethered shooting from the computer, as discussed in Chapter 10. Directly to the left of the USB port is the small charge lamp, which lights up while the battery is charging and turns off when charging is complete.

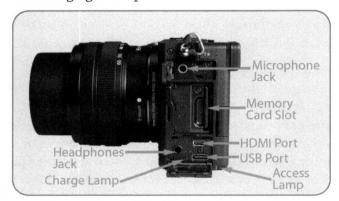

Figure 6-17. Left Side of Camera - Port Doors Open

The access lamp, located at the very bottom of the camera's side just outside the lowest protective door, lights up red when the camera is writing data to a memory card, indicating that you should not remove the battery or memory card while that process is underway.

NFC Active Area

On the right side of the camera is a decorative letter N, which marks the NFC active area for the a7C, as shown in Figure 6-18. This is where you touch the camera against the similar area on a compatible smartphone or tablet that uses the near field communication protocol.

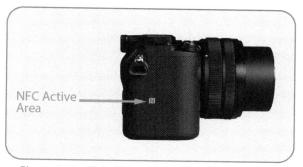

Figure 6-18. Right Side of Camera - NFC Active Area

As discussed in Chapter 10, when the two devices are touched together at their NFC active areas, they should automatically connect through a Wi-Fi connection. Once the connection is established, they can share images and the phone or tablet can control the camera remotely in some ways.

The items on the front of the camera are seen in Figure 6-19.

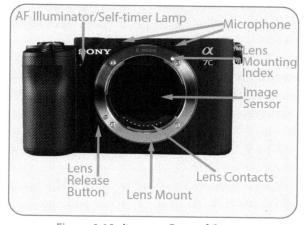

Figure 6-19. Items on Front of Camera

Lens Mount and Lens Release Button

The metallic area around the opening in the front of the camera's body is the lens mount, where you attach a compatible lens. To do this, remove the rear cap from the lens and the body cap from the camera, and, taking care not to let any dust or debris get inside the camera, line up the mounting index on the camera with the similar mark on the lens. Gently push the lens flat against the mount and turn the lens clockwise until it clicks definitely into place.

To remove the lens, press and hold the lens release button and rotate the lens counterclockwise until it comes free from the camera's body. Either attach another lens to the camera or cover the lens mount with the camera's body cap, and place caps on the front and rear of the lens to protect it.

AF Illuminator/Self-Timer Lamp

The lamp on the front of the camera next to the lens has two uses. Its reddish light blinks to signal use of the self-timer and it turns on in dark conditions to assist with autofocusing for still images. You can control the lamp's autofocus function with the AF Illuminator item on screen 5 of the Camera Settings1 menu, as discussed in Chapter 4. If you set that menu item to Auto, the lamp will light as needed for autofocus; if you set it to Off, the lamp will never light for that purpose, though it will still illuminate for the self-timer.

Microphone

The two openings for the camera's built-in stereo microphone are located above the area where the lens sits on the front of the camera. This microphone provides excellent quality for everyday video recording. However, if you need greater quality, there are several options available for using higher-quality external microphones, as discussed in Appendix A.

Bottom of Camera

The final items are on the bottom of the a7C, seen in Figure 6-20. The major items here are the tripod socket and the battery compartment. The battery compartment door has a small flap located at its edge. That flap is provided so you can insert an AC adapter or other power source into the battery compartment and run its cord through the flap, so the compartment's door can be latched securely shut. I will discuss the AC adapter and other power sources in Appendix A.

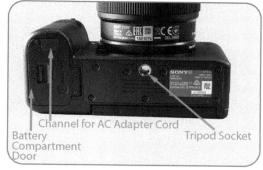

Figure 6-20. Items on Bottom of Camera

CHAPTER 7: PLAYBACK

Normal Playback

irst, you should be aware of the Auto Review option on screen 8 of the Camera Settings2 menu. This setting determines whether and for how long the image stays on the screen for review when you take a new picture. If your major interest for viewing images in the camera is to check them right after they are taken, this setting is all you need to be concerned with. As discussed in Chapter 5, you can leave Auto Review turned off or set it to two, five, or ten seconds.

To control how your images are viewed later on, you need to work with the options that are available in playback mode. For plain review of images, the process is simple. Once you press the Playback button (marked with a triangle icon), the camera is in playback mode, and you will see an image or video saved to the camera's memory card. (Which item is displayed depends on the setting for View Mode, discussed later, as well as on which one was viewed last.)

To move back through older items, press the Left button or turn the control wheel or control dial to the left. To see more recent ones, use the Right button or turn the control wheel or control dial to the right. To speed through the images, hold down the Left or Right button.

Index View and Enlarging Images

In normal playback mode, you can press the Down button to view an index screen of your images and videos. When you are viewing an individual image, press that button, and you will see a screen showing either 9 or 25 images, one of which is outlined by an orange frame, as shown in Figure 7-1.

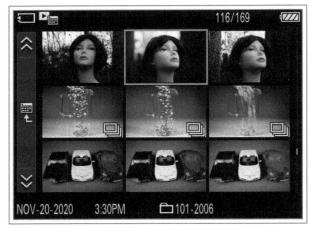

Figure 7-1. Index Screen - 9 Images

(You can choose whether this screen shows 9 or 25 images and videos using the Image Index option on the Playback menu, discussed later in this chapter.)

You can press the Center button to bring up the outlined image or video on the screen, or you can move through the items on the index screen by pressing the Left and Right buttons or by turning the control wheel. If you move the orange highlight to the vertical bar at the far left of the display, as seen in Figure 7-2, you can use the Up and Down buttons to move through the images a screen at a time.

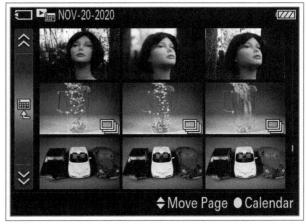

Figure 7-2. Orange Highlight on Bar to Left of Index Screen

Chapter 7: Playback | 157

If you press the Center button while that bar is highlighted, the camera displays the Calendar screen, as seen in Figure 7-3. On that screen, you can move the orange frame to any date and press the Center button to bring up a view with images and videos from that date. If you move the orange highlight to the narrow strip immediately to the left of the calendar, as seen in Figure 7-4, you can move through the items by months with the Up and Down buttons.

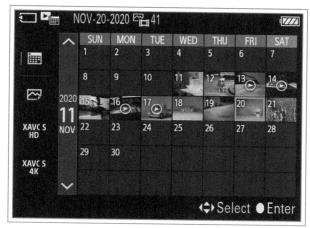

Figure 7-3. Calendar Index Screen

Figure 7-4. Highlight on Bar to Near Left of Calendar Screen

If you move the highlight to the bar at the extreme left of the calendar screen, you can use the Up and Down buttons to move through the four icons that are arranged vertically in that bar, as shown in Figure 7-5. From the top, those icons represent the date view, stillimages view, XAVC S HD videos view, and XAVC S 4K videos view. I will discuss those options later in this chapter, in connection with the View Mode item on the Playback menu.

Figure 7-5. Highlight on Bar to Far Left of Calendar Screen

At any time when you are viewing the thumbnails in the index screen, you can turn the control dial to move through the images and videos a screen at a time.

When you are viewing a single still image, a press of the AF-ON button enlarges the image, with the enlargement centered on the point where the camera used autofocus, if it did so. If the camera did not use autofocus, the camera will zoom in on the center of the image. (You can change this behavior with the Enlarge Initial Magnification and Enlarge Initial Position menu options, discussed later in this chapter.) You will see a display in the lower left corner of the image showing a thumbnail with an inset orange frame that represents the portion of the image that is now filling the screen in enlarged view, as shown in Figure 7-6. This feature is useful for quickly checking the focus of the image.

Figure 7-6. Enlarged Image in Playback Mode

If you keep pressing the AF-ON button, the image will be enlarged to increasing levels. While it is magnified, you can scroll in it with the four direction buttons; you will see the orange frame move around within the thumbnail image. To increase or decrease the magnification level, turn the control wheel. Press the Center button or the Menu button to revert immediately to normal size. You can press the Custom/ Delete button to bring up the Delete screen for the image while it is enlarged. To move to other images while the display is magnified, turn the control dial.

You also can enlarge an image in Playback mode by tapping twice on the LCD screen, if the Touch Operation option on screen 2 of the Setup menu has been set to turn on the touch features of the screen. You can then drag the enlarged image around with a finger, and tap twice again to reduce the image to normal size.

Playback Display Screens

When you are viewing an image in single-image display mode, pressing the Display button (Up button) repeatedly cycles through three playback screens: (1) the full image with no information; (2) the full image with basic information, including date and time it was taken, image number, aspect ratio, aperture, shutter speed, ISO, and image size and quality, as shown in Figure 7-7; and (3) a thumbnail image with detailed recording information, including aperture, shutter speed, ISO, shooting mode, white balance, focal length, DRO setting, and other data, plus a histogram, as shown in Figure 7-8.

Figure 7-7. Playback Display with Basic Information

A histogram is a graph showing distribution of dark and bright areas in the image. Dark blacks are represented by peaks on the left and bright whites by peaks on the right, with continuous gradations in between. With the a7C, the graph's top box gives information about the overall brightness of the image. The three lower boxes contain information about the brightness of the basic colors that make up the image: red, green, and blue.

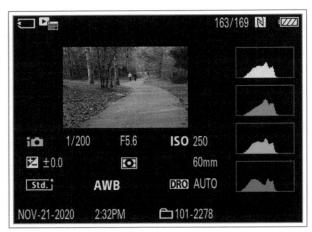

Figure 7-8. Playback Display with Detailed Information and Histogram

If a histogram has higher values bunched at the left side, there is an excessive amount of black and dark areas (high points on the left side of the histogram) and very few bright and white areas (no high points on the right). If the graph runs into the left side of the chart, it means the shadow areas are "clipped"; that is, the image is so dark that some details have been lost in the dark areas. The histogram in Figure 7-9 illustrates this degree of underexposure.

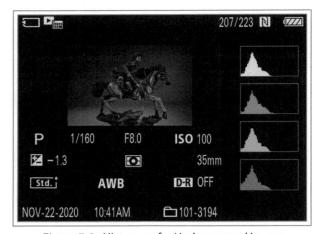

Figure 7-9. Histogram for Underexposed Image

A histogram with its high points bunched on the right means the image is too bright, as shown in Figure 7-10.

If the lines of the graph run into the right side of the chart, that means the highlights are clipped and the image has lost some details in the bright areas.

A histogram for a normally exposed image has high points arranged evenly in the middle. That pattern, illustrated by Figure 7-11, indicates a good balance of light, dark, and medium tones.

Chapter 7: Playback | 159

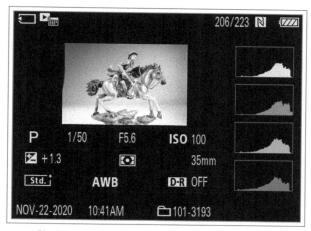

Figure 7-10. Histogram for Overexposed Image

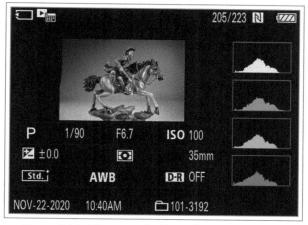

Figure 7-11. Histogram for Normally Exposed Image

When the playback histogram is on the screen, any areas containing highlights that are excessively bright or dark will flash to indicate possible overexposure or underexposure, alerting you that you might need to take another shot with the exposure adjusted to correct that situation.

The histogram is an approximation and should not be relied on too heavily. It can give you helpful feedback as to how evenly exposed your image is. There may be times when it is appropriate to have a histogram skewed to the left or right for intentionally "low-key" (dark) or "high-key" (brightly lit) scenes.

The histogram is not displayed in playback mode for movies; the detailed display includes the thumbnail image, but no shooting information or histogram.

If you want to see the histogram when the camera is in shooting mode, you can turn on that option for the monitor, the viewfinder, or both, using the Display Button option on screen 7 of the Camera Settings2 menu, as discussed in Chapter 5.

Deleting Images with the Delete Button

As I mentioned in Chapter 6, you can delete individual images by pressing the Delete button, also known as the Custom or C button, at the bottom right of the camera's back. If you press this button when a still image or a video is displayed, whether individually or highlighted on an index screen, the camera will display the Delete/Cancel box shown in Figure 7-12.

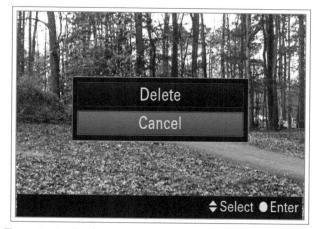

Figure 7-12. Confirmation Screen from Pressing Delete Button

Highlight your choice and press the Center button to confirm. You can delete only single images or videos in this way, except for bursts of continuous shots. If you press the C button while a set of continuous shots is displayed as a group, you can delete all shots in the group at once, as discussed later in this chapter. If you want to delete multiple items that are not part of the same group, you can use the Delete option on the Playback menu, discussed below in this chapter.

Playback Menu

The other options that are available for controlling playback on the a7C appear as items on the Playback menu, whose first screen is shown in Figure 7-13. You get access to this menu by pressing the Menu button and navigating to the menu marked by a triangle icon. Following is information about each item on this menu.

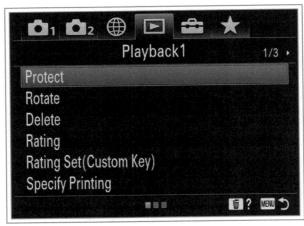

Figure 7-13. Screen 1 of Playback Menu

PROTECT

With the Protect feature, you can "lock" selected images or videos so they cannot be erased with the normal erase functions, including using the Delete button and using the Delete option on the Playback menu, discussed below. However, if you format the memory card using the Format command, all data on the card will be erased, including protected images.

When you select the Protect command, the menu offers you various choices, as shown in Figure 7-14.

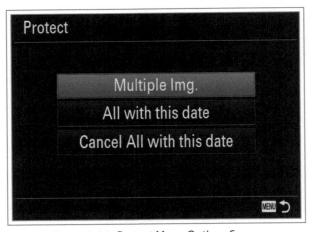

Figure 7-14. Protect Menu Options Screen

These choices may include Multiple Images, All in this Folder, or All with this Date, depending on the current view that has been selected with the View Mode option, discussed below. If you choose Multiple Images, the camera will display the still images or videos with a check box at the left side of each item, as shown in Figure 7-15.

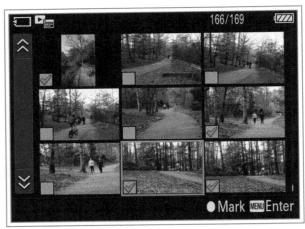

Figure 7-15. Image Selection Screen for Protect Menu Option

The images and videos may be shown individually or on an index screen, depending on whether you started from an individual image or an index screen. You can change from the full-screen view to the index view by pressing the Down button, even after choosing the Protect option.

Scroll through the images and videos with the control wheel, the control dial, or the Left and Right buttons. When you reach an item you want to protect, press the Center button to place a check mark in the box for that item. To unmark an image or video, press the Center button again. Continue with this process until you have marked all items you want to protect. Then, press the Menu button to move to the next screen, where the camera will prompt you to highlight OK or Cancel, and press the Center button to confirm. If you select OK, all of the marked items will be protected. If you want to cancel before you have marked any items, press the Playback button to return to normal playback mode.

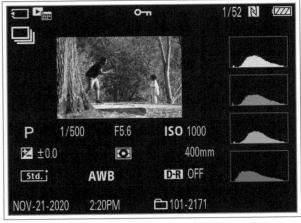

Figure 7-16. Protected Image with Key Icon at Top

Chapter 7: Playback | 161

If, instead of Multiple Images, you choose All in this Folder or All with this Date, the camera will display a screen asking you to confirm protection of all of those files. Any image that is protected will have a key icon in the top center of the display in playback mode, as shown in Figure 7-16.

To unprotect all images or videos in one operation, select the appropriate Cancel option from the Protect item on the Playback menu. That option will prompt you to Cancel All with this Date or to Cancel All in this Folder, depending on the View Mode setting.

ROTATE

The Rotate menu option gives you a way to rotate an image. Select this menu item, and you will see a screen like that in Figure 7-17, prompting you to press the Center button to rotate the image. Each time you press the button, the image will rotate 90 degrees counterclockwise. You can use this option for images taken vertically, when the Display Rotation option, discussed later in this chapter, is off. This option will be dimmed if View Mode is set to a view for videos only.

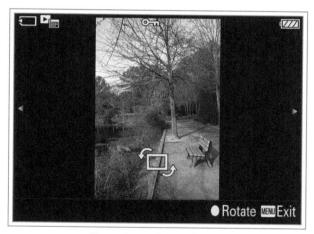

Figure 7-17. Rotate Screen

DELETE

The Delete menu item lets you erase multiple images and videos from your memory card in one operation. (If you just want to delete one or two items, it's usually easier to display each one on the screen, then press the Delete button and confirm the erasure.)

The procedure for using this option is similar to the one for protecting images, discussed earlier. The menu screen offers you two choices, as shown in Figure 7-18.

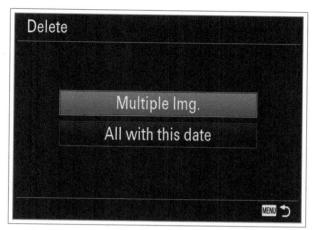

Figure 7-18. Delete Menu Options Screen

If you select Multiple Images, the camera will present you with either index screens or individual images. As with the Protect option, you can scroll through your images and videos and mark any item's check box for deletion by pressing the Center button. When you have finished marking them, press the Menu button and the camera will display a confirmation screen. If you select OK to confirm, the marked items will be deleted.

If you choose All in this Folder or All with this Date, the camera will display a screen asking you to confirm deletion of all of those files. If any images have a key icon displayed at the top, those images are protected, and cannot be deleted using this option unless you first unprotect them, as discussed earlier in this chapter.

RATING

This option lets you assign a rating from one to five stars to any still image. (This option does not work for movies or for images displayed as a group, taken as a burst.) When you select this item, the camera displays a rating selection screen, as shown in Figure 7-19.

Use the Left and Right buttons or turn the control wheel to display an image to be rated. When it is displayed, press the Center button and the camera will display a screen like that in Figure 7-20.

On that screen, press the Left and Right buttons or turn the control wheel or control dial to select a rating. The camera will change the number of orange stars at the top of the image.

When the star rating is changed as you want, press the Center button to confirm, and the stars at the top of the image will turn white, indicating the final rating, as shown in Figure 7-21. The rating you assigned will show up in software that reads such metadata, such as Adobe Bridge and Sony's Imaging Edge, and it will appear on all display screens in playback mode when the image is viewed on the camera.

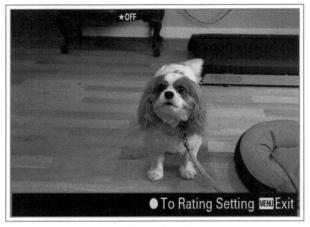

Figure 7-19. Initial Screen for Rating Menu Option

Figure 7-20. Screen to Adjust Number of Start for Rating

Figure 7-21. Screen with White Stars for Final Rating

RATING SET (CUSTOM KEY)

This menu option works in conjunction with the ability to assign a control button to the Rating option using the Custom Key (Playback) option on screen 9 of the Camera Settings2 menu. If you assign a button to the Rating option, you can use the Rating Set (Custom Key) menu option to choose the number of stars to be assigned by that button.

So, for example, if you choose three stars, then, in playback mode, if you press the assigned control button when a single still image is displayed, that image will be assigned a rating of three stars. If you choose more than one number of stars, you can use successive presses of the assigned button to cycle through those settings. For example, if you select one, three, and five stars as the available ratings for the assigned button, then, when you first press the button in playback mode, the camera will display one star on the image. If you press the button a second time, it will display three stars, and a third press will produce a rating of five stars.

Specify Printing

This option lets you use the DPOF (Digital Print Order Format) function, a standard printing protocol that is built into the camera. The DPOF system lets you mark various images on your memory card to be added to a print list, which can then be sent to a printer. Or, you can take the memory card to a commercial printing company to print out the selected images.

Figure 7-22. Specify Printing - Main Options Screen

To add images to the DPOF print list, select the Specify Printing option from the Playback menu. On the next screen, shown in Figure 7-22, select Multiple Images. Chapter 7: Playback | 163

The camera will display the first image with a check box at the left, or an index screen with an orange frame around the currently selected image and a check box in the lower-left corner of each image thumbnail, as shown in Figure 7-23.

Figure 7-23. Specify Printing - Image Selection Screen

You can choose to display individual images or index screens using the Down button. There will be a small printer icon in the lower left of the display with a zero beside it at first, meaning no copies of any images have been set for printing yet. Use the control wheel, control dial, or direction buttons to move through the images.

When an image you want to have printed is displayed, press the Center button to mark it for printing. Press that button again to unmark it. If you want to mark all images in a folder or for a date, scroll until you find and highlight with an orange line the box for that folder or date, and press the Center button to mark it. However, if the number of images to be marked exceeds the allowable limit of 100 images, that operation will not succeed.

You can keep browsing through your images and adding (or subtracting) them from the print list. As you add images to the list, the DPOF counter in the lower left corner of the display will show the total number of images selected for printing. You cannot use this function to print more than one copy of any given image. You cannot specify printing for Raw files, movies, or images in a group of continuous-shooting images while the group is expanded or displayed as a group. If you want to print images from such a group, you have to set the Display as Group option to Off on screen 3 of the Playback menu, or set View Mode to Folder View (Still) on that menu screen.

When you have finished selecting images to be printed, press the Menu button to move to a screen where you can confirm your choices by selecting OK.

You also can turn the Date Imprint option on or off to specify whether or not the pictures will be printed with the dates they were taken. To do this, go to the first screen of the Specify Printing menu option and select Print Setting. On the next screen, shown in Figure 7-24, set Date Imprint to On and then select Enter, to specify that the date should be printed on each image.

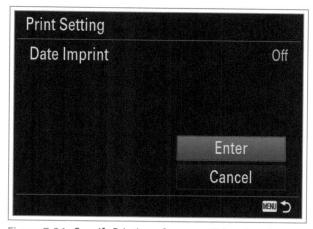

Figure 7-24. Specify Printing - Screen to Select Date Imprint

You can take the memory card with the DPOF list to a service that prints photos using this system. If you want to cancel a DPOF order, select the Specify Printing menu item, and choose the Cancel All option on the next screen.

The items on screen 2 of the Playback menu are shown in Figure 7-25.

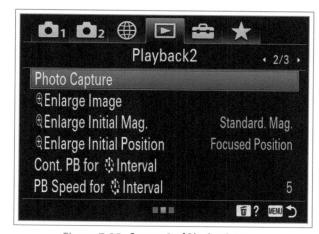

Figure 7-25. Screen 2 of Playback Menu

PHOTO CAPTURE

This next option on the Playback menu gives you tools for saving one or more frames from a movie that was recorded with the camera. To use this option, first, find the movie that you want to save a still image from. You can use the View Mode option discussed later in this chapter to find movies of various formats, to help narrow the search. If View Mode is set to Folder View (Still), this option will not be available for selection.

When you have the chosen movie displayed on the screen in playback mode, select the Photo Capture menu option, and the camera will display the movie again, but this time with a circular area with several icons at the right side of the display that represent the camera's direction buttons and Center button, as shown in Figure 7-26.

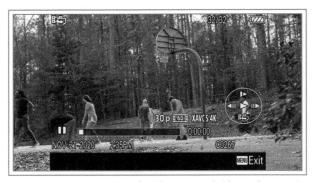

Figure 7-26. Movie Displayed in Camera with Photo Capture Icons

The top icon represents slow playback; the right one is for single-frame forward when paused; the left one is for single-frame reverse when paused; the center one is for play or pause; and the bottom one is for photo capture. When the movie is playing, the Right and Left buttons carry out fast-forward and fast-reverse, respectively. To find the exact frame you want, move to the approximate part of the film where it is located, then pause the film and use the Right and Left buttons to locate the exact frame you are looking for.

Using the four direction buttons and the Center button according to that scheme, play the movie to the exact frame you want to save, then press the Down button to capture the frame as a still image. The camera will display a Processing message briefly, and then will save the image to the memory card. The image will have the same resolution as the movie from which it was saved. For example, if you save a frame from a 4K movie, it will have a resolution of 3840 x 2160 pixels, or about eight

megapixels. Images captured from standard HD movies will be 1920 x 1080 pixels in resolution.

If you prefer, you can start the Photo Capture process without using the menu system. To do that, start a movie playing, and press the Center button to pause it. Then press the Down button, and you will see a control panel at the bottom of the screen, as shown in Figure 7-27.

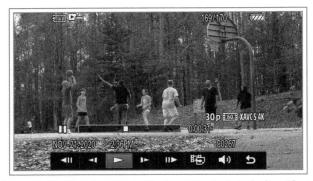

Figure 7-27. Detailed Movie Playback Controls Including Photo Capture

The Photo Capture icon is the third one from the right. Use the direction buttons to navigate to that icon and select it, to start using the Photo Capture feature. Figure 7-28 is a frame that was saved from a 4K video using this feature.

Figure 7-28. Frame Saved from 4K Video Using Photo Capture

ENLARGE MAGE

This option performs the same image magnification discussed earlier, which you can also do by pressing the AF-ON button or by tapping on the screen twice, if the touch screen features are enabled. When you select this option, the enlarged image will appear on the screen; you can use the control wheel to change the enlargement factor. When the image is enlarged, you can press the Center button or the Menu button, or tap twice on the screen, to return the image to normal size. You can move the enlarged image around the

screen with your finger, if the touch screen is turned on, or with the direction buttons. You can turn the control dial to move to other images at the current magnification level.

ENLARGE INITIAL MAGNIFICATION

This option lets you choose either Standard Magnification or Previous Magnification, as shown in Figure 7-29. With the Standard Magnification option, when you use any of the techniques mentioned above to enlarge an image in playback mode, the camera uses the standard magnification factor.

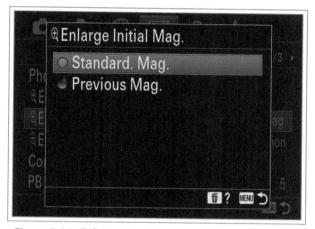

Figure 7-29. Enlarge Initial Magnification Options Screen

If you choose Previous Magnification, the camera will use whatever magnification level was used for the last image that was viewed. So, if you like to zoom your images in with three presses of the AF-ON button, you can choose Previous Magnification for this option, and, once you have enlarged one image to that degree, other images will be enlarged to that degree when you first press the button or use another method to enlarge them.

ENLARGE INITIAL POSITION

This option lets you choose whether, when an image is enlarged, the camera centers it on the point where focus was achieved (if any), or on the center of the image. The menu options screen is shown in Figure 7-30.

To check focus in playback mode, it can be convenient to have the enlarged image automatically centered on the focus point. For that option, choose Focused Position from this menu screen, which is the factory default setting

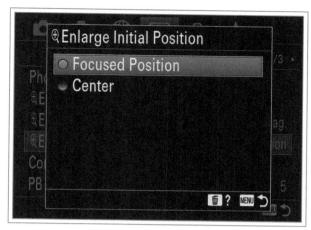

Figure 7-30. Enlarge Initial Position Options Screen

CONTINUOUS PLAYBACK FOR INTERVAL SHOOTING/PLAYBACK SPEED FOR INTERVAL SHOOTING

These two options work together to control the playback of a group of shots taken using the Interval Shooting option on screen 3 of the Camera Settings1 menu, also known as the time-lapse option.

To use these options, first, highlight Continuous Playback for Interval on the menu and press the Center button to activate it. Then, navigate to a group of shots taken with the Interval Shooting option. When you have located the group of shots, leave one of them on the camera's monitor in playback mode. If the Display as Group option on screen 3 of the Playback menu is turned on, the images in the group will be displayed as a single image that looks like a stack of frames.

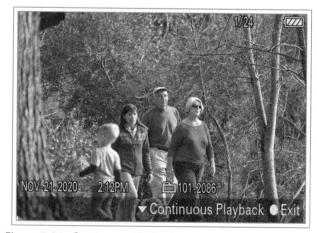

Figure 7-31. Continuous Playback Screen - Icon to Press Down Button to Play Images Again

Then, with a single image or group of images displayed, press the Center button, and the images should play

back quickly in a continuous stream. Press the Down button when the camera displays the screen shown in Figure 7-31, to play the images again. You can change speed of playback with the control wheel or control dial, or by using the Playback Speed for Interval Shooting option on screen 3 of the Playback menu.

This feature also provides continuous playback of images shot with the continuous shooting option of drive mode.

The items on screen 3 of the Playback menu are shown in Figure 7-32.

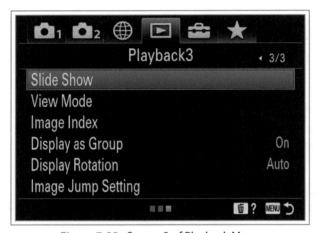

Figure 7-32. Screen 3 of Playback Menu

SLIDE SHOW

This feature lets you play your still images and videos in sequence at an interval you specify. This menu option will be dimmed and unavailable if the View Mode option on the Playback menu is set to either of the two XAVC S View settings. If that is the case, use the View Mode menu option to select either Date View or Folder View (Still). If you select Date View, the Slide Show option will display all of your movies, in all formats, along with your still images. Each movie will play in full before the show advances to the next item, unless you interrupt it with one of the controls. If you select Folder View (Still), the Slide Show option will display only the still images from the folder you selected.

When you select the Slide Show option and press the Center button, the next screen has two options you can set: Repeat and Interval, as seen in Figure 7-33. If Repeat is turned on, the show will keep repeating; otherwise, it will play only once.

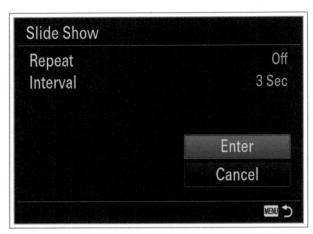

Figure 7-33. Slide Show Menu Options Screen

The camera will not power off automatically in this mode, so be sure to stop the show when you are done with it. The Interval setting, which controls how long each still image stays on the screen, can be set to one, three, five, ten, or 30 seconds. (The Interval setting does not apply to movies, each of which plays to its end.)

With the options set, navigate to the Enter box at the bottom of the screen using the control wheel, the control dial, or the Down button, and press the Center button to start the show. You can move forward or back through the images (and videos, if included) using the Right and Left buttons. Hold the buttons down to move quickly through the images and videos.

You can stop the show by pressing the Menu button or the Playback button. There is no way to pause the show and resume it. You can control the volume for movies at any time by pressing the Down button and adjusting the level with the Left and Right buttons or with the control wheel or control dial. Each movie plays fully before the next movie or image is displayed, but you can skip to the next movie or image using the Right button.

The Slide Show option does not provide settings such as transitions, effects, or music. You cannot select which images to play; this option just plays all still images from the selected folder, if you are using Folder View, or all still images and videos starting from the selected date, if you are using Date View.

VIEW MODE

This second option on screen 3 of the Playback menu lets you choose which images or videos are currently viewed in playback mode. The options are Date View,

Folder View (Still), XAVC S HD View, and XAVC S 4K View, as shown in Figure 7-34.

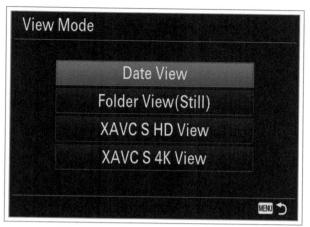

Figure 7-34. View Mode Menu Options Screen

If you select Date View, the camera will display the calendar screen shown earlier in Figure 7-3. You can navigate through the dates for a given month using the control wheel or the direction buttons. Highlight a date and press the Center button; the camera will display all images and videos starting from that date. You can move to other screens of images using the control dial.

If you select Folder View (Still), the camera will display the screen shown in Figure 7-35, which shows the folders available for selection.

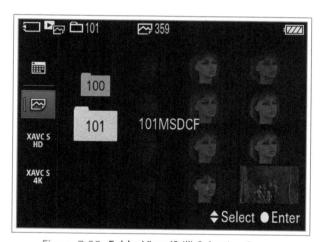

Figure 7-35. Folder View (Still) Selection Screen

Highlight the folder you want (there may be only one) and press the Center button; the camera will display all still images in that folder. You can navigate through the index screens for those images and select the image or images you want to view.

If you select XAVC S HD View or XAVC S 4K View, the camera will display a calendar screen showing the dates on which videos in the selected format were recorded. You can highlight any date with a thumbnail image and press the Center button to move to a video from that date.

My preference is to use the Date View option, because then I can view both images and videos from any date. However, if I want to locate a particular video, it can be quicker to choose one of the video views so I can limit my search to videos only.

You can select a view option from an index screen without using the Playback menu. When you are viewing the calendar display or the folder display, you can move the highlight to the line of four icons at the left of the screen that represent these four view modes, and select one of the modes from that display by highlighting its icon and pressing the Center button.

MAGE INDEX

This menu option, shown in Figure 7-36, gives you the choice of having the camera include either 9 images and videos or 25 images and videos when it displays an index screen.

Figure 7-36. Image Index Menu Options Screen

When you make this selection, the camera displays the index screen you chose, and it will display that screen whenever you call up the index screen using the Down button, as discussed earlier.

Whether you choose the 9-image screen or the 25-image screen depends on your personal preference as well as some other factors, including how many images and videos you have altogether and how easy

it is to distinguish one from another by looking at the small thumbnail images.

The thumbnails on the 9-image screen are considerably larger than those on the 25-image screen, and it may make sense to choose the 9-image screen unless you have so many images that it would be burdensome to scroll through them 9 at a time.

The Image Index menu option will be dimmed and unavailable for selection if there are no items available to view for the currently selected View Mode option. For example, if you have not recorded any 4K videos but View Mode is set to XAVC S 4K View, the Image Index item will not be available for selection.

DISPLAY AS GROUP

This option controls how the camera displays still images that were captured using the continuous shooting setting for drive mode or the Interval Shooting option on screen 3 of the Camera Settings1 menu. If this option is turned on, those images are displayed as a group that behaves like a single image.

Figure 7-37. Burst of Images Displayed as Group

For example, Figure 7-37 shows the playback screen when a group of continuous shots is displayed in the camera. The group is displayed in a stack, as indicated by the edges of the image frames at the right side of the screen. This group of images acts as a single image when scrolling through the images on the memory card. If you press the Custom/Delete button when this group is displayed, the camera displays the message shown in Figure 7-38, announcing that deleting this item will delete all images in the group.

Figure 7-38. Confirmation Screen to Delete Entire Group of Images

The message at the lower right of the screen in Figure 7-37 indicates that you can press the Center button to expand the group.

Figure 7-39. Image from Burst Displayed Individually

If you press that button, the display changes to one like that shown in Figure 7-39, which shows a single image in the group, and indicates by the numbers in the upper right corner that this is the first of 24 images in the group. Now you can scroll through all of those images individually and delete any one of them or otherwise manipulate it as needed. When you are finished viewing the images individually, you can press the Center button again to end the expansion, and view the images as a single group again.

If you turn off the Display as Group menu option, the images always display individually, rather than as a group. Also, it is important to note that this option works only when View Mode is set to Date View. With any other setting for View Mode, continuous-shooting

and interval-shooting images will display individually regardless of the setting for this menu item.

DISPLAY ROTATION

This next item on the Playback menu controls whether images shot with the camera held vertically appear that way when you play them back on the camera's screen. By default, this option is set to Auto, meaning images taken vertically are automatically rotated so that the vertical shot appears in portrait orientation on the horizontal display, as shown in Figure 7-40.

Figure 7-40. Image Captured Vertically Displayed on Horizontal Screen

Figure 7-41. Image Captured Vertically Displayed at Full Size

What is unusual about this setting is that, if you tilt the camera sideways so one side is up, a vertical image will rotate to fill the screen, as shown in Figure 7-41. In this way, you get the best of both worlds: Vertical images display in proper orientation (but smaller than normal) within the horizontal display, and, when you tilt the camera, they display at full size.

If you change the setting to Manual, a vertical image will appear vertically on the horizontal screen, in the same way as shown in Figure 7-40. The difference with this setting from Auto is that, if you tilt the camera, the image will not change its orientation.

If you set this option to Off, then a vertical image will display in landscape orientation on the display, as shown in Figure 7-41, so you would have to tilt the camera to see it in its proper orientation.

With all of these settings, you can use the Rotate option on the Playback menu, discussed earlier in this chapter, to rotate an image manually to a different orientation.

IMAGE JUMP SETTING

This final option on the Playback menu gives you a way to set one of the camera's dials to "jump" only to a certain category of images in playback mode, to help you locate a particular image more quickly than you can by scrolling through every image.

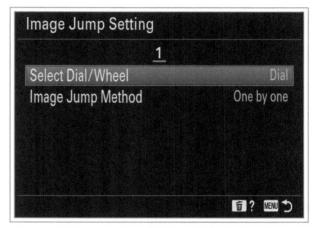

Figure 7-42. Image Jump Setting - Main Options Screen

When you select this option and press the Center button, the camera displays the screen shown in Figure 7-42, with options for Select Dial/Wheel and Image Jump Method. With the first option, you can select either the control dial (on the top edge of the camera's back) or the control wheel (on the back of the camera) as the control that will jump only to certain images. The control you do not select will continue to scroll through all of the images and videos one by one.

Next, go to the Image Jump Method option and select it to bring up the screen shown in Figure 7-43 with several options for the jump method. You can set the selected wheel or dial to move through images one by one; by tens or hundreds; to jump only to images protected using the Protect option, discussed earlier in this chapter; to jump only to images with some rating; to jump to images with a specific rating; or to jump to images with no rating. (You have to scroll down with the Down button or the control wheel to see all of the options.)

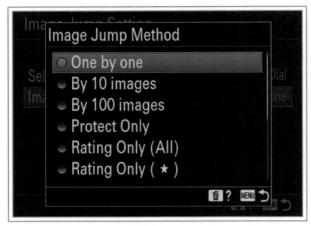

Figure 7-43. Image Jump Method - Options Screen

After you have made your selection, you can use the selected control to jump as you chose. That control will jump only to still images; it will always skip over videos unless you choose to jump by ones, tens, or hundreds. (If you want to view only videos, you can use the View Mode menu option, discussed earlier.) The Image Jump Method feature works with settings other than jumping by numbers of images only when View Mode is set to Date View. With any other setting, the selected control will scroll through all images and videos one by one, in the normal way.

CHAPTER 8: THE SETUP MENU AND MY MENU

In earlier chapters, I discussed the options available in the Shooting and Playback menu systems. The Sony a7C has one other menu system that helps you set up the camera and customize its operation—the Setup menu. In addition, the camera includes the My Menu feature, which you can use to create your own shortened menu with up to 30 of your most-used options, for quick access. In this chapter, I will discuss the use of the Setup and My Menu options. I'll discuss details of menu options for Movie mode in Chapter 9 and I'll discuss the options on the Network menu in Chapter 10.

Setup Menu

The Setup menu, represented by the toolbox icon, has its tab to the right of the tab for the Playback icon on the line of menu icons. The first screen of the Setup menu is shown in Figure 8-1. This six-screen menu contains options that control technical matters such as USB connections, display brightness, audio volume, file numbering, formatting a memory card, and others. I will discuss each menu item below.

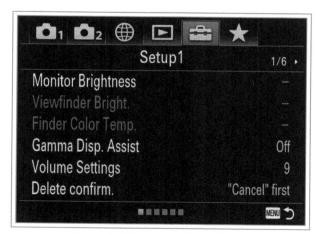

Figure 8-1. Screen 1 of Setup Menu

MONITOR BRIGHTNESS

When you highlight and select this menu option, the camera first displays a screen that shows the current setting, as seen in Figure 8-2.

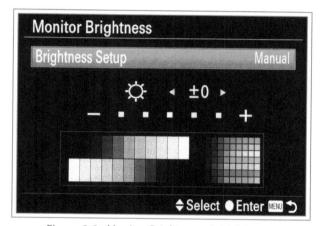

Figure 8-2. Monitor Brightness - Initial Screen

If you press the Center button with the current setting highlighted, you will see a screen for choosing one of two available settings for controlling the brightness of the LCD display: Manual or Sunny Weather, as shown in Figure 8-3.

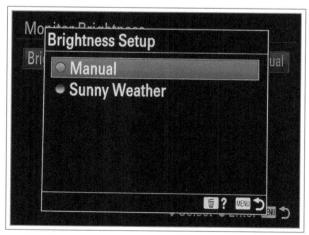

Figure 8-3. Monitor Brightness - Brightness Setup Selection Screen

If you choose Manual, the camera displays the screen shown earlier in Figure 8-2. Using the controls on that screen, you can adjust brightness to one or two units above or below normal. After pressing the Down button or turning the control wheel to highlight the brightness scale, press the Left or Right button or turn the control dial to make the adjustment.

If your battery is running low and you don't have a spare, you may want to set the monitor to its minimum brightness to conserve power. Conversely, you can increase brightness if you're finding it difficult to compose the image on the screen.

If you are shooting outdoors in bright conditions, you can choose Sunny Weather, which sets the display to a very bright level. Of course, you can switch to using the viewfinder in bright conditions, but there may be times when you want to hold the camera away from your head as you compose the shot, even in bright sunlight. Or, you may want to play back your images for friends or colleagues while outdoors. The Sunny Weather setting drains the camera's battery fairly rapidly, so you should turn it off when it is no longer needed.

VIEWFINDER BRIGHTNESS

This second option on the Setup menu is similar to the Monitor Brightness selection, discussed above, but it has some differences. With this option, you have to be looking into the viewfinder to make adjustments. There is no Sunny Weather setting, because the viewfinder is shaded from the sun and there is no need for a superbright setting. You can set the brightness to Auto or Manual. If you select Manual, you can make the same adjustments as with the LCD screen. If you select Auto, the camera adjusts the brightness according to ambient lighting conditions. Again, there is not much need for brightness adjustments because the view is always shielded from outside light.

When Finder Frame Rate on screen 7 of the Camera Settings2 menu is set to High, the only available option for Viewfinder Brightness is Manual.

FINDER COLOR TEMPERATURE

This option lets you adjust the color temperature of the view through the viewfinder. As with the Viewfinder Brightness setting, you have to look into the viewfinder to make the adjustments. You can use the camera's

controls to adjust the color temperature downward by one or two units, which will make the view appear slightly more reddish, or "warmer," or you can adjust upward by one or two units to make it more bluish, or "cooler."

I have not found a reason to take advantage of this adjustment, but, if it is helpful to you, it is easy to use.

GAMMA DISPLAY ASSIST

This option is a specialized one intended for use only if you are using a Picture Profile setting that includes the S-Log2, S-Log3, HLG, HLG1, HLG2, or HLG3 setting for gamma. As I discussed in Chapter 4, those gamma options are special settings that enable the camera to record video with an extended dynamic range, so it can record scenes clearly even if there is considerable contrast between shadowed areas and bright ones. One characteristic of the S-Log and HLG settings is that the image on the camera's display screen will appear quite dark and low in contrast. In order to take advantage of the high dynamic range available with the S-Log settings, the footage needs to be processed with software that can deal with the video files properly. For the HLG settings, the footage needs to be viewed on an HDR-compatible monitor to be appreciated fully.

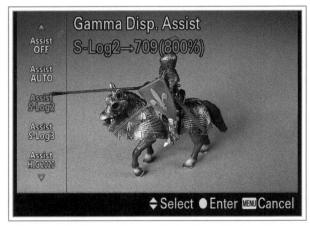

Figure 8-4. Gamma Display Assist Menu Options Screen

Therefore, Sony has provided the Gamma Display Assist option so you can clearly view a scene being recorded or played back with one of the listed gamma settings in effect. When Gamma Display Assist is activated, the images on the camera's display will be boosted in contrast to a level that makes it appear as if a more standard setting was used—specifically, the

ITU709(800%) setting, the HLG(BT.2020) setting, or the HLG(709) setting.

This option has six settings: Off, Auto, S-Log2, S-Log3, HLG 2020, and HLG 709, as shown in Figure 8-4.

If you choose Off, the option is not activated in any situation, and video shot with an S-Log or HLG gamma setting will appear rather dark and low in contrast, as it normally would. If you choose Auto, the camera will boost the contrast of the display if the Picture Profile setting in use includes an S-Log or HLG gamma setting. (The PP7 setting for Picture Profile includes the S-Log2 setting by default; the PP8 and PP9 settings include S-Log3; and PP10 includes HLG2. You can change any Picture Profile setting to include any of the S-Log or HLG settings, as discussed in Chapter 4.)

If you choose either of the other settings for Gamma Display Assist, labeled as S-Log2, S-Log3, HLG 2020, and HLG 709, the camera always boosts the contrast of the video (or still image) on the display, regardless of the Picture Profile setting.

My preference is to leave this option turned off. I do not have difficulty viewing the display when an S-Log or HLG gamma setting is in use. However, if you are having a problem viewing the scene on the display screen when using one of those settings, this menu option might be useful. It also can be useful to provide a preview of how the footage will look when properly processed or when viewed on the proper type of monitor.

VOLUME SETTINGS

This option lets you set the volume for video playback at a level anywhere from 0 to 15, with a default value of 7. You can also set this level when a movie is playing by pressing the Down button to get access to the detailed controls, which include a volume setting option.

DELETE CONFIRMATION

This menu item has two options as shown in Figure 8-5: "Delete" First or "Cancel" First. This option lets you fine-tune the way the menu system operates for deleting images. Whenever you press the Delete button to delete an image or video in playback mode, the camera displays a confirmation screen, as shown in Figure 8-6, with two choices: Delete or Cancel.

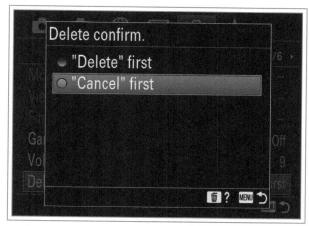

Figure 8-5. Delete Confirmation Menu Options Screen

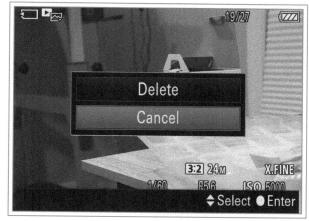

Figure 8-6. Confirmation Screen from Pressing Delete Button

One of those choices will be highlighted when the screen appears; you can then just press the Center button to accept that choice and the operation will be done. Of course, you also can use the control wheel, control dial, or Up or Down button to highlight the other choice before you press the Center button to carry out your choice.

Which option you choose for this menu item depends on your habits, and how careful you want to be to guard against the accidental deletion of an item. If you like to move quickly in deleting images and videos, choose "Delete" first. Then, as soon as the confirmation screen appears, you can press the Center button to carry out the deletion. If you prefer to have some assurance against an accidental deletion, choose "Cancel" first, so that, if you press the Center button too quickly when the confirmation screen appears, you will only cancel the operation, rather than deleting an image.

Unless you use this process often and need to save time, I recommend you leave this menu item set at the "Cancel" First setting to be safe.

The options on screen 2 of the Setup menu are shown in Figure 8-7.

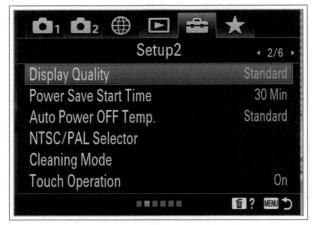

Figure 8-7. Screen 2 of Setup Menu

DISPLAY QUALITY

This menu item lets you choose Standard or High for the quality of the display. According to Sony, with the High setting the camera displays the live view on the LCD screen or in the viewfinder at a higher resolution than with the Standard setting, at the expense of additional drain on the battery.

I have tried experiments with these settings, viewing small print from a catalog using both the viewfinder and the LCD display with both Display Quality settings, and I have not found a noticeable difference. There may be situations in which this option has a more obvious impact on the display, but my recommendation is to leave it at Standard to conserve battery life.

POWER SAVE START TIME

This menu option lets you set the amount of time before the camera turns off automatically to save power, when no controls have been operated. The default setting is one minute; with this option you can also choose two, five, or thirty minutes, or ten seconds, as shown in Figure 8-8.

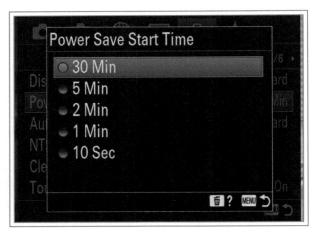

Figure 8-8. Power Save Start Time Menu Options Screen

When the camera goes to sleep with this option, you can wake it up by half-pressing the shutter button, or by pressing the Menu button or the Playback button. These presses will place the camera into shooting mode, the menu system, and playback mode, respectively.

You cannot turn the power-saving function off. However, the camera will not power off automatically when you are recording movies, when a slide show is playing, when the camera is connected to a computer, when it is being powered through the USB port, during an FTP transfer operation, or when Bluetooth Remote Control on screen 2 of the Network menu is turned on.

The setting you use depends on your habits and needs. In my case, I am usually well aware of the camera's status, and I like to use the maximum thirty-minute period for this option so the camera does not power down just when I am about to use it again. I always have extra batteries available and I'm not too concerned if I have to replace the battery. If you are out in the field and running low on battery power, you might want to choose a shorter time for this option to conserve battery life.

AUTO POWER OFF TEMPERATURE

This option lets you set the temperature at which the camera powers off automatically to keep it from overheating. The choices are Standard or High. I generally leave this option set to Standard. However, in an unusual case, such as if you are recording 4K video of a one-time event and you don't want the camera to power off in the middle of the event, you might want to set this menu item to High, to avoid a premature shutdown of the camera. In that case, Sony warns

that the camera may become hot enough to cause "low temperature burns" of your hands.

NTSC/PAL SELECTOR

This menu option controls which television system the camera uses for recording videos—NTSC or PAL. The NTSC system is used in the United States and other parts of North America, as well as Japan, South Korea, and some other countries. The PAL system is used in many parts of Asia, Africa, and Europe.

For purposes of using the a7C camera, the difference between the two settings is that the NTSC system uses multiples of 30 for video frame rates (such as 30, 60, or 120 frames per second), while the PAL system generally uses multiples of 25, such as 25, 50, or 100 frames per second. You will see these differences in the options for the Record Setting item on screen 1 of the Camera Settings2 menu. If you choose NTSC, the options will be mostly in multiples of 30, although there will be some entries for 24 fps, another NTSC standard. If you choose PAL, the options will be in multiples of 25.

In general, you should use the setting that is standard for the area where you will be using the camera. I live in the United States, so I set the camera to NTSC, where the frame rates are in multiples of 30 (except for the few 24p options).

Figure 8-9. Warning Message for Changing from NTSC to PAL

It is important to choose this setting before you start recording files on your memory card. Once you have started using a card under one of these systems, you cannot change to the other system without restarting the camera under the new system. When you select this menu option, you will see the message shown in Figure 8-9, warning that you will have to re-boot the camera

to continue, and you will not be able to play movies recorded under the original video system, once the camera has been re-booted.

If you then select Enter and press the Center button, the camera will proceed to convert its settings to the other video system.

CLEANING MODE

The image sensor is the shiny area immediately behind the lens, which is visible when the lens is removed. This menu option is provided to help you keep the sensor clean. If specks of dust accumulate on the sensor, they can cause dark spots to appear on images.

To use this option, with a lens attached, select this menu item and press the Center button to confirm. The camera will shake the sensor slightly to dislodge any dust. The camera will then prompt you to turn the power off. If you want to go further with the cleaning operation, you can remove the lens and clean the sensor manually with an air blower or other tools. Sony provides information on this process at http://support.d-imaging.sony.co.jp/www/support/ilc/sensor/index.php.

TOUCH OPERATION

As discussed in earlier chapters, you can control some operations of the a7C by touching the LCD screen on the back of the camera. As discussed in Chapter 6, with these functions activated, by touching the LCD screen you can select a focus point for a still photo, and you can "pull" the focus from one point to another while recording video. You can set the camera to take a picture when you touch the monitor. In addition, you can use the LCD screen as a touch pad while you are viewing the scene through the camera's viewfinder.

You can enlarge an image in playback mode by tapping twice on the LCD screen and return it to normal size by tapping twice again, and you can enlarge the shooting screen by tapping twice when the camera is using manual focus mode. When the manual focus screen is enlarged, you can drag on the screen to move the area that is magnified. When the Focus Magnifier frame is on the shooting screen, you can drag it around with your finger.

This menu option has only two choices—to turn touch operations on or off. If you are certain you don't want to use any of the touch operations for a shooting

session, it's easy to use this menu setting to disable all touch operations. Otherwise, leave this option turned on, and adjust which operations are active through other menu options, discussed below.

The options on screen 3 of the Setup menu are shown in Figure 8-10.

Figure 8-10. Screen 3 of Setup Menu

Touch Panel/Pad

This next option lets you determine which touch panel operations are turned on to enable various focusing actions, assuming you have set the Touch Operation option, discussed above, to On. The choices for this option are Touch Panel + Pad; Touch Panel Only; and Touch Pad Only, as shown in Figure 8-11. In order to activate the ability to enlarge the screen by tapping, both in playback mode and in shooting mode, select either Touch Panel + Pad or Touch Panel Only. If you select Touch Pad Only, the enlargement features will not work.

Touch Pad Settings

As noted above, using the Touch Operation menu option, you can turn on the camera's ability to use the LCD screen on the back of the a7C as a touch pad to select a focus point when you are viewing the scene through the viewfinder. The Touch Pad Settings menu option gives you several ways to control how this capability works in practice. It provides three options: Operation in Vertical Orientation; Touch Position Mode; and Operation Area, as shown in Figure 8-12.

Figure 8-11. Touch Panel/Pad Menu Options Screen

Figure 8-12. Touch Pad Settings Menu Options Screen

The first sub-option, Operation in Vertical Orientation, can be turned either on or off. If it is turned on, then the LCD screen can be used as a touch pad even when the camera is rotated to one side to capture vertically oriented images or videos. You may want to disable this option if you feel that your nose may accidentally touch the screen in that orientation, causing an unwanted movement of the focus point.

The second sub-option, Touch Position Mode, can be set to Absolute Position or Relative Position. With Absolute Position, the camera will set the focus point in the viewfinder at the same point you have touched on the LCD screen, and you can also drag a focus frame to a new location. With Relative Position, the camera will move the focus point to a new location based only on the direction and distance of your dragging an existing frame with a finger on the LCD screen, without regard to the actual location that you touch on the screen. If focus area is set to Wide with this setting, the camera will place a focus frame in the center of the screen if

you tap; you can then drag that frame to a new location. (You may have to tap firmly and leave your finger for a moment on the screen to make the focus frame appear.)

The final sub-option, Operation Area, can be used to restrict the area of the screen that can be used for repositioning the focus point, in order to make it easier to move the focus point with a short movement of your finger. When you select this sub-option, the camera displays numerous options, which take more than a full screen to display. The first screen of options is shown in Figure 8-13. The whole list is as follows: Whole Screen; Right Half; Right Quarter; Upper Right; Lower Right; Left Half; Left Quarter; Upper Left; and Lower Left.

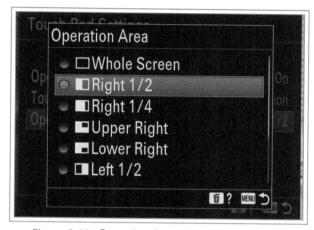

Figure 8-13. Operation Area Menu Options Screen

As you can see in Figure 8-13, each selection has a small diagram next to it to indicate in black where the operational area on the screen would be.

If you use this option when Touch Position Mode is set to Relative Position, you only have to move your finger on the screen within the restricted area in the direction and for the distance you want the focus point to move. If you use this option when Touch Position Mode is set to Absolute Position, the camera treats the restricted area as if it were a miniature version of the whole screen. So, for example, you can touch the upper left corner of the restricted area, and the camera will treat that as placing the focus point in the upper left corner of the display.

This choice is a matter of personal preference. You may want to designate a small operation area so you don't have to move your finger very far to carry out a movement, but the choice is yours.

TC/UB (TIME CODE/USER BIT) SETTINGS

This menu item provides several sub-options that are helpful if you use the a7C for advanced video production. For example, because of its ability to shoot 4K video (discussed in Chapter 9), the a7C camera can be used as part of a multi-camera setup for a professional production. In such a setup, it can be useful to control whether and how the camera outputs time code, a type of metadata that is used when editing video sequences. The user bit is another form of metadata that also can be used as an organizing aid.

This option will have all but one of the sub-options dimmed and unavailable for selection unless the mode dial is at the Movie or S & Q position. If it is in any other position, you can get access only to the first sub-option, TC/UB Display Setting. For this discussion, I will assume the mode dial is at the Movie position.

I won't discuss the use of time code in detail, but I will give a brief overview. Time code for video files includes numbers in a format like the following: 02:12:23:19, which stands for hours, minutes, seconds, and frames. In this example, the time code would mark the point in the video clip at 2 hours, 12 minutes, 23 seconds, and 19 frames into the next second.

Because video (in the NTSC system) is normally played back at 30 fps or 24 fps, the number in the final position is based on those values, even if the video is recorded in a format such as XAVC S HD with Record Setting set to 120p 100M. With a Record Setting value of 120p, 60p, or 30p, the number of frames can be set from 00 to 29. When Record Setting is set to 24p, the number of frames can be set only to 00, 04, 08, 12, 16, or 20. For PAL devices, the number of frames can go from 00 to 24, because the video is played back at 25 fps.

When you see a time code like the one in this example, you know what frame of the video is being identified, so you can make an edit at that point or synchronize this video clip with another video clip, as long as both clips are using the same time code format and had the time code recorded in synchronization.

If you are not going to use your camera for that sort of video production, you can largely ignore this menu option, though it is helpful to know what settings you can control. The sub-options, shown in Figure 8-14, are discussed below.

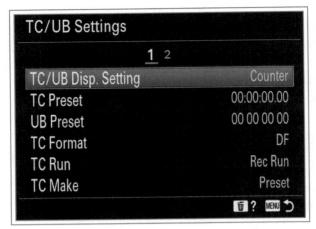

Figure 8-14. TC/UB Settings Menu Options Screen

TC/UB Display Setting

This first option controls what figures display in the lower left corner of the camera's screen during video recording. There are three choices—Counter, TC, or U-Bit, for user bit.

No matter which you choose, the display appears on the screen during recording in all shooting modes and before recording in Movie or S & Q mode. The characters are not recorded visibly with the video and will not appear during playback, although they can be used as reference points in appropriate video-editing software.

The first choice, Counter, places a simple display of minutes and seconds of elapsed recording time, as shown in Figure 8-15. This is the default choice, and it is what you probably will want to leave in place for general use. As I noted above, the only reason to use time code (or user bit) is for advanced-level video production.

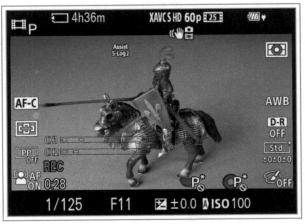

Figure 8-15. Counter in Use on Video Recording Screen

The second choice places time code on the screen, as shown in Figure 8-16.

You may want to use this setting for advanced video production, not just to display on the screen but to output to another device, such as a video recorder, through the camera's HDMI port, as I will discuss later in this chapter.

The third choice, user bit, lets you set the camera to display a set of four figures in hexadecimal notation, in the format 0B 76 11 F8. This amounts to a string of four numbers, each of which, in hexadecimal notation, can range from 00 (0 in decimal notation) to FF (255 in decimal notation).

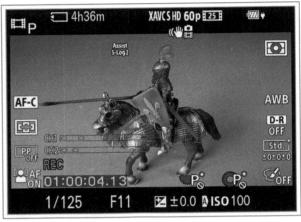

Figure 8-16. Time Code in Use on Video Recording Screen

In actual practice, I have never used the user bit for video production. Some videographers use this capability to place notes in the video file, using the few available letters (A through F) and the numbers to make notations like C1 for camera 1.

If you don't need to include a customized notation using the user bit option, the a7C gives you a way to have the user bit provide a running display of the current time. To do that, go to the last sub-option under TC/UB Settings, UB Time Record, and set it to On. That option sets the user bit to display the current time in the lower left corner of the display. To make that display appear, as shown in Figure 8-17, you also have to set the TC/UB Display Setting option to U-Bit.

TC Preset

This next option lets you set the initial time code for your video recording. You can set the code anywhere from all zeroes, the default, to 23:59:59:29 for some NTSC formats. As I noted earlier, the final figure can go as high as 29 for most NTSC settings and 20 for the

24p settings. For PAL systems, the highest value for that figure is 24.

You might want to use this option if you need to start with a particular time code for a technical reason, in order to synchronize your footage with existing footage or that from another camera. In addition, in some production environments the practice is to set the hours position to a particular value, such as 01, to designate some item, such as the reel number. Unless you have a need to make a setting of that nature, you can leave these values all at zero.

UB Preset

This option lets you set the user bit, as discussed above. Each of the four positions can be set anywhere from 00 to FF, using the hexadecimal system.

TC Format

This option lets you select either DF (drop-frame) or NDF (non-drop-frame) format for the time code, assuming you are using time code and are using the NTSC video system with a Record Setting option other than 24p. (Drop-frame time code is not used for PAL video.)

This is a technical setting that you may need to use in order to make sure the time code you use is compatible with that of other cameras and with your editing facilities. Drop-frame time code is used because the NTSC standard of 30 frames per second does not record exactly 30 frames every second. For technical reasons, the actual rate is 29.97 frames per second. To count the frames accurately, video editors use the drop-frame system, which drops a few frames from the counting process at specified intervals, so the actual number of frames is counted accurately.

You can leave this option set to DF if you are using the NTSC system, unless you know of a specific reason to use NDF.

TC Run

This option lets you choose either Rec Run or Free Run for the time code. With Rec Run, the time code increases only while the camera is actually recording. With Free Run, the time code continues to run all the time. Which system to choose is a matter of preference, depending on how you will use the time code for editing. With Rec Run, there should be no gaps in the time code, which can be an advantage. With Free Run, you can set up the

time code to match the time of day, which can be useful if you need to find a clip that corresponds to a particular time during the day's video recording.

Free Run time code continues to run even when the camera is powered off. When you turn the camera on again and set it to Movie mode, the current time should be displaying in the lower left corner of the display, assuming you set the initial value for the time code to the current time.

TC Make

This setting is what you use to set the camera to record the time code option you have selected. The two choices are Preset or Regenerate. If you choose Preset, the camera starts recording time code using the value you entered for TC Preset, discussed earlier. If you choose Regenerate, the camera starts the time code recording based on the last value recorded previously.

UB Time Record

This last option, found on the second screen of the TC/UB Settings menu item, lets you choose whether or not to set the user bit option to display and record the time of day instead of a user bit formula that you set yourself. If you select On for this option and set the TC/UB Display Setting option to U-Bit, the camera will display the current time in the lower left corner of the screen as the video is recorded, as shown in Figure 8-17. The display shows the hour (in the 24-hour format), minute, and second; the last pair of digits is left at zeroes. In this case, the time was three seconds after 10:58a.m.

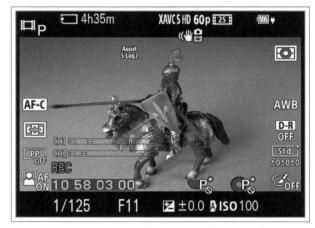

Figure 8-17. UB Time Record in Use on Video Recording Screen

HDMI SETTINGS

The HDMI Settings menu option has six sub-options on its single screen.

HDMI Resolution

The HDMI Resolution option can be set to Auto, 2160p/1080p, 1080p, or 1080i. This setting controls how the camera displays images and videos on an HDTV or other device that is connected to the camera with an HDMI cable. Ordinarily, the Auto setting will work best; the camera will set itself for the optimum display according to the resolution of the device it is connected to. If you experience difficulties with that connection, you may be able to improve the output image by trying one of the other settings. The 2160p/1080p setting is designed for connection to 4K-capable TV sets, which often have a resolution of 3840 x 2160 pixels.

This setting also can be of use if you are trying to capture video or other output from the camera, such as menu screens, to a video capture device, such as those made by Elgato, Blackmagic Design, Epiphan, and other companies. It may be necessary to adjust the HDMI Resolution setting so the HDMI output will transfer properly to the capture device.

24p/60p Output

This menu option is present only on cameras sold in NTSC areas. It is labeled with a movie-film icon, meaning it is for use when the camera is set to Movie mode, and it has a specific, limited use. It is applicable only when you have recorded video with Record Setting set to 24p 50M, 24p 60M, or 24p 100M using the XAVC S HD or XAVC S 4K File Format setting, and you have set the HDMI Resolution item, discussed above, to 1080p or 2160p/1080p.

If those conditions are met, that means you have some video footage recorded at 24 frames per second. That setting is slower than the standard NTSC setting of 30 frames per second, and produces what some people consider to be a more "cinematic" look for the footage.

When you send your 24p video footage out through an HDMI cable to an HDTV set, you may prefer to send it in a way that looks more like standard TV video, using the 60p setting. That is the function of this menu option. If the conditions described above are met, you can select 60p for the 24p/60p Output option, and your

24p footage will be sent out through the HDMI cable to the HDTV in a way that simulates 60p video.

This option also may be of use when you are sending 24p video footage out through the HDMI cable to an external video recorder, if 60p footage is a better option for use by the recorder.

HDMI Information Display

This feature also controls the behavior of the camera when you connect it to an HDTV set or other external device using an optional micro HDMI cable. However, unlike the HDMI Resolution option discussed above, which controls the resolution of the video that is output through the HDMI port, this menu option controls what information is output through that port.

If this menu option is set to On, which is the default setting, then, when the camera is connected to an HDTV or external recorder in shooting mode, the screen of the external device displays exactly what you would see on the camera's display in that mode if the camera were not connected to the device, including icons and figures showing camera settings.

With the On setting, the HDTV acts as a large, external monitor for the a7C, and the screen of the a7C itself is blank. I use this setting a great deal myself, because this is how I capture screen shots for this book. Once the camera is connected, I can capture all of the information and settings that appear on the shooting screens and menu screens of the camera, with a few exceptions for special settings that are not output through the HDMI port, such as the Zebra stripes.

If this menu option is set to Off, then, when the camera is connected to an HDTV or other external device in shooting mode, the external device's screen displays only the image that is being viewed by the camera, with no shooting information displayed at all. If you press the Display button, nothing will happen on the external screen; the view will not switch to another display with more information on it. However, at the same time, the camera's screen continues to display all of the shooting information it normally would, including the image and whatever information is chosen by presses of the Display button. You can even use the menu system on the camera while the external device is receiving the live image.

You might use the Off setting when you want to display images from the camera's shooting mode on a large HDTV screen, possibly at a wedding or other gathering, and not have the images cluttered or marred by any shooting information at all. For example, a camera may focus on an unsuspecting person in the audience at the event, and that person's image suddenly appears on the large screen for everyone to see.

Also, this option is useful for video production when you need to output a "clean" video signal that does not include any shooting information from the camera. That signal can be sent through an HDMI cable to a video recorder for recording to another medium, or for display on a large monitor being viewed by the production team. For example, you can record video directly from the camera to a computer by outputting the clean HDMI signal to a device such as the Intensity Pro by Blackmagic Design. There are similar devices available from companies such as AverMedia, Hauppage, and Elgato. You also can send the clean signal to an external 4K video recorder such as the Atomos Shogun, as I will discuss in Chapter 9.

With the On setting, you can press the Display button to show a screen with very minimal shooting information, but that screen still shows the basic information of aperture, shutter speed, exposure compensation, and ISO value at the very bottom of the screen. If you don't want even that minimal level of information to interfere with the video display, choose the Off setting.

This setting does not change the behavior of the camera for playback of images; its only effect is on the display of information in shooting mode through an HDMI connection.

TC Output

This option works together with the TC/UB Settings option discussed earlier. If you have set up the camera to record time code, you can use this option to have the time code output through the HDMI cable to an external recorder, so the time code will be available in the recorded footage for use in editing. The choices are On or Off.

Rec Control

This next sub-option for HDMI Settings is another one that applies only when recording to an external device by sending a clean signal through the HDMI cable. In this case, the option controls whether the camera sends a start-recording or stop-recording signal through the cable. If you turn this option on, you can control the external recorder using the camera's controls, if the external recorder is compatible with this camera.

For example, you can connect the Atomos Shogun 4K recorder with an HDMI cable and control the recorder's starting and stopping using the camera's Movie button, if the Rec Control option is turned on. (You also can use the shutter button to control movie recording, if the Movie w/Shutter option is turned on through screen 4 of the Camera Settings2 menu.) The Rec Control option can be turned on only if the TC Output option, discussed above, also is turned on.

CTRL for HDMI

This final sub-option is of use only when you have connected the camera to an HDTV and you want to control the camera with the TV's remote control, which is possible in some situations. If you want to do that, set this option to On and follow the instructions for the TV and its remote control. This option is intended to be used when you connect the camera to a Sony Bravia model HDTV.

4K OUTPUT SELECT

This next option on the Setup menu is for use only when the camera is connected to a 4K-capable external video recorder, such as the Atomos Shogun. Unless that connection is active, this option will be dimmed and unavailable for selection. Once the connection to the external recorder is made, the following sub-options are available:

Memory Card + HDMI

With this option, the camera will record video to the memory card in the camera and also output the signal to the external recorder through the HDMI cable. This option gives you an immediate backup copy of your footage.

HDMI Only (30p)

With this option, the camera sends a 4K video signal in 30p format to the external recorder but does not record the video to the camera's memory card. This option lets you record 4K video without having a memory card that

meets the specifications for that format, and, in fact, it lets you record with no memory card in the camera at all.

If you choose this option or the next one, for 4K/24p video with no card in the camera, the File Format and Record Setting items on the Camera Settings2 menu become unavailable, because the recording format has already been selected by choosing this option or the next one.

I tested this option with the a7C connected by an HDMI cable to an Atomos Shogun external 4K recorder, with no memory card in the camera. The camera sent a clean 4K signal through the HDMI cable and the Shogun recorded the video with no problems. If you turn on the Rec Control menu option on the camera, you may be able to control the operation of the external recorder by pressing the Movie button on the camera to start and stop the recording. (This function did not work for me in every case, as discussed in Chapter 9.)

HDMI Only (24p)

This option is the same as the previous one, apart from the use of the 24p frame rate instead of 30p.

HDMI Only (25p)

This setting is available only when the NTSC/PAL Selector option is set to PAL.

USB CONNECTION

This option sets the technical standard that the camera uses for connecting to a computer using a USB cable. This menu item has three choices, as shown in Figure 8-18: Auto, Mass Storage, and MTP, which stands for media transfer protocol.

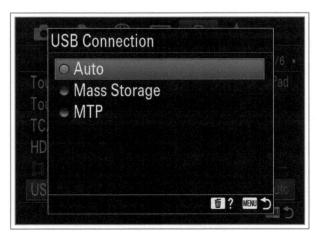

Figure 8-18. USB Connection Menu Options Screen

You ordinarily should select Auto, and the a7C should detect which standard is used by the computer you are connecting the camera to. If the camera does not automatically select a standard and start transferring images, you can try one of the other settings to see if it works better than the Auto setting.

Screen 4 of the Setup menu is shown in Figure 8-19.

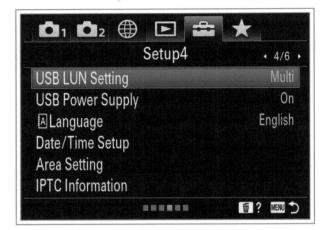

Figure 8-19. Screen 4 of Setup Menu

USB LUN SETTING

This first item on screen 4 of the Setup menu is a technical option that should not often be needed. LUN stands for logical unit number. This item has two possible settings—Multi or Single. Ordinarily, it should be set to Multi, the default. In particular, it should be set to Multi when the a7C is connected to a Windowsbased computer and you are using Sony's PlayMemories Home software to manage images. If you have a problem with a USB connection to a computer, you can try the Single setting to see if it solves the problem.

USB POWER SUPPLY

The USB Power Supply option, which can be turned either on or off, controls whether or not the camera's battery will be charged or the camera will be powered through the USB cable when the camera is connected by its USB cable to a computer.

If you use the AC adapter provided with the camera or an external USB power source, as discussed in Appendix A, to provide power to the camera, you do not need to have this menu option turned on. When the USB cable is connected to an external power supply, power will be provided to the camera even with this option turned off. Turning this option on gives you another avenue for keeping the a7C's battery charged. The only problem is that if your computer is running on its battery, then that battery will be discharged more rapidly than usual. If you are connecting the camera to a computer that is plugged into a wall power outlet, there should be no problem in using this option.

As I discuss in Appendix A, it's a good idea to get an external battery charger and at least one extra battery for the a7C because even if you can charge the battery in the camera using the USB cable, you don't have the ability to insert a fully charged battery into the camera when the first battery is exhausted.

I recommend leaving this option at its default setting of On, unless you will be connecting the camera to a battery-powered computer or other device and you don't want to run down the battery on that device.

LANGUAGE

This option gives you the choice of language for information on the camera's menus and display screens. Once you have selected this menu item, scroll through the language choices using the control wheel or the direction buttons and press the Center button when your chosen language is highlighted.

DATE/TIME SETUP

I discussed this item in Chapter 1. When the camera is new or has not been used for a long time, it will prompt you to set the date and time and will display this menu option. If you want to call up these settings on your own, you can do so at any time.

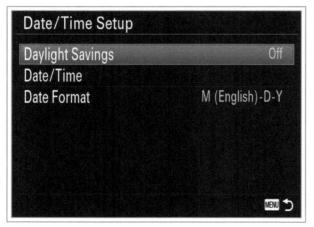

Figure 8-20. Date/Time Setup Menu Options Screen

When you press the Center button on this menu line, you will see a screen like that in Figure 8-20, which gives you the choice of adjusting Daylight Savings Time (On or Off), Date/Time, or Date Format. To adjust Date/Time, select that option and press the Center button. The camera will display a screen like that shown in Figure 8-21.

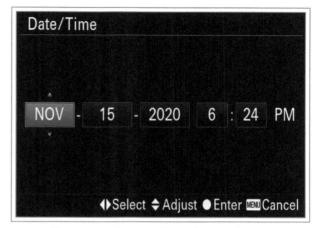

Figure 8-21. Date and Time Settings Screen

Scroll through the options for setting month, day, year, and time by turning the control wheel or pressing the Left and Right buttons. As you reach each item, adjust its value by using the Up and Down buttons or by turning the control dial. When all of the settings are correct, press the Center button to confirm them and exit from this screen.

You can also go back to the first menu screen and turn Daylight Savings Time on or off depending on the time of year, and you can choose a date format according to your preference. Note that the Daylight Savings Time option does not adjust itself automatically; you need to turn it on or off yourself when the time changes, which happens in March and November in my area.

AREA SETTING

The next option on screen 4 of the Setup menu, Area Setting, lets you select your current location so you can adjust the date and time for a different time zone when you are traveling.

When you highlight this item and press the Center button, the camera displays the map shown in Figure 8-22. Turn the control wheel or press the Left and Right buttons to move the light-colored highlight over the map until it covers the area of your current location, then press the Center button. The date and time will be

adjusted for that location until you change the location again using this menu item. You also can press the Up or Down button or turn the control dial when this screen is displayed to turn the Daylight Savings Time setting on or off.

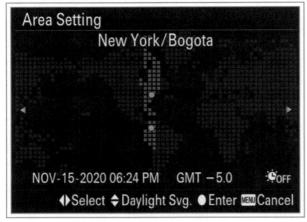

Figure 8-22. Area Setting Map Screen

IPTC INFORMATION

This item gives you a way to register metadata information in the standardized IPTC (International Press Telecommunications Council) format to your images, so it will be saved with the files. This information can include items such as copyright, name of photographer, email address, street address, and others.

In order to use this option, you have to download the IPTC Metadata Preset app from Sony, enter data using the app on a computer, and save it to a memory card as an .xmp file, using the Export option in the app.

You can then insert the memory card with the IPTC file in the camera, and use the IPTC Information menu option to register the information on the memory card to your a7C camera. Once that information is registered in the camera, go back to the Write IPTC Info sub-option and set it to On. With that setting in place, the camera will write the IPTC information that was registered to the camera to all images that you capture while that option is turned on. For more information, see the help files at https://www.sony.net/iptc/help.

Screen 5 of the Setup menu is shown in Figure 8-23.

COPYRIGHT INFO

This first item on screen 5 of the Setup menu gives you another way to add information about the

photographer and copyright holder to the metadata for images taken with the camera.

The first sub-option, Write Copyright Info, determines whether the copyright information entered for this item will be written to still images that you take. If you turn this option on, then the copyright information (names of photographer and copyright holder) will be added to the metadata for any still images captured after the option is turned on. The information will not appear on the images themselves, but can be read by any program that reads EXIF data for images, such as Adobe Bridge.

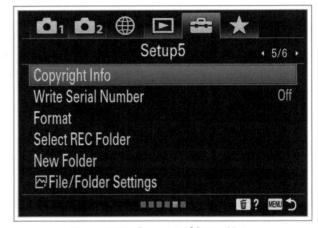

Figure 8-23. Screen 5 of Setup Menu

The second option, Set Photographer, lets you enter the name of the photographer. When you select this option, you will see a screen with a window for entering the name. Press the Center button when the window is highlighted and you will see the data-entry screen. Use that screen to enter any name you want. Use the control wheel and the control dial or the direction buttons to move the orange highlight bar to the first block on the left under the name window. When that block is highlighted, press the Center button to toggle between letters, numbers and symbols. Then move the highlight bar to the block for the letter you want. Move to the up arrow icon to shift to uppercase letters. Press the Center button repeatedly to choose the letter you want from each group of letters.

For example, to type the letter "e," move the highlight bar to the "def" block and press the Center button quickly two times to select e. After a second or two, the blinking white cursor will move to the right, and you can repeat this process. You can move the cursor forward or back using the left and right arrows at the upper right in the blocks of characters. When you have finished entering the name, highlight OK and press the Center button to accept the name.

The third option, Set Copyright, lets you set the name of the company or person who holds the copyright for the images to be taken with the camera.

Finally, the Display Copyright Info option lets you see what names are currently entered in the camera for these items.

WRITE SERIAL NUMBER

If you turn on this option, the camera will write its serial number to the metadata for each image. You may want to enable this option so you can easily identify which of several cameras you used to capture particular images, to help verify ownership of the camera in case it is lost or stolen, or to verify your copyright for an image.

FORMAT

The next option on the fifth screen—Format—is an important one. This command is used to prepare a new memory card with the appropriate data structure to store images and videos. The Format command also is useful when you want to wipe all the data off a card that has become full or when you have copied a card's images to your computer or other device. Choose this process only when you want or need to completely wipe all of the data from a memory card.

When you select the Format option, as shown in Figure 8-24, the camera will warn you that all data currently on the card will be deleted if you proceed. If you reply by highlighting Enter and pressing the Center button to confirm, the camera will format the card that is in the camera and the result will be a card that is empty and properly formatted to store new images and videos recorded by the camera.

With this procedure, the camera will erase all images, including those that have been protected from accidental erasure with the Protect function on the Playback menu.

It's a good idea to periodically save your images and videos to your computer or other device and re-format your memory card to keep it properly set up for recording new images and videos. It's also a good idea to use the Format command on any new memory card when you first insert it into the camera. Even though

it likely will work without that procedure, it's best to make sure the card is set up with Sony's method of formatting for the a7C.

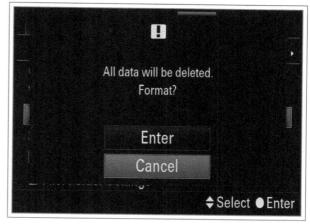

Figure 8-24. Format Confirmation Screen

SELECT REC FOLDER

When you select this item, the camera displays an orange bar with the name of the current folder, as shown in Figure 8-25. You can use the Up and Down buttons or turn the control wheel to scroll to the name of another folder if one exists, so you can store future images and videos in that folder. It might be worthwhile to use this function if you are taking photos or movies for different purposes during the same outing.

Figure 8-25. Select REC Folder - Selection Screen

For example, if you are taking some photos for business and some for pleasure, you can create a new folder for the business-related shots (see the next menu item, below). The camera will then use that folder. Afterward, you can use the Select REC Folder option to select the folder where your personal images are stored and take more personal images that will be stored in that folder.

New FOLDER

This menu item lets you create a new folder on your memory card for storing images and videos. Highlight this item on the menu screen and press the Center button; you will then see a message announcing that a new folder has been created, as shown in Figure 8-26.

Figure 8-26. New Folder - Message Upon Creation

Creating a new folder can be a good way to organize images and videos from a particular shooting session. If you are going to view and process the files on your computer, it can be useful to have images from different locations arranged in different folders, for example.

FILE/FOLDER SETTINGS (STILL IMAGES)

This next option on screen 5 of the Setup menu has three sub-options dealing with numbering and naming still-image files, as discussed below.

File Number

This option controls the way the camera assigns numbers to still images. There are two choices: Series and Reset, as shown in Figure 8-27.

With Series, the camera continues numbering where it left off, even if you create a new folder for images or put a new memory card in the camera. For example, if you have 112 images on your first memory card, the last image likely will be numbered 100-0112: 100 for the folder number and 0112 for the image number.

If you then switch to a new memory card with no images on it, the first image on that card will be numbered 100-0113 because the numbering scheme continues in the same sequence. If you choose Reset instead, the first image on the new card will be

numbered 100-0001 because the camera resets the numbering to the first number.

Figure 8-27. File Number Menu Options Screen

Set File Name

This menu item lets you specify the first three characters for file names of your images. By default, those characters are DSC, so a typical image might be named DSC00150.jpg. You can choose any other characters by using the data-entry screen for this option, shown in Figure 8-28. Those three characters will then appear at the beginning of the file name for any images captured after you change this setting, if the images use the sRGB color space. If the images use the Adobe RGB color space, the camera will add an underscore character before the file name, as shown in Figure 8-28.

Figure 8-28. Set File Name - Data Entry Screen

Folder Name

This menu option gives you a choice of two methods for naming the folders used for storing still images on your memory card, as shown in Figure 8-29: Standard Form or Date Form. The Standard Form option uses the folder number, such as 100, 101, or higher, followed by the letters MSDCF. An example is 100MSDCF. If you choose Date Form, folder names will have the same 100 or higher number followed by the date, in a form such as 10001114 for a folder created on November 14, 2020, using only one digit to designate the year.

Figure 8-29. Folder Name Options Screen

I find the date format confusing and hard to read, and I am used to the MSDCF format. If you use the date format, you will end up having a folder for every date on which you record still images. You may prefer having your image folders organized in that way so you can quickly locate images from a particular date. I prefer having fewer folders and organizing images on my computer according to my own preferences.

The options on screen 6 of the Setup menu are shown in Figure 8-30.

FILE SETTINGS (MOVIES)

This next main option on the Setup menu has four suboptions on two screens, as discussed below.

File Number

This first sub-option for File Settings (Movies) lets you set the way the camera assigns file numbers to movies. The options are Series or Reset. As with the similar option for still images, discussed earlier, with Series, the camera does not restart numbering of the movie files when a new memory card is used, but keeps numbering them consecutively. With Reset, the numbering is restarted back to a number such as C0001 when a new card is used.

Figure 8-30. Screen 6 of Setup Menu

Series Counter Reset

This sub-option resets the numbering of the movie files when the Series option is being used for movies.

File Name Format

This next sub-option lets you choose a format for the naming system for movies. The choices are Standard, Title, Date + Title, or Title + Date. However, if you are not using an SDXC memory card, the only option available is Standard.

Figure 8-31. Standard Option for File Name Format

When this sub-option is highlighted on the menu, the camera displays an example of the currently selected format in the lower half of the screen, as shown in Figure 8-31, where the Standard format is illustrated. The Standard format uses the letter C with a four-digit number, starting with C0001 and moving up from there.

Title Name Settings

If you choose Title, Date + Title, or Title + Date for File Name Format, you can use the Title Name Settings option, on screen 2 of File Settings (Movies),

to enter the title. You can enter up to 37 characters, using the standard text-entry system. For example, if you entered "Paris" for the title, the various options would look like Paris0001, 20201105_Paris0001, and Paris20201105_0001, using a date of November 5, 2020.

RECOVER IMAGE DATABASE

This menu item activates the Recover Image Database function. If you select this option and press the Center button to confirm it on the next screen, as shown in Figure 8-32, the camera runs a check to test the integrity of the file system on the memory card. I have rarely used this menu option, but if the camera is having difficulty reading the images on a card, possibly because the files were altered while the card was in a computer, using this option might recover the data.

Figure 8-32. Confirmation Screen for Recover Image Database

DISPLAY MEDIA INFO

The next item on screen 6 of the Setup menu gives you another way to see how much storage space is remaining on the memory card that is currently in the camera. When you select Display Media Info and press the Center button, the camera displays a screen like that in Figure 8-33, with information about the number of still images and the hours and minutes of video that can be recorded using the current settings for File Format (Still Images), JPEG Image Size, JPEG Quality, File Format (Movies), and Record Setting.

It is nice to have this option available, although the number of images that can be recorded is also displayed on the detailed shooting screen, and the available video recording time appears on the video recording screen once a recording has been started.

Figure 8-33. Display Media Information Screen

VERSION

This next option on the sixth screen of the Setup menu tells you the current version of the firmware in your camera. The a7C, like other cameras, is programmed at the factory with firmware, which is a set of electronically implanted computer instructions. These instructions control all aspects of the camera's operation, including the menu system, functioning of the controls, and in-camera image processing.

You may want to see what version is installed because the manufacturer may release an updated version of the firmware to fix problems or bugs in the system, provide minor enhancements, or, in some cases, provide major improvements, such as adding new shooting modes or menu options.

To determine the firmware version installed in your camera, highlight this menu option, then press the Center button, and the camera will display the version number, as shown in Figure 8-34. As you can see, my camera had Version 1.00 installed when this image was captured.

To see if firmware upgrades have been released, I recommend you visit Sony's support website, whose Internet address is http://esupport.sony.com. Find the link for Downloads, then the link for Cameras & Camcorders, and then a link to any updated version for the ILCE-7C. The site will provide instructions for downloading and installing the new firmware.

Figure 8-34. Version Screen - Showing Firmware Version

SETTING RESET

This final option on the Setup menu is useful when you want to reset some or all of the camera's settings to their original (default, or factory) values. This action can be helpful if you have been experimenting with different settings and you find that something is not working as expected.

When you select this item, the camera displays two choices: Camera Settings Reset and Initialize, as shown in Figure 8-35.

Figure 8-35. Setting Reset Menu Options Screen

With Initialize, the camera resets all major settings to their original values and deletes registered data, such as faces. With Camera Settings Reset, only the values that affect shooting of images and videos are reset. Picture Profile settings will not be reset with either option.

My Menu

Another menu system for the a7C, marked by a star icon at the far right of the main menu screen, is the My Menu system. This menu does not contain any options of its own, other than options for adding and organizing items from other menu systems. My Menu is a blank system that is provided for you to add your most-used options from the main menu systems, for quick access.

You can include up to 30 items from any of the menus except the Playback menu. That leaves a large number of useful options that can be selected from the Camera Settings1, Camera Settings2, Network, and Setup menus.

Figure 8-36. My Menu Screen to Add New Items

To add an item, first, navigate to the screen shown in Figure 8-36, with choices for adding, sorting, and deleting menu items. If no items have been added to My Menu yet, this will be the only screen available. If items have been added, you may have to navigate to a higher-numbered screen to reach the screen with Add Item. The highest-numbered screen is the one where you can add, sort, and delete items. You will see numbers in the upper right corner, such as 2/4, 4/4, or 2/2, as shown in Figure 8-36. Those numbers indicate which screen is being displayed out of the total number of screens available.

Once you have reached the screen shown in Figure 8-36, highlight and select Add Item. The camera will display a screen like that shown in Figure 8-37, which is one of 33 screens of menu options you can choose from to add to your personalized menus. Scroll through these screens by a full screen at a time using the Left and Right buttons or the control dial; scroll through the

items on a given screen using the Up and Down buttons or the control wheel.

Figure 8-37. My Menu - Screen with List of Items that Can Be Added

When you have highlighted a menu item you want to add to My Menu, press the Center button to select it. The camera will then prompt you to select a location for the selected item. For the first item you add, there is only one location possible. For later selections, you will see an orange line, as shown in Figure 8-38.

Figure 8-38. My Menu - Screen with Orange Line to Place Newly Added Item

Position the orange line below an item that is already added to the My Menu items, and the new item will be added in that location, below that existing item. When you have finished adding items, press the Menu button to return to the My Menu screen. From there you can navigate to another menu system or press the Menu button again to return to the shooting screen.

After you have added all of the items you have chosen for My Menu, you can later move them around to get the most convenient arrangement. To move an item, while My Menu is displayed, press the Right button enough times to get to the last screen of My Menu, which holds the options for managing the menu. Choose Sort Item from the My Menu screen. Then navigate to the item to move and select it by pressing the Center button. You can then move it to the new location you select. You also can delete an item, a whole page of items, or all items, by using the Delete Item, Delete Page, or Delete All option. Figure 8-39 shows the My Menu screen after several items have been added.

Figure 8-39. My Menu with Several Items Added

CHAPTER 9: MOTION PICTURES

Movie-Making Overview

n one sense, the basics of making movies with the a7C can be stated in four words: "Press the Movie button." (That is, by default, the red-ringed Movie button near the right edge of the camera's top, though a different button can be assigned to this function through the Custom Key menu options, as discussed in Chapter 5.)

In most situations, you can press and release the Movie button while aiming at your subject, and get results that are quite usable. You do not need to worry about special settings, particularly if you set the camera to Intelligent Auto mode. (You can record a normal-speed movie with the mode dial at any position except S & Q Motion, as discussed later in this chapter.)

To stop recording, press the Movie button again. If you prefer not to run the risk of recording unwanted movies by pressing the Movie button accidentally, you can change the button's operation so it activates movie recording only when the camera is in Movie or S & Q Motion mode. To do that, go to the Custom Key (Still Images) option on screen 9 of the Camera Settings2 menu, and set the Movie button to Not Set (or some other function, other than Movie Shooting). Then go to the Custom Key (Movies) option on the same menu screen, and make sure the Movie button is set to Movie Shooting.

If you're mainly a still photographer with little interest in movie making, you don't need to read further. Be aware that the Movie button exists, and if an interesting event starts to happen, you can turn the mode dial to Auto, press the Movie button, and capture footage to post on YouTube or elsewhere with a minimum of effort. But for a7C users who want to use this camera's strong motion picture capabilities, there is more information to discuss.

First, there is a requirement that may decide what memory card you get for your camera. To record movies with any format available on this camera, you have to use an SDHC or SDXC memory card with a speed of at least Class 10 or UHS speed class 1. If you want to record XAVC S 4K or XAVC S HD video using a Record Setting value of 100M, meaning 100 megabits per second, you have to use an SDHC or SDXC card rated in UHS speed class 3.

These are not just recommendations. If you do not use a card with the listed specifications, the camera will display an error message and will not record video using the format in question.

I have used the SD cards shown in Figure 9-1, all of which are rated in UHS speed class 3, for recording the highest-level formats on the a7C with no problems, and there are other choices available.

Figure 9-1. Memory Cards Rated in UHS Speed Class 3

Of course, if you are not going to use the highest-level formats, you can use a less-powerful card. And, as I'll discuss later in this chapter, you can record 4K video with no memory card at all, if you connect the a7C to an external video recorder.

The a7C, unlike many smaller cameras, does not have a built-in limitation on recording time. However, the camera can overheat, causing it to shut down, if you record high-quality video, such as 4K files, for an extended period of time. You should be able to record for more than 30 minutes in one session, in many cases. However, Sony notes that the recording time may be shorter, as low as 20 minutes, when the temperature in the environment is as high as 104 degrees Fahrenheit (40 degrees Celsius).

If you plan on recording a large amount of video, you should get a high-capacity and high-speed card. For example, a 64 GB card can hold about 70 minutes of the highest quality of 4K video, or about 4 hours and 30 minutes of the lowest-quality XAVC S HD video. (I will discuss these video formats later in this chapter.)

Details of Settings for Shooting Movies

As I noted above, the one necessary step for recording a movie with the a7C is to press the Movie button. However, there are numerous settings that affect the way the camera records a movie when that button is pressed.

I will discuss four categories of settings: (1) movierelated options on the Camera Settings2 menu; (2) the position of the mode dial on top of the camera; (3) options on the Camera Settings1 menu and other menus; and (4) settings made with the camera's physical controls.

MOVIE-RELATED MENU OPTIONS

First, I will discuss the movie-related options on the Camera Settings2 menu, because those options control the format and several other important settings for movies you record with the a7C. I discussed this menu in Chapter 5, but I did not provide details about all of the movie-oriented options in that chapter.

As noted above, you can press the Movie button to start a normal-speed video recording at any time and in any shooting mode (except for S & Q Motion), assuming you have assigned one of the camera's controls to perform this function in still-shooting modes, using the Custom Key (Still Images) option on screen 9 of the Camera Settings2 menu. Because of this ability to shoot movies in almost any shooting mode, you can

always change the settings for movie recording using the Camera Settings2 menu, no matter what shooting mode the camera is set to. I will discuss each item on the Camera Settings2 menu that has an effect on the recording of videos.

At this point, I will discuss the Camera Settings2 menu options that apply only to movies; later in this chapter, I will discuss options on other menus that affect movies as well as still images, such as white balance, ISO, Creative Style, Picture Effect, Picture Profile, and others.

Exposure Mode (Movies)

This menu item, the first option on screen 1 of the Camera Settings2 menu, can be selected only when the camera's mode dial is set to Movie mode, as shown in Figure 9-2. In other shooting modes, this menu option is dimmed and unavailable.

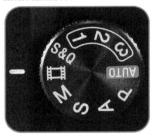

Figure 9-2. Mode Dial Set to Movie Mode

When the camera is in Movie mode, this option lets you select an exposure mode for shooting normal-speed movies.

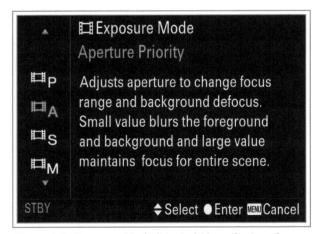

Figure 9-3. Exposure Mode (Movies) Menu Options Screen

With the mode dial set to Movie mode, highlight and select this menu option and a screen will appear with four options: Program Auto, Aperture Priority, Shutter Priority, and Manual Exposure, as shown in Figure 9-3.

Chapter 9: Motion Pictures | 193

Move through these choices by turning the control wheel or control dial, or by pressing the Up and Down buttons.

You also can call up this screen of options by assigning Shoot Mode to the Function menu using the Function Menu Settings option on screen 9 of the Camera Settings2 menu. If you do that, then, with the mode dial set to Movie, you can press the Function button to activate the Function menu, scroll to the Shoot Mode item, and select your choice of movie exposure mode, as shown in Figure 9-4. (The Shoot Mode item will be labeled Exposure Mode in the Function menu when the mode dial is at the Movie position.)

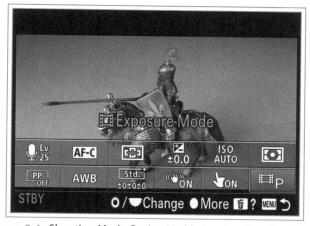

Figure 9-4. Shooting Mode Option Highlighted on Function Menu

Following are details about the behavior of the a7C when shooting movies with each of these settings.

Program Auto

With the Program Auto setting, which is highlighted in Figure 9-5, the a7C sets aperture and shutter speed according to its metering, and it uses settings from the Camera Settings1 menu that carry over to video recording, including ISO, white balance, metering mode, Face/Eye AF Settings, DRO, and others.

In this mode, the camera can use a shutter speed as fast as 1/4000 second. The camera will normally not use a shutter speed slower than 1/30 second, 1/45 second, 1/60 second, or 1/125 second, depending on the settings for File Format and Record Setting. It can use a slightly slower speed if you turn on the Auto Slow Shutter option, discussed later in this chapter.

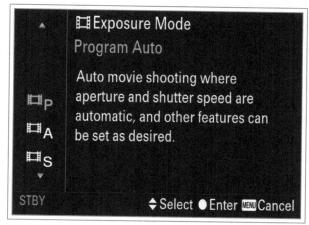

Figure 9-5. Program Auto Setting for Exposure Mode (Movies)

Aperture Priority

With the Aperture Priority setting, highlighted on the menu in Figure 9-6, you set the aperture, just as in the similar mode for still images, and the camera will set the shutter speed based on its metering. As with the Program Auto exposure mode for movies, discussed above, the camera will not use shutter speeds slower than those listed for that mode, unless you turn on the Auto Slow Shutter menu option.

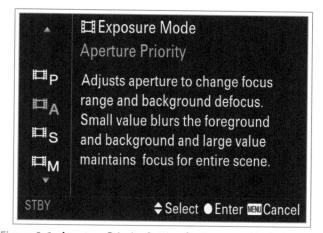

Figure 9-6. Aperture Priority Setting for Exposure Mode (Movies)

With this setting, you can adjust the aperture during a video recording. This may not be something you need to do often, but it can be useful in some situations. For example, you may be recording at a garden show, and at some point you may want to open the aperture wide to blur the background as you focus on a small plant. Afterward, you may want to close the aperture down to a narrow value to achieve a broad depth of field to keep a large area in focus.

Also, you can use the aperture setting to accomplish an in-camera fadeout. For example, in normal indoor conditions, if you are using a lens with a fairly wide maximum aperture, you may start with the aperture set to f/2.8 and ISO set to 640, with Auto Slow Shutter turned off. Press the Movie button to start recording. When you're ready, adjust the aperture value smoothly to the f/16.0 setting. You should get a nice fade to black. In brighter conditions, you may need to reduce ISO to a lower setting. (The minimum ISO value for recording movies is 100.)

Shutter Priority

With the Shutter Priority mode for movies, shown in Figure 9-7, you set the shutter speed, and the camera will set the aperture.

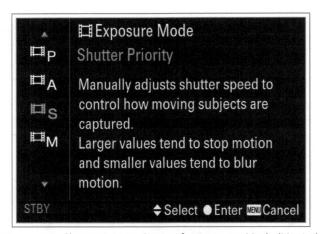

Figure 9-7. Shutter Priority Setting for Exposure Mode (Movies)

Unlike the situation with the Aperture Priority exposure mode for movies, in which the camera normally will not set the shutter speed slower than 1/30 second (or a higher value for some formats), you are able to set the shutter speed as slow as 1/4 second in this mode in most cases, even if Auto Slow Shutter is turned off. (If Record Setting is set to 120p for XAVC S HD video, the slowest shutter speed available is 1/125 second.) You can select a shutter speed from 1/4 second to 1/4000 second.

To expose your video normally at a shutter speed of 1/4000 second or other fast settings, you must have bright lighting, a high ISO setting, or both. Using a fast shutter speed for video can yield a crisper appearance, especially when there is considerable movement, as when shooting sports or other fast-moving events. In addition, having these very fast shutter speeds gives the camera flexibility for achieving a normal exposure when recording video in bright conditions.

With slower shutter speeds, particularly below the normal video speed of 1/30 second (equivalent to 30 fps), footage can become blurry with the appearance of smearing, especially with panning motions. If you are shooting a scene in which you want to have a drifting, dreamy appearance that looks like motion underwater, this option may be appropriate. You will not be able to achieve good lip sync at the slower shutter speeds, so this technique would not work well for realistic recordings of people talking or singing.

One interesting point is that you can preview this effect on the camera's display even before you press the Movie button to start recording. If you have the shutter speed set to 1/4 second in Movie mode, you will see any action on the screen looking blurry and jerky as if it had already been recorded with this slow shutter speed. (The Live View Display option on screen 8 of the Camera Settings2 menu is forced to the Setting Effect On option in Movie mode, and you cannot change it.)

With the Shutter Priority exposure mode for movies, you also can achieve a fadeout effect, as with Aperture Priority mode, discussed above. Just turn the control dial or wheel smoothly to increase the shutter speed to its fastest speed of 1/4000 second, and the scene may go black, depending on the lighting conditions. You may need to use a low ISO setting to achieve full darkness.

Manual Exposure

The last setting for the Exposure Mode item, shown in Figure 9-8, Manual Exposure, gives you more complete control over the exposure of your videos.

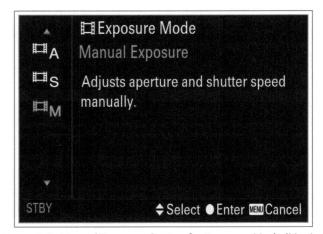

Figure 9-8. Manual Exposure Setting for Exposure Mode (Movies)

As with Manual exposure mode for stills, with this setting you can adjust both the aperture and the shutter

speed to achieve a desired effect. With video shooting, you can adjust the shutter speed from 1/4000 second to 1/4 second. (If Record Setting is set to 120p for XAVC S HD video, the slowest shutter speed available is 1/125 second.) Using these settings, you can create effects such as fades to and from black as well as similar fades to and from white.

For example, if you begin a recording in normal indoor lighting using settings of 1/60 second at f/3.5 with ISO set to 800, you can start recording the scene, and, when you want to fade out, start turning the control wheel slowly, increasing the shutter speed smoothly until it reaches 1/4000 second. Depending on how bright the lighting is, the result may be complete blackness. Of course, you can reverse this process to fade in from black.

If you want to fade to white, here is one possible scenario. Suppose you are recording video with shutter speed set to 1/500 second and aperture set to f/4.0 at ISO 6400. When you want to start a fade to white, turn the control wheel smoothly until the shutter speed decreases all the way to 1/4 second. In fairly normal lighting conditions, as in my office as I write this, the result will be a fade to a bright white screen.

There are, of course, other uses for Manual Exposure mode when recording videos, such as shooting "day for night" footage, in which you underexpose the scene by using a fast shutter speed, narrow aperture, low ISO, or all three of those settings, to turn day into night for creative purposes. Also, you might want to use Manual Exposure mode when you are recording a scene in which the lighting may change, but you do not want the exposure to change. In other words, you may want some areas to remain dark and some to be unusually bright, rather than have the camera automatically adjust the exposure. In some cases, having a constant exposure setting can be preferable to having the scene's brightness change as the metering system adjusts the exposure.

Note that you can set ISO to Auto ISO with the Manual Exposure setting. With the Auto ISO setting, you can maintain a constant aperture and shutter speed, but the camera will adjust exposure using the ISO setting to the extent that it can. You might want to use that setup if you need to maintain a narrow aperture to have a broad depth of field.

Exposure Mode (S & Q)

This second option on screen 1 of the Camera Settings2 menu lets you select an exposure mode when the mode dial is at the S & Q position, for recording slow and quick motion video. I will discuss the process for that mode of recording later in this chapter.

File Format (Movies)

The third item on screen 1 of the Camera Settings2 menu, the File Format (Movies) option gives you a choice of the two available movie recording formats on the a7C—XAVC S 4K and XAVC S HD, as shown in Figure 9-9. This setting determines the format the camera will use to record movies when you press the Movie button.

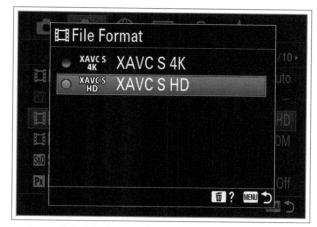

Figure 9-9. File Format (Movies) Menu Options Screen

XAVCS4K

The XAVC S format is a consumer version of the XAVC format, developed for use with 4K video recording, sometimes known as Ultra HD. The term "4K" refers to a horizontal resolution of roughly 4,000 pixels, instead of the 1920 pixels in standard HD video (sometimes called "2K" video). On the a7C, video recorded with the 4K format has a pixel count of 3840 x 2160. Because of its high resolution, this option provides excellent quality for your videos. To enjoy the full benefit of the format, you should view the videos on a TV set that is equipped for 4K viewing.

However, even without that type of TV, you can edit 4K videos with appropriate software, such as Adobe Premiere Pro, Sony Vegas Pro, and others. Sony provides a list of such programs at the following website: http://support.d-imaging.sony.co.jp/www/support/application/nle/en.html. In the editing process, you can downsample the 4K video clips to a

standard HD format, such as 1920 x 1080 pixels, and they will have greater quality than videos originally recorded in an HD format.

As noted earlier, if you use this format, you have to use a memory card rated at least in Class 10 or UHS speed class 1. If you use the highest-quality Record Setting option, the card must be rated in UHS speed class 3.

However, as I will discuss later in this chapter, you can avoid this restriction if you connect the a7C to an external video recorder, such as the Atomos Shogun, using an HDMI cable, and record to the external recorder without recording to the camera's memory card. I'm not suggesting that that system is simple or inexpensive, but it is available if you need to use the a7C for 4K video recording without having to use a particular type of memory card.

XAVC S HD

This second option for File Format uses the high-quality XAVC S format, but records using an HD resolution of 1920 x 1080 pixels rather than the higher 4K resolution. This option will give you excellent quality without the larger files and greater computing resources involved with 4K recording. It carries with it the same requirement for a high-speed memory card as the 4K format.

Record Setting

The Record Setting item on screen 1 of the Camera Settings2 menu is another quality-related option for recording video. (The accent is on the second syllable of "Record.") The choices for this item are different depending on whether you choose XAVC S 4K or XAVC S HD for File Format. I will discuss these options assuming you have your camera set for NTSC, the video standard used in the United States, using the NTSC/PAL Selector option on screen 2 of the Setup menu, as discussed in Chapter 8. If your camera is set for PAL, the choices for Record Setting will include numbers such as 50p and 25p instead of 60p, 30p, and 24p.

XAVC S 4K

If you choose XAVC S 4K for File Format, the four options for Record Setting are 30p 100M, 30p 60M, 24p 100M, and 24p 60M, as shown in Figure 9-10.

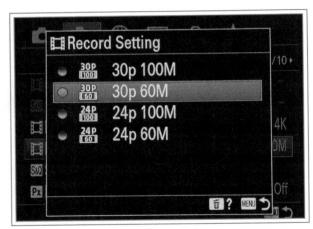

Figure 9-10. Record Setting Options for XAVC S 4K File Format

For these choices, the letter "p" stands for progressive, which means the camera records 30 or 24 full video frames per second. (The other option, used with some older video formats not included with this camera, is designated by the letter "i," standing for interlaced. With an interlaced setting, such as 60i, the camera records 60 fields, or half-frames, per second, which yields lower quality and fewer possibilities for editing.)

The standard speed for recording video in the United States is 30 frames per second, and using either of the 30p settings will yield excellent quality.

If you select 24p 100M or 24p 60M, your video will be recorded and played back at 24 fps. The 24p rate is considered by some people to be more "cinematic" than the 30p format. This may be because 24 fps is a standard speed for movie cameras that shoot with film. My preference is to use the 30p format, but if you find that 24p suits your purposes better, you have that option with the a7C.

The 60M or 100M designation means that these formats record video with a variable bit rate up to a maximum of 60 or 100 megabits per second, which are high rates that yield excellent quality. As noted earlier, when you record using the 100M setting, you have to use a memory card rated in UHS speed class 3.

My recommendation for this setting is to use 30p 60M unless you have a definite need for the super-high quality of the 30p 100M setting.

XAVC S HD

If you choose XAVC S HD for File Format, the seven choices for Record Setting are 60p 50M, 60p 25M, 30p 50M, 30p 16M, 24p 50M, 120p 100M, and 120p 60M,

Chapter 9: Motion Pictures | 197

as shown in Figure 9-11. (The last of these settings is not visible in this figure; you have to scroll down to see it.)

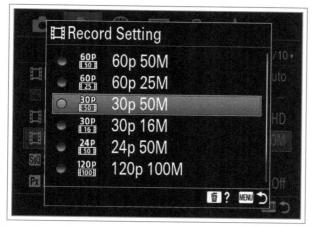

Figure 9-11. Record Setting Options for XAVC S HD File Format

If you use a 60p or 120p option, the camera will record at two or four times the normal speed, and therefore will record two or four times as much video information as with the 30p choice. If you use one of those higher speeds, you will be able to produce a slow-motion version of your footage at very high quality. For example, 60p footage is recorded with twice the number of full frames as 30p footage, so the quality of the video does not suffer if it is played back at one-half speed.

If you think you may want to slow down your footage significantly for playback, you should choose the 60p setting, or, for even slower motion, the 120p setting.

Video taken with the 60p or 120p setting will play back at normal speed in the camera. To play it back in slow motion, you can use a program such as iMovie for the Mac, Movies and TV for Windows, or Sony's PlayMemories Home. Just set the playback speed to a factor such as 0.5x or 0.25x to play the footage at the slower speed.

The 24p option is not a substantially slower rate than the 60p format or the 120p format, because the video playback rate in the United States is 30 fps, and the 60p and 120p formats are converted to 30 fps for playback in the camera.

All of these options are recorded in full HD, meaning the pixel count for each video frame is 1920×1080 . The 120p selections (100p for cameras using the PAL system) are not available with Intelligent Auto mode. With either of the 120p options, the camera cannot

use face detection, non-optical zoom, Touch Tracking, Proxy Recording, or Auto Slow Shutter.

Here again, as with the 4K settings, you have to use a memory card rated in UHS speed class 3 if you use the 100M setting, and at least a Class 10 or UHS speed class 1 card for the other settings.

S & Q Settings

This menu option lets you set up the camera for slow-motion or speeded-up video, which you can record when you turn the mode dial to the S & Q position, for slow and quick motion shooting. I will discuss these options later in this chapter, in a section on S & Q shooting.

Proxy Recording

This option is somewhat like a video version of the Raw & JPEG setting for still images. When it is turned on, the camera also saves a copy of the video in a smaller file format (XAVC S HD, 1280 x 720 pixels, at 9 Mbps bit rate), giving you a second video file that is easier to edit and share through social media and other means.

The proxy files are saved to the memory card along with the main video file, but the proxy file cannot be played in the camera; it is of use only for editing or viewing on a computer. The main file is stored on the memory card in the folder Private-M4Root-Clip, and the Proxy file is stored in the folder Private-M4Root-Sub. When I tested this function by recording a brief video with proxy recording turned on, the main file, named C0053.mp4, was about 132 MB in size, while the proxy file, named C0053S03.mp4, was about 52 MB.

Because the copy is equivalent to the original in terms of frame rate and other attributes, it also can be used as a proxy file in video editing software that uses proxy editing. With that system, you can edit the smaller proxy file easily without having to wait for the computer to process effects and handle large files that can strain the memory and processor. Then, at the final editing stage, you can substitute the original, larger file for the final rendering of the video.

Proxy recording is not available when Record Setting is set to 120p (100p with PAL systems).

I recommend leaving this option turned off unless you have a specific reason to use it.

AF Transition Speed

This first option on screen 2 of the Camera Settings2 menu controls the speed at which the camera's autofocus system changes focus when recording video. The choices range from 7 (Fast) to 1 (Slow), with intermediate settings from 2 through 6 and a default value of 5. You adjust the setting on the scale displayed, using the Left and Right buttons, the control wheel, or the control dial, as shown in Figure 9-12.

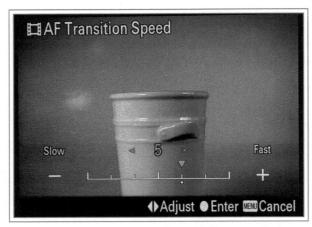

Figure 9-12. AF Transition Speed Adjustment Scale

The fastest settings are suitable for sports or other activities when the most important goal is to keep the subject in focus, and quick focus shifts are not a problem. The slower options are for use when you are shooting static or slow-moving subjects, and it may be preferable for focus to adjust gradually, to avoid jarring the audience with abrupt focus changes.

This option is particularly useful when you are using the touch screen features of the camera to carry out a "pull focus" action. As discussed in Chapter 6 in connection with the LCD screen, you can touch one spot on the screen, and then another, to shift the focus point, or you can drag the focus frame to a new location, depending on the focus area setting. The choice you make for AF Transition Speed will have a clear impact on the nature of the pull focus effect.

The setting you choose for this menu option depends on your preference and what you are trying to accomplish; you may want to experiment with several settings and see which one suits your taste best for a given situation.

AF Subject Shift Sensitivity

This option, located after AF Transition Speed on the menu, controls how quickly the autofocus system

switches to a different subject when recording video. There are five choices, adjusted on a scale similar to that for the AF Transition Speed option. For AF Subject Shift Sensitivity, the settings range from 5 (Responsive) to 1 (Locked On). With Responsive, which is the default value, the focus will shift quickly, to track a new subject. With Locked On, the focus does not shift when other subjects come into the focusing area.

For example, if a person walks in front of the camera while you are recording a scene in the distance, with the Locked On setting the camera is likely to maintain focus on your actual subject, rather than quickly shifting focus to the person who is temporarily in the way. I recommend using a moderate setting of 3 or lower unless you need to track a variety of subjects, such as different actors in a play, different athletes at a sporting event, or several children at play.

Auto Slow Shutter

This menu option can be set either on or off. When it is turned on and the a7C is recording a movie with autoexposure, the camera will automatically use a slower shutter speed than normal if the lighting is too dim to achieve proper exposure otherwise. The details of this option depend on the setting for Record Setting on screen 1 of the Camera Settings2 menu. (The File Format setting does not matter; the rules stated here apply for both File Format settings.)

If Record Setting is at a 60p setting, the camera normally will not use a shutter speed slower than 1/60 second. (In order to record 60 frames per second with good quality, a shutter speed of 1/60 second is needed.) If Auto Slow Shutter is on, the camera can use a shutter speed as slow as 1/30 second.

If Record Setting is at one of the 30p settings, the camera ordinarily will use a shutter speed no slower than 1/30 second, but it will go down to 1/15 second with Auto Slow Shutter turned on.

If Record Setting is at a 24p setting, the camera ordinarily will use a shutter speed no slower than 1/45 second, but it will go down to 1/20 second with Auto Slow Shutter turned on.

If Record setting is at one of the 120p settings (available only when File Format is set to XAVC S HD), the slowest shutter speed available is 1/125 second, and the Auto Slow Shutter option is not available.

Chapter 9: Motion Pictures | 199

Auto Slow Shutter cannot operate unless ISO is set to Auto ISO. In addition, it will not operate if Exposure Mode (Movies) is set to Shutter Priority or Manual Exposure, even though you can turn it on through the menu, and it will appear to be on.

The use of an unusually slow shutter speed can produce a slurred or blurry appearance because the shutter speed may not be fast enough to keep up with the motion in the scene. But, if you are recording in a dark area, this option can help you achieve properly exposed footage, so it is worth considering in that situation.

Initial Focus Magnification (Movies)

This option is similar to the one with the same name for still images, discussed in Chapter 4. This menu item is different from that one because the magnification factor for the Focus Magnifier can only be x1.0 or x4.0 for movies, rather than the greater levels of magnification that are available when shooting still images.

Audio Recording

The Audio Recording menu option can be set either on or off. If you are certain you won't need the sound recorded by the camera, you can turn this option off. I never turn it off, because I can always turn down the volume of the recorded sound when playing the video. Or, if I am editing the video on a computer, I can delete the sound and replace it as needed—but there is no way to recapture the original audio after the fact if this option was turned off during the recording.

Audio Recording Level

This last option on screen 2 of the Camera Settings2 menu is available for selection only when the mode dial is set to Movie mode. If you record movies in any other shooting mode, the camera will set the level for recording sound, and you cannot control it. In Movie mode, you can control the recording sound level using this menu option.

When you select this option, the camera displays a screen like that in Figure 9-13, with a scale of values from 0 to 31. While the scale is highlighted by the orange box, use the control wheel, control dial, or the Left and Right buttons to select your desired value on the scale. If you highlight the Reset block and press the Center button, the level will be reset to the default value of 26. You can check the level of the sound by

watching the audio level meters on the lower right area of the screen for setting the volume level.

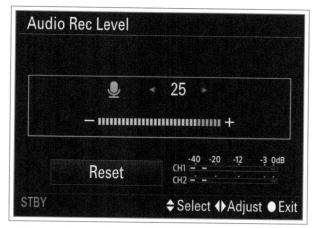

Figure 9-13. Audio Recording Level Adjustment Screen

Once the adjustment is made, press the Center button to exit to the live view. The new setting will be reflected in the behavior of the volume meters on the screen, when those meters are displayed in shooting mode, as shown in Figure 9-14.

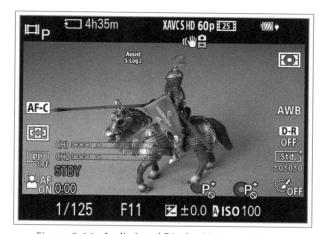

Figure 9-14. Audio Level Display Meters on Screen

The meters will be displayed only when the Audio Level Display option is turned on through screen 3 of the Camera Settings2 menu. If that menu option is turned on, the meters will appear on the screen during video recording in any shooting mode and they also will appear on the screen before the recording begins when the camera is in Movie mode.

When the screen in Figure 9-13 is shown, the audio level meters will react to sounds you make, so, in Movie mode, you can test the sound level before the recording starts. For example, before you start recording an interview, you can ask your subject to speak normally

to test the level. You should try to adjust the level so the green bars never extend all the way to the right sides of the meters; if the bars reach into the red zones, the result is likely to be distorted sound.

No matter what level is set, the camera uses a limiter an electronic circuit that keeps the volume from getting excessively loud.

The audio recording level meters will operate when you are using the built-in microphone or when using an external microphone, as discussed in Appendix A.

Audio Level Display

This first option on screen 3 of the Camera Settings2 menu controls whether audio level meters appear during movie recording in any shooting mode and before recording a video when the camera is set to Movie mode. The meters have green indicators that move farther to the right to indicate increases in the volume of audio, as shown in Figure 9-14.

The meters appear on detailed information screens; if this option is turned on and you don't see the meters when recording a video, press the Display button to call up one of the other screens. Also, check to see if the Audio Recording menu option, discussed above, is turned on; if that option is turned off, the meters will not be displayed. I generally leave this option turned on; seeing the movement of the audio levels on the meters reassures me that the audio is being recorded successfully.

Audio Out Timing

I discussed this option in Chapter 5. It controls how audio is output through headphones as you monitor audio while recording video. It can be set to either Live or Lip Sync. With the Live setting, the camera outputs the sound without delay. With Lip Sync, the camera delays the audio output slightly, to synchronize the audio and video.

This setting appears to be of use mainly when you are recording video to an external recorder. If this setting is left at Live in that situation, the sound is likely to be heard before the video is seen, by a fraction of a second. If that is the case, setting this option to Lip Sync may bring the audio and video back into synchronization.

Wind Noise Reduction

This option, if turned on, activates an electronic filter designed to reduce the volume of sounds in the frequencies of wind noise. I recommend not activating this feature unless the wind is strong, because it limits the sounds that are recorded. With video (or audio) editing software, you can remove sounds in the frequencies that may cause problems for the sound track, but using this built-in wind noise filter may permanently remove or alter some wanted sounds. This option does not affect recordings with an external microphone.

Marker Display

This option, which can be turned either on or off, determines whether or not various informative guidelines, called "markers," are displayed on the camera's screen during movie recording. There are four special markers available, which outline the aspect ratio and other areas on the screen. Any or all of them can be selected for use with the Marker Settings menu option, directly after this one on this menu screen. If you turn Marker Display on, then any of the four markers that you have selected will be displayed on the shooting screen while a movie is being recorded in any mode. The markers also will be displayed while the mode dial is set to the Movie mode position or the S & Q position, even before recording starts.

If this option is turned on, the selected markers will display on the camera's display screen, but they will not be recorded with the movie.

Marker Settings

This menu option works together with the Marker Display option, discussed above. This option lets you activate any or all of the four available markers—Center, Aspect, Safety Zone, and Guideframe.

If you turn on the Center marker, it places a cross in the center of the display, as illustrated in Figure 9-15. If you are shooting video in a busy or hectic environment, this marker may help you keep the main subject centered in the display so you don't cut it off.

The Aspect marker can be off, or set to any one of seven settings: 4:3, 13:9, 14:9, 15:9, 1.66:1, 1.85:1, or 2.35:1. Figure 9-16 shows the display with the 13:9 setting.

Chapter 9: Motion Pictures 201

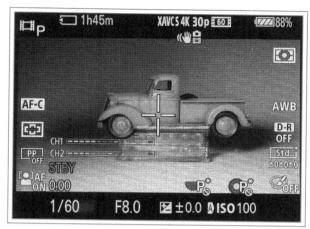

Figure 9-15. Center Marker Displayed on Recording Screen

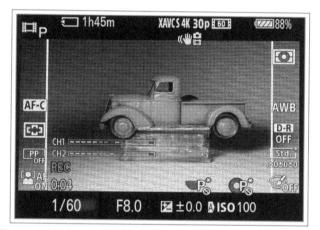

Figure 9-16. Aspect Marker 13:9 Displayed on Recording Screen

This setting places vertical white lines at the sides of the frame or horizontal white lines at the top and bottom of the frame, to outline the shape of the movie frame for the chosen aspect ratio. These lines are useful if you plan to alter the aspect ratio of your footage in post-production, to show what parts of the image will be cut off and help you frame your shots accordingly.

The Safety Zone marker can be off, or set to outline either 80% or 90% of the area of the display. The purpose of this marker's guidelines is to provide a margin for safety, because the average consumer television set may not display the entire video signal provided to it. If you set these lines to mark a safety zone, you can make sure your important subjects are included in the area that definitely will be displayed on most television sets. Figure 9-17 shows the display with the 90% safety zone activated.

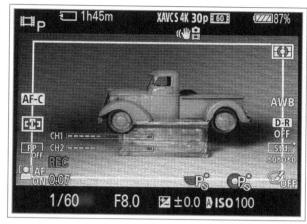

Figure 9-17. 90% Safety Zone Displayed on Recording Screen

Finally, the Guideframe option, if turned on, displays a grid that is similar to the Rule of Thirds grid available with the Grid Line option, discussed in Chapter 5. That option uses thin, black lines, which may be hard to see when you are shooting video under difficult conditions. The bold, white lines of the Guideframe setting may be more useful for video shooting. You cannot use both options at the same time; Grid Line is not available when Marker Display is turned on. Figure 9-18 shows the Guideframe option in use.

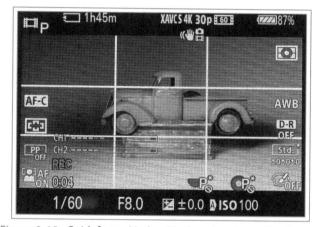

Figure 9-18. Guideframe Marker Displayed on Recording Screen

Video Light Mode

This menu option is of use only when the camera has a compatible video light attached to the Multi Interface Shoe. The only compatible model as of this writing is the Sony HVL-LBPC, which is discussed in Appendix A. This menu item offers four choices, as shown in Figure 9-19: Power Link, REC Link, REC Link & STBY, and Auto.

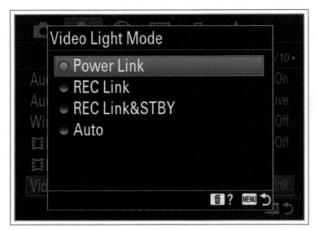

Figure 9-19. Video Light Mode Menu Options Screen

With Power Link, the light turns on or off when the camera is powered on or off. With REC Link, the light turns on or off when the camera starts or stops video recording. With REC Link & STBY, the light turns on when the camera starts and dims when the camera stops recording. With this setting, the light does not dim all that much, so I did not find it as useful as other settings. Finally, with Auto, the light turns on when the environment becomes dark. However, it does not turn off if the camera is then brought into a brighter area; once it turns on it stays on until some other control turns it off.

These options worked as described when I tested them with the Sony HVL-LBPC light with a different camera. I have not tested them with the a7C, because I no longer have the light, but there is no reason to believe they do not work as expected.

If you are recording events that develop quickly, it could be useful to have the light turn on as soon as you power on the camera or press the Movie button to start recording, depending on your preference.

When you are using this menu option, you switch the video light to its Auto setting. If you want to use the light without relying on the menu option, you can just switch it on or off manually.

Movie with Shutter

This single option on screen 4 of the Camera Settings2 menu can be turned either on or off. If it is turned on, you can start and stop movie recording by pressing the shutter button when the camera is set to Movie mode or S & Q Motion mode. If it is left off, you have to press the Movie button to start or stop movie recording. (You

also can set a different control button to the Movie Shooting option using the Custom Key options on screen 9 of the Camera Settings2 menu.) Some people find it more natural to use the shutter button to control the recording process, because the button is directly under the right index finger.

Turning this option on does not reduce the functionality of the shutter button for taking still images, because you cannot take still images when the mode dial is at the Movie or S & Q position. However, it does remove the ability to cause the camera to focus by half-pressing the shutter button during movie recording.

Custom Key (Movies)

This option, on screen 9 of the Camera Settings2 menu, is quite useful for movie recording. It lets you assign a movie-related function to each of several control buttons, so you can call up that function while recording a movie, when the mode dial is set to either the Movie or the S & Q Motion position. The items that can be assigned were discussed in Chapter 5.

EFFECTS OF MODE DIAL POSITION ON RECORDING MOVIES

The second category of setting that affects video recording with the a7C is the position of the mode dial. As I discussed above, you can shoot normal-speed movies with the dial in any position except S & Q Motion, and you can get access to many movie-related menu items no matter what position the dial is in. However, as I noted above, the shooting mode does make some difference for your movie options.

First, the position you select on the mode dial determines whether you can adjust the aperture and/ or shutter speed for your movies. If the dial is set to the Intelligent Auto or Program mode, the camera will set both aperture and shutter speed automatically. However, if the dial is set to the Aperture Priority, Shutter Priority, or Manual exposure position, you will be able to adjust the aperture, shutter speed, or both aperture and shutter speed, just as you can when shooting still images. The range of available shutter speeds is different for movies than for still images, but you can make those adjustments at any time.

You also can make those adjustments when the mode dial is set to the Movie position and you select one of the more advanced exposure modes using the Exposure Mode item on screen 1 of the Camera Settings2 menu. For example, as discussed earlier in this chapter, if you select Manual Exposure for Exposure Mode with the mode dial at the Movie position, you can adjust both aperture and shutter speed for your movies, in the same way as if the mode dial were set to the M position. (If you set the mode dial to the S & Q Motion setting, you can shoot slow-motion or quick-motion movies. I will discuss those options in an S & Q Motion section later in this chapter.)

Because of the ability to adjust aperture and shutter speed in the advanced still-shooting modes, you might wonder why you would ever use the Movie position on the dial—why not just set the dial to A, S, or M if you want to adjust aperture and/or shutter speed while recording a movie, or to AUTO or P if you want the camera to set the aperture and shutter speed automatically?

The answer is that several options or settings are available only when the mode dial is at the Movie position. For one thing, you will see how the video recording will be framed before you press the Movie button to start recording. If the mode dial is at a still-oriented position (Intelligent Auto or a PASM mode), the display will show the live view according to the current setting for Aspect Ratio on screen 1 of the Camera Settings1 menu. If the setting is 3:2, 4:3, or 1:1, it will not correspond to the framing of the video, which will be recorded in widescreen format, until you press the Movie button to start recording. (If Aspect Ratio is set to 16:9, the display will show approximately how the framing will look before you press the Movie button.)

When the mode dial is at the Movie position, the camera adjusts the live view to show how the video will look before you press the Movie button, so you will know before you start the recording how to set up the shot to include all of the needed background and foreground elements.

In addition, when the mode dial is at the Movie position, you can take advantage of two options for customizing the camera. You can get access to any settings you have made using the Custom Key (Movies) option on screen 9 of the Camera Settings2 menu, to assign functions to various control buttons. Also, you can take advantage of the movie-oriented settings

on the Function menu, which has separate groups of custom settings for still-shooting and video recording.

Moreover, several menu options are not available unless the mode dial is at the Movie position (or, in some cases, the S & Q Motion position). In particular, on screen 3 of the Setup menu, the 4K Output Select option is not available, nor are most of the sub-settings of the TC/UB Settings option. All of these settings can be useful when recording to an external video recorder.

In addition, the Marker Display option on screen 3 of the Camera Settings2 menu can be selected in any shooting mode, but any marker you have selected for display will not appear in still-oriented modes until you actually start recording a video. When the mode dial is at the Movie position (or the S & Q position), you will see the marker on the display before the recording starts, so you can set up your composition ahead of time.

You also can use the Audio Recording Level option on screen 2 of the Camera Settings2 menu to set the audio input level, which cannot be controlled in other shooting modes.

Also, the camera's shooting mode has an effect on what options are available on the Camera Settings1 menu and with the control buttons, as discussed in following sections of this chapter. For example, if the mode dial is set to Intelligent Auto, the Camera Settings1 menu options are limited. If the mode dial is set to Program, Aperture Priority, Shutter Priority, or Manual exposure, the options are greater. This point is important for video shooting because, as discussed below, several important Camera Settings1 menu options carry over to movie recording.

If the camera is set to Program mode (P on the mode dial), you can make several settings that will affect the recording of videos while the mode dial is in that position. The camera will set the aperture and shutter speed automatically, as it does with still-image shooting. You can use exposure compensation to vary the exposure, but only within the range of plus or minus 2 EV, instead of the 5-EV positive or negative range for still shooting.

If the camera is set to Aperture Priority mode (A on the mode dial), you will have the same Camera Settings1 menu options as in Program mode, and you can also set the aperture; the camera will set the shutter speed

automatically, but the range of available shutter speeds will be somewhat different than for still images. That range is also affected by the Record Setting option selected and the setting of the Auto Slow Shutter menu option, as discussed earlier in this chapter.

If the camera is set to Shutter Priority mode (S on the mode dial), you will have the same Camera Settings1 menu options as in Program mode, and you can also set the shutter speed. You can set it anywhere from 1/4 second (the camera's slowest setting for movies) to 1/4000 second (the camera's fastest setting for movies), regardless of the Record Setting or Auto Slow Shutter settings, with one exception. The one exception is that the slowest setting available is 1/125 second when

Record Setting is set to either of the 120p settings (100p for the PAL system), which are available when File Format is set to XAVC S HD.

If the camera is set to Manual exposure mode (M on the mode dial), you will have the same Camera Settings1 menu options as before. You can set both shutter speed and aperture, with the same restrictions for shutter speed settings noted above for Shutter Priority mode.

There is a lot of information involved in outlining the differences in the a7C's behavior for video recording in different shooting modes, so I am including here a table that lays out the more important differences, for reference.

Table 9-1. Behavior of a7C Camera for Recording Video in Various Shooting Modes

SHOOTING MODE:	INTELLIGENT AUTO	S & Q MOTION	Movie	М	S	Α	Р
ADJUST APERTURE DURING VIDEO RECORDING	No	DEPENDS ON EXPOSURE MODE (S & Q) MENU OPTION SETTING	DEPENDS ON EXPOSURE MODE (MOVIES) MENU OPTION SETTING	YES	No	YES	No
Adjust Shutter Speed During Video Recording	No	DEPENDS ON EXPOSURE MODE (S & Q) MENU OPTION	DEPENDS ON EXPOSURE MODE (MOVIES) MENU OPTION SETTING	YES	YES	No	No
SEE VIDEO FRAMING BEFORE RECORDING STARTS	No	YES	YES	No	No	No	No
USE 4K OUTPUT SELECT	No	No	YES	No	No	No	No
USE ALL TC/UB SETTINGS Options	No	ALL EXCEPT TC RUN	YES	No	No	No	No
Adjust Audio Recording Level	No	No	YES	No	No	No	No
SEE MARKER DISPLAY ITEMS BEFORE RECORDING STARTS	No	YES	YES	No	No	No	No
Use 120p/100p Record SETTINGS OPTIONS	No	S & Q VIDEO ONLY	YES	YES	YES	YES	YES

EFFECTS OF CAMERA SETTINGS 1 MENU SETTINGS ON RECORDING MOVIES

Although the settings on the Camera Settings1 menu are largely oriented toward still images, several of them affect the recording of movies. I will discuss those options in this section.

One of the main reasons the shooting mode is important for movies is that, just as with still photography, some menu options are not available in some modes. For example, in an advanced still-shooting mode like Aperture Priority or Program, video recording is affected by the settings for focus area, ISO, metering mode, white balance, DRO, Creative Style, Picture Effect, Picture Profile, Focus Magnifier, Face/Eye Priority in AF, Face Priority in Multi Metering,

DRO, and Lens Compensation. In some cases, you can adjust these settings while the video is being recorded.

You cannot get access to the Camera Settings1 menu (or any menu) by pressing the Menu button (or another button assigned to the Menu function) during video recording; you have to use a control button, the Function menu, or the control dial or wheel to call up the item to adjust. Of course, you have to have that setting assigned to the button, menu, dial, or wheel ahead of time.

For example, you can adjust ISO while recording a video, but only if you have assigned ISO to the control wheel, the control dial, or one of the control buttons using the Custom Key menu options on screen 9 of the Camera Settings2 menu, or to the Function menu. (For

Chapter 9: Motion Pictures 205

the dial and wheel to be assigned, you would need to use other menu options also, such as My Dial Settings.)

Another option from the Camera Settings1 menu that is particularly useful for video recording is Picture Profile, found on screen 11 of that menu. Although Picture Profile is applicable for both still images and video recording, it is really oriented to shooting video. I discussed the details of its settings in Chapter 4.

If you want to have the greatest amount of dynamic range available in your video sequences and are willing to go through the effort of color grading your clips with post-processing software, you can choose PP7, PP8, PP9, or PP10 for the Picture Profile setting, to take advantage of the S-Log2, S-Log3, or one of the HLG settings for gamma curve. Otherwise, choose one of the lower-numbered profiles, or no profile at all. If you want to get involved with parameters such as gamma, black level, detail, and knee, you can create your own profile with settings you prefer.

If you want to experiment with different Picture Profile settings, you can assign this menu option to one of the control buttons using the Custom Key options on the Camera Settings2 menu or to the Function menu. You can then call up different Picture Profile settings while recording a video, to see how they affect the recording.

If you use a profile that includes the S-Log2, S-Log3, or an HLG gamma setting, you can use the Gamma Display Assist option, discussed in Chapter 8, to increase the apparent contrast of the footage as it is displayed by the camera during recording and playback, so it will be easier to judge composition, exposure, and focus, etc.

Table 9-2, below, provides information about the options on the Camera Settings1 menu that are the most useful for video recording, showing which of these settings carry over to video recording if set before recording starts, and which of those also can be adjusted while a video recording is in progress, when the camera is set to a shooting mode in which that adjustment is possible. (This table does not include some options that have no effect on your videos, such as File Format (Still Images), Raw File Type, Circulation of Focus Point, Display Continuous AF Area, and others of that nature.)

Table 9-2. CAMERA SETTINGS 1 MENU ITEMS THAT AFFECT MOVIES AND CAN BE ADJUSTED BEFORE OR DURING VIDEO RECORDING

CAMERA SETTINGS 1 MENU ITEM	CARRIES OVER TO VIDEO IF ADJUSTED BEFORE VIDEO RECORDING	Can Adjust During Video Recording
Focus Mode	YES	YES
Focus Area	Yes (Tracking Not Available)	YES
FACE/EYE PRIORITY IN AF	YES	No
SUBJECT DETECTION	YES	YES
RIGHT/LEFT EYE SELECT	YES	YES
FACE/EYE FRAME DISPLAY	YES	YES
EXPOSURE COMPENSATION	YES	YES
ISO SETTING	YES	YES
METERING MODE	YES	No
FACE PRIORITY IN MULTI METERING	Yes	No
SPOT METERING POINT	YES	No
WHITE BALANCE	YES	No
DRO/Auto HDR	YES (DRO ONLY)	No
CREATIVE STYLE	YES	No
PICTURE EFFECT	YES	No
PICTURE PROFILE	YES	YES
Focus Magnifier	N/A	YES
PEAKING DISPLAY SELECT	YES	YES

There are built-in limitations with some of these settings. Exposure compensation can be adjusted to plus or minus 2.0EV only, rather than the 5.0EV range for still images. The ISO range includes Auto ISO and specific values from 100 to 104000, omitting several of the lowest and highest settings.

With Picture Effect, you cannot use the Rich-tone Monochrome setting when recording a movie. (As noted on the table, you cannot get access to the Picture Effect settings during video recording.)

There are some other options on the Camera Settings1 menu that have no effect for recording movies. Some of these settings are clearly incompatible with shooting movies, such as drive mode, flash mode, and interval shooting. Some are less obvious, such as AF Illuminator.

There are two other points to make about using Camera Settings1 menu settings for movies. First, you have a great deal of flexibility in choosing settings for your movies, even when the camera is not set to the Movie position on the mode dial. You can set up the camera with the ISO, metering mode, white balance, Creative

Style, Picture Effect (with one exception), and other settings of your choice, and then press the Movie button to record using those settings. In this way, you could, for example, record a black-and-white movie in a dark environment using a high ISO setting. Or, you could record a movie that is monochrome except for a broad selection of red objects, using the Partial Color-Red effect from the Picture Effect option, with the red color expanded using the color axis adjustments of the white balance setting. (Note that you can't use Creative Style and Picture Effect settings at the same time.)

Second, you have to be careful to check the settings that are in effect for still photos before you press the Movie button. For example, if you have been shooting stills using the Posterization setting from the Picture Effect menu option and then suddenly see an event that you want to record on video, if you press the Movie button, the movie will be recorded using the Posterization effect, making the resulting footage practically impossible to use as a clear record of the events.

Of course, you may notice this problem as you record the video, but it takes time to stop the recording, change the menu setting to turn off the Picture Effect option, and then press the Movie button again, and you may have missed a crucial part of the action by the time you start recording again.

One way to lessen the risk of recording video with unwanted Camera Settings1 menu options is to switch the mode dial to the Auto position before pressing the Movie button. That action will cause the camera to use more automatic settings and will disable the Creative Style and Picture Effect options altogether.

EFFECTS OF PHYSICAL CONTROLS WHEN RECORDING MOVIES

Other settings that carry over to some extent from shooting stills to video recording are those set by the physical controls. In this case, as with Camera Settings1 menu items, there are differences depending on the position of the mode dial. I will not try to describe every possible combination of shooting mode and physical control, but I will discuss some settings to be aware of.

First, you can use the focus mode switch on the lens (if the lens has one) to change between autofocus and manual focus modes while recording a movie. The only two modes available for video recording with the a7C

are continuous autofocus and manual focus. If you set a focus switch on the lens to the AF position, the camera will use continuous autofocus. If you set the switch to the MF position, the camera will use manual focus. If autofocus is in use, you can half-press the shutter button to cause the camera to re-focus.

Second, the touch screen operates during video recording, but in a somewhat different way than it does for shooting still images, assuming touch screen features are turned on through the Touch Operation item on screen 2 of the Setup menu.

If focus area is set to Wide, Zone, or Center, you can touch the screen to select a focus point, and the camera will direct its focus to that point. It will not display a focus frame there, but the focus will become sharp at that point. At the same time, the camera will switch the focus mode to manual focus so the focus will stay locked at that spot. It stays in manual focus mode until you touch the screen at another point, or touch the finger icon with an X that turns off the Touch Focus feature, or press the Center button to cancel the Touch Focus operation. You can use this feature, which Sony calls "spot focus," to carry out a "pull-focus" operation by touching one subject and then another. The speed of that operation is governed by the setting for AF Transition Speed on screen 2 of the Camera Settings2 menu.

If focus area is set to Flexible Spot or Expand Flexible Spot, you can drag the focus frame to a new location, and the camera will focus at the new point. You can use this operation for a "pull focus" effect by dragging the focus frame from one subject to another. You also can tap any spot to set a new focus frame, but the camera does not switch to manual focus as it does when focus area is set to Wide, Zone, or Center, as discussed above.

If manual focus mode is in use, you can tap twice on the screen to enlarge the view. However, if the Initial Focus Magnification (Movies) option on screen 2 of the Camera Settings2 menu is set to x1.0, the double-tap will just turn on the Focus Magnifier frame; you then have to press the Center button to enlarge the view.

Next, you can adjust exposure compensation using the exposure compensation dial (or another control assigned to control exposure compensation) while recording movies when the mode dial is set to the P, A, S, M, Movie, or S & Q setting. That setting is not available in Intelligent Auto mode. The range of exposure compensation for movies is plus or minus 2.0 EV, rather than the plus or minus 5.0 EV for still images. If you set exposure compensation to a value greater than 2.0 (plus or minus), the camera will set it back to 2.0 after you press the Movie button to start shooting a movie.

Also, the Function button operates normally. For example, if the mode dial is set to P for Program mode, then, after you press the Movie button to start recording a movie, you can press the Function button and the Function menu will appear on the screen. This menu will let you control only those items that can be controlled under current conditions.

If you start recording a movie while the mode dial is set to Intelligent Auto mode, in which most options on the Function Button menu are not available, the a7C will display the menu, but few items will be available for selection.

If you assign a control button to carry out an operation using the Custom Key (Still Images) or Custom Key (Movies) option on screen 9 of the Camera Settings2 menu, you can use that button to perform the operation while recording a movie if the action is compatible with movie recording in the current shooting mode. The situation is similar if you assign exposure compensation to the control wheel or dial using the Dial/Wheel EV Compensation option on screen 10 of the Camera Settings2 menu, or if you assign temporary settings to the control wheel and/or dial using the My Dial Settings options on screen 9 of the Camera Settings2 menu.

There are numerous options that can be assigned to a control button that will function during video recording, if the current context permits that control. For example, if the Right button is set to control ISO and you are shooting a movie with the mode dial set to P, pressing the Right button will bring up the ISO menu and you can select a value while the movie is recording. If the mode dial is set to AUTO, though, pressing the button will have no effect during recording, because ISO cannot be adjusted in that shooting mode.

If the Center button (or another button) is assigned the Focus Standard setting through the Custom Key (Still Images) or Custom Key (Movies) menu option, you can press the button during video recording to activate a movable focus frame or to cause the camera to focus in the center of the frame, depending on the current focus

area setting. Of course, to use either of those options, the camera must be set to use autofocus rather than manual focus.

If you set the AF-ON button (or some other button) to the AEL Hold or AEL Toggle function, you can press that control while recording a movie to lock the exposure setting. This ability can be useful when recording a movie, when you don't want the exposure to change as you move the camera over different areas of a scene.

Following is a list of functions that can be assigned to one of the control buttons, dial, or wheel, or to the Function menu, and that can be controlled during video recording by using the assigned control:

- Self-timer During Bracketing
- Focus Mode
- AF/MF Control Hold
- AF/MF Control Toggle
- Focus Standard
- Focus Area
- Switch Focus Area
- Eye AF
- Subject Detection
- Switch Right/Left Eye
- AF Tracking Sensitivity (Still Images)
- Aperture Drive in AF
- Switch AF Frame Move Hold
- AF On
- Focus Hold
- Exposure Compensation
- ISO Setting
- AEL Hold
- **AEL Toggle**
- Spot AEL Hold
- Spot AEL Toggle

- ° AWB Lock Hold
- ° AWB Lock Toggle
- Picture Profile
- Focus Magnifier
- Peaking Display Select
- ° Peaking Level
- Peaking Color
- ^o Anti-Flicker Shooting
- In-Camera Guide (provides help for Function menu items during recording)
- Movie (button operates to start/stop video recording)
- ° Frame Rate (S & Q Motion)
- AF Transition Speed (Movies)
- [°] AF Subject Shift Sensitivity (Movies)
- ^o Audio Recording Level
- [°] Audio Level Display
- Marker Display Select
- SteadyShot
- SteadyShot Adjustment
- SteadyShot Focal Length
- ° Zoom
- ° Finder/Monitor Select
- ° Finder Frame Rate
- ^o Zebra Display Select
- ° Zebra Level
- ° Grid Line
- My Dial 1/2/3 During Hold
- My Dial 1—2—3
- Toggle My Dial 1/2/3
- * Audio Signals

- [°] Gamma Display Assist
- * Touch Operation Select
- TC/UB Display Switch (switches among counter, time code, and user bit displays)

Several items on this list, including Self-timer During Bracketing, AF Tracking Sensitivity (Still Images), Aperture Drive in AF, and Anti-Flicker Shooting, are not useful during video recording. However, Sony for some reason has made those items available for use with an assigned button during movie recording, so I have included them on the list.

Slow and Quick Motion Recording

The a7C camera can record video at a higher-thannormal frame rate, which results in slow-motion sequences when played back at a normal rate, or at a lower-than-normal rate, resulting in a speeded-up movie. If you are using the NTSC system, you can record at a rate as high as 120 frames per second (fps) or as low as 1 fps; with the PAL system, you can record at up to 100 fps or as low as 1 fps.

With the NTSC system, you can create a video sequence to be played back in the camera at up to five times slower or 60 times faster than normal; with PAL, the limits are four times slower and 50 times faster. Because there are several settings and steps to be taken to use this feature, I will provide a step-by-step guide.

- 1. Set the mode dial to S & Q, as shown in Figure 9-20.
- 2. On screen 1 of the Camera Settings2 menu, highlight the second option, Exposure Mode (S & Q), and select one of the available exposure modes, as shown in Figure 9-21—Program Auto, Aperture Priority, Shutter Priority, or Manual Exposure. These modes are similar to those for normal-speed movie shooting, discussed earlier in this chapter. If you choose S or M, the shutter speed that can be set will depend on the Frame Rate setting you make in Step 6. For example, if you select 120 fps for the Frame Rate, the shutter speed will have to be 1/125 second or faster.

Chapter 9: Motion Pictures 209

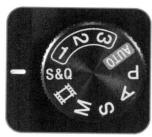

Figure 9-20. Mode Dial Set to S & Q Motion

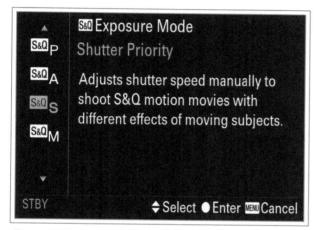

Figure 9-21. Exposure Mode (S & Q) Menu Options Screen

- 3. Make any control or menu adjustments that are needed. For example, if you selected Aperture Priority for the exposure mode, set the aperture. Also set ISO, metering mode, white balance, and any other available settings, if needed. Set the focus mode using the focus mode menu option. Select the zoom amount for the lens (if using a zoom lens) and adjust the focus for your subject.
- On screen 1 of the Camera Settings2 menu, highlight S & Q Settings and press the Center button. You will see a screen like that in Figure 9-22.
- This setting is not the same as Record Setting on the Camera Settings2 menu screen, which applies for normal video recording. This setting sets the video quality for your S & Q Motion videos, and determines the frame rate for playback of those videos. If your camera is set for the NTSC system, the choices for Record Setting are 60p, 30p, or 24p. The bit rate is set at 50M for each of the three settings. The video will be recorded using the XAVC S HD format. For highest quality of the final video, select 60p. For the greatest amount of slowing

down of the final video, select 24p. (The 60p setting is not available if Frame Rate is set to 120 fps.)

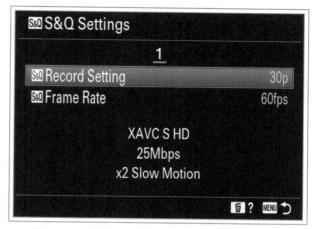

Figure 9-22. S & Q Settings Menu Options Screen

- 6. Go back to the S & Q Settings options and select Frame Rate. The choices are 120 fps, 60 fps, 30 fps, 15 fps, 8 fps, 4 fps, 2 fps, or 1 fps. You can determine how slow the slow-motion footage will be by dividing this number by the Record Setting figure. For example, if Frame Rate is 120 and Record Setting is 30, the final video will be slowed down four times when played back in the camera.
- 7. If Frame Rate is greater than Record Setting, the final movie will be in slow motion. If Frame Rate is smaller than Record Setting, the final movie will be in speeded-up motion, like an old-time silent movie, or, at the lowest Frame Rate settings, such as 1 fps, similar to a time-lapse movie. If the two values are equal, the video will play back at normal speed, but (like all S & Q movies) with no sound.
- 8. When you are ready to start recording, press the Movie button. You can adjust focus and call up available functions during the recording, using control buttons and dials, in the same way as with normal-speed video recording.

The final movie can be played back like any other movie. Movies recorded in S & Q mode are recorded with no sound.

Recording to an External Video Recorder

For recording everyday videos such as clips of vacations or family events, the a7C will serve you well. However, the camera has some options that are useful for

Focus Point Link if needed

Snot Metering Point

professional video production. Several of these options control how the camera sends video to an external video recorder. I will not discuss all possible scenarios for using the a7C with a recorder, but I will describe the steps I took to record video with the camera connected to an Atomos Shogun 4K recorder, discussed in Appendix A, with the caveat that there undoubtedly are other approaches that will work; this is one that worked for me.

First, make sure the Shogun is powered by a battery or power supply and has a formatted storage disk installed. I used a SanDisk Extreme Pro 480 GB solid state drive (SSD). Connect headphones to monitor sound. On the Input menu, enable HDMI input and HDMI Trigger. I selected Apple ProRes HQ as the recording format.

Connect the HDMI input port of the Shogun to the HDMI output port of the a7C using a micro HDMI cable. Make sure the camera has an SDHC or SDXC memory card rated at least in Class 10 or UHS speed class 1. Then turn on both the camera and the recorder and make the settings on the camera shown in Table 9-3. Set the camera's mode dial to the Movie position. Set the APS-C/Super 35mm menu option to Off unless you are using a lens designed for an APS-C sensor. Set focus mode to AF-S, AF-A, AF-C, or DMF so the camera will use autofocus, unless you prefer to use manual focus.

Table 9-3. Recommended Settings on A7C Camera for Recording 4K
Video to an Atomos Shogun Recorder

tings1 Menu	
Auto	
Continuous AF	
Wide	
Off	
On if recording faces	
Human, unless recording pets	
Off unless needed	
Adjust as needed	
Auto, or adjust as needed	
Multi	
On if recording faces	

Spot Metering Point	Focus Point Link if needed
White Balance	Auto White Balance
Priority Set in AWB	Standard
DRO/Auto HDR	DRO if needed
Creative Style	Standard
Picture Effect	Off
Picture Profile	PP1, or other preferred
Camera Se	ettings2 Menu
Exposure Mode (Movies)	Program Auto
File Format	XAVC S 4K
Record Setting	30p 60M
Proxy Recording	Off
AF Transition Speed	5
AF Subject Shift Sensitivity	5
Auto Slow Shutter	Off
Initial Focus Magnification	x1.0
Audio Recording	On
Audio Recording Level	26, or as needed
Audio Level Display	On
Audio Out Timing	Live
Wind Noise Reduction	Off
Marker Display	On if needed
Marker Settings	As needed
Movie w/Shutter	On if desired
Release w/o Lens	Disable
Release w/o Card	Disable
SteadyShot	On unless using tripod
Zoom	Off (not Available)
Zoom Setting	Optical Zoom Only
Zebra Setting	Set if needed
Grid Line	Off unless needed
Exposure Settings Guide	Off
Dial/Wheel EV Comp.	Use if Desired
Func. of Touch Operation	Touch Focus
Set	tup Menu
Gamma Display Assist	Off unless using S-Log or HLG setting
NTSC/PAL Selector	NTSC (in U.S., etc.)
Touch Operation	On
Touch Panel/Pad	Touch Panel Only (unless using viewfinder)
Setup Men	u: TC/UB Settings
TC/UB Display Setting	TC
TC Preset	00:00:00
UB Preset	00 00 00 00
	DF
NTSC/PAL Selector Touch Operation Touch Panel/Pad Setup Men TC/UB Display Setting TC Preset	setting NTSC (in U.S., etc.) On Touch Panel Only (unless usin viewfinder) su: TC/UB Settings TC 00:00:00:00 00 00 00 00

Chapter 9: Motion Pictures 211

TC Run Rec Run
TC Make Preset
UB Time Rec Off

Setup Menu: HDMI Settings

HDMI Resolution Auto 24p/60p Output 60p

HDMI Info Display Off (Not Available)

TC Output On

REC Control On (If Available; Otherwise Off)

CTRL for HDMI Off

4K Output Select Memory Card + HDMI

Some of the above settings are optional or unnecessary and some, such as white balance and metering mode, can be changed according to your preferences. The important ones are File Format (Movies), Record Setting, the TC/UB settings, and the HDMI settings. It also is important to have Proxy Recording turned off. I have not listed some other settings that are unlikely to be needed, such as USB Connection and several others.

The REC CTRL setting under HDMI Settings on screen 3 of the Setup menu may not be available or may not work properly, as noted on the table. When I tried to record 4K video to the external recorder, the a7C camera displayed an error message when I tried to turn on REC CTRL. The message said that setting is not available with File Format (Movies) set to XAVC S 4K. If that happens, or if REC CTRL will turn on but does not work to turn on the external recorder, it is necessary to start the external recorder and the camera recording separately, using their record controls, rather than just pressing the Movie button on the camera to start both the camera and the external recorder.

Once the connections and settings are made, press the Movie button on the a7C (and on the external recorder, if necessary). The screen on the Shogun recorder should indicate that the recording has begun. Use the controls on the camera to zoom or adjust settings as needed. When you are ready to stop the recording, press the Movie button again, and the recorder should stop.

I also tried a modified version of these settings with no memory card in the camera, setting 4K Output Select on the Setup menu to HDMI Only (30p). The Shogun recorded the video as expected and the resulting file imported readily into Adobe Premiere Pro CC for viewing and editing.

Capturing Still Images from Video Recording

The a7C cannot shoot still images while recording a video sequence. If you want to save a still frame from a video sequence, you can use a good video editing program, such as Adobe Premiere Pro CC, or others. However, there is a way to capture a still frame in the camera itself—by using the Photo Capture feature, as discussed in Chapter 7. For example, if you record video using the XAVC S 4K format, the video clips will have the relatively high resolution of 4K video (about 8 megapixels), giving you the option to save a still frame that is of high enough quality to stand on its own. If you use an exposure mode that lets you set the shutter speed, you can choose a fast shutter speed to stop action, and use this technique as a type of super burst shooting. Figure 7-28 in Chapter 7 and Figure B-6 in Appendix B are examples using this approach.

Summary of Options for Recording Movies

As I have discussed, there is some complication in trying to explain all of the relationships among the controls and settings of the a7C for recording movies. To simplify matters, I will provide a summary of options for recording movies with the a7C.

To record a video clip with standard settings, set the mode dial to the Intelligent Auto position and press the Movie button. The camera will adjust exposure automatically, and you can use either continuous autofocus (set for video recording using the AF-S, AF-A, AF-C, or DMF setting for focus mode) or manual focus (MF setting). In that shooting mode, you cannot adjust many shooting options, such as ISO, white balance, DRO, Creative Style, or Picture Effect. You can use options such as Focus Magnifier, Peaking, and SteadyShot. You can choose File Format and Record Setting options to control the video quality.

For more control over video shooting, set the mode dial to the P, A, S, or M position. Then you can control several additional Camera Settings1 menu options, including ISO, white balance, metering mode, Creative Style, and Picture Effect, among others. You can choose continuous autofocus or manual focus in the same way as in Intelligent Auto mode. You can adjust aperture, shutter

speed, or both, or let the camera set them, depending on which shooting mode you select.

For maximum control over movie recording, set the mode dial to the movie film icon for Movie mode. Then select an option for the movie exposure mode from the Exposure Mode (Movies) item on screen 1 of the Camera Settings2 menu. To control aperture, choose Aperture Priority; to control shutter speed, choose Shutter Priority; to control both aperture and shutter speed, choose Manual Exposure. Other options can be selected from the Camera Settings1 menu.

Control buttons and dials operate during movie recording if the context permits, as discussed earlier. If you want a set of functions tailored for video recording, use the list in Table 9-4 to start, and adjust it for your own needs. Remember that you may need to use two menu options to make these assignments: Custom Key (Still Images) if you will be recording video with the mode dial at AUTO or a PASM mode; and Custom Key (Movies) if you will be recording with the mode dial at the Movie position.

Table 9-4. Suggested Control Assignments for Movie Recording

Control	Function
AF-ON button	Focus Mode
Custom (C) button	Focus Area
Center button	Focus Standard
Left button	Zebra Display Select
Right button	ISO
Down button	AEL Hold
Movie Button	Movie Shooting
Focus Hold button (if any)	Focus Hold

To record good, standard video footage at a moment's notice without having to remember a lot of settings, I recommend that you set up one of the seven registers of the Memory Recall shooting mode with a solid set of movie-recording settings. Table 9-5 lists one group of settings to consider. (Settings not listed here can be set however you like.) The Record Setting option and the Picture Profile setting in this table make some other settings unavailable, as noted in the table. If you want to use those settings, turn Picture Profile off and use a different option for Record Setting. I am assuming the mode dial is at the Movie position.

SUGGESTED MENU SETTINGS FOR RECORDING MOVIES IN MOVIE

Table 9-5.	SUGGESTED MENU SETTI MODE	NGS FOR RECORDING MOVIES IN MOVIE		
	Camera Set	tings1 Menu		
Focus Mode		AF-S, AF-A, AF-C, or DMF		
Focus Area		Wide		
Face/Eye AF Settings: Face/Eye Priority in AF		On, if recording people		
				Face/Eye AF Settings: Subject Detection
Human				
ISO		ISO Auto		
Metering Mode		Multi		
Face Priority in Multi Metering		On		
White Balance		Auto White Balance		
Priority Set in AWB		Standard		
DRO		Not available with Picture Profile Activated		
Creative Style		Not available with Picture Profile Activated		
Picture Effect		Not available with Picture Profile Activated		
Picture Pro	ofile	PP1 or other as needed		
	Camera Se	ttings2 Menu		
Exposure I	Mode (Movies)	Program Auto		
File Forma	t	XAVC S HD		
Record Set	tting	30p 50M		
Proxy Reco	ording	Off		
AF Transiti	on Speed	5		
AF Subject	t Shift Sensitivity	5		
Auto Slow	Shutter	Off unless needed		
Initial Foci	us Magnification	x1.0		
Audio Recording		On		
Audio Recording Level		Adjust as needed		
Audio Level Display		On		
Wind Noise Reduction		Off unless needed		
Marker Display		Off unless needed		
Marker Settings		All off unless needed		
Movie w/Shutter		Off		
SteadyShot		On; Off if using tripod		

Optical Zoom Only

Use as needed

Touch Focus

Off

Off

Zoom Setting

Zebra Setting

Exposure Settings Guide

Function of Touch Operation

Grid Line

Chapter 9: Motion Pictures 213

Other Settings and Controls for Movies

There are several other points to be made about recording and playing back videos that don't concern the Camera Settings1 or Camera Settings2 menu or the major physical controls. Here are brief notes about these issues.

The Display button operates normally to change the information that is viewed during video recording. The screens that are displayed are controlled by the Display Button option on screen 7 of the Camera Settings2 menu. However, the For Viewfinder screen does not appear for video shooting, even if it was selected through that menu option.

In playback mode, the Display button operates normally for movies. The screen with space for a histogram will display, but the spaces for histogram and other information will be blank. Only the thumbnail image of the first frame of the video will appear.

The MF Assist option on screen 13 of the Camera Settings1 menu does not operate for video recording, so the camera will not magnify the display when you turn the focus ring to adjust manual focus. However, you can assign the Focus Magnifier function to one of the control buttons and use that capability to enlarge the screen when using manual focus (or autofocus).

After you press the assigned control button to put the orange Focus Magnifier frame on the display, press the Center button to enlarge the area within the frame to 4.0 times normal. (This is less than the 5.9x enlargement factor for still shooting.) Then turn the focus ring or press the shutter button halfway to adjust the focus. Half-press the shutter button to dismiss the Focus Magnifier frame. (If the Initial Focus Magnification (Movies) option on screen 2 of the Camera Settings2 menu is set to x4.0, the screen will be magnified as soon as you press the assigned control button to activate Focus Magnifier.)

The Setting Effect Off choice for the Live View Display option on screen 8 of the Camera Settings2 menu does not function for video recording; the Setting Effect On choice is locked in. So, for example, if you are shooting movies in Movie mode using Manual Exposure for the Exposure Mode setting and you have the aperture and

shutter speed set for strong underexposure, you cannot adjust this option to make the display more visible.

Program Shift does not function during video recording. If you turn the control dial while the camera is set to Program mode, the exposure settings will not change while the camera is recording a movie. The menu button and Playback button do not operate during video recording.

Finally, when focus mode is set to MF for manual focus and Touch Operation is turned on through screen 2 of the Setup menu, you can tap the LCD screen twice during video recording to bring the Focus Magnifier frame onto the monitor, as discussed above. You can drag the magnified image around the display with a finger, and you can tap twice again to return the screen to its normal viewing size.

Movie Playback

As with still images, you can transfer movies to a computer for editing and playback or play them back in the camera, either on the camera's display or on a TV connected to the camera.

If you want to play your movies in the camera, there is one feature of the a7C to be mindful of. As I discussed in Chapter 7, the View Mode option on screen 3 of the Playback menu controls what images or videos you will see in playback mode. If you don't see the video you are looking for, check to make sure that menu option is set to display all files from a certain date (Date View), XAVC S HD View, or XAVC S 4K View.

Once you have selected a proper mode to view your video, navigate to that file by pressing the direction buttons or turning the control wheel or control dial. When the first frame of the selected video is displayed on the screen, you will see a playback triangle inside a circle, as shown in Figure 9-23. In the lower right corner of the screen will be a Play prompt with a white circle icon indicating that you can press the Center button to play the video. (If you don't see that prompt, press the Display button one or more times until it appears.)

After you press the Center button to start playback, you will see more icons at the bottom of the screen, as shown in Figure 9-24. From the left, these icons indicate: Rewind/Fast Forward; Pause; Open Control Panel; and Exit. From this screen, you can press the Left

or Right button repeatedly to play the movie rapidly forward or backward; multiple presses increase the speed up to four times.

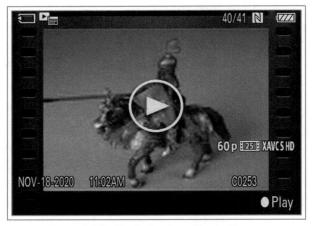

Figure 9-23. Movie Ready to Play in Camera

Figure 9-24. Basic Movie Playback Control Icons When Playing

When the movie is paused, the icons change, as shown in Figure 9-25, to indicate Previous File or Next File; Play; Open Control Panel; and Exit.

Figure 9-25. Basic Movie Playback Control Icons When Paused

While the video is playing or paused, press the Down button, and you will see a new line of controls at the bottom of the screen, as shown in Figure 9-26. When the movie is playing, these icons indicate, from left to right: Previous File; Fast Reverse; Pause; Fast Forward; Next File; Photo Capture; Volume Setting; Exit.

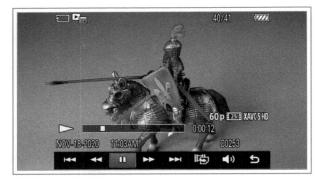

Figure 9-26. Detailed Movie Playback Control Icons When Playing

When the movie is paused, the icons change, as seen in Figure 9-27. Those icons indicate, from left to right: Previous Frame; Reverse Slow Playback; Normal Playback; Forward Slow Playback; Next Frame; Photo Capture; Volume Setting; and Exit.

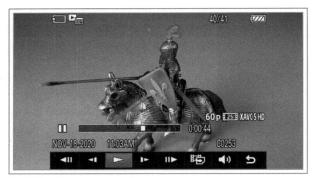

Figure 9-27. Detailed Movie Playback Control Icons When Paused

On any of these screens, move through the icons with the Left and Right buttons, and press the Center button to select the function for the selected icon.

When a movie is playing, you can fast-forward or fast-reverse through it at increasing speeds by turning the control wheel or control dial right or left or by pressing the Right or Left button.

Editing Movies

The a7C cannot edit movies in the camera. If you want to do any editing, you need to use a computer or other external device. For Windows, you can use software such as the Movies & TV app that comes with Windows 10. If you are using a Mac, you can use iMovie or any other movie editing software that can deal with XAVC S files.

Chapter 9: Motion Pictures 215

I use Adobe Premiere Pro CC on my PC, and it handles these file types well.

You also can use the PlayMemories Home software that is available from Sony for use with the a7C. To install PlayMemories Home, you need to download the software from the Internet at http://www.sony.net/pm/. This software is updated with new features periodically, so be sure to keep checking the website for updates. You also can refer to the list of programs for editing 4K video provided by Sony at https://support.d-imaging.sony.co.jp/www/support/application/nle/en.html.

Stabilizing Movies Using Software

One excellent feature of the a7C camera is its in-body stabilization, or IBIS, which corrects to some extent for camera motion when you are recording video with the camera hand-held instead of on a tripod. In addition, some lenses have Sony's Optical SteadyShot built into them, which also can help stabilize the video. You can also use a gimbal, which is a handle that includes gyroscopes and motors that physically stabilize the camera while you are shooting. However, if you have shot some video footage that was not stabilized with any of those techniques, there is another option available with the a7C and a few other Sony cameras: stabilization using software, after the video has already been recorded.

For the a7C, there are two software products that can be used: Catalyst Browse or the Movie Edit add-on for the Imaging Edge Mobile app. Catalyst Browse can be downloaded at https://www.sonycreativesoftware.com/download/catalystbrowse. The Movie Edit add-on is available through the App Store for iOS or the Google Play Store for Android devices. In either case, the software uses stabilization metadata that is recorded along with the video footage in the a7C, taken from the internal gyroscope that is included inside this and certain other Sony camera models.

CATALYST BROWSE

When you load a video clip into Catalyst Browse, the clip's thumbnail will have a stabilization icon displayed on it if the clip has stabilization data available, as shown in the upper right corner of Figure 9-28. You can then right-click on the thumbnail and select the option for Stabilize Clip. On the next screen, you can choose Auto

or Manual for the stabilization process. If you choose Manual, you can specify the degree of stabilization that is used. After the clip has been stabilized, you can export it to your computer with a new file name, by clicking on the Export button in the application.

Figure 9-28. Stabilization Icon in Upper Right Corner of Frame

One important point is that the stabilization process uses pixels from the existing video frames to create the stabilization, which results in cropping of the frames. The more stabilization you use, the greater the cropping. So, if the video clip requires considerable stabilization, the stabilized clip will be heavily cropped, as if you have zoomed in fairly closely on the subject matter. So, if you anticipate that software stabilization of this type may be needed, it is a good idea to record the clip using a wideangle lens or with the lens zoomed back to a wide angle, if possible, so there will be extra pixels available at the edges of the video frames for use in stabilization.

MOVIE EDIT ADD-ON FOR IMAGING EDGE MOBILE APP

Another option for taking advantage of the built-in gyroscopic data in the a7C camera is to edit videos using Sony's Movie Edit app, available for both iOS and Android smart devices. It is available for download at https://support.d-imaging.sony.co.jp/app/movieedit/en/. This app works with Sony's Imaging Edge Mobile app to edit videos recorded by the a7C. It can handle any format with any Record Setting option other than XAVCS HD 120p 100M and XAVCS 120p HD 60M. It also can handle proxy movies.

After you have downloaded both the Imaging Edge Mobile app and the Movie Edit add-on app to your smart device, use the Send to Smartphone option on the a7C camera to transfer a compatible video to the

smart device through the Imaging Edge Mobile app. Then open the Movie Edit app, and import that video from Imaging Edge Mobile to the Movie Edit app. The app will automatically use the included gyroscopic data to stabilize the video. The instructions for carrying out this process are available at https://support.d-imaging.sony.co.jp/app/movieedit/en/instruction/.

Chapter 10: Wi-Fi, Bluetooth, and Other Topics

WI-FI AND BLUETOOTH FEATURES

he a7C can connect to computers, smartphones, and tablets using a Wi-Fi network. With some devices, the a7C can use NFC (near field communication) technology to establish a Wi-Fi connection without going through all the steps that are ordinarily required. The camera also can use a Bluetooth connection to transfer images to a smartphone, to be operated by a remote control device, and to add location data to images. I will discuss these features in this chapter.

First, here is one note to remember when using any of the camera's Wi-Fi and Bluetooth features: The Network menu, marked by a globe icon, has an option called Airplane Mode near the bottom of its first screen. If that option is turned on, no wireless features will work. Make sure that menu setting is turned off when using the wireless options.

SENDING IMAGES TO A SMARTPHONE

If you don't need to print your images or do heavy editing, you may want to transfer them to a smartphone or tablet so you can share them on social networks, display them on the larger screen of your tablet, or otherwise enjoy them.

You can transfer images and videos wirelessly from the a7C to a smartphone or tablet that uses the iOS (iPhone and iPad) or Android operating system. For XAVC S 4K videos or XAVC S HD videos recorded with the 120p/100p Record Setting option, you may encounter problems using an older phone. Raw files are converted to JPEG for transfer. With iOS, you have to use the camera's menu system to connect. With some Android devices, you can use NFC technology, which establishes

a Wi-Fi connection automatically when the camera is touched against the smartphone or tablet.

Here are the steps for connecting using the menu system, using an iPhone as an illustration:

1. Install Sony's Imaging Edge Mobile app on the phone; it can be downloaded from the App Store for the iPhone or from Google Play for Android devices. Figure 10-1 shows the app's icon on an iPhone.

Figure 10-1. Imaging Edge Mobile App Icon on iPhone

- 2. Put the camera into playback mode and display an image or video to be transferred to the phone.
- 3. On the Network menu, select Send to Smartphone Function, then, on the next screen, Send to Smartphone. From that option choose Select on This Device. On the next screen, you can choose to transfer This Image, All with this Date, or Multiple Images. For now, choose This Image.

 On the next screen, as shown in Figure 10-2, the camera will display the SSID (name) of the Wi-Fi network it is generating.

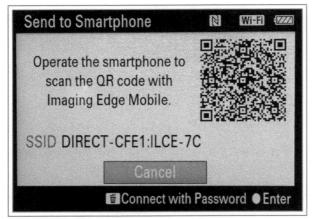

Figure 10-2. Camera Screen Displaying its Wi-Fi Network

- 5. The first time you connect to the camera's network, you will have to scan the QR code on the camera's screen with the phone, using the Imaging Edge Mobile app. Or, if you prefer, you can press the Custom/Delete button to go to a screen that displays the network password, which you can enter in the phone. After that initial connection, you can connect to that network without entering the password.
- 6. The camera will display a message saying "Connecting." At this point, launch the Imaging Edge Mobile app, unless it was already started so you could scan the QR code from the camera's screen.

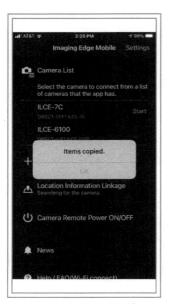

Figure 10-3. Screen on iPhone to Confirm Images Copied

- 7. The phone will display a message saying it is copying the images or videos from the camera, and will confirm the copying with a screen like that in Figure 10-3. The images or videos will appear in the Camera Roll area on an iPhone.
- 8. If you prefer, you can initiate the Send to Smartphone process by pressing the Function button when the camera is in playback mode, assuming that button is assigned to that operation. The Function button is assigned to Send to Smartphone by default, but that operation can be assigned to a different button using the Custom Key (Playback) option on screen 9 of the Camera Settings2 menu.

View and Transfer Images on Smartphone, Even When Camera Is Powered Off

If you want to be able to view images on the camera from your smart device and transfer them from the camera to your smart device even when the camera is turned off, that is possible by following these steps:

- On screen 2 of the Network menu, Select Bluetooth Settings and, on the next screen, turn on Bluetooth Function.
- 2. On screen 1 of the Network menu, under Send to Smartphone Function, go to the Connect During Power Off item, and turn it on.
- 3. On screen 2 of the Network menu, select Bluetooth Settings and, on the next screen, select Pairing.
- 4. Start the Imaging Edge Mobile app on your smart device, and tap on the Camera Remote Power ON/ OFF item, as shown in Figure 10-4.
- 5. Make sure the camera is turned off, then go to the Camera Remote Power ON/OFF item on the smart device, and tap on the name of the ILCE-7C camera to power it on. Follow the prompts or confirmation screens, and the app will then let you begin browsing and transferring the images on the camera. For additional help, see Sony's support information at https://support.d-imaging.sony.co.jp/app/iemobile/en/instruction/.

This option drains the camera's battery, so do not leave it turned on unless you need to use it.

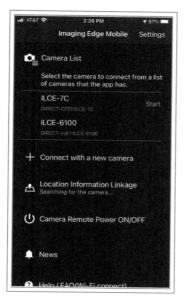

Figure 10-4. Camera Remote Power On/Off Option in App

CONNECTING WITH NFC

If you are using an Android device with NFC, you should be able to connect the phone to the camera with fewer steps than usual. I tested the procedure using a Sony Xperia XA2 phone, but the same process should work with other Android devices that have NFC included. Here are the steps:

1. On the Android device, go to the Google Play Store and find and install the Imaging Edge Mobile app.

Figure 10-5. NFC Turned on on Sony Xperia XA2 Phone

- On the Android device, go to the Settings app, and find the settings for NFC. On the device I used for this test, it was under Settings—Device Connection—Connection Preferences—NFC. Make sure the setting for NFC data transfer is turned on, as shown in Figure 10-5.
- 3. Put the a7C into playback mode and display an image you want to send to the Android device.
- 4. Find the NFC icon on the right side of the camera, which looks like a fancy "N," as shown in Figure 10-6.

Figure 10-6. NFC Active Area on a7C Camera

- 5. While both devices are active, touch the N on the camera to the NFC area on the Android device. (On the Sony Xperia XA2 that I used, this area is on the back, just below the main camera.) Be sure the two areas touch; you cannot have the two NFC spots separated by more than about a millimeter, if that.
- 6. Hold the devices together, and within a few seconds you may hear a sound, depending on settings, and the camera will transfer the image to the Android device; you may see a message on the camera as the connection is established. You may see a message to select an option on the phone such as Connect to Camera to complete the operation. However, if you wait a few seconds, the camera and phone should complete the connection and transfer the image without any further action on your part.
- 7. If you want to transfer multiple images, select that option from the camera's menu before touching the camera to the Android device to start the transfer.

By default, when you transfer images to a smartphone or tablet, the maximum image size will be 2 MP. If the image originally was larger than that, it will be reduced to that size. You can change this setting to send the images at their original size or at the smaller VGA size. To do that on your device, find the settings for the Imaging Edge Mobile app, then the Copy Image

Size setting. On an iPhone, go to Settings, then scroll to find Imaging Edge Mobile. On an Android device, open Imaging Edge Mobile, then tap the Settings icon. If the images were taken with Raw quality, they will be converted to JPEG format before being transferred to the smartphone or tablet, even if the device is set for transfer at the original size.

SENDING IMAGES TO A COMPUTER USING THE FTP TRANSFER FUNCTION

Although you can edit and print images and edit videos to some extent using a smartphone or tablet, some people (including me) prefer to transfer them to a computer, where there are greater possibilities for editing. The traditional ways to do this are to connect the camera to the computer with the camera's USB cable or to use a memory card reader. However, there also is a way to transfer your images and videos from the a7C to a computer over a wireless network, eliminating the need to use a USB connection or a card reader. This can be accomplished using the FTP Transfer Function option on screen 1 of the Network menu.

This option lets you transfer still images (not videos) directly from the camera using an FTP (file transfer protocol) server. This is a technical option that requires some computer network knowledge, but it is very useful once it is set up. For example, if you are shooting photos for a magazine or newspaper and have access to a Wi-Fi network where you are shooting, you can upload the images directly from your camera to the publication's FTP server. Or, even if just shooting for your personal use, you can set up an FTP server that can be accessed from your computer and transfer images directly to that server via FTP.

I have to say that I found this option to be quite difficult to use at first, because I am not very knowledgeable about FTP servers, port forwarding, DNS servers, and the like. I worked for many hours over several days to get this working. However, I eventually realized that the problems I was having arose because I was trying to set up an FTP server on my own computer, and it eventually became clear that it was not possible to allow FTP access to my router over the internet, at least not in any way that I could figure out.

I then set up an account with a company called hostedftp.com, which provides an account that can

be accessed using standard FTP procedures. (Another company that appears to offer similar service is drivehq. com, though I did not try that one.)

Once I had an account, I just entered the hostname as ftp.hostedftp.com, along with my username and password, and the camera easily sent several image files to my online account with that company. If you have good knowledge in this area, or don't mind signing up for a hosted FTP account, I recommend it as a useful option, but otherwise, I recommend using other ways to transfer your images.

Following is a list of necessary steps, or at least the steps that I followed to get this option to work.

- 1. Make sure other networking options on the camera, such as Control with Smartphone, are turned off.
- Select a wireless (Wi-Fi) network that the camera will connect to in order to upload files via FTP, using the Network Menu – Wi-Fi Settings – WPS Push option, or the Network Menu – Wi-Fi Settings – Access Point option.
- 3. On the camera's Network menu, go to FTP Transfer Function, then to Server Setting, and select it, which will take you to a screen like that shown in Figure 10-7, with a list of servers.

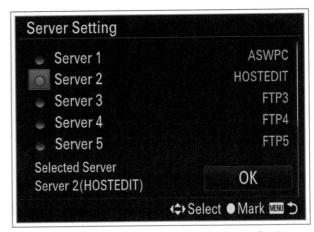

Figure 10-7. List of FTP Servers Under Server Setting

4. Highlight an unused server, and, if necessary, press the Right button or turn the control dial, to move the orange highlight bar so the entire line for that server is highlighted in orange, as shown in Figure 10-8.

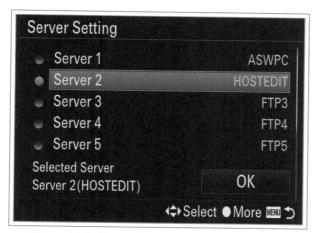

Figure 10-8. Name of FTP Server Fully Highlighted

5. Select the line listing that server with the Center button, taking you to a screen like that in Figure 10-9.

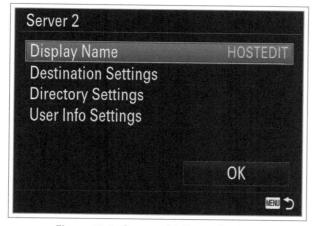

Figure 10-9. Screen with Server Settings

6. Press the Center button for the Display Name item, and, using the on-screen keyboard, enter a display name for the server, as shown in Figure 10-10.

Figure 10-10. Screen to Enter Display Name for FTP Server

- 7. Then select the Destination Settings items, and, on the next screen, enter the host name, such as (in my case) ftp.ftphosted.com. Then complete the other blanks on that screen, including those for Secure Protocol and Port. I did not use the secure protocol; if you do use it, you have to obtain a root certificate and save it to the camera using a memory card, using the Network Menu Import Root Certificate option. Then highlight and select the OK block at the bottom left of the screen.
- 8. Go back to the previous screen, and select the Directory Settings item. If you leave this field blank, the system will upload files to the root directory of the server and username you have specified. You also can specify the directory hierarchy and whether or not to overwrite files with the same name as files being uploaded.
- Go back to the previous screen and select User Info Settings, then specify the username and password that are needed for logging on to the FTP server on the destination computer.

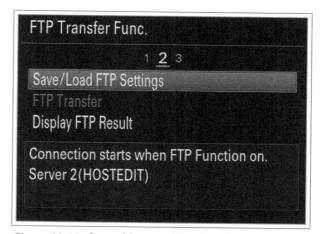

Figure 10-11. Second Screen of FTP Transfer Menu Option

10. Go back to the main screen for the FTP Transfer item, press the Right button or turn the control dial to move to the second screen of the menu option, shown in Figure 10-11. Select the FTP Transfer item, and select the target group of images to transfer to the remote site, the target images, and whether to transfer all available images, or just those that were not transferred earlier or failed to transfer earlier. (In moving through the various options for the FTP Transfer process, it can be very helpful to press the button assigned to In-Camera Guide (usually the Delete/Custom button) when an

item is highlighted, for a reminder about how that option works.)

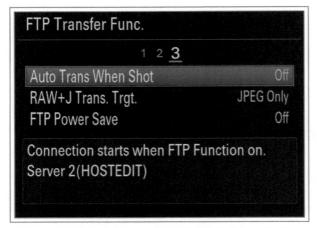

Figure 10-12. Third Screen of FTP Transfer Menu Option

- 11. Go to screen 3 of the main FTP Transfer menu option, shown in Figure 10-12, and choose settings for the items shown there, including whether to transfer images automatically via FTP as they are shot.
- 12. On screen 1 of the Network menu, select FTP Transfer Function, and, on the next screen set FTP Function to On.
- 13. The transfer should start once you have all options selected. If it does not, go to the second screen of the menu option, select FTP transfer, and select options there if necessary.

Sony has a provided a help guide at https://rd1.sony.net/help/di/ftp/h_zz/. It may take some effort to get this option set up successfully, but once it is running properly it is a convenient way to transfer images.

Using a Smartphone or Tablet as a Remote Control

You can use a smartphone or tablet as a remote control to operate the a7C camera from a distance of up to about 33 feet (10 meters), as long as the devices are in sight of each other. Here are the steps to do this with an iPhone:

 Go to the camera's Network menu, select Control with Smartphone, and set it to On. Then make a selection for Always Connected, either On or Off. (I recommend Off.) Next, highlight the Connection option and press the Center button. The camera will initiate a connection to the phone.

- The camera will display a screen with the identification information for its own Wi-Fi network, along with a QR code for scanning and a message saying to press the Custom/Delete button to use a password.
- 3. On the phone, open the Imaging Edge Mobile app and choose Scan QR Code of the Camera. Or, if you prefer, you can press the Custom/Delete button on the camera to see the password, and enter the network password on the phone; you will not have to scan the QR code or enter the password for future connections unless the network ID is changed. You may be prompted on the phone to install a profile. If so, follow the prompts.
- 4. Set up the camera on a tripod or just place it where you want it, aiming at your intended subject.
- 5. Open the Imaging Edge Mobile app on the iPhone, if it is not already open.
- 5. The camera will display a screen with an icon in the upper middle of the display showing that the camera can now be controlled from the phone, as shown in Figure 10-13.

Figure 10-13. Remote Control Icon on Camera's Screen

- 7. The phone will display a screen like that in Figure 10-14, showing the view from the camera's lens and several control icons. (If you don't see that view, press the DISP icon in the lower right corner one or more times until it appears.)
- Using the controls on the app's screen, you can adjust various settings, including exposure compensation, white balance, focus mode, ISO, aperture, autoexposure lock, metering mode, shutter speed, continuous shooting, and self-timer,

depending on the shooting mode. You also can adjust several options using the camera's controls. You can take a still image by tapping the large white circle at the bottom center of the screen.

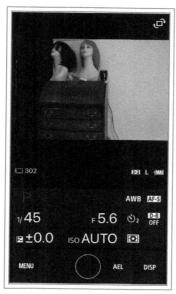

Figure 10-14. Remote Control Screen on Imaging Edge Mobile App

9. You can tap the Menu icon in the lower left corner of the app to get access to a menu that includes options such as flash mode, white balance, self-timer, metering mode, aspect ratio, movie format and several others, as shown in Figure 10-15. You can tap the DISP icon in the lower right corner of the app's main screen to remove the icons from the screen, leaving only the live view.

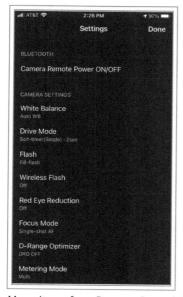

Figure 10-15. Menu Items from Remote Control Screen of App

- 10. If you turn the camera's mode dial to the Movie position, the circle at the bottom of the app changes to a red dot, which you can tap to record a movie. You can change the Exposure Mode setting for movies on the camera by tapping the mode icon on the app, at the upper left corner of the control area. You can change the format for movie recording by tapping the Menu icon, giving access to those settings and others. You can record S & Q Motion movies if you turn the mode dial to S & Q.
- 11. By default, images saved to the phone will be resized down to 2 MP unless they already were that small or smaller. Movies will be saved only to the camera; they cannot be saved or displayed on the phone.
- 12. When you have set up the shot as you want it, press the photo icon on the iPhone app to take the picture or the red icon to start the video recording.
- 13. If you are using an Android device with NFC capability, you should be able to connect to the camera by touching the device to the camera, as discussed above in connection with transferring images. First, turn on the camera with Control with Smartphone turned on on the Network menu, and put the camera into shooting mode, then touch the two devices together at their NFC areas.
- 14. Once the connection has been made, you can separate the devices to the standard remote-control distance of up to about 33 feet (10 meters). If you have difficulty making an NFC connection, start the Imaging Edge Mobile App on the Android device before touching the camera to that device. The camera can then be controlled using the Imaging Edge Mobile app on the Android device, as noted in the numbered steps above.
- 15. You can use the remote-control setup if you want to place your camera on a tripod in an area where birds or other wildlife may appear, so you can control the camera from a distance without disturbing the animals. (The wireless remote will work through glass if you are indoors behind a window.)

REMOTE CONTROL OF CAMERA FROM COMPUTER (TETHERED SHOOTING)

For shooting certain types of subject, such as still lifes or products, it can be useful to control the camera from a computer, so you can view the scene on a large monitor and control the camera's settings from the keyboard without having to adjust the controls on the camera. The a7C camera can make use of Sony's versatile Imaging Edge (Remote) software to carry out this sort of shooting. The basic steps are as follows.

First, download the free Sony Imaging Edge software from http://support.d-imaging.sony.co.jp/app/imagingedge/en/download/. Imaging Edge comes as part of a software suite that includes image viewing and editing in addition to remote control of the camera. You use the Remote module of the software for remote control through tethering.

Once the remote control software is installed on your computer, go to the Network menu on the a7C, select PC Remote Function, and set it to On. Then connect the camera to the computer with the Sony USB-C cable (or, preferably, a longer cable than the one that comes with the camera), and turn the camera on. Then start the software application. You will see on the computer a window like that in Figure 10-16, showing the various items you can control from the computer. The view on the computer should include a large window at the left with a live view of the subject, but I have cropped that out of Figure 10-16 so I can show the remote control icons at a more legible size.

You will have to turn the camera's mode dial to select the shooting mode, but you can control quite a few items from the software, depending on what shooting mode is selected. These include drive mode, including all settings for continuous shooting and the self-timer; white balance; ISO; Picture Effect; DRO/Auto HDR; JPEG quality and image size; and aspect ratio.

You can set autoexposure lock, flash exposure lock, or auto white balance lock by clicking on the AEL, FEL, or AWBL icon near the top of the window. To control exposure compensation, click on the arrows next to the exposure compensation value, below the EV label. The same technique works for flash exposure compensation to the right of exposure compensation. You also can control ISO by clicking on the arrows next to the ISO reading.

When the mode dial is set to Shutter Priority or Manual exposure, you can control the shutter speed by clicking on the arrows next to that setting. When Aperture Priority or Manual exposure mode is selected, you can control the aperture from this software. You can click

on the button with the AF label in the upper left of the window to simulate a half-press of the shutter button, locking focus and exposure, if autofocus is in effect.

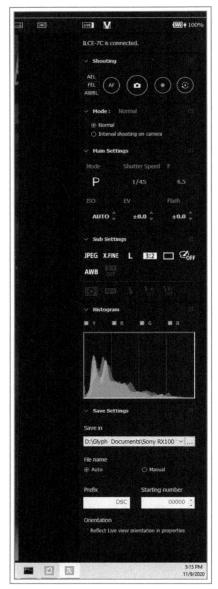

Figure 10-16. PC Remote Window on Computer

Click on the red button at the top of the window to start or stop a video recording. Click on the camera icon to the left of that button to capture a still image. Click and hold down on the camera icon to fire a burst of shots when continuous shooting is selected for drive mode. You also can make focus-related settings and control several menu options using other icons on the screen.

If you want to use this tethered-shooting capability to save images to your computer, use the Save In . . . dialog box at the bottom right of the remote control window and select a folder; the images captured using

this feature will be stored in that folder. You can set the camera to store images only to the computer, or to both the computer and the camera, using the Still Images Save Destination option on screen 2 of the PC Remote Function item on screen 1 of the Network menu. That menu screen also includes the Raw + JPEG PC Save Images option, which lets you set the storage destinations for files taken with the Raw & JPEG setting for File Format. That option is available for use only when File Format (Still Images) is set to Raw + JPEG and Still Images Save Destination is set to PC + Camera.

If you click on the small button with a timer dial, to the right of the red video recording button, a new window will open up with options for setting interval shooting from the Remote application on your computer. In that window, you can set the interval between shots to a value from ten seconds to 180 minutes and the number of shots from two to 1000, or leave the number of shots unspecified.

The program also gives you the option of setting up interval shooting on the camera. In that case, you can select interval-shooting options using the camera's menu system, and activate the shooting session remotely by pressing the camera icon in the remote window. Interval shooting cannot be started if there are any files currently saved in the destination folder designated in the remote window. If interval shooting will not start, be sure all files have been deleted or moved out of that folder, or designate a new folder with no files in it. For further information about remote shooting, see https://support.d-imaging.sony.co.jp/support/tutorial/ilc/ilce-7c/l/pcremote.php.

You also can connect the camera to the computer using a direct Wi-Fi connection or a Wi-Fi connection through an access point. Those options are discussed later in this chapter, in connection with the items on the Network menu. I found both methods worked quite well, and added to the convenience of remote shooting.

Adding Location Information to Images Using Bluetooth Connection from Smart Device

The steps to take for setting up a Bluetooth connection to send location information to images captured by the a7C are set forth below.

 Install the Imaging Edge Mobile app on your smartphone, and use it to transfer at least one image from the camera to the phone, as discussed earlier in this chapter. After that procedure has been done, the Location Information Linkage item will appear on the main page of the app, as shown in Figure 10-17.

Figure 10-17. Location Information Linkage Item in IEM App

- 2. Make sure the Bluetooth setting is turned on on the smartphone. On an iPhone, go to Settings—Bluetooth—On.
- 3. On the iPhone, go to Settings, scroll down to the list of apps, select Imaging Edge Mobile, and under the Location item, set Allow Location Access to Always, as shown in Figure 10-18.
- 4. On the a7C, go to screen 2 of the Network menu, select Bluetooth Settings, and, on the next screen, set Bluetooth Function to On, as shown in Figure 10-19.
- 5. On the a7C, on the Bluetooth Settings screen, select Pairing.
- 6. On the phone, launch the Imaging Edge Mobile app and tap Location Information Linkage on the main page. Then tap the button for that setting to the On position, so a green circle appears.

- 7. On the phone, select the option to Set the Camera, then select the name of the a7C camera from the list on the app's screen.
- 8. When the camera displays a message prompting you to allow the connection from the a7C, select OK. The app also may ask you to confirm the pairing operation.

Figure 10-18. Allow Location Access Setting on iPhone

Figure 10-19. Bluetooth Function Turned on on Camera

- On the a7C, go to screen 2 of the Network menu, select Location Information Link Setting, and set it to On. The phone and camera will then be paired.
- 10. As the camera shoots images, it will obtain location information from the smartphone via the Bluetooth connection. As it obtains information, the camera will display a small icon in the upper right corner of the display that looks like a pin sticking up out of a map, as shown in Figure 10-20.

It will also display a Bluetooth icon to the right of that icon.

Figure 10-20. Location Information Pin Icon on Shooting Screen

11. You can view the location information using various software programs, such as Adobe Bridge and the Viewer module of Sony's Imaging Edge software. In PlayMemories Home, each image will have a GPS satellite icon displayed in the upper right corner, and the latitude and longitude can be read using the Properties panel. When the images are viewed in playback mode in the camera, they will show the location information in the lower left corner on the screen with detailed information, as shown in Figure 10-21.

Figure 10-21. Location Information on Image Played in Camera

12. Once the Location Information Link has been established between the smartphone and the camera, you can continue to take pictures and the smartphone will gather location information, as long as the app is running, even in the background. It may take a while for the phone to transmit the GPS data to the camera when the camera is turned on after having been turned off for a while. If you

don't need to gather location information for a time, you can save battery power by turning off the Bluetooth settings on the camera.

USING THE A7C CAMERA AS A WEBCAM

As this book is being written, in the days of the COVID-19 pandemic, many people are working from home using webcams for video conferencing to confer with colleagues and clients remotely. If you have already invested in an expensive camera such as the Sony a7C, you may want to take advantage of its high quality and excellent lens selection to use it as your webcam for this or other purposes. Following are the basic steps to accomplish this.

- 1. First, download the free Imaging Edge Webcam software at https://support.d-imaging.sony.co.jp/app/webcam/en/download/ and install it on your computer. Then, on the Network menu, set Control with Smartphone to Off and PC Remote PC Remote Function to On. Also, set PC Remote Function-PC Remote Connect Method to USB.
- 2. Next, set the camera to Movie mode using the mode dial, and connect the camera to the computer using the camera's USB-C cable, or another compatible capable. (It is convenient to use a relatively long cable so the camera can reach to the area where video conferencing will take place.)
- 3. Finally, start whatever video-streaming software you will be using, and the camera should be detected by that software as an available webcam. The camera will not transmit audio to the software, so you will need to use an external microphone or the microphone included in the computer, if one is present, for that purpose.
- 4. Note that using this technique does not produce the highest-quality video signal. According to the online Sony support page for Imaging Edge Webcam at https://support.d-imaging.sony.co.jp/app/webcam/en/instruction/, the resolution is 1024 x 576 pixels, considerably less than the resolution of high definition TV at 1920 x 1080 pixels. You may get better results using the HDMI output from the camera, using an interface that accepts HDMI video, such as Cam Link 4K from Elgato. For more information on using that approach, see https://

primalvideo.com/how-to-use-a-video-camera-live-streaming-or-dslr-as-webcam/.

The Network Menu

I have discussed some of the items on the Network menu, but there are several other options to discuss. Following is information about each of the items on this menu, whose first screen is shown in Figure 10-22.

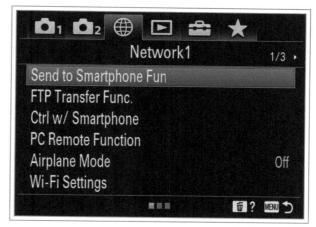

Figure 10-22. Screen 1 of Network Menu

SEND TO SMARTPHONE FUNCTION

This first Network menu option lets you transfer images or videos from the a7C to a smartphone or tablet. This menu item has three sub-options: Send to Smartphone, Sending Target, and Connect During Power Off, as shown in Figure 10-23. I discussed the steps for using the Send to Smartphone option earlier in this chapter. You also can press the Function button (or other button assigned to this option) when the camera is in playback mode, to carry out this action.

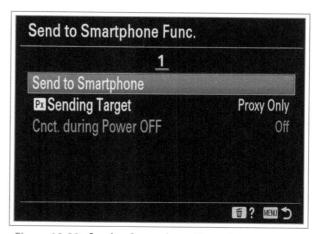

Figure 10-23. Send to Smartphone Menu Options Screen

The Sending Target option lets you choose how to transfer movies that are recorded with Proxy Recording turned on—specifically, whether to transfer to your smartphone just the original video file, just the proxy file, or both. (Proxy recording is turned on with the Proxy Recording item on screen 1 of the Camera Settings2 menu; it creates a smaller version of a video file as the file is recorded.)

The choices for this option are Proxy Only, Original Only, or Proxy & Original. Make this choice according to your own preference and needs. If you just want to view a particular video on your smartphone, Proxy Only will make the transfer go more rapidly and should be sufficient. Otherwise, select the original, with or without the proxy.

Finally, as discussed earlier in this chapter, the Connect During Power Off option lets you determine whether the camera will connect via Bluetooth with a smartphone or tablet while the camera is powered off. If you have this setting turned on, you will be able to send images from the camera to the smart device or view the images on the camera's memory card while the camera is turned off. As you would expect, having this setting turned on can deplete the camera's battery, so leave it on only if you find it useful. This option is available for selection only when Bluetooth Function is turned on through screen 2 of the Network menu.

FTP TRANSFER FUNCTION

I discussed this option earlier in this chapter. I will briefly review the menu item and its sub-options, because I did not discuss all of them earlier.

The first screen of the FTP Transfer Function menu item includes two sub-options: FTP Function, which must be turned on to initiate the transfer process, and Server Setting, which includes the list of registered servers, each of which includes various options that must be entered, including Display Name, Destination Settings, Directory Settings, and User Info Settings. One point to be aware of is that, when you want to enter the details for a particular server in the list, you have to highlight the full line for that server with the orange highlight bar before you can select it to enter the data.

The second screen of the FTP Transfer Function item, reached by pressing the Right button, includes three items: Save/Load FTP Settings, FTP Transfer, and

Display FTP Result. With the first option, you can save the current settings for the FTP Transfer Function option to a smartphone, and then recall them later. With the FTP Transfer option, you can select settings for Target Group, Target Image, and Transfer Status. These options allow you to specify whether to transfer all images on the memory card or just those from the current date; all images or just protected ones; and all images in the specified group as opposed to only those that have not been transferred before or only those that have previously failed to transfer. With these settings, you can limit what gets transferred, so you do not inadvertently set the camera to transfer hundreds or thousands of images currently on your memory card.

The final option on the second screen of the FTP Transfer item, Display FTP results, reports how many images were transferred successfully and how many failed to transfer, after a completed attempt to transfer.

The third and final screen of the FTP Transfer Function menu item includes three sub-options: Auto Transfer When Shot, RAW + JPEG Transfer Target, and FTP Power Save. The first option, if turned on, transfers new images automatically as you shoot them. The second option determines which images are transferred when File Format (Still Images) is set to Raw + JPEG—just the Raw, just the JPEG, or both. The final sub-option, if turned on, deactivates the network connection when it has not been used for a period of time, to conserve battery power.

CONTROL WITH SMARTPHONE

I discussed this menu option earlier in this chapter, when I discussed the steps for controlling the camera using the Imaging Edge Mobile app on a smartphone. The first sub-option, Control with Smartphone, needs to be turned on; you then establish a connection using the Connection sub-option. The third sub-option, Always Connected, can be turned on or off. If it is turned on, the connection between the phone and camera will stay in place and will not need to be reestablished. That setting uses up power more rapidly than letting the connection end, so I recommend not enabling the persistent connection unless you have a definite need to do so. Also, note that the Control with Smartphone option interferes with some other camera operations, such as the PC Remote menu item, so it is

a good idea to turn off Control with Smartphone when you won't be using it for a while.

PC REMOTE FUNCTION

This menu option includes seven sub-options that let you set up the camera to be controlled by a computer, for tethered or wireless remote shooting. These suboptions are discussed below.

PC Remote

This first sub-option, which can be turned either on or off, determines whether the PC Remote function is available for use. If you don't turn this setting on, you cannot shoot remotely using this option.

PC Remote Connect Method

This next sub-option has three possible choices for the remote connection: USB, Wi-Fi Direct Access, or Wi-Fi Access Point. The first choice involves connecting the camera to the computer using the USB-C cable supplied with the camera, or another compatible cable.

The second method involves connecting the camera wirelessly to the computer using a Wi-Fi network generated by the camera. The camera will display the name of the network and information on how to connect; you need to use that information to cause the computer to connect to that network.

With the third method, you connect the camera and the computer to the same external Wi-Fi access point, after first pairing the camera with the computer using the Pairing option, discussed below. As noted earlier, I found both wireless tethering options worked quite smoothly.

Pairing

As discussed immediately above, when you select Wi-Fi Access Point as the method for connecting the camera to a computer for remote shooting, you have to use this Pairing sub-option to pair the camera with the computer. To do that, first, go to the Wi-Fi Settings option on the Network menu. (That option is discussed later in this chapter.) Under that option, select either WPS Push or Access Point Settings as the method for connecting the camera to the Wi-Fi access point you will be using to connect the camera and the computer. With WPS Push, you only need to press the WPS button on the Wi-Fi access point (router); with Access Point Settings, you need to follow a few more steps to make the connection.

Once those connections have been made, select Pairing from screen 1 of the PC Remote menu option. Then start the Sony Imaging Edge Desktop (Remote) software on the computer, and use it to pair the computer with the camera. Select OK on the camera's display screen to confirm the pairing. You can then use the Imaging Edge Desktop (Remote) software to control the camera. Once the camera and computer are paired, you will not have to pair them again for future connections.

The second screen of the PC Remote menu item has three sub-options: Wi-Fi Direct Info, Still Images Save Destination, and Raw + JPEG Save Images. The Wi-Fi Direct Info option displays the information needed to connect to the camera's own Wi-Fi Network when the PC Remote Connection Method is set to Wi-Fi Direct. The Still Images Save Destination item determines whether still images are saved to the computer or camera only, or to both at the same time.

The Raw + JPEG Save Images option determines whether both Raw and JPEG images are saved to the computer when File Format is set too Raw & JPEG and Still Images Save Destination is set to PC + Camera. On the third screen of the PC Remote option, the PC Save Image Size option determines whether the JPEG images saved to the computer are at the original size or reduced to 2 megapixels, when Still Images Save Destination is set to PC + Camera.

AIRPLANE MODE

This option is a quick way to disable all of the camera's wireless network connection functions, including the camera's internal Wi-Fi network and its Bluetooth connectivity. As indicated by its name, this option is useful when you are on an airplane and you are required to disable electronic devices. In addition, this setting can save battery power, so it may be worthwhile to activate it when you are on an outing with the camera and you won't need to use any Wi-Fi or Bluetooth capabilities for a period of time.

If you try to use any of the camera's Wi-Fi or Bluetooth functions such as Send to Smartphone or Send to Computer and notice that the menu options are dimmed, it may be because this option is turned on. Turn it off and the Wi-Fi and Bluetooth options should be available again.

WI-FI SETTINGS

This last option on screen 1 of the Network menu has several sub-options, as discussed below.

WPS Push

The WPS Push option gives you an easy way to set up your camera to connect to a computer over a Wi-Fi network. Ordinarily, to connect to a wireless network, you have to use the Access Point Settings option and then enter the network password into the camera to establish the connection. The WPS Push option gives you a shortcut if the wireless access point or wireless router you are connecting to has a WPS button. That option, if it is present, is likely to be a small button on the back or top of the router, and it is likely to have the WPS label next to it or on it.

If the router has a WPS button, you will not have to make any manual settings or enter a password. All you have to do is select the WPS Push menu option on the a7C, and then within two minutes after that, press the WPS button on the router. If the operation is successful, the camera's display screen will show that the connection has been established.

Once that connection has been made, you will be able to connect your camera to a computer on that network to use the PC Remote option.

If the connection does not succeed using WPS Push, you will need to use the Access Point Settings option, the second sub-option for the Wi-Fi Settings menu item.

Access Point Settings

This option is for connecting the camera to a Wi-Fi router if WPS Push, discussed above, is not available or does not work. With this option, the camera will search for Wi-Fi access points in the area, and prompt you to enter the password for the one you select.

Frequency Band

This option lets you select either 5 GHz or 2.4 GHz for the frequency of the Wi-Fi network created by the camera for purposes of the Send to Smartphone, Control with Smartphone, and PC Remote/Wi-Fi Direct options, discussed above. You can experiment to see which of these settings provides a stronger or more reliable connection when using those options.

Display Wi-Fi Info

This menu option causes the camera to display a screen like that in Figure 10-24, which shows your camera's MAC address. MAC stands for media access control.

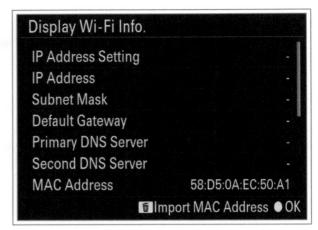

Figure 10-24. Display Wi-Fi Info Screen

The MAC address is a string of characters that identifies a device that can connect to a network. In some cases, a router can be configured to reject or accept devices with specified MAC addresses. If you are having difficulty connecting your camera to a Wi-Fi router using the options discussed above, you can try configuring the router to recognize the MAC address of your camera, as reported by this menu item. I have not had to use this option, but it is available in case it is needed.

In addition to the MAC address, this menu option will display information about an FTP connection if one has been established using the FTP Function option, discussed above. It also will display information about a PC Remote connection if the Wi-Fi Access Point method is in use for a remote connection.

SSID/PW Reset

When you connect your a7C to a smartphone or tablet, either to transfer images or to control the camera remotely with the other device, the camera generates its own Wi-Fi network internally. With this option, whose main screen is shown in Figure 10-25, you can force the camera to change the SSID (name) and password of its own wireless network.

You might want to do this if, for example, you have attended a conference where you allowed other people to connect their smartphones to your camera, and now you want to reset the camera's network ID so they will no longer have access to the camera's network.

Figure 10-25. SSID/PW Reset Menu Options Screen

The items on screen 2 of the Network menu are shown in Figure 10-26.

BLUETOOTH SETTINGS

I discussed this menu option in connection with the procedure for sending GPS location information to the camera from a smartphone. You use this menu option to turn on or off the camera's Bluetooth functionality and to pair it with a smartphone. You also can use the Display Device Address option to show the BD address, or Bluetooth Device address, of the camera, in case you need that information for troubleshooting or other purposes.

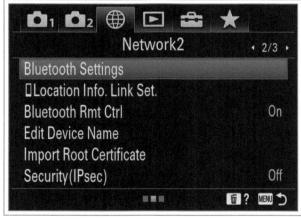

Figure 10-26. Screen 2 of Network Menu

LOCATION INFORMATION LINK SETTING

I discussed this option earlier, in connection with setting up the camera to receive location information. Once you have paired the camera with a smartphone through Bluetooth, you need to turn on the Location Information Link sub-option to cause the phone to send GPS data to the camera. You can also turn on the

Auto Time Correction and Auto Area Adjustment suboptions, if you want the camera to obtain updated time and location information from the phone.

BLUETOOTH REMOTE CONTROL

This next item on the Network menu lets you set up the camera to be operated by Sony's Bluetooth Remote Commander, model number RMT-P1BT. This option also works with other compatible accessories, including Sony's Shooting Grip with Wireless Remote Commander, model number GP-VPT2BT. Those devices are discussed in Appendix A. Here are the steps to take to use the RMT-P1BT. (The steps for the GP-VPT2BT are similar.):

- 1. On the a7C camera, on screen 2 of the Network menu, select Bluetooth Settings, and turn on the Bluetooth Function sub-option.
- On the same screen of the Network menu, select Location Information Link Settings, and make sure the Location Information Link sub-option is turned off.
- 3. On the same screen of the Network menu, select Bluetooth Remote Control, and turn it on.
- 4. On the same screen, select Bluetooth Settings, then select the Pairing sub-option. Select OK when the camera prompts you to confirm the pairing of the camera to the remote control.
- 5. On the remote control, hold down the main shutter button and the plus (zoom-in) button together for about seven seconds. You should see a message on the camera asking you to confirm pairing with the device. Press the Center button on the camera to confirm the pairing.
- 6. Use the remote control to shoot stills or videos. You also can zoom the lens using the plus and minus buttons, if you are using a power zoom lens (with the PZ indication as part of its name), or a non-power zoom lens with Clear Image Zoom, Digital Zoom, or Smart Zoom turned on. If you move the Zoom/Focus switch on the remote to the Focus position, you can focus a power zoom lens when it is in manual focus mode, using the plus and minus buttons. You can press the C1 button to call up an option that has been assigned to the C button on the camera using the Custom Key (Still Images),

Custom Key (Movies), or Custom Key (Playback) menu option. You can press the AF-ON button on the remote to call up an option programmed to the AF-ON button on the camera.

- 7. If you plan on using those two programmable buttons, it is advisable to program functions that switch between settings with each button press, rather than ones that require you to scroll through menu options, which requires using the camera's controls. For example, you might want to assign items such as AEL Hold, AF On, AF/MF Control Toggle, or Peaking Display Select. You probably should not assign options such as white balance, which require selecting one of several choices on a menu.
- 8. When you press the zoom controls (plus and minus buttons) on the remote when the camera is in playback mode with a still image on the display, the image will be enlarged or reduced with each button press. (The Zoom/Focus switch must be set to the Zoom position for this function to operate.)
- 9. Note that, as reflected in the steps above, you cannot have the Bluetooth Remote Control option turned on at the same time as the Location Information Link option. So, if one of those options is not working properly, check to see if the other one is turned on.

EDIT DEVICE NAME

This next option, shown in Figure 10-27, lets you change the name of your camera as it is displayed on the network. The default name is ILCE-7C, and I have found no reason to change it.

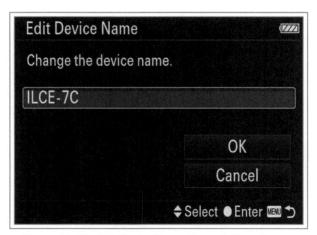

Figure 10-27. Edit Device Name Menu Options Screen

This option could be useful, though, if you are in an environment where other a7C cameras are present and you need to distinguish one camera from another by using different names.

IMPORT ROOT CERTIFICATE

This option is provided in case you need to import a root certificate from a memory card, in order to verify a server in connection with the use of encrypted communications. This situation may arise if you are using the FTP Transfer option, discussed earlier in this chapter.

SECURITY (IPSEC)

This setting is available to set a security option to encrypt data transferred between the camera and a computer via Wi-Fi, using the Internet Protocol Security system. This is a technical option that needs to be configured in consultation with the administrator of a computer network.

Screen 3 of the Network menu is shown in Figure 10-28.

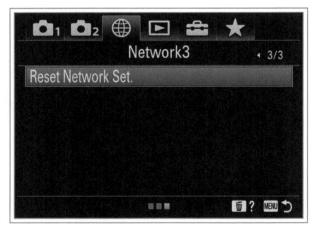

Figure 10-28. Screen 3 of Network Menu

RESET NETWORK SETTINGS

This single option on screen 3 of the Network menu lets you reset all of the camera's network settings, not just the camera's Wi-Fi SSID and password. This option is useful if you are having problems and need to get a fresh start with the wireless functions, if you are switching to a new wireless network where you use the camera, or if you are selling the camera and want to erase these settings.

Other Topics

STREET PHOTOGRAPHY

The a7C is well suited for street photography—that is, shooting candid pictures in public settings, often without the subject being aware of your activity. You can use a wide-angle lens that takes in a broad field of view, so you can shoot from the hip without framing the image carefully on the screen. You can tilt up the LCD screen and look down at it to frame your shot, which lets you take photographs without attracting attention to yourself. The camera performs well at high ISO settings, so you can use a fast shutter speed to avoid motion blur. You can silence the camera by turning off its beeps and shutter sounds using the Silent Shooting and Audio Signals menu options.

The settings you use depend in part on your style of shooting. One technique that some photographers use is to shoot in Raw, and then use post-processing software such as Photoshop or Lightroom to convert their images to black and white, along with any other effects they are looking for, such as extra grain to achieve a gritty look. (Of course, you don't have to produce your street photography in black and white, but that is a common practice.)

If you decide to shoot using Raw quality, you can't take advantage of the image-altering settings of the Picture Effect menu option. You can, however, use the Creative Style option on the Camera Settings1 menu. (You may have to use Sony's Imaging Edge software for the Creative Style setting to be effective with Raw images.) You might want to try using the Black and White setting; you can tweak it further by increasing contrast and sharpening if you want. Also, try turning on continuous shooting, so you'll get several images to choose from for each shutter press.

You also can experiment with exposure settings. I recommend you shoot in Shutter Priority mode at a fairly fast shutter speed, 1/100 second or faster, to stop action on the street and to avoid blur from camera movement. You can set ISO to Auto, or use a high ISO setting, in the range of 800 or so, if you don't mind some noise.

Or, you can set the image type to JPEG at Large size and Extra Fine quality to take advantage of the camera's image-processing capabilities. To get a gritty "street" look, try using the High Contrast Monochrome setting of the Picture Effect item on the Camera Settings1 menu, with ISO set in the range of 800 or above, to include some grain in the image while boosting sensitivity enough to stop action with a fast shutter speed.

Figure 10-29. Street Photography Example 1

For Figure 10-29, I used Program mode with high-speed continuous shooting turned on, to catch this image of a man photographing a child in a local park. The image was exposed at 1/500 second, at f/5.6 with ISO at 1000. I used the Sony FE 100mm-400mm G Master lens, so I could photograph from a reasonable distance.

For Figure 10-30, I took a different approach during the same photo session in the park. For this shot, I used Intelligent Auto mode with the 28mm-60mm kit lens to capture an image of people playing basketball. The image was exposed at 1/200 second, f/5.6, ISO 200.

Figure 10-30. Street Photography Example 2

Another possibility is to take advantage of the camera's ability to shoot 4K video. You can shoot video using an exposure mode such as Shutter Priority that lets you use a fast shutter speed to avoid motion blur, and record a street scene for several seconds, or even a minute

or more. You can then use video-editing software or the camera's Photo Capture feature to extract a single frame. Because of the relatively high resolution of 4K video, the quality is likely to be quite acceptable. I used that technique for Figure 7-28, discussed in Chapter 7 in connection with Photo Capture.

ASTROPHOTOGRAPHY AND DIGISCOPING

Astrophotography involves photographing sky objects with a camera connected to (or aiming through) a telescope. Digiscoping is the practice of using a digital camera with a spotting scope to get shots of distant objects such as birds and other wildlife.

There are many types of scope and several ways to align a scope with the a7C's lens. I will not describe all of the methods; I will discuss the approach I used and hope it gives you enough guidance to explore the area further.

I used a Meade ETX-90/AT telescope with the a7C connected to it directly, without an eyepiece, using the "prime focus" method of connecting. To make that connection, you need an adapter to connect the a7C camera's body to the telescope. I purchased an astrophotography adapter kit, model BNEX, from telescopeadapters.com, which included a T-ring as well as another adapter that was useful for digiscoping, discussed below. I set the Release w/o Lens option on screen 5 of the Camera Settings2 menu to Enable.

I took the image of the moon in Figure 10-31 with the a7C connected to the telescope using the T-ring adapter. I set the camera to Manual exposure mode and used manual focus, adjusting the telescope's focus control until the image was sharp on the camera's LCD. I used Auto ISO and the camera set the ISO to 16000.

At first I used the MF Assist option so I could fine-tune the focus with an enlarged view of the moon's craters. After some experimenting, I found I got better results using the Peaking Level function at High, and Peaking Color set to red. When focus was sharp, I saw a bright, red outline on the outer edge of the moon, which made focusing much easier than relying on the normal manual focus mechanism, even with MF Assist activated.

I set the self-timer to five seconds to minimize camera shake. I set Quality to Raw & JPEG so I would have a Raw image to give extra latitude in case the exposure seemed incorrect. As you can see in Figure 10-31, the a7C did a

good job of capturing the moon in its first quarter. The image was exposed for 1/90 second at ISO 2500.

Figure 10-31. Image of Moon Taken with a7C through Telescope

I tried a similar setup for digiscoping, attaching the a7C to a Celestron Regal 80F-ED spotting scope with the same adapter I used with the telescope, using a standard telescope eyepiece in conjunction with the adapter, and a "projection body" that was part of the adapter kit I had purchased. With that setup, I was able to get the image in focus by adjusting focus on the scope. The result was Figure 10-32. As you can see, there is considerable vignetting, and the overall quality is not great, but at least I was able to get a magnified shot of the birds.

Figure 10-32. Digiscoping Example Using Celestron Scope

Appendix A: Lenses and Accessories

Lenses

The a7C camera uses Sony's E-mount system for attaching a lens to the camera's body. There are several categories of lenses available for this camera: E-mount lenses designed for the a7C and similar Sony cameras that use a full-frame sensor, such as the a9 II, a7S III, and a7R IV; E-mount lenses designed for cameras such as the Sony a6000, a6100, a6300, a6400, a6500, and a6600, which use an APS-C sensor; A-mount lenses designed for older Sony cameras, such as the a99 II; and lenses made by other manufacturers, such as Sigma, Canon, Leica, and others.

Lenses from the first two categories can be mounted directly on the a7C with no need for an adapter. Lenses from the A-mount category require the use of an adapter, discussed later in this section. Lenses from other manufacturers require the use of other adapters. You can find information about adapters for such lenses at sites such as https://briansmith.com/gear/sony-lens-adapters/ and https://www.dpreview.com/reviews/buying-guide-best-lenses-for-sony-mirrorless.

E-MOUNT LENSES FOR FULL-FRAME CAMERAS

These lenses could be considered "native" lenses for the a7C, because they are designed for use on the a7C and other models with a full-frame sensor. These lenses, when made by Sony, have the FE designation in their names. One example is the Sony FE 28mm-60mm f/4-f/5.6 lens, shown in images earlier in this book, including Figure 2-1 and others. That lens was newly introduced in 2020 as the standard kit lens for the a7C camera.

Another example is the Sony FE 100 mm-400 mm f/4.5-5.6 GM OSS, shown in Figure A-1. The GM designation stands for "G Master," a category that Sony says is higher than its G category. (The letter G

included in the name stands for Gold, and designates what Sony considers to be an especially high-quality lens.) It currently sells new for about \$2,500.00. This lens, designed presumably for professional sports photographers using full-frame cameras, is quite large and heavy, but it fits nicely with the a7C and can yield excellent images.

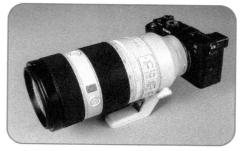

Figure A-1. Sony FE 100mm-400mm f/4.5-5.6 GM OSS

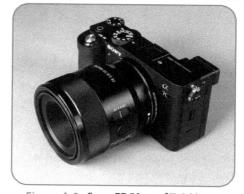

Figure A-2. Sony FE 50mm f/2.8 Macro

There are many lenses available in this category. Two other examples are the Sony FE 50mm f/2.8 Macro, a macro lens designed for closeup shots of small items, shown in Figure A-2, and the Sony FE 85mm f/1.8 lens.

E-MOUNT LENSES FOR APS-C SENSOR CAMERAS

The next category includes lenses that are designed for cameras with APS-C sensors, such as the a6000, a6400, and the older NEX series of Sony cameras. One example is the Sony E 18-135mm f/3-f/5.6 lens, often sold in a

kit with one of the a6000 series cameras. It is shown in Figure A-3.

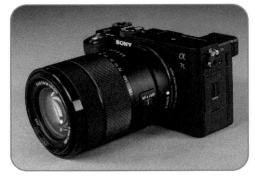

Figure A-3. Sony E 18mm-135mm f/3-5.6 Lens

With lenses in this category, the focal length range, such as 18-135mm, is stated in terms of the actual focal length of the lens. However, when used on a camera body with an APS-C sensor, a lens in this category has an effective focal length that is one and one-half times the stated value, because the sensor has a smaller area than a full-frame sensor. So, for example, when used on an a6100 camera body, this lens has an effective focal length of 27-202mm.

When used on the a7C or another full-frame camera body, the effective focal length of the lens is as stated, 18-135mm. However, because the lens is designed for use with an APS-C sensor camera, the lens is not designed to project an image over the entire area of the sensor.

Therefore, in order for the lens to produce full-sized images with the a7C, the camera must be set to its crop mode, using the APS-C/Super 35mm option on screen 1 of the Camera Settings1 menu, as discussed in Chapter 4. That setting is usually made automatically when the camera detects the APS-C lens through the contacts on the lens mount. If that setting is turned off, the images produced by the lens will show vignetting, unless the lens is zoomed in somewhat.

It's also important to note that, when using an APS-C lens on the a7C, the effective resolution of images is reduced to a maximum of about 10 megapixels, instead of the 24 MP available with native, full-frame lenses.

So, if you are going to use a lens designed for APS-C cameras on the a7C, you have to be aware of the mismatch in image size and resolution, but you still can get the benefits of the features of the lens, as long as you are willing to accept those limitations.

When, as with this lens, there are two numbers listed for the maximum aperture (f/3.5-5.6), the first one (f/3.5) is the maximum aperture when the lens is zoomed back to its full wide-angle focal length of 16mm; the second (f/5.6) is the maximum aperture when the lens is zoomed in to its highest focal length of 50mm.

The OSS designation means that the lens has optical SteadyShot (image stabilization) built in. That feature is not as important for use with the a7C as with some other Sony models that do not include inbody stabilization (IBIS). However, the a7C can take advantage of the OSS as well as the IBIS, so using a lens with OSS does have some advantages.

There are several other lenses made specifically for Sony's E-mount APS-C cameras. I will mention just a few of them, to illustrate the variety available. One option is the Sony E PZ 18-105mm f/4 G OSS lens. In addition, even though this is a zoom lens, it has only a single aperture listed, f/4. That means that the lens maintains a constant aperture of f/4 even when zoomed in to its highest focal lengths. With this sort of lens, you can maintain the widest aperture at all times, thereby letting in plenty of light and having a good ability to achieve a blurred background.

Another possibility is the Sony E 16mm f/2.8 lens. This is an example of a prime lens, meaning it has only a single focal length (16mm), and therefore does not zoom. This lens is also considered to be a "pancake" lens, although that is not part of its official designation. That means that it has a particularly thin structure, so it could be a good choice when you want to keep down the weight and bulk of the camera and lens combination, and plan to shoot wide-angle images, possibly for landscape or street photography.

Another example is the Sony E 16mm-50mm f/3.5-5.6 PZ OSS lens, shown in Figure A-4. This is one of the relatively few power zoom lenses available. This lens can be zoomed by pressing the switch on the lens barrel, which yields a steady zooming motion suitable for video recording.

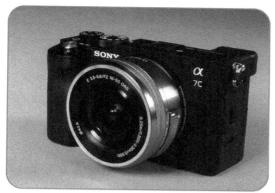

Figure A-4. Sony E 16mm-50mm f/3.5-5.6 PZ Lens

There also are quite a few E-mount lenses for Sony APS-C cameras that are made by other manufacturers. One example is the Sigma 16mm f/1.4 DC DN Contemporary Lens for Sony E, which offers a very wide aperture of f/1.4. Another option is the Sigma 35mm f/1.4 DG HSM Art Lens for Sony E. A "fisheye" lens with a very short focal length that provides a distorted super-wide-angle view is the Meike MK-6.5mm f/2 Circular Fisheye Lens for Sony E. This is an inexpensive, manual focus lens. Other lenses are available from Rokinon, Samyang, Neewer, and others.

A-MOUNT LENSES

The final category to be discussed is lenses designed for Sony's older A-mount system. Use of these lenses requires an adapter, which is fairly expensive and awkward to use, so I don't recommend this approach unless you already own, or have access to, one or more good A-mount lenses. However, you may find that in some cases there is an A-mount lens that works better for your application than the other lenses available. Some photographers have a very favorable view, for example, of the Sony DT 16-50mm f/2.8 SSM lens. DT stands for "digital technology," and designates a lens designed for an APS-C sensor camera; SSM stands for SuperSonic Motor, a particular type of focusing motor. Other good options are the Sony 50mm f/1.4 lens and the Sony DT 50mm f/1.8 SAM lens. SAM stands for Smooth Autofocus Motor.

For any A-mount lens you need to use an adapter to mount it on the a7C. Sony currently makes three adapters, called Mount Adaptors, the LA-EA3, the LA-EA4, and the LA-EA5. The LA-EA4 is shown on the a7C in Figure A-5, with the Sony 50mm f/1.4 lens attached to the adapter. Figure A-6 shows the newer LA-EA5

adapter, with the Sony DT 50mm f/1.8 SAM lens attached.

Figure A-5. Sony 50mm f/1.4 Lens with LA-EA4 Adapter

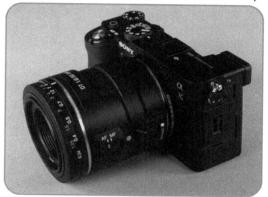

Figure A-6. Sony DT 50mm f/1.8 Lens with LA-EA5 Adapter

As you can see from the images here, the LA-EA4 adapter is considerably bulkier than the newer LA-EA5 adapter. However, the LA-EA5 adapter, at least as of the time of this writing in late November 2020, does not support autofocus on older Sony lenses. It supports autofocus only on lenses with built-motors, designated as either SAM or SSM. For lenses like the 50mm f/1.4, you need to use the LA-EA4 adapter if you want to use autofocus. (You can use a lens such as that with the LA-EA5 adapter, if you are willing to use manual focus.) The LA-EA5 adapter, however, has the advantage of enabling the use of features such as Eye AF and tracking autofocus, if used with a compatible lens. I have seen some discussion indicating that Sony may eventually update the a7C camera to allow the LA-EA5 to use all of its features with additional lenses.

Some A-mount lenses do not support the DMF (direct manual focus) mode for autofocus. In addition, when you are using one of these lenses with the Mount Adaptor on the a7C, the AF Illuminator will not illuminate for autofocus, even if the AF Illuminator menu option is set to Auto. Also, there is no focus

distance scale on the camera's display when using an A-mount lens on the a7C in manual focus mode, and MF Assist does not work. Touch Tracking does not function properly, although a tracking frame will appear on the display. The AF in Focus Magnification and pre-AF options also do not function when using the Mount Adaptor, and continuous AF will not function during high-speed burst shooting.

On the other hand, two menu options, Eye-Start AF and AF Micro Adjustment, are available only when using an A-mount lens with the Mount Adaptor.

You can refer to the following Sony website for more information about what lenses are compatible with the a7C camera: https://support.d-imaging.sony.co.jp/www/cscs/lens_body/index.php?mdl=ILCE-7C&area=gb&lang=en. For a chart setting forth the differences among these and other lens adapters, see https://www.sony.co.th/en/electronics/support/lensesmount-adaptors/la-ea4/articles/00021281.

Cases

You don't have to get a case for your a7C, but I always use one when I'm going out for a photo session, so I can carry along filters, extra batteries, memory cards, and other items. I will discuss a few of the many possible choices.

Figure A-7. Ruggard Hunter 25 Holster Bag with a7C

One option that works well for the a7C with the 28mm-60mm kit lens attached is the Ruggard Hunter 25 Holster Bag, shown with the camera inside it in Figure A-7. This is a "top-loading" case, meaning the camera is placed in it with the lens facing down, so you can quickly grab the camera in its shooting position. This case protects the camera well, and has room for small

items such as filters, batteries, and memory cards, but not for another lens.

A larger option is the Lowepro Passport Sling, shown in Figure A-8. This bag easily can hold the a7C with the 28mm-60mm kit lens, as well as a second lens and various accessories. There are more recent versions since this one was released a few years ago, but they are similar in size and features. I like this bag for the convenience of carrying it over one shoulder and its flexibility for holding numerous small items.

Figure A-8. Lowepro Passport Sling Bag with a7C

There are many other options available, such as the Lowepro Apex 110 AW, or, if you are using a smaller lens, the Lowepro Apex 100 AW. Beyond those, you can find backpacks, other sling packs, and many traditional cases.

Batteries and Chargers

These are items I recommend you purchase when you get the camera or soon afterward. You can't use disposable batteries, so if you're out taking pictures and the battery dies, you're out of luck unless you have a spare battery, or you can plug the camera's charging cable into a power outlet or USB port. You can get a spare Sony battery, model number NP-FZ100, for about \$78 as I write this. It won't do you a great deal of good by itself, though, because the battery is designed to be charged in the camera.

There is an easy solution to this problem. You can find generic replacement batteries, as well as chargers to charge the batteries outside the camera, inexpensively from eBay, B&H Photo, and elsewhere. Figure A-9 shows a RAVPower external charger and two replacement batteries, which have worked well with my a7C. As I write this, you can purchase a similar generic charger with two batteries for about \$50. One drawback is that the camera is likely to occasionally display a message saying the battery's operation cannot be guaranteed (because it is

not a Sony battery). You can dismiss that message with a press of the Center button. In addition, the battery icon on the monitor may not always show the percentage of battery like remaining. So far, I have not had any issues beyond those two. I also have used replacement batteries by Wasabi Power with good results in the past, though I have not tested them with the a7C.

Figure A-9. RAVPower Batteries and Charger

AC Adapters and Other Power Sources

As I discussed in Chapter 1, the battery charger that comes with the camera, model no. AC-UUD12 in the United States, can be used as an AC adapter as well as a battery charger. If you plug the camera's USB cable into that charger and into the camera's USB port, and then plug the charger into an electrical outlet, the camera will be powered by the charger when the camera is turned on, as long as there is a battery in the camera. If you turn the camera off, the charger will charge the battery inside the camera. However, you cannot use the supplied charger to power the camera if you are using the USB port for some other purpose, such as uploading images and videos to a computer, or controlling the camera from a computer connected to the USB cable. In those situations, an optional AC adapter would be useful.

One option is a generic adapter like the one seen in Figure A-10, the Gonine AC Power Adapter Kit. As you can see, this item is quite cumbersome. It consists of a power brick with a separate cord that plugs into an AC outlet, and a smaller cord that terminates in a block shaped like the camera's battery. That block (sometimes called a "dummy battery") is inserted into the camera, and the cord is routed through a small flap in the battery compartment door. You have to pull that flap out to leave room for the cord, so the door can be

closed and latched. All this accessory does is power the camera. It does not recharge the battery, because the battery has to be removed from the camera in order to use this setup. However, this item does the job of supplying AC power to the camera continuously.

Figure A-10. Generic AC Power Adapter Kit

Another option is the Tether Tools Case Relay external power system, shown connected to the camera in Figure A-11. This system, like the adapter discussed above, uses a dummy battery that is inserted into the camera's battery compartment, and connects to the power adapter with a cord.

That cord, like that for the generic adapter discussed above, has to be routed through the small channel in the camera's battery compartment door, as shown in Figure A-11.

Figure A-11. Tether Tools Case Relay Power Adapter System

The difference with this accessory from the Gonine version is that it provides an "infinite" power supply. That means that it has its own internal battery, which supplies power to the camera and that can be recharged constantly from an external power source, such as a portable USB battery or a USB wall charger. If you use a USB battery, you can "hot-swap" a new one as an old one loses its charge. In this way, you could keep

the camera powered on for many hours or days, while recording time-lapse sequences or carrying out other long processes. (Of course, you might run the risk of the camera overheating, so you would have to monitor the setup from time to time.)

One more option that I have used with the a7C may not be as practical as the ones discussed above because of its expense, but it is quite useful. This device is the Sony NPA-MQZ1K Multi Battery Adaptor Kit, shown in Figure A-12. This device can charge up to four NP-FZ100 batteries at a time, and it comes as a kit that includes two of those batteries, which are the type of battery used in the a7C.

Besides charging NP-FZ100 batteries, the device can hold up to four of those batteries, and output power through an attached cable and "dummy battery," which can fit into the a7C's battery compartment, just as is the case with the AC adapters discussed above.

Figure A-12. Sony NPA-MQZ1K Multi Battery Adapter Kit

The dummy battery comes with an adapter that lets it fit into the a7C camera, and if you remove that adapter, the dummy battery fits perfectly into the battery compartment of any Sony camera that uses the smaller NP-FW50 battery, such as the RX10 IV. The device also includes USB ports, so it can provide power to USB-powered devices as well as to a camera, though not both at the same time .

This device can supply power for a long period of time, especially if you use it with multiple fully charged NP-FZ100 batteries. The device is quite expensive, at about \$400 with two NP-FZ100 batteries included. But, if you also have another camera that uses Sony's NP-FZ100 or NP-FW50 batteries, this option is worth considering.

Another device that is useful for providing power for the a7C is a USB power bank, like the RAVPower 6-Port Desktop USB charger, model number RP-UC10, shown in Figure A-13. That device also recharges the battery inside the camera while the camera is turned off.

I use it to charge my iPhone and iPad, and it does a good job of charging the Sony battery inside the a7C camera at the same time, or powering the camera when I am using it near my desk. You also can use this device to charge the Tether Tools Case Relay, discussed above. There are many other USB chargers available from companies such as Aukey and Anker.

Figure A-13. RAVPower 6-Port Desktop USB Charger

Figure A-14. Mophie PowerStation XL

One more option for an external power supply is a portable USB battery like the Mophie PowerStation XL, shown in Figure A-14, which can be recharged from a USB wall charger and can provide power to the camera using the camera's USB-C cable or any standard USB-C cable. Devices like this are available from various manufacturers, such as Aukey, RAVPower, Anker, and Poweradd.

This device has two standard-sized USB ports. You can plug the camera's USB cable into one of those ports and connect the other end to the camera to provide a long-lasting source of power, or to charge the camera's battery. You can charge the power supply through its own micro-USB port, using any compatible AC adapter.

The Mophie device is not very large and weighs about 7.65 ounces (217 grams).

External Flash Units and Flash Triggers

The a7C is equipped with Sony's special Multi Interface Shoe, where you can attach an external flash unit, among other items. The most obvious choice for using external flash is to use one of the units offered by Sony. The smallest Sony flash currently available for use with the a7C is model number HVL-F20M, shown in Figure A-15. (A possibly smaller unit, the HVL-F28RM, was not available in the United States when this book was written; it should be available by early 2021.)

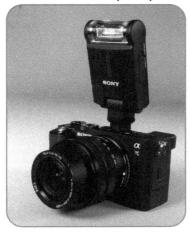

Figure A-15. Sony HVL-F20M Flash

This unit fits with the camera nicely. It has a guide number of up to 20 at f/2.8 and ISO 800, meaning it can reach up to 20 meters (66 feet) with those settings; it has a shorter range at higher apertures and with lower ISO values. It has a Bounce switch, which rotates the flash head upward by 75 degrees to let you bounce the flash off a ceiling or high wall.

The F20M is capable of acting as the trigger unit for Sony's optical wireless flash control system. If you want to fire other flash units remotely using Sony's optical wireless system, the F20M is the least expensive option for that purpose. Note, though, that the F20M cannot be fired remotely using that system; it can act as the master unit, but not as a slave unit.

The next step up with Sony's external flash options is a considerably larger unit, the HVL-F32M, shown in Figure A-16. This powerful flash can act as either

the trigger unit or a remote unit with Sony's optical wireless flash system.

The next model, HVL-F43M, not shown here, also can assume either role for optical wireless flash and includes a video light that can provide continuous illumination.

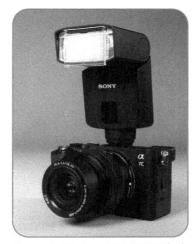

Figure A-16. Sony HVL-F32M Flash

The HVL-F45RM, shown in Figure A-17, has built-in capabilities as both a wireless commander unit and a wireless receiver unit for both of Sony's remote flash systems—optical and radio. I will discuss it again below, when I discuss radio flash triggers.

Or, you can opt for the largest unit, the Sony HVL-F60RM, not shown here, which also can perform optical and radio wireless functions.

Another option is to use an older Sony flash that was not designed for the Multi Interface Shoe. In that case, you need Sony's shoe adapter, model number ADP-MAA, so the flash will work automatically with the a7C. Note that not all older Sony flash units will work with the a7C, even with this adapter. In particular, I have been advised that the Sony HVL-F32X flash will not work with newer cameras, even with the adapter.

You also can use a non-Sony flash that is designed to be compatible with the Multi Interface Shoe. One example is the Neewer NW320, shown in Figure A-18, which works with the a7C to provide automatic flash output. You need to be sure to purchase the version of this flash designed for the Sony Multi Interface Shoe.

Another third-party flash unit that is compatible with the a7C is the Godox TT350 for Sony, shown in Figure A-19.

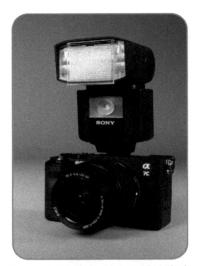

Figure A-17. Sony HVL-F45RM Flash

There are some other non-Sony flash units that work with the hot shoe of the a7C and fire whenever the camera's shutter button is pressed. However, with these units, there is no communication with the flash unit through the camera's accessory shoe. Therefore, you have to set both the camera and the flash to their manual modes and determine the exposure through trial and error or by measuring the light with a meter.

If you are not using a Sony flash, you probably will want to set the camera's white balance to its Flash setting, because the Auto White Balance setting will not take account of the use of flash unless the flash communicates with the camera.

There is one other issue you need to be aware of when using a non-Sony flash unit. When you set the camera to Manual exposure mode, the camera's display screen is likely to be black or very dark because the Manual exposure settings would result in a dark image if you were not using flash, and the camera will not "know" about the effects of the non-Sony flash. Therefore, it may be difficult to compose the shot.

The a7C has a menu option that deals with this type of situation—the Live View Display option on screen 8 of the Camera Settings2 menu. If you select the Setting Effect Off option for that menu item, then, when you use Manual exposure mode, the camera's display will not show the dark image that would result from the shot without flash; instead, the display will show the image with normal brightness (if there is enough ambient light), so you can compose the shot with a clear view of the scene in front of the camera.

Another way to use external flash units with the a7C is to fire them with a radio flash trigger system. Sony offers a radio triggering unit and a matching receiver that work well with the a7C camera for this purpose. These units are the Sony Wireless Radio Commander, model number FA-WRC1M, shown in Figure A-20, and the Wireless Radio Receiver, model number FA-WRR1, shown in Figure A-21.

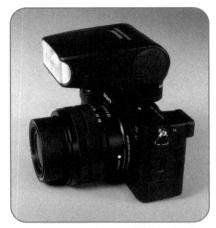

Figure A-18. Neewer NW320 Flash

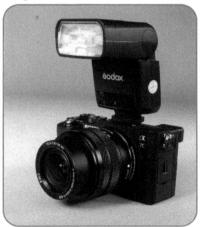

Figure A-19. Godox TT350 Flash

I won't discuss the details of their use here, but I tested them and they worked well, as discussed in Chapter 4. I attached a Sony HVL-F32M flash to the receiver, and I attached the commander to the Multi Interface Shoe on top of the a7C. After I followed the steps to pair the two devices, when I pressed the shutter button on the camera, the flash fired in its remote position.

I also tested the commander unit using the Sony HVL-F45RM flash as the remote unit. That flash unit has a built-in radio receiver, so there was no need to use the separate radio receiver unit. This setup also worked as expected, with the HVL-F45RM firing when I pressed

the shutter button on the camera, with the commander unit attached to the Multi Interface Shoe.

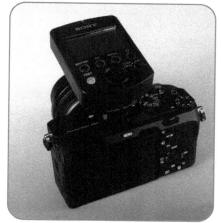

Figure A-20. Sony Wireless Radio Commander

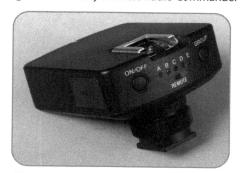

Figure A-21. Sony Wireless Radio Receiver

I also have used other radio triggers, such as model number RF603N II, by Yongnuo. I purchased these in a pair, each of which can act as either a transmitter or a receiver, by moving a switch on its side. As seen in Figure A-22, I mounted the transmitter unit in the camera's accessory shoe. I attached the receiver unit to the LumoPro LP180, an external flash unit, which I placed on a small stand. With the flash set to its Manual mode and the camera's flash mode set to Fill-flash, when I pressed the shutter button, the external flash fired.

With this system, you can use any flash unit that is compatible with the receiver. I have found that you need to use a flash that has a Manual mode, like the LumoPro unit. External flash units that have only automatic (TTL) exposure systems do not work, in my experience.

I also tested another radio transmitter, the Hensel Strobe Wizard Plus, not shown here, which I use for triggering monolight flash units. It worked well in the accessory shoe of the a7C, triggering the monolights properly.

Figure A-22. Yongnuo RF603N II Transmitter and Receiver

If you want to use continuous lighting that is attached to the camera, rather than flash, there are several options. One that I recently tried and found useful is the Lume Cube Panel GO, shown on the a7C camera in Figure A-23. This compact panel provides bright light from 112 LEDs. Its output can be varied in brightness and in color temperature, ranging from 3200K to 5500K, to match other lighting in the area.

Another option is Sony's own video light, model no. HVL-LBPC, which has special features that can be controlled by the Video Light Mode option on screen 3 of the Camera Settings2 menu, as discussed in Chapter 5. I have not tested this light with the a7C camera, but Figure A-24 shows it attached to the Sony RX10 IV camera, which also has the Video Light Mode menu option. I have found this light to be unavailable for purchase in the United States as of late 2020, so it may have been discontinued by Sony.

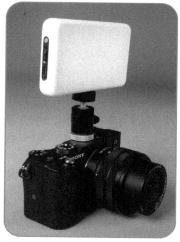

Figure A-23. Lume Cube Panel GO

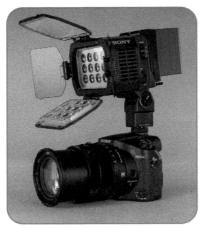

Figure A-24. Sony HVL-LBPC Video Light with RX10 IV Camera

Remote Controls

In several situations, it is useful to control the camera remotely. For example, when you are using slow shutter speeds, holding the shutter open with the Bulb setting, or doing closeup photography, any camera motion during the exposure is likely to blur the image. If you control the camera remotely, you lessen the risk of blurred images from moving the camera as you press the shutter button. Remote control also is helpful when you need to be located away from the camera, as for taking self-portraits or images of wildlife.

As I discussed in Chapter 10, the a7C has built-in Wi-Fi capability for connecting a computer, smartphone, or tablet to the camera wirelessly. Besides using the wireless features to transfer images from the camera to the other device, you can use a smartphone or tablet as a wireless remote control. However, it can be tricky to establish and maintain the connection between the camera and the phone or tablet.

As of this writing in late 2020, Sony has not released any remote controls that can plug into the USB-C port of the a7C camera. However, the company does offer a couple of Bluetooth remote controls that work with this camera.

One of these is the RMT-P1BT, which I discussed in Chapter 10. That device, shown in Figure A-25, can control the shutter, movie recording, and zoom, and it has a C1 and an AF-ON button, both of which can be programmed through the camera. It is activated through the Bluetooth Remote Control option on screen 2 of the Network menu. Also shown in this image is the JJC BTR-S1, which provides the same functions as the Sony remote and is less expensive,

costing about \$29 as opposed to the \$78 cost for the Sony version, as of this writing. There also are other generic versions of this remote available.

Another Bluetooth remote that is available as of this writing is the GP-VPT2BT, which I also discussed briefly in Chapter 10. It is shown with the a7C camera in Figure A-26. This item attaches to the camera as a shooting grip, and includes shutter release, Movie, and zoom buttons, as well as a C1 button that is compatible with the camera's C button.

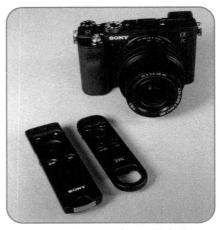

Figure A-25. Sony RMT-P1BT and JJC BTR-S1 Remote Controls

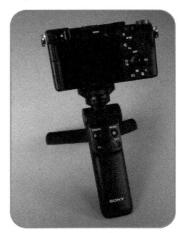

Figure A-26. Sony GP-VPT2BT Shooting Grip and Remote

External LCD Monitor

There is another accessory to consider for viewing live and recorded images with the a7C. The Sony Clip-On LCD Monitor, model number CLM-FHD5, is an add-on unit with a 5-inch (12-cm) screen. This small monitor comes with a foot that attaches securely to the accessory shoe of the a7C. The unit includes a short HDMI cable that ends in a micro-HDMI plug at the camera end, for connecting to the HDMI port of the camera.

This monitor works well with the a7C. It adds visibility for viewing the shooting screen and for playing back images and videos. The screen can rotate 180 degrees, so you can view the scene from the front of the camera for self-portraits. It also can tilt up or down for viewing from high or low angles. The monitor has numerous controls for settings such as Peaking, brightness, and contrast, and it has a special display mode for boosting the contrast when you are using the S-Log2 or S-Log3 gamma curve, whose use produces dark footage that is hard to see before it has been processed with a computer.

This unit costs about \$700 at the time of this writing, but if you need the extra screen size or versatility, it is worth looking into. It does not come with a battery, but it can use any one of several Sony batteries from the M, V, or W series.

A considerably less expensive similar option is the Neewer LCD Field Monitor, shown with the a7C camera in Figure A-27, which sells for about \$110 without battery, but is available in a kit that includes a battery.

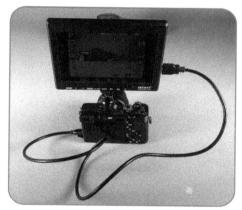

Figure A-27. Neewer LCD Field Monitor

External Microphones

The a7C camera has two features that enable the use of an external microphone—a standard 3.5mm audio input port on the left side of the camera, and the Multi Interface Shoe, which allows a compatible Sony microphone to get its power and audio connections from that shoe.

One relatively inexpensive microphone that connects through the camera's special interface shoe is Sony's model number ECM-XYST1M, shown in Figure A-28. This compact device has two microphone units that can

be kept together or separated by 120 degrees, as shown here, to pick up sounds from different directions.

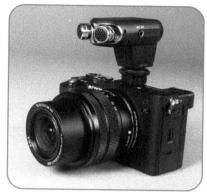

Figure A-28. Sony ECM-XYST1M Microphone

Another option, which provides wireless capability, is Sony's Bluetooth microphone, model number ECM-W1M, shown in Figure A-29. With this unit, you attach a small receiver to the camera's Multi Interface Shoe as shown here. You then can clip the separate microphone to a shirt pocket or any other location, and the camera will pick up sounds from the microphone within a range of about 300 feet or 100 meters.

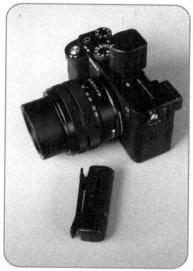

Figure A-29. Sony ECM-W1M Bluetooth Microphone

If you want a shotgun-style microphone, Sony offers model number ECM-GZ1M, shown in Figure A-30. It comes with a windscreen that you can slip over the microphone; that accessory is shown here lying beside the camera.

A newer model of Bluetooth microphone is Sony's ECM-B1M, shown in Figure A-31. This microphone is interesting for several reasons. First, it uses digital technology to process its sound, so it feeds a digital

audio signal into the camera. The camera has a switch to select digital or analog for its audio processing; the digital feature works on only a few of the newer Sony cameras, including the a7C. Also, the microphone is small and light, and, like the other models designed for the Multi Interface Shoe, it does not need a battery or a cable to connect it to the camera. It has several audio pickup patterns as well as a noise-cancellation switch and an attenuator. The microphone provides excellent sound quality, but it comes at a price; the retail price when I purchased mine was about \$300.

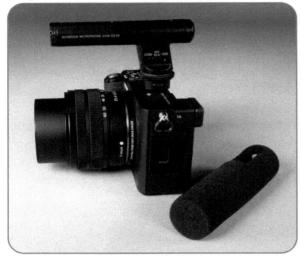

Figure A-30. Sony ECM-GZ1M Shotgun Microphone

Sony also offers a more expensive and sophisticated option for using external microphones—the XLR-K2M adapter kit, shown in Figure A-32.

The kit connects to the camera's Multi Interface Shoe and provides inputs for two professional-quality XLR microphones. That type of microphone provides balanced input, resulting in lower noise and cleaner sound.

The kit includes a single Sony shotgun microphone with an XLR connection and an adapter for attaching the kit to the camera, as well as a connector for another microphone and controls for both inputs.

You may not want to spend \$600.00 to add this capability to a compact camera, but, given the a7C's excellent video features, it could be a worthwhile expense if you use the camera heavily for video production.

You also can use any of a multitude of other external microphones with the a7C, as long as the microphone has a cable that terminates in a standard 3.5mm stereo

plug. One example from Sony is another shotgun mic, model number ECM-CG50. You also can use third-party mics, such as the Rode VideoMic Pro, or various models from Shure or Audio-Technica. Figure A-33 shows a Rode microphone attached to the camera.

Figure A-31. Sony ECM-B1M Microphone

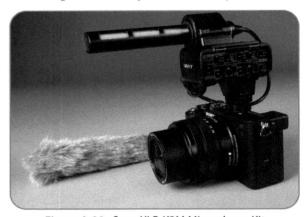

Figure A-32. Sony XLR-K2M Microphone Kit

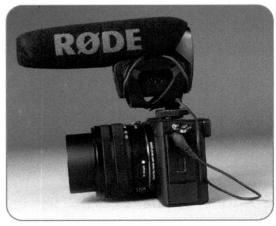

Figure A-33. Rode VideoMic Pro Microphone

External Video Recorder

In Chapter 9, I discussed how to take advantage of the a7C's video features to output its 4K video signal via the HDMI port to an external video recorder. Using this system, you can record 4K video without having to obtain an especially fast memory card for the camera; you can record with no memory card in the camera at all.

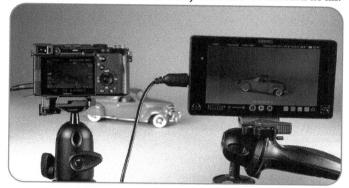

Figure A-34. Atomos Shogun Video Recorder with a7C

The recorder I used for this process is the Atomos Shogun 4K recorder. In Figure A-34, the recorder is mounted to the side of the a7C, on a Manfrotto accessory arm, model number 131DDB. combination of a7C and Shogun performed well in producing high-quality 4K video files. The menu system is easy to work with and the recorder produces highquality files. At the highest quality, the files can be extremely large (more than 220 GB in one of my tests), so be prepared with a strong computer capability for editing. There are more recent 4K video recorders by Atomos and other brands that are less expensive, but I have not tested any of those with the a7C camera.

Appendix B: Quick Tips

his section includes tips and facts that might be useful as reminders. My goal is to provide information that might help you in certain situations or that might not be obvious to everyone. I have tried to include points you might not remember from day to day, especially if you don't use the a7C constantly.

Use continuous shooting settings. Consider turning continuous shooting on as a matter of routine, unless you are running out of storage space or battery power, or have another reason not to use it. Even with portraits, you may get the perfect expression on your subject's face with the fourth or fifth shot. Call up drive mode, scroll to continuous shooting, and select it. Continuous shooting is incompatible with the Picture Effect setting of Rich-tone Monochrome, interval shooting, and Auto HDR.

Use autofocus and autoexposure with continuous shooting. With the a7C, you can do high-speed continuous shooting, even with File Format (Still Images) set to Raw, and still have the camera adjust focus and exposure for each shot. To do that, after turning on continuous shooting through the drive mode menu, set focus mode to AF-C for continuous autofocus. For exposure adjustments, go to screen 9 of the Camera Settings1 menu and set AEL w/Shutter to Auto or Off. To maximize the camera's ability to focus sharply, go to screen 4 of the Camera Settings1 menu and set Priority Set in AF-C to AF.

Use shortcuts. You can speed up access to many settings by placing them on the Function menu for recall with a press of the Function button. You can assign your most-used settings to a control button using the Custom Key (Still Images) and Custom Key (Movies) options on screen 9 of the Camera Settings2 menu. Speed through the menus by using the control wheel to move rapidly through the items on each screen, and use the Right and Left buttons or the

control dial to move through the menu system a full screen at a time. Use the Function button to move quickly from one menu system to another.

Use the Register Custom Shooting Settings option to recall settings quickly. This powerful feature lets you call up temporarily a group of basic shooting settings, including shutter speed, aperture, ISO, focus mode, and others, at the press of one button. To use this feature, go to the Register Custom Shooting Settings item on screen 3 of the Camera Settings1 menu, and register a group of settings to Recall Custom Hold 1, 2, or 3. Then go to the Custom Key (Still Images) option on screen 9 of the Camera Settings2 menu and assign a control button to the Recall Custom Hold slot you chose.

Use the Memory Recall shooting mode. Having three numbered MR positions on the mode dial gives you a powerful way to customize the a7C by storing seven groups of settings. You also can use the Memory Recall mode for more specific purposes. One thing I like to do is have one slot set up to remove all "special" settings, such as Creative Style, Picture Effect, Picture Profile, and drive mode, so I can quickly set up the camera to take a shot with no surprises. Details are in Chapter 3.

Use the extra settings for white balance and Creative Style. When you set white balance, even with the Auto White Balance setting, you can press the Right button to use the amber-blue and green-magenta axes to further adjust the color of your shots. This setting is not obvious on the menu screen, but it gives you a useful tool to alter color settings. Just remember to undo any color shift when you no longer need it. Also, you can press the Right button or turn the control dial after selecting a Creative Style option and then adjust the contrast, saturation, and sharpness settings. (Saturation is not adjustable for the Black and White or Sepia setting.)

Use the touch screen features. These are summarized in Chapter 6, in the discussion of the LCD screen. You

Appendix B: Quick Tips | 249

can tap to choose a focus point when shooting stills or movies. You can tap the screen twice to enlarge it in playback mode, and you can also tap twice to enlarge it when shooting stills or movies in manual focus mode. You can turn on the Touch Shutter function, which lets you take still images by just tapping the LCD monitor.

Use the self-timer to avoid camera shake. The self-timer is not just for group portraits; you can use the two-second or five-second self-timer whenever you use a slow shutter speed and need to avoid camera shake. It also is useful for macro photography. Don't forget that you can set the self-timer to take multiple shots, which can increase your chances of getting a number of usable images.

Be aware of conflicting settings. There are times when a feature will not operate because a conflicting setting is in place. One excellent feature of the a7C is that it often will explain the conflict when you try to select the feature. For example, if you have Picture Effect turned on and then try to select Creative Style, when you press the Center button to select it, the a7C will display an error message about the conflict. There are many such conflicts; one is that you cannot take still images when the mode dial is set to Movie or S & Q Motion mode. Also, the Control with Smartphone option on screen 1 of the Network menu, when turned on, interferes with items such as PC Remote on the same menu screen.

Use Flexible Spot for the focus area setting. With this option, you can move the focus frame around the display. To use the feature most efficiently, set the Center button or one of the other control buttons to Focus Standard with the Custom Key (Still Images) menu option. Then, just press the assigned button in shooting mode to make the focus frame movable. You also can drag the frame with your finger if Touch Operation is enabled through screen 2 of the Setup menu.

Touch Tracking works where the Tracking settings for focus area do not. The Tracking settings for focus area are not available for use with video recording on the a7C or with any setting for focus mode other than continuous autofocus. However, the Touch Tracking setting works with video recording and with all focus mode settings other than manual focus. To use Touch Tracking, turn on Touch Operation on screen 2 of the Setup menu and turn on Touch Tracking through the

Function of Touch Operation item on screen 10 of the Camera Settings2 menu.

Take advantage of functions available only by assigning a button. The a7C has several features that do not appear on any menu and that can be used only if you use the Custom Key options on screen 9 of the Camera Settings2 menu to assign them to a button. These include AEL Hold or Toggle; AF/MF Control Hold or Toggle; Recall Custom Hold; Register AF Area Hold; AF On; In-camera Guide; Focus Hold; FEL Lock Hold or Toggle; Tracking On; My Dial Settings; and others. Also, Eye AF, when assigned to a button, is more powerful in some ways than the Face/Eye Priority in AF setting available on the Camera Settings1 menu.

Use DMF for focusing. Set focus mode to DMF for direct manual focus. Then you can use autofocus, but still turn the focusing ring for further adjustments with manual focus. You have to half-press the shutter button to adjust the focus when DMF is in effect. If you set focus mode to DMF when recording video, the camera will use continuous autofocus. DMF is not available with all lenses.

Use Auto ISO in Manual exposure mode. Not all cameras allow this. With this setting, you can set aperture and shutter speed as you want for a particular effect, and let the camera adjust the exposure by setting the ISO automatically. This works when shooting either still images or movies.

Try time-lapse photography. With time-lapse photography, the camera takes a series of still images at regular intervals, several seconds, minutes, or even hours apart, to record a slow-moving event such as the rising or setting of the moon or sun or the opening of a flower. The images are played back at a much faster rate to show the whole event unfolding quickly. You can do time-lapse photography using the Interval Shooting Function option on screen 3 of the Camera Settings1 menu, or with the interval-shooting features of Sony's Imaging Edge/Remote software when the a7C is tethered to a computer.

Use the self-timer for bracketed exposures. To do this, use the Bracket Settings option on screen 3 of the Camera Settings1 menu and select the first sub-option, Self-timer During Bracket.

Use the camera's automatic HDR option. To do this, go to screen 11 of the Camera Settings1 menu, select DRO/Auto HDR, then Auto HDR. You cannot use certain other settings with Auto HDR, including Raw for File Format (Still Images), Picture Effect, or Picture Profile.

Use the Picture Profile feature to full advantage. If you are serious about getting the maximum benefit from the Picture Profile feature, especially PP7, PP8, and PP9 with their use of the S-Log2 and S-Log3 gamma curve settings, or PP10 with its use of an HLG setting, you need to use color-grading software. A good software package can take advantage of the profiles and bring out the colors, contrast, and other aspects of your video files in the way you intend. One powerful program is DaVinci Resolve 17, which is available in a free version as well as a professional one. See https://www.blackmagicdesign.com/products/davinciresolve.

Use tethered shooting. On screen 1 of the Network menu, choose the PC Remote Function option. Then use a USB-C cable to connect the camera to a computer that has Sony's Imaging Edge software installed, and run the Remote module of that software. Using the icons in the window that appears on the computer, you can control several settings on the camera and capture images directly to the computer. You can do time-lapse shooting with the software's built-in interval timer. You also can connect the camera to the computer wirelessly using the camera's own Wi-Fi network or a Wi-Fi access point that both the camera and the computer are connected to. Details are in Chapter 10.

Capture images of birds. The a7C, with its excellent autofocus and continuous-shooting features, well suited for photographing birds. Here are some suggested settings to start with. Some of them can be saved to a Recall Custom Hold slot, as discussed earlier in the Quick Tips section. Use Spot metering, with the Standard or Large setting for the spot size, depending on how large the subject is. Use continuous shooting, with high speed or medium speed. Set focus mode to AF-C and AEL w/Shutter to Auto on screen 9 of the Camera Settings1 menu. Use Shutter Priority mode with ISO Auto with shutter speed set to 1/1000 second or faster. Set focus area to Tracking: Flexible Spot S. For another perspective on this sort of shooting see the following link: https://petapixel.com/2017/11/25/tipsphotographing-birds-flight/.

Figures B-1 through B-3 are examples I captured using continuous shooting. I used the Sony FE 100-400mm f/4.5-5.6 GM OSS lens with high-speed continuous shooting turned on. The shutter speed was 1/500 second or faster, and the ISO rose as high as 5000 for some images.

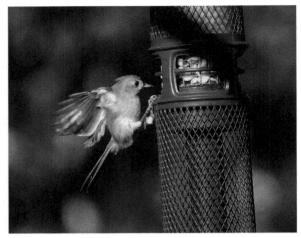

Figure B-1. Bird Example 1: 1/2000, f/5.6, ISO 1250

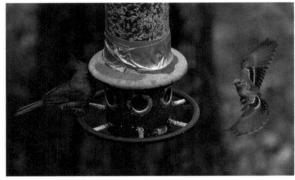

Figure B-2. Bird Example 2: 1/500, f/5.6, ISO 3200

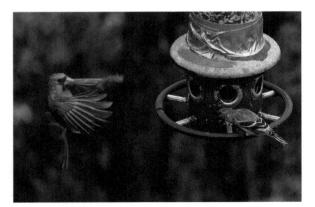

Figure B-3. Bird Example 3: 1/500, f/5.6, ISO 5000

Use the Photo Capture option to save a frame from a 4K video. This feature is not all that obvious, but it can yield excellent results as another way to get shots of

Appendix B: Quick Tips 251

elusive birds and other wildlife, among other subjects. Put the camera into Movie mode with File Format set to XAVC S 4K and Exposure Mode (Movies) set to Shutter Priority. Set the shutter speed to a high value, such as 1/1000 second or faster. Record a movie of birds in flight or another subject with lots of motion. When you have finished, use the Photo Capture option on screen 2 of the Playback menu to find and save some of the best frames from the movie as individual images. Because of the fast shutter speed, the shots should not suffer from motion blur. Figures B-4 and B-5 are examples of shots saved with the Photo Capture option. Figure B-4 was taken from a movie recorded through a spotting scope, as discussed in Chapter 10.

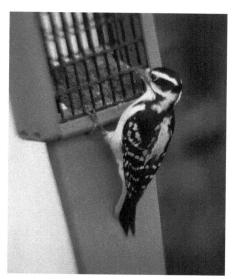

Figure B-4. Photo Capture Image 1: 1/2000, Digiscoping, ISO 20000

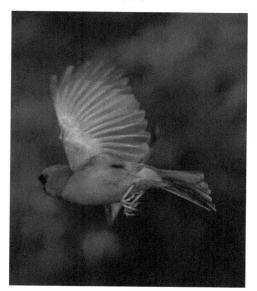

Figure B-5. Photo Capture Image 2: 1/2000, f/5.6, ISO 25600

Use the Imaging Edge Mobile app or a Bluetooth remote to control the camera remotely for Bulb exposures. The general procedure for remote control using the app is discussed in Chapter 10. To use the Bulb setting for shutter speed, move the camera's mode dial to the M position for Manual exposure and connect it to your smartphone using the Control with Smartphone option on screen 1 of the Network menu. On the smartphone's screen, set the shutter speed to Bulb, then use the Bulb icon in the app by sliding it to the side and holding it there for the duration of the exposure, as shown in Figure B-6. You also can use one of the Sony Bluetooth remote controls for this purpose; they are discussed in Chapter 10 and Appendix A.

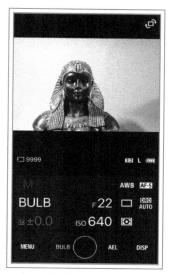

Figure B-6. Screenshot of Bulb Shooting Screen in Imaging Edge Mobile App

Appendix C: Resources for Further Information

Websites and Videos

It's impossible to compile a list of sites that discuss the a7C that will be accurate far into the future. I will include here a list of some sites or links I have found useful, with the caveat that some of them may not be accessible by the time you read this.

DIGITAL PHOTOGRAPHY REVIEW

Listed below is the current web address for the "Sony Alpha Full Frame E-Mount Talk" forum within the dpreview.com site. Dpreview.com is one of the most established and authoritative sites for reviews, discussion forums, technical information, and other resources concerning digital cameras.

https://www.dpreview.com/forums/1064

Reviews and Demonstrations of the A7C

The links below lead to reviews or previews of the a7C by dpreview.com, photographyblog.com, and others.

https://youtu.be/X6N1XDs3jyo

https://www.dpreview.com/reviews/sony-a7C-review

https://www.imaging-resource.com/PRODS/sony-a7C/sony-a7CA.HTM

https://www.cameralabs.com/sony-a7c-review/

https://www.photographyblog.com/reviews/sony_a7C_review

https://www.pcmag.com/reviews/sony-a7c

https://www.pocket-lint.com/cameras/reviews/sony/154286-sony-a7c-review

https://www.thephoblographer.com/2020/09/15/using-the-sony-a7c-with-leica-m-mount-lenses-is-anoverdue-dream/

WHITE KNIGHT PRESS

My own site, White Knight Press, provides updates about this book and other books, offers support for download of PDFs and ebooks, and provides a way for readers or potential readers to contact me with questions or comments.

http://www.whiteknightpress.com

OFFICIAL SONY SITES

The United States arm of Sony provides resources on its website, including the downloadable version of the user's manual for the a7C and other technical information.

http://esupport.sony.com

https://www.sony.com/electronics/support/e-mount-body-ilce-7-series/ilce-7c

https://www.sony.com/electronics/support/e-mount-body-ilce-7-series/ilce-7c/manuals

https://helpguide.sony.net/ilc/2020/v1/en/index.html

https://www.sony.com/electronics/support/e-mount-body-ilce-7-series/ilce-7c/downloads

https://www.sony.com/electronics/support/e-mount-body-ilce-7-series/ilce-7c/specifications

https://www.sony.com/electronics/interchangeablelens-cameras/ilce-7c

The link below has a list of software that Sony says can be used to edit 4K video files:

http://support.d-imaging.sony.co.jp/www/support/application/nle/en.html

The link below leads to Sony's listing of lenses compatible with the a7C body, as of October 2020:

https://support.d-imaging.sony.co.jp/www/cscs/lens_body/index.php?mdl=ILCE-7C&area=gb&lang=en&id=hg_stl

The next link is to a guide for using the Picture Profile feature with the a7C:

http://helpguide.sony.net/di/pp/v1/en/index.html

The link below is to the operating instructions for the Imaging Edge Mobile app for Android and iOS:

http://support.d-imaging.sony.co.jp/www/disoft/int/playmemories-mobile/en/operation/index.html

The link below leads to a site with information about using the location information linking features of the camera with the Imaging Edge Mobile app:

http://support.d-imaging.sony.co.jp/app/iemobile/en/instruction/2_1_location.php

The next link points to a page with information about Sony accessories.

http://support.d-imaging.sony.co.jp/www/cscs/accessories/?area=gb&lang=en

The link below leads to the site where you can download PlayMemories Home and Imaging Edge software for use with the a7C:

https://support.d-imaging.sony.co.jp/app/disoft/en/

The link below has instructions for using the Remote module for tethered shooting with Imaging Edge software:

http://support.d-imaging.sony.co.jp/app/imagingedge/en/instruction/

The link below has information about the S-Log settings for Gamma used with the Picture Profile feature:

https://www.sony.com/electronics/support/articles/00145908

OTHER RESOURCES

The link below leads to an excellent video on the use of SteadyShot settings on camera bodies and lenses.

https://www.markgaler.com/sony-steadyshot-settings

The link below points to a video review of the a7C:

https://youtu.be/yVpLoNYeG0E

This next link leads to a video discussion of the a7C being used with the Atomos Ninja V video recorder:

https://youtu.be/odjZvfA-v68

The link below provides a detailed analysis of the differences between S-Log2 and S-Log3.

http://www.xdcam-user.com/2016/12/the-great-s-log2-or-s-log3-debate/

The next link is to a video comparison of the a7C and the Sony a7 III:

https://youtu.be/yVpLoNYeG0E

The link below is to an article on why you might want to record video using an external video recorder:

https://www.dpreview.com/articles/3388025881/whywould-i-want-an-external-recorder-monitor

The link below provides information about settings that can be adjusted for Picture Profiles:

http://www.xdcam-user.com/picture-profile-guide/

The links below provide information about lenses available for Sony E-mount cameras such as the a7C:

https://www.alphashooters.com/e-mount-lenses/

https://briansmith.com/aps-e-mount-lenses-for-sony-mirrorless-cameras/

https://thewirecutter.com/reviews/first-sony-e-mount-lenses-to-buy/

https://www.dpreview.com/reviews/buying-guide-best-lenses-for-sony-mirrorless

https://www.digitalcameraworld.com/buying-guides/the-best-sony-lenses

Index

AF Transition Speed menu option 106, 153, 198

Symbols	using to change speed of pull focus effect 153, 206
5) III 515	AF w/Shutter menu option 66, 143
4K Output Select menu item 181-182, 203, 211	using with back button focus 128
4K video	Airplane Mode menu item 217, 229
in general 195–196	Animal Eye Display menu option 64
using as a type of continuous shooting 211	Anti-Flicker Shooting menu option 104
24p, 30p, 60p, and 120p video frame rates 196-197	Aperture
24p/60p Output menu option 180	availability of settings when using zoom lens 25
120p and 100p video formats	range of available settings
incompatibility with other settings 197	effect of focal length on 25
	relationship to depth of field 23-24
A	Aperture Drive in AF (Still Images) menu option 65-66
AC adapter	Aperture Preview option for control button 131
optional type for powering camera through battery compart-	Aperture Priority exposure mode for movies 193-194
ment 155, 239–240	Aperture Priority mode 23–25
Sony AC-UUD12 4, 239	APS-C/Super 35mm menu option 39-40, 236
Sony NPA-MQZ1K Multi Battery Adaptor Kit 240	using with lens designed for APS-C sensor 236
Tether Tools Case Relay external power system 239-240	reduction in image resolution from 236
Access lamp 12, 154	using with lens for full-frame camera attached 40
behavior during continuous shooting 44	Area Setting menu item 183–184
Access Point Settings menu option 230	Aspect ratio menu item 38–39
Adobe Bridge software	relationship to JPEG Image Size menu item 37
viewing location information with 226	Asterisk indicating autoexposure lock 29
Adobe Camera Raw software 35, 91	Astrophotography 234
Adobe Photoshop software	Atomos Shogun video recorder 196, 210–211, 247
using to process HDR images 88-89	controlling from a7C camera 181
Adobe Premiere CC software 211	recording video to 182, 210–211
AEL Hold option for control button 128–129	Audio Level Display menu option 107, 199, 200
AEL Toggle option for control button 128	Audio Out Timing menu option 107, 200
AEL w/Shutter menu item 76, 143	Audio Recording Level menu option 106, 199, 203
using with continuous shooting 43, 76	Audio Recording menu item 106, 199
AF Area Auto Clear menu item 67	Audio Signals menu item 142
AF Area Registration menu item 66–67	using to silence self-timer 45
AF Frame Move Amount menu option 68	Auto Area Adjustment menu option 231
AF Illuminator menu item 11, 64, 155	Autoflash setting 77–78
AF Illuminator/Self-timer Lamp 11, 64, 155	Autofocus
controlling operation of 64	using while in manual focus mode 126
AF in Focus Magnifier menu option 101, 102	Autofocus point
AF/MF Control Hold option for control button 125–126	zooming in on in playback mode 165
using for back button focus 125	Auto ISO setting setting minimum and maximum values for 71–72
AF/MF Control Toggle option for control button 57, 126	
AF Micro Adjustment menu option 68–69	setting minimum shutter speed for use with 72–73
AF-ON button 145	using with Manual exposure mode 28, 72, 249
general functions of 11	using with Manual Exposure Mode setting for movies 195
AF On option for control button 128	Automatic AF setting 15, 54 Auto Power Off Temperature menu item 174–175
AF Subject Shift Sensitivity menu option 106, 198	Auto Review menu item 121–122, 156
AF Tracking Sensitivity (Still Images) menu option 65	Auto Review menu item 121-122, 130

deleting an image in Auto Review 122

Auto Slow Shutter menu item 106, 198–199	Lowepro Passport Sling 238
works only when Auto ISO is in effect 199	Ruggard Hunter 25 Holster Bag 238
Auto Time Correction menu option 231	Catalyst Browse software
Auto Transfer When Shot menu item 228	using to stabilize recorded movies 215
AverMedia video capture device 181	Center button 150
Av/Tv Rotate menu item 139	assigning a function to 133
AWB Lock Hold option for control button 100, 130	Focus Standard setting for 150
AWB Lock Toggle option for control button 100, 130	general functions of 11, 150
В	using to adjust location of Flexible Spot focus frame 150
В	using to determine reason for setting conflict 249
Back button focus feature 66, 125, 128	using to expand or collapse group of continuous shots 44
Battery	using to magnify focus area 150
charging 3-4	using to mark or unmark images for Playback menu options
indicator light 4	150
time for full charge 4	using to play a video 150
generic replacement 238-239	using to return enlarged image to normal size 150, 157
iinserting into camera 4	Center option for focus area 59–60
Sony NP-FZ100 3, 238, 240	distinguishing focus frame from Spot metering circle 74
Battery charger	using to focus on off-center subject 60
generic external charger 238	Center option for metering mode 74, 75
Sony AC-UUD12 4, 239	Charge lamp 12, 154
using as external power source 3-4, 239	behavior during charging of battery 4
Battery compartment 12, 155	Chromatic Aberration Compensation 41–42
flap in door for AC adapter cord 12, 155	Circulation of Focus Point menu option 68
Birds	Clean HDMI signal output 12, 154, 181
photographing 250–251	Clear Image 7 com 110 113
Bit rates of video formats 196	Clear Image Zoom 110–113
Black and white	Color Depth 99 Color Mode 99
Picture Profile setting for 99	Color Phase 99
shooting in 90, 93, 94, 95	
Black Gamma 99	Color Space menu item 41 Color temperature
Black Level 98	using to set white balance 84
Blackmagic Design video capture device 180	Color temperatures of various light sources 83
Blank screen	Compression of JPEG files 36
selecting for LCD monitor 115	Conflicting settings
Bluetooth Remote Control menu item 231–232, 244	identifying 249
incompatibility with other settings 232	Connect During Power Off menu item 218, 228
Bluetooth Settings menu item 225–226, 231	Continuous AF setting 15, 54–55
Blurred background 23–24 Bokeh 24	only autofocus option available for recording movies 55
	Continuous exposure bracking setting of drive mode. See Ex-
Bracket Order menu option 48 Bracket Settings menu item 47–48, 249	posure bracketing
Bright Monitoring option for control button 131	Continuous Playback for Interval menu option 49–50,
incompatibility with other settings 131	165–166
Bulb setting for shutter speed 28	Continuous Shooting Length menu option 45, 121
incompatibility with other settings 29	Continuous shooting option of drive mode 43–47, 248
using remote control from Imaging Edge Mobile app for 28,	displaying images taken in burst 44, 168
251	displaying indicator showing remaining capacity 121
201	displaying indicator showing remaining capacity for burst
C	45
	display on monitor during 44
Calendar display of images in playback mode 157	incompatibility with other settings 45, 248
Camera Settings1 menu	selecting speed of 43
effects of settings on recording movies 204–206	using autoexposure with 43, 248
Cases for a7C camera	using autofocus with 43, 248
Lowepro Apex 100 AW 238	using flash with 44
Lowepro Apex 110 AW 238	Contrast

adjusting 90-91	DaVinci Resolve software 250
Control dial 10	Day for night movie recording 195
assigning to adjust exposure compensation 140	Daylight Savings Time
changing assignment to aperture or shutter speed 139	adjusting 8, 183, 184
changing rotation direction of 139	Delete Confirmation menu item 173
general functions of 10	Delete menu item 161
locking operation of 141–142	Delete Registered AF Area menu item 67
using to move to other enlarged images 158	Deleting images or videos 159, 161, 173
Control wheel 149–150	Depth of field
assigning a temporary function to 150	relationship to aperture setting 23-24
assigning to adjust exposure compensation 140, 150	Detail (Picture Profile parameter) 99
changing assignment to shutter speed or aperture 139	Dial/Wheel EV Compensation menu option 140, 150
changing rotation direction of 139	Dial/Wheel Lock menu option 10, 141-142, 148
general functions of 11, 150	Dial/Wheel Setup menu option 10, 26, 139, 150
locking operation of 141–142	Digiscoping 234
using for Program Shift 23	Digital Zoom 110–113
using to change magnification of enlarged image 150, 157	Dimmed menu items 33-34
using to move through images in playback mode 150	Diopter adjustment wheel 145
using to set aperture 150	Display as Group menu option 44, 168
using to set shutter speed 150	Display button 11
Control with Smartphone menu item 222-223, 228	using to cycle through display screens 151
incompatibility with other settings 228	Display Button menu item 114-116
Copyright Info menu item 184–185	Display Continuous AF Area menu item 55, 67-68
Counter option for movie recording 178	Display FTP Result menu item 228
Creative Style comparison charts 92	Display Media Information menu item 188
Creative Style menu item 89–93	Display My Menu option for control button 133
adjusting contrast, saturation, and sharpness 90-91, 248	Display Quality menu item 174
descriptions of individual settings 92-93	Display Rotation menu item 161, 169
saving custom settings 91	Display screens
using with Raw images 91	for video recording and playback 213
CTRL for HDMI menu item 181	playback mode 158
Custom/Delete button 10, 149	shooting mode
assigning function to 133	descriptions of 114–115
general functions of 10	selecting with Display button menu item 114
using for In-Camera Guide option 149	Display Wi-Fii Info menu item 230
using to delete images or videos 149, 159	Distortion Compensation menu option 42
using to return movable focus frame to center 149	DMF (direct manual focus) 15, 55, 249
Custom Key (Movies) menu item 134–135, 202	requirement to hold shutter button down halfway with MI
assignments for Center button 135	Assist 55
assignments for Custom button 134–135	Down button
assignments for Down button 135	assigning a function to 134, 151
assignments for Left button 135	using to display index screens in playback mode 11, 151
assignments for Right button 135	using to open movie playback control panel 151
list of possible assignments 134–135	DPOF (Digital Print Order Format) printing 162–163
Custom Key (Playback) menu item 135–136	Drive mode menu 42–47
list of options that can be assigned 136	basic procedure for using 17
Custom Key (Still Images) menu item 122-134, 249	DRO/Auto HDR menu item 86-89
list of items that can be assigned to a button 123–125	incompatibility with other settings 89
Custom white balance	DRO bracketing setting of drive mode 47
how to set 84–85	incompatibility with other settings 47
D	order not affected by Bracket Order menu setting 47, 48
D	using with self-timer 48
Date and Time	DRO (dynamic range optimizer) setting
setting with Setup menu 7–8, 183	effect on Raw images 89
Date Imprint option for printing images 163	Drop-frame time code 179
Date/Time Setup menu item 7–8, 183	Dummy battery
1	using to power camera 239–240

E	using with 4K video recording 65
Edit Device Name menu item 232	Face Priority in Multi Metering menu item 75
Electronic viewfinder 10, 144	Face Registration menu option 104
adjusting brightness of 172	Fadeout
adjusting color temperature 172	in-camera effect for movies 193–194, 194, 195
adjusting frame rate of 116	FEL Lock Hold/Toggle options for control button 129–130
switching between EVF and LCD screen 116, 145	File/Folder Settings (Still Images) menu item 186
Elgato video capture device 180, 181, 227	File Format (Movies) menu option 105, 195–196
Enlarge Image menu item 164–165	File Format (Still Images) menu option 34–36, 114–116
Enlarge Initial Magnification menu item 165	File Name Format (Movies) menu item 187
Enlarge Initial Position menu item 165	File Number (Movies) menu item 187
Enlarging images by pressing AF-ON button 20, 157	File Number (Still Images) menu item 186
Enlarging images by tapping touch screen 20, 153, 158	File Settings (Movie) menu item 187–188
Entire Screen Average option for metering mode 74	Fill-flash setting 78
Epiphan video capture device 180	Finder Color Temperature menu item 172
Expand Flexible Spot setting for focus area 61	Finder Frame Rate menu option 116
Exposure bracketing	Finder/Monitor menu item 116
continuous 46	Firmware 188
using with Manual exposure mode 46	checking for updates 188
incompatibility with other settings 47	displaying version 188
order of bracketed exposures 46	Flash
changing 48	basic procedure for using 16–17
single 46–47	Flash Compensation menu item 80
using flash with 46	Flashing aperture value
using self-timer with 47-48, 249	meaning of 26
Exposure compensation	Flashing areas of image in playback mode
assigning to control wheel or control dial 140	indicating areas of overexposure or underexposure 159 Flashing shutter speed value
limited adjustment range for movies 70, 205, 206-207	meaning of 24
methods for adjusting 68, 144	Flash Mode menu item 77–79
unavailable in Intelligent Auto mode 70	Flash Off setting 77
using with Manual exposure mode 28, 70	Flash synchronization speed 77
Exposure compensation dial 9	Flash triggers
operation of 69, 70, 144	Hensel Strobe Wizard Plus 243
Exposure Compensation menu item 68–69	Sony Wireless Radio Commander, FA-WRC1M 242–243
Exposure Compensation Setting menu option 80	Sony Wireless Radio Receiver, FA-WRR1 242
Exposure Mode (Movies) menu option 105, 192–195	Yongnuo RF603N II 243
Exposure Mode (S & Q) menu option 105, 195, 208	Flash units
Exposure Settings Guide menu item 22, 24, 26, 119	Godox TT350 241
Exposure Standard Adjustment menu item 76–77	LumoProo LP180 243
Exposure Step menu option 24, 75–76	Neewer NW320 241
External Flash Setting menu option 82–83	Sony F60M 81
External LCD monitor	Sony HVL-F20M 80–81, 241
Neewer LCD Field Monitor 245	Sony HVL-F28RM 241
Sony model no. CLM-FHD5 244–245	Sony HVL-F32M 81–82, 241, 242
Eye AF option for control button 127	Sony HVL-F43M 81, 82, 241
compared to Face/Eye Priority in AF menu option 127	Sony HVL-F45RM 241, 242
Eye sensor 10, 145	updating firmware for 82
Eye-Start AF menu option 66, 238	Sony HVL-F60RM 241
F	Flexible Spot option for focus area 60–61, 249
	Focus Area Limit menu option 62–63
Face/Eye AF Settings menu option 64–65	Focus area menu item 58–62
using with tracking autofocus 62	Focus frame
Face/Eye Frame Display menu option 64	changing location of 60–61, 249
Face/Eye Priority in AF menu option 64	quickest ways to make changes 60–61
incompatibility with other settings 65	Focus Frame Color menu option 67
relatiionship to focus area setting 64	Focus Hold button on lens 128

assigning a control button option to 128, 134 Focus Hold option for control button 55, 128	Gamma Display Assist menu item 172–173 Geotagging. See Location information: adding to images using
Focusing	Bluetooth connection
during video recording 206	GPS information. See Location information
general procedures for 15–16	Grid Line menu item 118–119
tracking moving subjects. See Tracking autofocus	Grip, accessory
using touch screen 16	Sony GP-VP2BT 244
Focus Magnification Time menu item 56, 102	John Gi Vizbi Zii
Focus Magnifier menu item 100–102	Н
assigning to control button 102	
cannot be used with continuous autofocus 100	Hauppage video capture device 181
	HDMI cable
compared to MF Assist option 101	using to connect camera to television set 180
different enlargement factors wihen APS-C/Super 35mm	HDMI Information Display menu option 180–181
turned on 101	HDMI Only menu items 181–182
using touch screen with 101, 154, 213	HDMI port 12, 154
using with autofocus 101, 102	HDMI Resolution menu option 180
using with video recording 102, 199, 213	HDMI Settings menu item 180–181
Focus mode menu item 53–57	HDR (high dynamic range) photography 87-90
Focus point	HDR setting in camera 88-89, 250
checking in playback mode 165	incompatibility with Raw format 250
Focus Standard option for control button 60–61, 126, 150	HDR video
Folder Name (Still Images) menu item 186–187	using HLG gamma curves to create 99
Follow Custom (Still Images) option for assignment to control	Headphones jack 12, 154
button 134	Help system 130
Follow Custom (Still Images or Movie) option for control but-	High ISO Noise Reduction menu item 41
ton 136	incompatibility with other settings 41
Format menu item 6–7, 185	Highlight option for metering mode 74, 75
For Viewfinder display screen 114, 147	Histogram
not available for video recording or in Movie or S & Q Mo-	activating in shooting mode 114, 159
tion mode 115	playback mode 158–159
used with Quick Navi system 115	not available for movies 159
Frequncy Band menu item 230	HLG (hybrid log-gamma) setting for gamma curve 99
FTP Function menu item 228	
FTP Power Save menu item 228	I
FTP Transfer Function menu item 220–222, 228	IRIS (in hady image stabilization) 100, 226
FTP Transfer menu item 228	IBIS (in-body image stabilization) 109, 236 using in conjunction with OSS (Optical SteadyShot) 109,
Function button 146–149	236
assigning option to for playback mode 135–136	Icons for menu items for still images or movies 34
general functions of 10	
using to activate Send to Smartphone option 149	Image Index menu item 156, 167–168 Image Jump menu item 169–170
using to navigate through menu screens 146	
using to register AF area 66-67	Image sensor 11
using with Dial/Wheel Lock menu item 141–142	cleaning to remove dust 175
using with Quick Navi system 147–148	resolution of 11
Function menu 146–147, 248	Imaging Edge Mobile app
assigning options to 136–138, 146	using to add location information to images 225–226
list of options that can be assigned to 136–138	using to control camera remotely 222–223
using during video recording 207	using to transfer images to smartphone 217–220
using to adjust settings 146-147	using with Movie Edit add-on 215–216
using to select Exposure Mode (Movies) settings 193	Imaging Edge Software 91
Function Menu Settings menu item 136–138, 146–147	using to control camera from computer 12, 109, 224–225,
Function of Touch Operation menu option 62, 140–141	229
Function Ring (Lens) menu option 140	using to create time-lapse movie 50
C	viewing location information with 226
G	where to download 3
Gamma 98-99	Imaging Edge Webcam software 227

iMovie software 197, 214–215

using as touch pad 153

Import Root Certificate menu item 232	using when lighting is dim 131			
In-Camera Guide option for control button 130	Left button			
Index screens of images in playback mode 156-157	assigning a function to 133, 151			
selecting number of images shown 167–168	Lens Compensation menu item 41–42			
Initial Focus Magnification menu option 100, 102	Lenses			
Initial Focus Magnification (Movies) menu option 106, 199	A-mount category 237–238			
Intelligent Auto Mode 21–22	limitations when used on a7C camera 237-238			
settings unavailable with 21, 62	attaching to a7C camera 3, 155			
Interlaced video formats 196	Compatibility with a7C camera 238			
Internal memory	E-mount category 235–237			
lack of for Sony a7C 4	for APSC-C camera			
Interval shooting by remote control from computer 225	attaching to a7C camera 39-40			
Interval Shooting Function menu option 48–50	for APS-C sensor cameras 235–237			
incompatibility with other settings 50	for full-frame sensor cameras 235			
IPTC Information menu item 184 ISO	for Super 35mm camera 40			
	Meike MK-6.5mm f/2 Circular Fisheye Lens for Sony E 237			
basic procedure for setting 71–72	Sigma 16mm f/1.4 DC DN Contemporary Lens for Sony E			
effect of setting in Manual exposure mode 27, 72	237			
minimum setting of 500 for some Picture Profile settings 72 native settings 72	Sigma 35mm f/1.4 DG HSM Art Lens for Sony E 237			
range of available settings 71	Sony 50mm f/1.4 237			
how to limit 72	Sony DT 50mm f/1.8 SAM 237			
range of available settings for movies 99–100, 205	Sony E 16mm-50mm f/3.5-5.6 PZ OSS 236			
setting minimum and maximum values for Auto ISO 71–72	Sony E 18 135 mm f/2.8 236			
ISO Auto Minimum Shutter Speed menu item 72–73	Sony E 18-135mm f/3-f/5.6 235–236			
ISO menu option 71–72	Sony EF 28 60mm f/4 G OSS 236			
ISO Range Limit menu option 72	Sony FE 28-60mm f/4-5.6 9–10, 235 minimum focus distance of 10			
relationship to Auto ISO setting 72	retractable feature of 10–11			
ISO Setting menu option 71–73	Sony FE 100mm-400mm f/4.5-5.6 GM OSS 109, 235			
	Sony FE 400mm f/2.8 GM OSS 140			
J	Lens mount 11, 155			
JPEG images 35–38	Lens Mount Adaptor			
JPEG Image Size menu item 37–38	Sony LA-EA3 237			
relationship to Smart Zoom feature 113	Sony LA-EA4 237			
JPEG Quality menu item 36–37	Sony LA-EA5 237			
effect on number of images that fit on memory card 38	Lens release button 11, 155			
of mages that he on memory card 50	Level display screen 115			
K	Live View Display menu item 25, 26, 27, 120			
Volvin units of colors and one	forced to Setting Effect On in some shooting modes 121,			
Kelvin units of color temperature 83 Knee 99	194, 213			
Kilee 99	using when using external flash units 120, 242			
L	Location information			
	adding to images using Bluetooth connection 225-226			
Language	viewing 226			
selecting on Setup menu 8	Location Information Link Setting menu option 226, 231			
Language menu item 8, 183	Locations of still images and videos on memory card 197			
Large focus frame	Locking focus 54, 55			
indicating focusing difficulty or non-optical zoom 113	Locking operation of control wheel and control dial 141-142			
LCD monitor 151–154	Long Exposure Noise Reduction menu item 29, 40-41			
ability to rotate up, down, or 180 degrees forward 151–152	incompatibility with other settings 40			
adjusting brightness of 171–172	M			
in general 11, 151	M			
setting information display screens for 114–116	MAC address			
switching between LCD screen and EVF 116	displaying 230			
touch features of 11, 58, 152–154, 248–249	Manual exposure mode 26–29			
turning off with Monitor Off display screen option 114, 115	using Auto ISO setting with 28–29, 249			

using Auto ISO setting with 28-29, 249

using exposure compensation with 28	Sony XLR-K2M 246
using for HDR photography 29	Minimum shutter speed
using for silhouettes 29	setting for use with Auto ISO 72–73
Manual Exposure mode for movies 194–195	M.M. icon for metered manual value 27
using Auto ISO with 195	Mode dial 9, 143–144
Manual focus 16, 55–57	effects of shooting mode on recording movies 202–204
focusing aids 55–57	Monitor Brightness menu item 171–172
using autofocus while in manual focus mode 126	Monitor Off display screen option 114, 115
Manual Shift feature 29, 128	Mophie PowerStation XL portable USB battery 240
Marker Display menu item 107, 200, 203	Movie button 9, 144
Marker Settings menu item 107, 200–201	assigning a function to 144
Megapixels	limiting operation to Movie mode 191
used in measuring image size 37	Movie Edit add-on app
Memory buffer	using to stabilize recorded movies 215–216
	Movie option for control button 131
icon on display with continuous shooting 44	Movie position on Mode dial
Memory Card + HDMI menu option 181	
Memory cards	reasons for using 203 Movies
capacity for storing images and videos 37–38	
formatting in camera 6–7	editing 20, 214–216
inserting into camera 6	playback 213–214
micro SD cards 5	recording
operating camera without card 182, 196	adjusting sound level 199
Sony Memory Stick cards	basic procedure 18–19, 192–193, 211–212
incompatible with a7C camera 5	focus modes available for 206
special requirements for video recording 5–6, 18, 191, 196, 197	functions that work from control buttons during video recording 207–208
types of 5-6	location of files 197
Memory card slot 12, 154	time limits 19, 192
Memory menu item 30–31, 51	to external video recorder 182, 200, 209-211
Memory Recall mode 29-31, 50-51, 248	Movies & TV software for Windows 197, 214-215
recalling saved settings 50–51	Movie w/Shutter menu item 108, 143, 202
Menu button 10, 145–146	Multi Interface Shoe 9, 144, 241
assigning different button to its function 32, 145	Multi option for metering mode 74
using to return enlarged image to normal size 145	My Dial 1 2 3 During Hold options for control button 131-
Menu items	132
dimmed because of conflicting settings 33-34	My Dial 1-2-3 option for control button 132
preceded by icons: stills, movies, etc. 34	My Dial Settings menu option 10, 131–132, 138–139, 150
MENU option for assignment to control button 132–133	using to move AF frame 68
Menus	My Menu 189–190
listing of 32	adding items to 189–190
navigating through 13, 32-33	
Metering Mode menu item 73-75	N
MF Assist menu item 56, 101, 102–103	Naturally many 227 220
compared to Focus Magnifier option 56, 101, 103	Network menu 227–230
need to press shutter button halfway when using with DMF	New Folder menu item 186
103	NFC (resp. field some graphication) material 154
not available for movies or when using Mount Adaptor 56,	NFC (near field communication) protocol 154
213	using to connect camera to Android device 219–220
Microphone, built-in 12, 155	NO CARD warning message 4, 108–109
Microphones, external	Non-drop-frame time code 179
jack for plugging into camera 12, 154	selecting 179
Rode VideoMic Pro 246	Non-optical zoom range 110–113
Sony ECM-B1M 245–246	Not Set option for assignment to control button 133
Sony ECM-CG50 246	NTSC/PAL Selector menu item 175
Sony ECM-GZ1M 245	0
Sony ECM-W1M 245	· ·
Sony ECM-XYST1M 245	On/off switch 143
,	

	Optical zoom 110–113	Power Save Start Time menu item 174
	OSS (Optical SteadyShot) 109, 236 Overheating of camera 174	Power zoom (PZ) lens 111, 113, 236
	Overheating of camera 1/4	reversing rotation direction of zooming with 113
	P	Pre-AF menu item 66, 128
	D : : (D)	using with Touch Focus 141
	Pairing (Bluetooth Settings) menu option 231	Printing images directly to printer 162–163
	Pairing (PC Remote) menu item 229	Priority Set in AF-C menu option 57–58
	PC Remote Connect Method menu item 229	effect on continuous shooting performance 43, 57–58
	PC Remote Function menu option 229	Priority Set in AF-S menu option 57
	PC Remote menu item 229, 250	Priority Set in Auto White Balance menu item 86
	PC Save Image Size menu item 229	Program Auto exposure mode for Movies 193 Program mode 22–23
	Peaking Color menu item 57, 103 Peaking Display menu option 56, 103	Program Shift feature 22–23
	Peaking Level menu item 56, 103	not available for movie recording 213
	Peaking Setting menu item 56, 103	Progressive video formats 196
	using with DMF 103	Protect menu item 160–161
	Phase detection autofocus points 43	Proxy Recording menu item 106, 197
	Phase detection autofocus system	location of proxy files 197
	limits on compatible aperture settings 43	Pull focus effect for movie recording 128, 153, 198, 206
	Photo Capture menu item 164, 211, 234	
	using for bird photography 250-251	Q
	Photomatix software 89	Quick Navi system 115, 147-148
	Picture Effect menu item 93–95	Quick (vavi system 113, 147–146
	comparison chart 95	R
	descriptions of individual settings 94-95	P. d
	incompatibility with other settings 93	Rating menu item 161–162
	using for movies 205	Rating Set (Custom Key) menu item 162
	Picture Profile menu item 96–100, 250	Raw + JPEG Save Images menu option 229
	adjusting parameters for a Picture Profile 98-99	RAW + JPEG Transfer Target menu item 228
	assigning to a control button for movie recording 205	Raw File Type menu option 36 Raw format 34–36
	characteristics of 10 preset options 96–97	advantages and disadvantages of 34–36
	comparison chart 97	compressed vs. uncompressed type 36
	effect of setting on Raw images 99	correcting images taken with bad camera settings 35
	incompatibility with other settings 99	incompatibility with other settings 35–36
	minimum ISO values for some settings 99	size of files 35–36
	using S-Log or HLG settings for increased dynamic range in movie recording 98–99	Raw & JPEG option for File Format (Still Images) 36
	Picture Profiles comparison chart 97	Rear Sync flash setting 79
	Playback	Recall Custom Hold options for control buttons 51–53, 125
	images shot with continuous shooting 44, 168	248
	jumping through images quickly by numbers or other op-	Recall menu item 50–51
	tions 169–170	Rec Control menu option 181
	movies	not always available for use 211
	basic procedure 20, 213–214	Record Setting menu option 105, 196–197
	changing volume 173, 214	Recover Image Database menu item 188
	selecting still images or videos to view 166-167	Red Eye Reduction menu item 82
	still images	incompatibility with other settings 82
	basic procedures 19-20, 156	Register Custom Shooting Settings menu option 51–53, 248
I	Playback button 10, 149	Registered AF Area Hold option for control button 67, 126
I	Playback menu 159–170	Registered AF Area Toggle option for control button 67, 126
I	Playback option for assignment to control button 132	Registered Faces Priority menu option 104
I	Playback Speed for Interval Shooting menu item 165–166	Release without Card menu item 4, 108–109
I	PlayMemories Home software 215	Release without Lens menu option 108, 234
	using to create time-lapse movie 50	Remaining Images or Video Recording time
	viewing location information with 226	displaying 188 Remote control devices
	where to download 3, 215	TEMPORE CONTROL GEVICES

JJC BTR-S1 244

list of 21 Sony GP-VPT2BT 110, 231-232, 244 Shot Result Preview option for control button 131 Sony RMT-P1BT 110, 231-232, 244 Shoulder strap Remote control of camera from computer 223-225 using to save images with no memory card in camera 109 attaching to a7C camera 3 Shutter Auto White Balance Lock menu option 100 Remote control of camera from smartphone or tablet 222-Shutter button 9, 143 223 pressing halfway to focus during movie recording 206 Reset EV Compensation menu option 70-71 Shutter Priority exposure mode for movies 194 Reset Network Settings menu item 232 Shutter Priority mode 25-26 Resetting camera settings 189 Shutter speed Resetting network SSID and password 230 Bulb setting for. See Bulb setting for shutter speed Resolution of still images 37-38 range of available settings 22, 24, 25, 28 Right button range of available settings for movies 193, 194, 195 assigning a function to 134, 151 Silent Shooting in Interval option for Interval Shooting Func-Right/Left Eye Select menu option 64 tion 49 Rotate menu item 161, 169 Silent Shooting menu option 108, 142 S incompatibility with other settings 108 Single exposure bracketing setting of drive mode 46-47 Saturation Single shooting setting for drive mode 42 adjusting 90-91 Single-shot AF setting 15, 53-54 Saturation (Picture Profile parameter) 99 Slide Show menu item 166 Save/Load FTP Settings menu item 228 Slow and Quick Motion Recording 208-209 Saving frame from movie in camera 164 Slow-motion video 208-209 Saving settings with Memory Recall mode 29-31 creating using 60p or 120p setting 197 Scene recognition feature 21-22 Slow Sync flash setting 78-79 Security (IPSEC) menu item 232 Smartphone or tablet Sekonic C-700 color meter 84 controlling camera with 222-223 Select REC Folder menu item 185 transferring images and videos to 217-219 Self-timer (Continuous) setting of drive mode 45-46, 249 Smart Zoom 110-113 using to take multiple shots 45 Sony alpha a7C camera Self-timer During Bracket menu option 48, 249 disadvantages of 1 Self-timer setting of drive mode 45 features of 1 basic procedure for using 45 items supplied with in box 3 incompatibility with other settings 45 Sony Bravia HDTV 181 silencing beeps 45 Sony DT 16-50mm f/2.8 SAM 237 using for closeup photography 45 Sony FE 50mm f/2.8 Macro 235 using with exposure bracketing 47-48 Sony FE 85mm f/1.8 235 Sending images to a computer using FTP 220-222 Sony HVL-LBPC video light 201, 202 Sending images to a smartphone 217-220 Sony ILCE-7C camera. See Sony alpha a7C camera Sending Target menu option 228 Sony Mount Adaptor. See Lens Mount Adaptor Send to Smartphone Function menu item 217-218, 227-228 Sony Shoe Adapter, ADP-MAA 241 Send to Smartphone menu option Sony user's guide for a7C camera activating with Function button 149, 218 where to download 3 Sensor plane indicator 9, 144 Sony Wireless Radio Commander 82 Serial number of camera updating firmware for 82-83 recording with images 185 Sony Wireless Radio Receiver 82 Series Counter Reset (Movies) menu item 187 Sounds made by camera Server Setting menu item 228 silencing 108, 142 Set File Name (Still Images) menu item 186 Speaker Setting Reset menu item 189 location of 9, 144 Setup menu 171-189 Specify Printing menu item 162-163 Shading Compensatiion menu option 41 Spot AEL Hold option for control button 129 Sharpness Spot AEL Toggle option for control button 129 adjusting 90-91 Spot focus for movie recording 141, 153, 206 Shooting Iinterval Priority option for Interval Shooting Func-Spot Metering Point menu item 75 tion 49 Spot option for metering mode 74, 75 Shooting modes distinguishing spot circle from focus frame 74

TC Format menu option 179

TC Preset menu option 178-179

TC Make menu option 179
TC Output menu option 181

linking spot circle to movable focus frame 74, 75 TC Run menu option 179 Spotting scope, connecting camera to 234 TC/UB Display Setting menu option 178, 203 S & Q Settings menu option 105, 197, 209 TC/UB Settings menu item 177-179 SSID/PW Reset menu option 230 unavailable in certain shooting modes 177 Stabilizing movies using software 215–216 Telescope, connecting camera to 234 SteadyShot menu item 109 Temperature of camera SteadyShot Settings menu option 109 regulating with menu option 174-175 Step-by-step guides Tethered shooting 154, 223-225, 250 adding location information to images 225-226 Time code connecting with NFC 219 in general 177 creating time-lapse movie with Interval Shooting Function options for displaying and recording 178, 179 option 48 Time-lapse movie 249 sending images to a smartphone 217-218 creating using Sony software 50 sending images to computer using FTP Transfer function using Interval Shooting Function option for 48-50, 249 220-221 using remote control of camera from computer for 225, 249 Slow and quick motion recording 208-209 Time zone taking pictures in Auto mode 13-14 selecting 183-184 using a Bluetooth remote control 231 Title Name Settings (Movies) menu item 187 using smartphone as remote control for a7C 222-223 Toggle My Dial 1 2 3 options for control button 132 using Sony's light-based wireless flash system 81 Touch Focus menu option 58, 141, 152-153 using Sony's radio-based remote flash system 82 incompatibility with other settings 141 using the a7C camera as a webcam 227 using with video recording 141, 153 using tracking autofocus 16 Touch Operation menu item 152, 158, 175-176 view and transfer images on smartphone when camera pow-Touch Pad Settings menu item 153, 176-177 ered off 218 Touch Panel/Pad Menu Item 176 Still images Touch Position Mode menu option 153 saving from video recording 164, 211 Touch Shutter menu option 140-141 Still Image Save Destination menu option 109, 229 incompatibility with other settings 141 Street photography 233-234 Touch Tracking menu option 62, 141, 249 extracting still frames from 4K video for 233-234 available for video recording 141 using tilting LCD screen for 233 incompatibility with other settings 141 Subject Detection menu option 64 Tracking autofocus 16, 61-62, 153, 249 assigning to control button 127 turning on temporarily using control button 126-127 Switch AF Frame Move Hold option for control button 68, using touch focus with 153 Tracking On + AF option for control button 62, 127 Switch Focus Area option for control button Tracking On option for control button 62, 126-127 using in conjunction with Focus Area Limit menu option 63 Tracking option for focus area 61-62 Switch Right/Left Eye option for control button 128 Tripod socket 12, 155 Switch Vertical/Horizontal AF Area menu item 63 Tv notation for shutter speed 26 T U Tables UB Preset menu option 179 behavior of a7C for video recording in various modes 204 UB Time Record menu option 179 Camera Settings1 menu items that affect movies and can be Up button. See Display button adjusted for movie recording 205 USB Connection menu item 182 number of images that fit on 64 GB memory card 37 USB LUN Setting menu item 182 settings on a7C for recording video to Shogun recorder 210 USB port 12, 154 suggested control assignments for movie recording 212 USB power bank suggested menu settings for recording movies in Movie using to charge battery or power camera 240 mode 212 USB Power Supply menu item 182–183 suggested settings for Auto Mode still images 13 User Bit option for movie recording 178 suggested settings for movies in Intelligent Auto mode 18 setting to display current time 178, 179

\mathbf{V}

Variable bit rate setting for video formats 196 Version menu item 188 Video Light Mode menu option 107, 201–202
Video lights
Lume Cube Panel GO 243
Sony HVL-LBPC 243
View and transfer images on smartphone when camera powered off 218
Viewfinder. See Electronic viewfinder
Viewfinder Brightness menu item 172
VIEW icon on screen to indicate Setting Effect Off 120
View Mode menu item 157, 166–167
Volume Settings menu item 173

W

Webcam using a7C camera as 227 White balance bracketing setting of drive mode 47 changing order of exposures 48 using with self-timer 48 White balance comparison chart 86 White Balance menu item 83-86 adjusting setting using Raw software 85 adjusting setting with color axes 85, 248 available settings 84 fixed to Auto in Intelligent Auto mode 86 Wide option for focus area 58-59 Wi-Fi Direct Info menu option 229 Wi-Fi Settings menu item 230-231 Wind Noise Reduction menu item 107, 200 Wireless Flalsh menu option 80-81 using Sony light-based remote flash system 80-81 using Sony's radio-based remote flash system 81-82 Wireless network settings resetting 230 Wireless Test Flash option for control button 81, 129 Wireless tethered shooting 225, 229 WPS Push menu option 230 Write Serial Number menu item 185

\mathbf{X}

XAVC S 4K format for movies 195–196, 211 XAVC S HD format for movies 196

Z

Zebra Setting menu item 117–118
saving custom settings 117–118
using with movie recording 117
Zone focusing 126
Zone option for focus area 59
Zooming lens beyond optical zoom range 110–113
Zoom menu option 110–111
assigning to control button 110
not available for use with Power Zoom lens 110
using with Bluetooth remote control 110
Zoom Setting menu item 111–113
Zooom Ring Rotate menu option 113

•